DIASPORA AND VISUAL CULTURE

Diaspora and Visual Culture: Representing Africans and Jews is the first book to examine the connections between diaspora – the movement, whether forced or voluntary, of a nation or group of people from one homeland to another – and its representations in visual culture. Focusing on the visual culture of the African and Jewish diasporas, contributors address the rich complexity of diasporic cultures and art, and explore their potential to transform the way we look at ourselves and others.

Two foundational articles by Stuart Hall and the painter R.B. Kitaj provide points of departure for an exploration of the meanings of diaspora for cultural identity and artistic practice. In the second section, contributors examine the ways in which diaspora disrupted national and essentialist identity claims in nineteenth-century visual culture, focusing on the work of Caribbean-Jewish Impressionist painter Camille Pissarro; the African/Native American sculptor Mary Edmonia Lewis; and considering the notorious Dreyfus Affair.

The third section looks at the art of African-American women in the nineteenth and twentieth centuries, Yoruba diaspora art and performance in Brazil and New York, and the formation of American, European and Israeli artistic identity, addressing issues of identity, gender and sexuality in relation to diaspora. In the final section contributors focus on visual culture in Poland and Brazil – two countries exemplifying the fictitiousness of nation and national identity – considering how artists there have made sense of their unique multicultural societies.

DIASPORA AND VISUAL CULTURE

Representing Africans and Jews

Edited by Nicholas Mirzoeff

London and New York

First published in 2000
by Routledge
11 New Fetter Lane, London EC4P 4EE

Simultaneously published in the USA and Canada
by Routledge
29 West 35th Street, New York, NY 10001

Routledge is an imprint of the Taylor & Francis Group

Typeset in Bembo by
J&L Composition Ltd, Filey, North Yorkshire
Printed and bound in Great Britain by
T.J. International Ltd, Padstow, UK.

British Library Cataloguing in Publication Data
A catalogue record for this book is available from the British Library

Library of Congress Cataloging in Publication Data
Diaspora and visual culture/edited by Nicholas Mirzoeff.
 p. cm.
 Includes bibliographical references.
 ISBN 0–415–16669–1 (harbound : alk. paper). — ISBN 0–415–16670–5
(pbk. : alk. paper)
 1. Art, Jewish. 2. Art, African. 3. Art, Modern—19th century.
4. Art, Modern—20th century. 5. Jewish diaspora. 6. African
diaspora. 7. Identity (Psychology) in art. I. Mirzoeff, Nicholas,
1962– .
N7417.6.D53 1999
701′ .03—dc21

ISBN 0 415 16669 1 (hbk)
ISBN 0 415 16670 5 (pbk)

CONTENTS

CONTENTS

ILLUSTRATIONS

All illustrations are by the author with the exception of the following. We are indebted to the people and archives below for permission to reproduce these photographs. Every effort has been made to trace copyright holders, but in a few cases this has not been possible. Any omissions brought to our attention will be remedied in future editions.

CONTRIBUTORS

Paula J. Birnbaum is an Affiliated Scholar at the Institute for Research on Women and Gender at Stanford University and teaches art history at several institutions in the San Francisco Bay Area. She completed her doctorate at Bryn Mawr College in May 1996. The essay included here will be expanded upon in her forthcoming book on women artists and questions of modern identity in interwar France. She also lectures on issues of gender and ethnic displacement in the work of contemporary women artists.

Aline Brandauer is currently Curator of Contemporary Art at the Museum of Fine Arts in Santa Fe, New Mexico. She has lectured and written about twentieth-century art on three continents. Brandauer is currently working on a book about cultural slippage between France and Mexico during the 1920s and 1930s.

Henry John Drewal, Evjue-Bascom Professor of Art History and Afro-American Studies at the University of Wisconsin–Madison, has lived and worked with Yoruba-speaking people in West Africa, and African Brazilians in Salvador, Bahia over many years, publishing several books and numerous articles on their visual culture. He is presently conducting research in Brazil under NEH and Fulbright awards.

Margaret Thompson Drewal is Professor of Performance Studies at Northwestern University. Her publications include *Yoruba Ritual: Performers, Play, Agency* (1992).

Stuart Hall, Professor of Sociology at Goldsmiths' College, University of London, was for a decade director of the Centre for Contemporary Cultural Studies at Birmingham University. His many publications include (as editor), *Culture, Media and Language*, and *Resistance Through Rituals*, as well as his *The Hard Road to Renewal: Thatcherism and the Crisis of the Left*.

Dr Juanita Marie Holland is an independent scholar living in College Park, Maryland. Her research and writing concern African-Americans and Afro Caribbeans in the nineteenth century.

R.B. Kitaj is a distinguished painter and writer who has recently returned to the United States after long residing in Great Britain.

Norman L. Kleeblatt is the Susan and Elihu Rose Curator of Fine Arts at The Jewish Museum. Among the exhibitions he has curated are *The Dreyfus Affair: Art, Truth and Justice* (1987–8) and most recently, *Too Jewish? Challenging Traditional Identities*, which is completing its American tour. Mr. Kleeblatt is currently co-organizing an exhibition of the works of Chaim Soutine.

Eunice Lipton is a writer and art historian who lives in New York City. She publishes regularly for the *Nation* and the *Women's Review of Books*. Her books include *Looking into Degas: Uneasy Images of Women and Modern Life* and *Alias Olympia: A Woman's Search for Manet's Notorious Model and Her Own Desire*.

Nicholas Mirzoeff is Associate Professor of Art at SUNY Stony Brook. His publications include *An Introduction to Visual Culture* (1999) and *Silent Poetry: Deafness, Sign and Visual Culture in Modern France* (1995).

Moyo Okediji is an artist and art historian. Originally from Nigeria, he now teaches at the University of Colorado, Denver.

Simone Osthoff is a Brazilian artist and writer who lives in Evanston, Illinois. Her articles have appeared in *World Art*, *Blimp*, *Leonardo*, and the *New Art Examiner*. She can be contacted at ssinsley@starnetinc.com or at The School of the Art Institute of Chicago, Department of Art History, Theory and Criticism, 37 South Wabash Avenue, Chicago, IL 60603.

Irit Rogoff is Professor of Visual Culture at Goldsmiths College, University of London.

Alan Sinfield is editor of the journal *Textual Practice* and teaches English at the University of Sussex.

Carol Zemel is Professor and Chair of the Department of Art History at the State University of New York at Buffalo. She is author of *Van Gogh's Progress: Modernity and Utopia in Late-Nineteenth Century Art*, University of California Press, 1997. This essay is part of a book-length study, *Graven Images: Modern Visual Culture and Eastern European Jews* (in progress).

ACKNOWLEDGMENTS

1 Stuart Hall, "Cultural Identity and Diaspora", in Jonathan Rutherford (ed.), *Identity, Community, Culture, Difference* (London: Lawrence & Wishart, 1990), pp. 222–37. © Stuart Hall.

2 R.B. Kitaj, "Manifesto", in *First Diasporist Manifesto* (London: Thames and Hudson, 1989), pp. 19–49.

3 Juanita Marie Holland, "Mary Edmonia Lewis's 'Minnehaha': Gender, Race and the 'Indian Maid' ", in *Bulletin of the Detroit Institute of Arts* Vol. 69, no. 1/2 (1995), pp. 26–35.

6 Alan Sinfield, "Diaspora and Hybridity", from *Textual Practice* Vol. 10 Issue 2, Summer 1996, pp. 271–93.

8 Irit Rogoff, "Daughters of Sunshine – Diasporic Impulses and Gendered Identities" in Lisa Bloom (ed.), *With Other Eyes: Looking at Race and Gender in Visual Culture* (MN: University of Minnesota Press, 1999).

INTRODUCTION

The multiple viewpoint: diasporic visual cultures

Nicholas Mirzoeff

> The Jew and I: Since I was not satisfied to be racialized, by a lucky turn of fate, I was humanized. I joined the Jew, my brother in misery.
>
> <div align="right">Frantz Fanon (Fanon 1967: 122)</div>

> Kishinev and St Louis – the same soil, the same people. It is a distance of four and half thousand miles between these two cities and yet they are so close and so similar to each other
>
> <div align="right">*The Forward*, 1917 (quoted in Takaki 1995)</div>

When Marshall MacLuhan first coined the phrase "global village" in the 1950s, it must have had a comforting ring. It implies that despite the astonishing proliferation of new technologies, life in the information age will have the same sense of belonging and rootedness that goes along with village life. From our fin-de-siècle perspective, the information age seems much less optimistic. In place of firm notions of identity has come an era of mass migrations, displacements, exile and transition. Capitalism has become postnational, operating in the blocs constituted by such agreements as the North American Free Trade Association, GATT and the European Union. From France to Rwanda and the Middle East, virulent right-wing nationalist movements have sprung up in response to these challenges to the nation state. On the other hand, artists, critics and writers have re-examined the cultures of diaspora as a means of understanding and even embracing the new modes of postnational citizenship. For, as Arjun Appadurai has observed, "[i]n the postnational world we are seeing emerge, diaspora runs with, and not against, the grain of identity, movement and reproduction" (Appadurai 1993: 803). From academic journals like *Transition* and *Diaspora* to popular music anthems like Soul II Soul's *Keep On Movin'*, artworks like Vera Frenkel's . . . *from the Transit Bar* and films such as *Mississippi Masala*, the idea that culture must be based in one nation is increasingly being challenged. Now it is time to look at the way that culture crosses borders and oceans with ease in a constant state of evolution.

1

The new insistence on the diasporic in the work of such critics as Rey Chow (1993), James Clifford (1997), Paul Gilroy (1993), Stuart Hall (1990) and others results from a changed perception of the nature and meaning of diaspora itself. In the nineteenth century, diaspora peoples were seen as a disruption to the natural economy of the nation state. Diaspora peoples themselves envisaged an end to diaspora, whether in Theodore Herzl's Zionism or Marcus Garvey's return to Africa. For the self-conceived domestic population, diaspora peoples were an excess to national need to be disposed of by migration, colonial resettlement or ultimately by extermination. Diaspora was something that happened to "them" not "us." That comforting division no longer holds good. Olabiyi Babalola Yai tells us that the Yoruba peoples of West Africa consider themselves to be a permanently diasporic people, a consequence no doubt of the experiences of slavery and colonization (Yai 1994). In the late twentieth century, that feeling has gone global. Whereas nineteenth-century diasporas revealed interconnected nations, our current experience is of an increasingly interdependent planet.

There is a growing sense that we now find ourselves at, to use Stuart Hall's phrase, "the in-between of different cultures." This book is dedicated to thinking through what that in-between looks like in the African and Jewish diasporas. It is motivated by the belief that diaspora is an inevitably plural noun, meaning that diasporas cannot be properly understood in isolation. As the citations at the head of this chapter indicate, Africans and Jews have long looked to each other for an explanation of what it means to be in diaspora, an understanding that is now in urgent need of renewal. For the inability of traditional politics to cope with the postnational world has been accompanied by a remarkable efflorescence of cultural work of all kinds dedicated to understanding the genealogy of the new global culture and its potential to transform the way we look at ourselves and at others.

There is, however, a problem concerning the representation of diasporas. Diaspora cannot by its very nature be fully known, seen or quantified, even – or especially – by its own members. The notion of diaspora and visual culture embodies this paradox. A diaspora cannot be seen in any traditional sense and it certainly cannot be represented from the viewpoint of one-point perspective. The nation, by contrast, has long been central to Western visual culture. While we have become accustomed to thinking of the nation state as an "imagined community" (Anderson 1992), it can nonetheless call on a range of geographical sites, monuments and symbols to create a powerful visual rhetoric of nationality. The nineteenth-century creation of an extensive museum culture based on the idea of unfolding national histories gave institutional force to this vision of national culture (Sherman and Rogoff 1994; Clifford 1991). A distinction was made between historical objects that were displayed in national museums and the disinterested category of art, both of which excluded diaspora peoples. Museums served to emphasize the Western notion that history logically tended towards the dominance of the imperial

powers, while art collections served to reinforce the perceived "superiority" of Western culture. Diaspora peoples have been marginalized by this visualization of national cultures in museums, while consistently using visual means to represent their notions of loss, belonging, dispersal and identity. For example, the Border Art Workshop/Taller de Arte Frontizero and the collaborative work of Guillermo Gómez-Peña and Coco Fusco have provided a powerful alternative way of conceiving the US/Mexican relationship to the xenophobic simplicities of Ross Perot and California's Governor Pete Wilson (Fusco 1995: 145–201). In the academy, art history's notion of stylistic influence is another case in point. A successful attribution of stylistic influence relies on a clear visual homology between a source and its descendant together with evidence that the source was known to the artist. Martin J. Powers argues that

> [w]hat we call "style" is an important means whereby social groups project their constructed identities and stake their claims in the world. It may have been precisely for this reason that nineteenth- and much of twentieth-century art history stressed the "national" and personal element in style, since it was thought to be the visual counterpart of some internal essence.
>
> (Powers 1995: 384)

That essence was, of course, race. Powers does not mean to suggest that all art history must be rejected as racist but that, when we are involved in cross-cultural work, the traditional tools of the discipline must be handled with the greatest of care. Writing the history of diaspora visual cultures will, then, pose important methodological questions for both diaspora studies and the visual disciplines.

Diasporas and intervisuality

In much diaspora scholarship, the Jewish diaspora has been taken as the "ideal type" of the experience (Clifford 1997: 247–8), leading other diasporic experience to be mapped against this model. However, diasporas are rarely considered in tandem. For Jews, the parallel has often been to compare "Jewish" (nomadic) culture with "Greek" (national) culture in a tradition stemming from Matthew Arnold's *Culture and Anarchy* (1864) via James Joyce's formulation of the neologism "jewgreek." In the case of the African diaspora, the key question has been continuity with African traditions, rather than relations with other diaspora groups (Thompson 1983). Recent discussions of African–Jewish relations have thus concentrated almost exclusively on the case of North America since the Civil Rights era of the 1960s (Salzmann 1992). Even in this limited geographic space, Africans and Jews have been encountering one another since the seventeenth century, meaning that the hybridity generated by diaspora is not just an interaction with the "host" nation but

among diasporas themselves. For much of this time, Africans and Jews have seen their histories as mirroring one another. The nineteenth-century African diaspora theorist Edward Wilmot Blyden stated the parallel directly: "The Hebrews could not see or serve God in the land of the Egyptians; no more can the Negro under the Anglo-Saxon." In the contemporary world in which the dominant tension between center and periphery has been replaced by a global pattern of flows and resistances (Appadurai 1996), both Africans and Jews can benefit from renewing their sense of diaspora culture with reference to the other as well as the self. It is no coincidence that Paul Gilroy, who has taken a strong position against essentialist notions of African identity, has also brought the African–Jewish comparison to the heart of his work (Gilroy 1993: 205–16), implying a challenge to the historians of the Jewish diaspora to follow suit. The complete history of such parallel diasporas is beyond the scope of this book and probably beyond any one individual writer. What can be achieved is the re-opening of a discussion and the beginnings of new patterns of thought. By bringing together the work of a variety of scholars working on the visual cultures of African and Jewish diasporas, this book offers the reader an opportunity to undertake the traditional art historical task to "compare and contrast."

More importantly, it highlights new ways of thinking of diaspora as becoming, in the lineage of Stuart Hall's now classic essay "Cultural Identity and Diaspora," reprinted in this volume. For Hall, "diaspora identities are those which are constantly producing and reproducing themselves anew, through transformation and difference." This insight was in part inspired by Jacques Derrida's notion of *différance*, a state between differing and deferring. For Derrida himself, this implies that Jewishness, as opposed to Judaism, is "open to a future radically *to come*, which is to say indeterminate, determined only by this opening of the future to come" (Derrida 1996: 70). Similarly, the Jewish-American artist R.B. Kitaj, whose *Diasporist Manifesto* is reprinted in this volume, notes: "I try to be, along with many artists, forward-looking" (Kitaj 1989: 65).[1] Diaspora has long been understood as determined by the past, by the land which has been lost. More exactly, W.E.B. Dubois' concept of "double consciousness" has dominated understandings of diaspora: "One ever feels his twoness – an American, a Negro; two souls, two thoughts, two unreconciled strivings; two warring ideals in one dark body, whose dogged strength alone keeps it from being torn asunder" (Dubois 1989 [1903]: 5). Dubois saw this double consciousness as the defining problem of the twentieth century, and so it has proved. This tension can in part be understood as a dialectic between past and present. It may be possible, by developing the notion of the future into the diaspora identity, to discover additional dimensions to diaspora consciousness. If it can now be rethought as an indeterminate future to come, that will imply a significant re-evaluation of diasporas past, present and future to which this volume can only contribute.

However, debate over the African and Jewish diasporas has been dominated

instead by the highly effective and notorious preaching of Minister Louis Farrakhan of the Nation of Islam (Berman 1994). Farrakhan straightforwardly asserts that "[s]ome of the biggest slave merchants were Jews. The owners of the slave ships were Jews ... It's been a master–slave relationship" (Gardell 1996: 260). Although historians have shown the absolute inaccuracy of such statements (Faber 1998), their work has had little effect on the impact of Farrakhan's comments, not least because of persistent racism in some sections of the Jewish community. His goal is not to change the academic consensus on slavery but for the Nation of Islam to take over the metaphorical place of the Jews in modern American popular culture:

> I declare to the world that the people of God are not those who call themselves Jews, but the people of God who are chosen in this critical time in history are you, the black people of America, the lost, the despised, the rejected
>
> (Gardell 1996: 258).

Farrakhan's argument is, in effect, that the present relative wealth of American Jews by comparison with African–Americans invalidates any claim that they might have to be the people of God. This message has found a significant audience in the world of rap and hip-hop, where many performers have turned to the Nation of Islam. One of the most notorious Farrakhan aides, Khallid Abdul Mohammad, has performed with the rap group Public Enemy and the L.A. gangsta rapper Ice Cube. Rap now sells extensively to white teenagers in the suburbs but individual artists continue to base their claim to authenticity or "realness" on their roots in the black ghetto. While not every American Jew has achieved great wealth, few can claim "realness" on this level. However, this is not a sociological debate, as demonstrated by the success of the suburban Jew turned rapper, Adam Horowitz of the Beastie Boys. What is at stake is the claim to a metaphorical and rhetorical position as the absolute Diaspora, perceived as a singular and exclusive condition. Both Farrakhan's supporters and some of those who use him as demon figure use the Other diaspora as a means of disciplining their own. That is to say, in a world marked by hybridity and diversity, the absolute evil of the Other is perhaps the only means by which the integrity of the same can be sustained. As long as "realness" is perceived solely in performative terms of the "origin" of diaspora, this debate will continue to be as unproductive as it has been to date. In some senses, it could be argued that the tensions between Africans and Jews in the United States stem from this insistence that diaspora is only about origins and the past. Both groups claim to have suffered most in diaspora and at the same time assert a crucial place in modern "Americanness." To adopt Gilroy's distinction, both groups need to reassert their "routes" over their "roots," while also paying attention both to those places where African and Jewish routes have overlapped in the past and to ways in which they might again merge in the future.

The notion of a "route" may be too singular. In his *Diasporist Manifesto* Kitaj defines the diasporist as appearing in "every polyglot matrix," an appropriately fractal metaphor for these complicated times. He later glossed the "polyglot" to mean "Jew, Black, Arab, Homosexual, Gypsy, Asian, emigré from despotism, bad luck etc.," divorcing the idea of diaspora from any essentialist notion of "race" or ethnicity (Kitaj 1989: 75). By extending the categories of the diasporist beyond the dispersed nation state, Kitaj challenges us to rethink the notion of authenticity, as applied to both national and diaspora cultures. It further opens diaspora to categories beyond the national, especially sexual minorities. Indeed, it almost suggests that diaspora is becoming a majority condition in global capitalism. This polymorphous notion of diaspora transforms the visual image itself as "the Diasporist painting I have always done also often represents more than one view" (Kitaj 1989: 73). Kitaj's sense of the multiplicity of diaspora is not limited to his own art but, as the essays in this collection show, is also part of the revision of modernism commonly known as postmodernism. Diaspora generates what I shall call a "multiple viewpoint" in any diasporic visual image. This viewpoint incorporates Derrida's *différance*, Kitaj's many views and what Ella Shohat and Robert Stam have called a "polycentric vision" in which the visual is located "*between* individuals and communities and cultures in the process of dialogic interaction" (Shohat and Stam 1998: 46). The multiple viewpoint moves beyond the one-point perspective of Cartesian rationalism in the search for a forward-looking, transcultural and transitive place from which to look and be seen. In the contemporary moment, when imagination itself "is neither purely emancipatory nor entirely disciplined but is a space of contestation in which individuals and groups seek to annex the global into their own pratices of the modern" (Appadurai 1996: 4), changing the way in which people see themselves is in all senses a critical activity.

For those contemporary artists, critics and historians concerned with diaspora, the key question thus becomes determining what such multiple viewpoints look like now, in the past and in the future. Indeed, the multiple viewpoint has much to offer all those seeking new ways to formulate key questions of the gaze and spectatorship. Just as theories of hybridity and *mestizaje* developed in the Caribbean, India and Latin America now seem the most contemporary tools with which to examine the "West," so may visual theory developed in rethinking diaspora contribute to the ongoing rethinking of the visual that has come to be termed visual culture. Such questions, by their nature, are unlikely to produce an answer in the form of traditional "evidence." Homi Bhabha has situated his influential endorsement of hybridity under the sign of a double negative, "neither the one, nor the other." He nonetheless hopes that a new art may emerge from the working through of these contradictions, provided that it

> demands an encounter with "newness" that is not part of the continuum of past and present. It creates a sense of the new as an insurgent

act of cultural translation. Such art does not merely recall the past as social cause or aesthetic precedent; it renews the past, refiguring it as a contingent "in-between" space, that innovates and interrupts the performance of the present. The "past-present" becomes part of the necessity, not the nostalgia, of living.

(Bhabha 1994: 7)

From the fragments of the past-present – that is to say, double consciousness – Bhabha sees the creation of multiple diaspora futures, futures forged from memory and experience but not dependent on them. This kind of work cannot be done by standard histories and realist representations. It is what Jean-François Lyotard meant when he called the sublime the modern mode of presenting the unpresentable. This, then, is the postmodern diasporic dilemma: how can something be visualized that is adequate to guide us round what is so widely felt to be new, when all that is available is the discredited apparatus of the modern? One method of constructing answers to that question lies in writing diasporist genealogies of the present that refigure the past in order to facilitate the theoretical and phenomenological understanding of the multiple viewpoint of diaspora. Such work entails a certain risk, described by Iain Chambers as "embracing a mode of thought that is destined to be incomplete" (Chambers 1994: 70). Any writing that addresses the future must, by its very nature, fail to fully succeed.

The diasporic visual image is necessarily intertextual, in that the spectator needs to bring extratextual information to bear on what is seen within the frame in order to make full sense of it. However, in the visual image, intertextuality is not simply a matter of interlocking texts but of interacting and interdependent modes of visuality that I shall call intervisuality. From a particular starting point, a diasporic image can create multiple visual and intellectual associations both within and beyond the intent of the producer of that image. Robert Farris Thompson's example of the yodel shows how even a certain sound becomes the gateway to a multiple viewpoint on the African diaspora.[2] The yodel is "a chest/head, high low snap across an octave [that] is one of the hallmarks of the singing of rainforest pygmies in Central Africa." Thompson hears the echo of that yodel in Kongo music and from there in the Mississippi Delta blues, a sound that resonated with the wail of a steam engine:

By the 1940s, if your ear were culturally prepared, you could hear a lonesome train whistle in the night and immediately think of black people, on the move. From Memphis to Mobile. Goin' to Chicago, sorry that I can't take you.

(Thompson 1989: 98)

The American railway was the means by which the Great Migration of African-Americans from South to North took place, as depicted by Jacob

Lawrence in his series painting *The Migration of the Negro* (1940). This modern diaspora inevitably evoked the forced transatlantic diaspora of slavery that had brought Africans to America, creating different music like the blues, jazz and soul in which the train was both inspiration and subject-matter. In short, the train whistle had become what Mikhail Iampolski has called a "hyperquote," an artifact generating multiple intertextual references (Iampolski 1998: 35). Learning to hear under Thompson's tuition, one could even go further. The American railroads were built by Africans, Chicanos, Chinese, Irish, Japanese and other immigrants, each with their own song expressing the pain of the work. Frederick Douglass heard echoes of African song in Irish ballads (Takaki 1995: 21–2). Others have made a similar connection to the Yiddish music of Eastern Europe. As has been widely noted, the train itself is a privileged site in the creation of Western visual culture, for the view from the train window was the first perception of the moving image that later became institutionalized as cinema. The train, to use Stephen Heath's distinction, was where the seen first became the scene. By the 1940s, the railway had been transformed from a symbol of European progress to the facilitator of the Holocaust, with special meaning for Jews, gypsies, gays, the disabled and the other victims of slaughter. This resonance informs work as various as R.B. Kitaj's painting *The Jewish Rider*, Vera Frenkel's installation piece and web site . . . *from the Transit Bar* and Claude Lanzmann's epic documentary *Shoah*. Diasporas do not occur one by one but inevitably overlap, creating polyvalent symbols that are sometimes shared, sometimes contested. Diaspora moves like that, adjacently and in free-style.

Diaspora politics

There is, however, a danger that diaspora can be taken as truly "authentic," a new universalism in contrast to the formal structures of national culture. It certainly seems to come packaged in an attractive "alternative" wrapping, promising interdisciplinary and cross-cultural ideas that hope to resist the normalizing tendencies of the critical process. However, the attractions of the nomad lifestyle are as clear to elites as to popular and critical groups. Almost all Americans now seek a connection to alterity, as shown by every recent President discovering their "Irish" roots on the campaign trail. Suddenly, diaspora as a subject position has become fashionable, leaving the historical diaspora communities with some quandries. In an age when the most marked diaspora is that of capital, we are all the "wretched of the earth." Cyberprophet Jacques Attali heralds the emergence of a new class he calls "liberated nomads bound by nothing but desire and imagination, greed and ambition" (Owen 1996: 31). This new superclass will use their "nomadic objects" like laptops with fax modems, cellular phones and DAT recorders to regulate a workforce compelled to be nomadic in pursuit of ever-diminishing employment. As diaspora becomes a way of life, it is emerging as a fragmented class-riven norm,

rather than the romanticized refuge of the persecuted. In Latin America, hybridity under the name *mestizaje* is already a central element of government strategy, as Sean Cubitt explains:

> When presidents in Bolivia or Brazil want to lay claim to legitimacy in a continent whose cultures and economies are overlays of indigenous, colonial and slave populations, they claim *mestizaje*: no longer the property of resistance, this hybridity is the authority of rule – like Clinton's saxophone, it marks a place between, a fictive and utopian space, a territory of meeting, empathy, commonality.
>
> (Cubitt 1995: 71)

Thus the claim to hybridity that may seem to be the mark of resistance in former colonial powers can be the sign of political authority in some former colonies. The Latin American experience can stand as a useful corrective to some of the more present-centered approaches all too common in today's cultural studies. Even if that work often refers only to Great Britain, it ignores Britain's ethnic diversity in the eighteenth century, whose visibility was diminished in the nineteenth century through intermarriage but far from eradicated, as historians have recently argued (Wilson 1995). Further, as Robert Young has shown, hybridity was a central goal of nineteenth-century imperial administrators (Young 1995). Caution is therefore required in making exclusively positive use of such terms as hybridity and diaspora.

Indeed, the African critic V.Y. Mudimbe has recently critiqued the new focus on diasporic culture as being governed by an unthinking continuity with the nineteenth-century nation state:

> [O]ur contemporary thought seems to be a thought of exile, a thought hiding behind a nostalgia for the recent past, a thought speaking from spaces and cultures that no longer exist and were dead long before the death of the long nineteenth century
>
> (Mudimbe 1995: 983)

Mudimbe might perhaps have had in mind James Clifford's earlier celebration of the traveler or Paul Gilroy's focus on the sailor as a hero of diaspora narratives. At the same time, this re-emergence of nineteenth-century discursive practice as a motive force of late twentieth-century culture was by no means self-evident until the end of the Cold War. Mudimbe's critique thus highlights the ways in which the postmodern permits a re-reading of the modern in the light of the failure of modernist grand narratives. It suggests that the nation state depended on its diasporic others as a means of negative differentiation. That is to say, diaspora peoples like Africans, Armenians, Gypsies and Jews were the definition of what a nation was not and, as a consequence, were the target of sustained nationally organized terror throughout the modern period.

Simply inverting the terms to privilege the diasporic over the national will not, in Mudimbe's view, change the fundamental structure of the discourse. The contained dialogue of the past with the present needs to be broken by the indeterminate figure of the future.

One way to think through this problem was supplied by Jean-François Lyotard in his response to the Heidegger affair. In 1987, Victor Farias published a book called *Heidegger and Nazism*, demonstrating that the German philosopher Martin Heidegger had far more extensive connections with the Nazi party than had previously been thought (Steiner 1995: 177–88). Although Heidegger's Nazi past was no secret – Jean-Paul Sartre had refused to meet him for this very reason – the charges took on greater importance due to the centrality of Heidegger's thought in French poststructuralism. Could it in some way be said that poststructuralism's questioning of Western philosophy was tainted by association with Nazism? For those opposed to poststructural thought, the answer was simply "yes," forcing many into equivocal defences of Heidegger. By contrast, Lyotard realized that the crisis in modern thought was precisely that Heidegger was at one and the same time a great thinker and someone who had a "deliberate, profound [and] persistent" involvement with National Socialism. Consistent with his earlier assertion that we have paid too high a price for the sustainment of modernism's grand narratives, Lyotard argued that this contradiction in Heidegger was most strikingly apparent in his inability to understand those who are not authentic to his twin principles of Being (*Dasein*) and people (*Volk*). Lyotard names these people "the jews":

> They are what cannot be domesticated in the obsession to dominate, in the compulsion to control domain, in the passion for empire . . . "The jews," never at home wherever they are, cannot be integrated, converted or expelled. They are also always away from home when they are at home, in their so-called own tradition.
>
> (Lyotard 1990: 22)

For both Kitaj and Lyotard, then, the diasporists or "the jews" are the sign that modern aspirations to a fully authentic national culture can never be realized. The past cannot be synthesized into the present without creating a remainder.

One incident may serve to indicate how much work there is to be done. In 1995 Ethiopian Israelis vehemently protested when it was revealed that Israeli authorities had been disposing of Ethiopian blood donations motivated by an unfounded fear of AIDS. There is no more charged symbol in African and Jewish history than blood. Since the early Christian era, Jews have been slandered with the infamous blood libel, that is to say, the belief that Jews murder Christians in order to make various religious uses of their blood. Far from being restricted to medieval persecutions, the blood libel was revived periodically throughout modern history, with a rash of cases in the late nineteenth

century. Both the Spanish Inquisition and the Nazis sought to keep the blood of their Gentile population "pure" of contamination by Jewish blood. So intense was this passion that the Inquisition "investigated" the Virgin Mary herself in order to prove her racial purity. This same doctrine lay behind much of the racist practice of the American South, where individuals were defined as "black" by the "one drop of blood" rule. In other words, anyone who had any African ancestry whatsoever was perceived as black. By this logic, of course, the entire world population is black, but logic has had little role to play in such debates. One would therefore imagine that it ought to have been impossible for Israeli "white" Jews to believe that "black" Jews had contaminated blood. It seems that the myths of hundreds of years of diaspora have not been ended by forty years of statehood nor are diasporists themselves immune to such mistaken but powerful myths. Blood is a powerful symbol that is remarkably intervisual in ways that cannot always be contained.

Diaspora and visual culture: the essays

This volume begins with the essays by Stuart Hall and R.B. Kitaj, described above, that provide the key point of departure for diaspora visual studies. In these insightful pieces, we are challenged to rethink our assumptions about what constitutes diaspora and how it might be represented. Neither claims to be writing universally. Hall departs from his own experience in the African diaspora, having grown up in Jamaica and then lived and worked as an adult in Great Britain. Kitaj observes laconically that he lives in "post-Holocaust diasporism," a specific and difficult freedom, to use Levinas's term. For both writers, as Hall puts it, "we can't literally go home again" but nonetheless our cultural work must allow us "to see and recognise the different parts and histories of ourselves, to construct those points of identification, those positionalities we call in retrospect our 'cultural identities'."

In the second section, three essays examine the ways in which diaspora disrupted national and essentialist identity claims in nineteenth-century visual culture. Juanita Marie Holland examines the complex interaction of gender and "race" in the work of the nineteenth-century sculptor Mary Edmonia Lewis. It was unusual enough for a woman to sculpt in this period, but Lewis had an African-American father and a Native American mother of the Ojibwa/Chippewa people. Holland shows how Lewis created "multiple identities" to negotiate her need for artistic training, subject matter and patrons. She concludes that "Lewis created or greatly embellished her Indian past to enhance the public's interest in her life and work," while playing down her more problematic African-American ancestry. In my essay, I show how the Impressionist artist Camille Pissarro was also strongly influenced by the dynamic of his background as a Caribbean Jew. Arguing that "Jewishness" in visual culture should not be restricted to traditional Jewish iconography, I argue that for Pissarro, the question was precisely how to be Jewish and

11

modern at once, provided that Jewishness was understood neither as race nor religion. Ethnicity and "race" were not simply denoted in avant-garde art but rather connoted as an aspect of pictorial technique. Pissarro's focus on sensation as the key aspect of his work thus engaged with the locus of ethnic difference in modern France. He termed this work "passage," a term that resonates with intervisual connections to diaspora, "race" and sexuality. Curator of the influential exhibitions *The Dreyfus Affair* and *Too Jewish*, Norman L. Kleeblatt concludes the section with a reconsideration of the most notorious of all Jewish bodies, that of Captain Alfred Dreyfus. Kleeblatt here highlights the little-regarded coincidence that in the very wastepaper basket where the French intelligence discovered the *bordereau* – the document used to convict Dreyfus – they also discovered unmistakeable passionate homosexual love letters between the Italian and German military attachés in Paris. Public exposure of this scandal might have led to serious political and even military confrontation. Kleeblatt argues that "Dreyfus's victimization offered a transference of the threatened manhood and power of the French military." He shows that these anxieties were played out not only in the Dreyfus case but in the later development of Zionism and its notion of the "muscle Jew." This paper presents the fin-de-siècle as an interplay of representation, sexuality, stereotype, medical discourse and political action with intriguing homologies with our own time.

Engendering diaspora

Diaspora has seemed very much a (heterosexual) man's world in some studies as James Clifford has pointed out (Clifford 1997: 272–3). It is in this field that visual culture has perhaps the most to contribute to diaspora studies. Since the 1970s, art history, film and media studies have all developed significant theoretical and historical analyses of the gendering of looking, the representation of gender and sexuality, and the role of women, gay and lesbian artists. The first corrective move was simply to include women, lesbians and gay men in the history of diaspora and its visual culture. Increasingly, critics are seeking to understand the ways in which diaspora itself is gendered and the role sexuality plays in shaping diaspora identity. Almost all of the chapters in this volume show that gender and sexuality combined to add a third layer to the "double consciousness" of diasporic modernity. The chapters in the third section directly address these issues from a variety of perspectives that seem to suggest collectively new directions for both historical and theoretical work.

In seeking to provide answers to some of these questions, it is noticeable that the authors in this volume have limited themselves to a series of specific circumstances, attending to the complexities of the local as a means of approaching the global, rather than vice versa. Picking up on Stuart Hall's notion of diaspora as an identity in itself, Alan Sinfield argues that queer

identity could more profitably be thought of as diasporic, in distinction to the national rhetoric of groups like Queer Nation or the ethnic model in which gay rights are claimed in the manner of the United States' Civil Rights Movement. He proposes that lesbians and gay men envisage themselves as a subculture constituted around the "queer diasporic experience." Taken in concert with other work in queer theory that has problematized the (heterosexual) gendering of the gaze as providing only a masculine/feminine binary viewpoint (Mayne 1993), Sinfield's perspective offers fruitful new ways of conceptualizing diaspora. Margaret Thompson Drewal provides us with a fascinating insight into the performance of diasporic gender and sexual identities in what has become termed "Yoruba reversionism," the recreation of Yoruba religious practices in diaspora. Stressing the importance of actual performance over the theoretical construct of performativity advanced by Judith Butler and others, Drewal describes how the deities invoked at the *bembe*, descend and "mount" participants, often crossing genders and sexualities in their manifestations. The performance of the *bembe* shows how diaspora traditions are in no sense fixed but are "continuously reinterpreted, re-invented and recreated anew." Taking as his starting point the televising of the Egungun masquerade in contemporary Nigeria, artist and art historian Moyo Okediji next examines the figuration of what he terms "metamodern masks" in the work of three African-American women artists, Howardena Pindell, Adrian Piper and Renée Stout. Okediji highlights the "diasporic transmutations" undertaken in different ways by these artists transforming the body as they transform national and diasporic identities. For both Drewal and Okediji, the body is a key site of diaspora experience but one that is neither stable nor fixed. The last two essays reflect on what it means to undertake art history writing as what Donna Haraway has called a "situated knowledge" when the writer's situation is in fact diaspora. At the same time, they suggest that the sensibility of Jewish diaspora has recently increased, rather than diminished, despite – or even because of – the existence of the state of Israel. Irit Rogoff reflects on the ways in which her identity in the newly-formed state of Israel was formed from a "conjunction of Judaism, femininity and modernity," in itself constantly referenced to European origins to create "the diaspora's diaspora." Eunice Lipton has previously explored how she came to embrace and then reject a professional art history career in her remarkable book *Alias Olympia*, creating a voice that moved fluently between autobiography, fictional recreation and scholarly analysis. In similar vein, she uses her essay as the occasion to reflect on how her interest in art was formed in her Jewish childhood in New York City by a rather unlikely nineteenth-century academic painting. Further she considers why, as a professional art historian, she came to write at length from a Marxist and feminist perspective on the artist Edgar Degas without considering his anti-Semitism. Lipton's frank self-examination reminds us that every insight is enabled by another oversight.

Poland–Brazil

The last section of essays looks at the specificities of diaspora in the different circumstances of Brazil and Poland. Bringing these two nations together creates an unfamiliar axis with which to examine what Joseph Roach has called the "circum-Atlantic world" away from the familiar binary of colonizer and colonized (Poland does not border the Atlantic, of course, but the way "out" of Poland for her Jews was across the ocean). Both countries are examples of the fictitiousness of nation and national identity, constituted as much by various forms of diasporic memory as by any internal nationalism. Poland has struggled for existence caught between larger imperial powers to the East and West. Nonetheless, Poland's Jewish comunity, the most populous and most hated in Europe before the Second World War, found no sympathy from their Gentile counterparts. Poland is a particularly resonant site for many Ashkenazi Jews as Polish Jewish culture all but disappeared in the Shoah. Carol Zemel considers contrasting photographic representations of *shtetl* (Yiddish for small town or village) life in 1920s and 1930s Poland. She shows how both documentary and modernist photographic styles created a narrative of diaspora life which "literally reframed diaspora consciousness, linking both content and readers to modernity." Although nostalgia was certainly evoked for the early twentieth-century viewer, Zemel provocatively concludes that these images take on a different hue in the present moment as we debate both Jewish identity and the "conflicts of multiculturalisms." Paula J. Birnbaum also pursues this theme of Polish-Jewish diaspora by examining the work of two exiled painters, Alice Halicka and Louis Marcoussis. Her reading of their work shows that they went to great lengths to conceal their Jewishness and to evoke symbols of metropolitan belonging. While Marcoussis continued to use a Cubist style to claim French nationality, Halicka created "a more complicated and shifting response . . . to the problems of displacement and marginalization faced by diaspora peoples." From 1920 onwards, Jewish iconography, physical "types" and subjects appear frequently in Halicka's work. The Jewish mother became a central figure in her work, as ever represented in highly ambivalent style. These chapters combine to show that "Jewishness" did not simply exist awaiting figuration by artists but was an unstable identity, fissured by gender and modernism, and in constant need of renewal.

Two intriguing essays next consider strikingly different aspects of Afro-Brazil. Brazil is an entity carved out of the South American continent by the colonial enterprise of the Portuguese. Extensive indigenous cultures were destroyed by force and by the devastating effect of European diseases on a population without immunity. In their place came the (in)famous coffee and sugar plantations of Brazil, built on the labor of enslaved Africans. Not only was Brazil the destination for at least four million Africans, Brazilian slavery remained in force until 1888. Modern Brazil's mix of indigenous peoples, Europeans, Africans and all varieties of combination make it in some ways par-

adigmatic of the twenty-first century nation. Economist Goran Therborn has argued that the economies of Western Europe and North America are currently undergoing a Brazilianization, entailing the construction of a permanent and significant subaltern underclass and a small but powerful elite. For Europeans and North Americans, understanding Brazil is more than a gesture to multiculturalism, it is a look into the near future.

Simone Osthoff investigates the work of her fellow Brazilian artist Hélio Oiticica, in particular his widely-known body of work, the Parangolés. A fusion of words, materials and performance, the Parangolés were Oiticica's attempt to create a hybrid from European high modernism and Brazilian vernacular culture, especially that of Afro-Brazil. Osthoff argues that they should be seen "under the light of diaspora and of the nomadic experiences of seeing the world from an inside/outside perspective, a viewpoint between cultures." "Parangolé" is a slang term meaning "sudden confusion between people" and Osthoff pursues the ways in which Oiticica's exploration of form necessarily involved broader ethical, social and political questions. He denied the possibility of purity, and adopted the practice of carnival as emblematic of the new Brazilian hybrid he was trying to create. Henry J. Drewal is similarly concerned to explicate "how Afro-Brazilians forged and continue to forge distinctive artistic worlds despite Euro-Brazilian attempts at cultural hegemony." Drawing on a remarkable range of sources, from contemporary Brazilian art practice to the ethnography of French neo-classical artist Jean-Baptiste Debret and the martial art of *capoeira*, Drewal argues that the diaspora caused by slavery created what he terms "multiple consciousness." Africans in Brazil developed this strategy as a means for survival in the harsh conditions of the colonial plantation by continuing to use African theories of agency, adapted to their new surroundings. Drewal shows how Brazilian ecclesiastical architecture, language and festivals contained hidden histories that enabled Afro-Brazilians to sustain a distinct cultural identity. Based on her response to these four papers at the College Art Association meeting in Boston (1996), Aline Brandauer suggests here that the Latin American theme of "interpenetration" may help us develop cross-diaspora understandings. She notes that interpenetration is "that most feared and *gendered* enemy of formulations of 'modernism' and the nation state." Drawing on the criticism of Trinh T. Minh-ha, Brandauer seeks to move beyond the critique of the phallocentrism of modernism to question both the positive aspects of the formation of modernism and the nature of the evidence we as critics bring to that task.

Time for a change?

In sum, all the writers in this volume describe an ambivalent intervisual multiple viewpoint on diaspora that is not only our best means of understanding diasporas past but of producing diasporic work in the present and future. From Henry J. Drewal's "multiple consciousness" to Rogoff's "diaspora of diaspora"

via Pissarro's "passage" and the "metamodern masks" of Pindell, Piper and Stout, multiplicity is the key to identity, interpretation and visual pleasure. The intervisual encounter continues to produce new transcultural meanings for diasporic cultures. In Mathieu Kassovitz's striking 1995 film *La Haine* (*Hate*), depicting life in the Parisian projects, there is a moment in which the polyphony of diaspora is actively visualized. After a riot in which one young Arab man is left in a coma, Sayid and his friends Vinz and Hubert are killing time in their project when a DJ opens his windows and begins to play. He scratches up a break beat and overlays it with the chorus from Edith Piaf's *Je Ne Regrette Rien*. The trio – composed of one Arab, one Jew and one black African – are mesmerized by the sound. The transcultural mix incorporates African-American hip-hop beats with classic French cabaret singing to create a new mix that, just for a moment, transforms the empty space of the housing project into a place where people from different backgrounds can belong. This brief moment of optimism is offset by a violent and ultimately fatal series of confrontations between the young men and the police. It is in the interstices of such moments, at once contradictory, polyphonic and utopian, that the investigation of the visual cultures of diaspora will go on.

Notes

1 Interestingly, Kitaj hints that he was also influenced by deconstruction: "Thirty years later, I've learnt of the Diasporists of the Ecole de Yale [de Man and his students] and their crazed and fascinating Cult of the Fragment (based on their French Diasporist mentor)" (Kitaj 1989: 59).
2 While this is not the place to pursue the argument, Derrida has shown that sound is incorporated into any "pictogram" in alphabetic societies: "the sound may also be an atomic element itself entering into the composition" (Derrida 1976: 90). In other words, it is entirely consistent with the logic of phonocentric culture to begin with a sound in pursuing the visual image.

References

Anderson, Benedict (1992), *Imagined Communities*, 2nd edn, London: Verso.

Appadurai, Arjun (1993), "The Heart of Whiteness," *Callaloo* 16.4 (1993): 796–807.

Appadurai, Arjun (1996), *Modernity at Large: Cultural Dimensions of Globalization*, Minneapolis: University of Minnesota Press.

Berman, Paul (1994), *Blacks and Jews: Alliances and Arguments*, New York: Delacorte Press.

Boyarin, Jonathan (1993), *Storm from Paradise*, Minneapolis: Minnesota University Press.

Chambers, Iain (1994), *Migrancy Culture Identity*, London: Routledge.

Chow, Rey (1993), *Writing Diaspora*, Bloomington: Indiana University Press.

Clifford, James (1991), *The Predicament of Culture*, Cambridge Ma.: Harvard University Press.

Clifford, James (1997), *Routes: Travel and Translation in the Late Twentieth Century*, Cambridge Ma.: Harvard University Press.

Cubitt, Sean (1995), "Dispersed Visions: 'About Place'," *Third Text* 32 (Autumn 1995): 65–74.

Derrida, Jacques (1976), *Of Grammatology*, Baltimore: Johns Hopkins Press.

Derrida, Jacques (1996), *Archive Fever: A Freudian Impression*, Chicago: Chicago University Press.

Dubois, W.E.B. (1989 [1903]), *The Souls of Black Folk*, London: Penguin.

Faber, Eli (1998), *Jews, Slaves and the Slave Trade: Setting the Record Straight*, New York: New York University Press.

Fanon, Frantz (1967), *Black Skin, White Masks*, New York: Grove Weidenfeld.

Fusco, Coco (1995), *English Is Broken Here: Notes in Cultural Fusion in the Americas*, New York: New Press.

Gilman, Sander (1991), *The Jew's Body*, New York: Routledge.

Gilroy, Paul (1993), *The Black Atlantic: Modernity and Double Consciousness*, Cambridge Ma: Harvard University Press.

Iampolski, Mikhail (1998), *The Memory of Tiresias: Intertextuality and Film*, Berkeley: University of California Press.

Kitaj, R.B. (1989), *First Diasporist Manifesto*, London: Thames and Hudson.

Lippard, Lucy (1990), *Mixed Blessings: New Art in a Multicultural America*, New York: Pantheon.

Mayne, Judith (1993), *Cinema and Spectatorship*, New York: Routledge.

Mbembe, Achille (1995), "Figures of the Subject in Times of Crisis," *Public Culture* 7: 323–52.

Mudimbe, V.Y. (1995), "Introduction" to *Nations, Identities, Cultures*, special issue of *South Atlantic Quarterly* 94 : 4 (Fall 1995).

Owen, Frank (1996), "Let Them Eat Software," *Village Voice* (February 6, 1996).

Powers, Martin J. (1995), "Art and History: Exploring the Counterchange Condition," *Art Bulletin* Vol. LXXVII no. 3 (September 1995): 382–7.

Said, Edward (1993), *Culture and Imperialism*, New York: Alfred Knopf.

Salzmann, Jack (ed.) (1992), *Bridges and Boundaries: African Americans and American Jews*, New York: George Brazilier.

Sherman, Daniel and Rogoff, Irit (1994), *Museum Culture*, Minneapolis: Minnesota University Press.

Shohat, Ella and Stam, Robert (1998), "Narrativizing Visual Culture: Towards a

Polycentric Aesthetics," in Nicholas Mirzoeff (ed.), *The Visual Culture Reader*, London and New York: Routledge.

Steiner, Wendy (1995), *The Scandal of Pleasure*, Chicago: University of Chicago Press.

Takaki, Ronald (1995), "A Different Mirror," in *Points of Entry: Tracing Cultures*, San Francisco: The Friends of Photography.

Thompson, Robert Farris (1983), *Flash of the Spirit: African and Afro American Art and Philosophy*, New York: Random House.

Thompson, Robert Farris (1989), "The Song That Named the Land: The Visionary Presence of African-American Art," in Robert V. Rozelle, Alvia Wardlaw and Maureen A. McKenna (eds), *Black Art Ancestral Legacy: The African Impulse in African-American Art*, New York: Harry N. Abrams/Dallas Museum of Art.

Wilson, Kathleen (1995), "Citizenship, Empire and Modernity in the English Provinces 1720–90," *Eighteenth Century Studies*.

Yai, Olabiyi Babalola (1994), "In Praise of Metonymy: The Concepts of 'Tradition' and 'Creativity' in the Transmission of Yoruba Artistry over Time and Space," in Roland Abioudun, Henry J. Drewal, and John Pemberton III (eds), *The Yoruba Artist: New Theoretical Perspectives on African Arts*, Washington DC: Smithsonian Institution Press, pp. 107–15.

Young, Robert (1995), *Colonial Desire: Hybridity in Theory, Culture and Race*, London: Routledge.

Part I

POINTS OF DEPARTURE

1

CULTURAL IDENTITY AND DIASPORA

Stuart Hall[1]

A new cinema of the Caribbean is emerging, joining the company of the other "Third Cinemas." It is related to, but different from, the vibrant film and other forms of visual representation of the Afro-Caribbean (and Asian) "blacks" of the diasporas of the West – the new post-colonial subjects. All these cultural practices and forms of representation have the black subject at their center, putting the issue of cultural identity in question. Who is this emergent, new subject of the cinema? From where does he/she speak? Practices of representation always implicate the positions from which we speak or write – the positions of *enunciation*. What recent theories of enunciation suggest is that, though we speak, so to say "in our own name," of ourselves and from our own experience, nevertheless who speaks, and the subject who is spoken of, are never identical, never exactly in the same place. Identity is not as transparent or unproblematic as we think. Perhaps instead of thinking of identity as an already accomplished fact, which the new cultural practices then represent, we should think, instead, of identity as a "production" which is never complete, always in process, and always constituted within, not outside, representation. This view problematizes the very authority and authenticity to which the term "cultural identity" lays claim.

We seek, here, to open a dialogue, an investigation, on the subject of cultural identity and representation. Of course, the 'I' who writes here must also be thought of as, itself, "enunciated." We all write and speak from a particular place and time, from a history and a culture which is specific. What we say is always "in context," *positioned*. I was born into and spent my childhood and adolescence in a lower-middle-class family in Jamaica. I have lived all my adult life in England, in the shadow of the black diaspora – "in the belly of the beast." I write against the background of a lifetime's work in cultural studies. If the chapter seems preoccupied with the diaspora experience and its narratives of displacement, it is worth remembering that all discourse is "placed," and the heart has its reasons.

There are at least two different ways of thinking about "cultural identity."

21

The first position defines "cultural identity" in terms of one, shared culture, a sort of collective "one true self," hiding inside the many other, more superficial or artificially imposed "selves," which people with a shared history and ancestry hold in common. Within the terms of this definition, our cultural identities reflect the common historical experiences and shared cultural codes which provide us, as "one people," with stable, unchanging and continuous frames of reference and meaning, beneath the shifting divisions and vicissitudes of our actual history. This "oneness," underlying all the other, more superficial differences, is the truth, the essence, of "Caribbeanness," of the black experience. It is this identity which a Caribbean or black diaspora must discover, excavate, bring to light and express through cinematic representation.

Such a conception of cultural identity played a critical role in all post-colonial struggles which have so profoundly reshaped our world. It lay at the center of the vision of the poets of "Negritude," like Aimé Césaire and Léopold Senghor, and of the Pan-African political project, earlier in the century. It continues to be a very powerful and creative force in emergent forms of representation amongst hitherto marginalized peoples. In post-colonial societies, the rediscovery of this identity is often the object of what Frantz Fanon once called a

> passionate research . . . directed by the secret hope of discovering beyond the misery of today, beyond self-contempt, resignation and abjuration, some very beautiful and splendid era whose existence rehabilitates us both in regard to ourselves and in regard to others.

New forms of cultural practice in these societies address themselves to this project for the very good reason that, as Fanon puts it, in the recent past,

> Colonisation is not satisfied merely with holding a people in its grip and emptying the native's brain of all form and content. By a kind of perverted logic, it turns to the past of oppressed people, and distorts, disfigures and destroys it.[2]

The question that Fanon's observation poses is, what is the nature of this "profound research" which drives the new forms of visual and cinematic representation? Is it only a matter of unearthing that which the colonial experience buried and overlaid, bringing to light the hidden continuities it suppressed? Or is a quite different practice entailed – not the rediscovery but the *production* of identity. Not an identity grounded in the archaeology, but in the *re-telling* of the past?

We should not, for a moment, underestimate or neglect the importance of the act of imaginative rediscovery that this conception of a rediscovered, essential identity entails. "Hidden histories" have played a critical role in the emergence of many of the most important social movements of our time –

feminist, anti-colonial and anti-racist. The photographic work of a generation of Jamaican and Rastafarian artists, or of a visual artist like Armet Francis (a Jamaican-born photographer who has lived in Britain since the age of 8) is a testimony to the continuing creative power of this conception of identity within the emerging practices of representation. Francis's photographs of the peoples of The Black Triangle, taken in Africa, the Caribbean, the USA and the UK, attempt to reconstruct in visual terms "the underlying unity of the black people whom colonization and slavery distributed across the African diaspora." His text is an act of imaginary reunification.

Crucially, such images offer a way of imposing an imaginary coherence on the experience of dispersal and fragmentation, which is the history of all enforced diasporas. They do this by representing or "figuring" Africa as the mother of these different civilizations. This Triangle is, after all, "centered" in Africa. Africa is the name of the missing term, the great aporia, which lies at the center of our cultural identity and gives it a meaning which, until recently, it lacked. No one who looks at these textural images now, in the light of the history of transportation, slavery and migration, can fail to understand how the rift of separation, the "loss of identity," which has been integral to the Caribbean experience only begins to be healed when these forgotten connections are once more set in place. Such texts restore an imaginary fullness or plenitude to set against the broken rubric of our past. They are resources of resistance and identity, with which to confront the fragmented and pathological ways in which that experience has been reconstructed within the dominant regimes of cinematic and visual representation of the West.

There is, however, a second, related but different view of cultural identity. This second position recognizes that, as well as the many points of similarity, there are also critical points of deep and significant *difference* which constitute "what we really are"; or rather – since history has intervened – "what we have become." We cannot speak for very long, with any exactness, about "one experience, one identity," without acknowledging its other side – the ruptures and discontinuities which constitute, precisely, the Caribbean's "uniqueness." Cultural identity, in this second sense, is a matter of "becoming" as well as of "being." It belongs to the future as much as to the past. It is not something which already exists, transcending place, time, history and culture. Cultural identities come from somewhere, have histories. But, like everything which is historical, they undergo constant transformation. Far from being eternally fixed in some essentialized past, they are subject to the continuous "play" of history, culture and power. Far from being grounded in mere "recovery" of the past, which is waiting to be found, and which when found, will secure our sense of ourselves into eternity, identities are the names we give to the different ways we are positioned by, and position ourselves within, the narratives of the past.

It is only from this second position that we can properly understand the traumatic character of "the colonial experience." The ways in which black

people, black experiences, were positioned and subject-ed in the dominant regimes of representation were the effects of a critical exercise of cultural power and normalization. Not only, in Said's "Orientalist" sense, were we constructed as different and other within the categories of knowledge of the West by those regimes. They had the power to make us see and experience *ourselves* as "Other." Every regime of representation is a regime of power formed, as Foucault reminds us, by the fatal couplet "power/knowledge." But this kind of knowledge is internal, not external. It is one thing to position a subject or set of peoples as the Other of a dominant discourse. It is quite another thing to subject them to that "knowledge," not only as a matter of imposed will and domination, by the power of inner compulsion and subjective con-formation to the norm. That is the lesson – the sombre majesty – of Fanon's insight into the colonizing experience in *Black Skin, White Masks*.

This inner expropriation of cultural identity cripples and deforms. If its silences are not resisted, they produce, in Fanon's vivid phrase, "individuals without an anchor, without horizon, colourless, stateless, rootless – a race of angels."[3] Nevertheless, this idea of otherness as an inner compulsion changes our conception of "cultural identity." In this perspective, cultural identity is not a fixed essence at all, lying unchanged outside history and culture. It is not some universal and transcendental spirit inside us on which history has made no fundamental mark. It is not once-and-for-all. It is not a fixed origin to which we can make some final and absolute return. Of course, it is not a mere phantasm either. It is *something* – not a mere trick of the imagination. It has its histories – and histories have their real, material and symbolic effects. The past continues to speak to us. But it no longer addresses us as a simple, factual "past," since our relation to it, like the child's relation to the mother, is always-already "after the break." It is always constructed through memory, fantasy, narrative and myth. Cultural identities are the points of identification, the unstable points of identification or suture, which are made, within the discourses of history and culture. Not an essence but a *positioning*. Hence, there is always a politics of identity, a politics of position, which has no absolute guarantee in an unproblematic, transcendental "law of origin."

This second view of cultural identity is much less familiar, and more unsettling. If identity does not proceed in a straight unbroken line from some fixed origin, how are we to understand its formation? We might think of black Caribbean identities as "framed" by two axes or vectors, simultaneously operative: the vector of similarity and continuity; and the vector of difference and rupture. Caribbean identities always have to be thought of in terms of the dialogic relationship between these two axes. The one gives us some grounding in, some continuity with, the past. The second reminds us that what we share is precisely the experience of a profound discontinuity: the peoples dragged into slavery, transportation, colonization, migration, came predominantly from Africa – and when that supply ended, it was temporarily refreshed by indentured labor from the Asian subcontinent. (This neglected fact explains why,

when you visit Guyana or Trinidad, you see, symbolically inscribed in the faces of their peoples, the paradoxical "truth" of Christopher Columbus's mistake: you *can* find "Asia" by sailing west, if you know where to look!) In the history of the modern world, there are few more traumatic ruptures to match these enforced separations from Africa − already figured, in the European imaginary, as "the Dark Continent." But the slaves were also from different countries, tribal communities, villages, languages and gods. African religion, which has been so profoundly formative in Caribbean spiritual life, is precisely *different* from Christian monotheism in believing that God is so powerful that he can only be known through a proliferation of spiritual manifestations, present everywhere in the natural and social world. These gods live on, in an underground existence, in the hybridized religious universe of Haitian voodoo, pocomania, Native pentecostalism, Black baptism, Rastafarianism and the black Saints Latin American Catholicism. The paradox is that it was the uprooting of slavery and transportation and the insertion into the plantation economy (as well as the symbolic economy) of the Western world that "unified" these peoples across their differences, in the same moment as it cut them off from direct access to their past.

Difference, therefore, persists − in and alongside continuity. To return to the Caribbean after any long absence is to experience again the shock of the "doubleness" of similarity and difference. Visiting the French Caribbean for the first time, I also saw at once how different Martinique is from, say, Jamaica: and this is no mere difference of topography or climate. It is a profound difference of culture and history. And the difference *matters*. It positions Martiniquains and Jamaicans as *both* the same *and* different. Moreover, the boundaries of difference are continually repositioned in relation to different points of reference. Vis-à-vis the developed West, we are very much "the same." We belong to the marginal, the underdeveloped, the periphery, the "Other." We are at the outer edge, the "rim," of the metropolitan world − always "South" to someone else's *El Norte*.

At the same time, we do not stand in the same relation of the "otherness" to the metropolitan centers. Each has negotiated its economic, political and cultural dependency differently. And this "difference," whether we like it or not, is already inscribed in our cultural identities. In turn, it is this negotiation of identity which makes us, vis-à-vis other Latin American people, with a very similar history, different − Caribbeans, *les Antilliennes* ("islanders" to their mainland). And yet, vis-à-vis one another, Jamaican, Haitian, Cuban, Guadeloupean, Barbadian, etc. . . .

How, then, to describe this play of "difference" within identity? The common history − transportation, slavery, colonization − has been profoundly formative. For all these societies, unifying us across our differences. But it does not constitute a common *origin*, since it was, metaphorically as well as literally, a translation. The inscription of difference is also specific and critical. I use the word "play" because the double meaning of the metaphor is important. It

suggests, on the one hand, the instability, the permanent unsettlement, the lack of any final resolution. On the other hand, it reminds us that the place where this "doubleness" is most powerfully to be heard is "playing" within the varieties of Caribbean musics. This cultural "play" could not therefore be represented, cinematically, as a simple, binary opposition – "past/present," "them/us." Its complexity exceeds this binary structure of representation. At different places, times, in relation to different questions, the boundaries are re-sited. They become, not only what they have, at times, certainly been – mutually excluding categories, but also what they sometimes are – differential points along a sliding scale.

One trivial example is the way Martinique both *is* and *is not* "French." It is, of course, a *department* of France, and this is reflected in its standard and style of life: Fort de France is a much richer, more "fashionable" place than Kingston – which is not only visibly poorer, but itself at a point of transition between being "in fashion" in an Anglo-African and Afro-American way – for those who can afford to be in any sort of fashion at all. Yet, what is distinctively "Martiniquais" can only be described in terms of that special and peculiar supplement which the black and mulatto skin adds to the "refinement" and sophistication of a Parisian-derived *haute couture*: that is, a sophistication which, because it is black, is always transgressive.

To capture this sense of difference which is not pure "otherness", we need to deploy the play on words of a theorist like Jacques Derrida. Derrida uses the anomalous "a" in his way of writing "difference" – *différance* – as a marker which sets up a disturbance in our settled understanding or translation of the word/concept. It sets the word in motion to new meanings without erasing the *trace* of its other meanings. His sense of *différance*, as Christopher Norris puts it, thus

> remains suspended between the two French verbs "to differ" and "to defer" (postpone), both of which contribute to its textual force but neither of which can fully capture its meaning. Language depends on difference, as Saussure showed . . . the structure of distinctive propositions which make up its basic economy. Where Derrida breaks new ground . . . is in the extent to which "differ" shades into "defer" . . . the idea that meaning is always deferred, perhaps to this point of an endless supplementarity, by the play of signification.[4]

This second sense of difference challenges the fixed binaries that stabilize meaning and representation and show how meaning is never finished or completed, but keeps on moving to encompass other, additional or supplementary meanings, which, as Norris puts it elsewhere,[5] "disturb the classical economy of language and representation." Without relations of difference, no representation could occur. But what is then constituted within representation is always open to being deferred, staggered, serialized.

Where, then, does identity come into this infinite postponement of meaning? Derrida does not help us as much as he might here, though the notion of the "trace" goes some way toward it. This is where it sometimes seems as if Derrida has permitted his profound theoretical insights to be reappropriated by his disciples into a celebration of formal "playfulness," which evacuates them of their political meaning. For if signification depends upon the endless repositioning of its differential terms, meaning, in any specific instance, depends on the contingent and arbitrary stop – the necessary and temporary "break" in the infinite semiosis of language. This does not detract from the original insight. It only threatens to do so if we mistake this "cut" of identity – this *positioning*, which makes meaning possible – as a natural and permanent, rather than an arbitrary and contingent "ending" – whereas I understand every such position as "strategic" and arbitrary, in the sense that there is no permanent equivalence between the particular sentence we close, and its true meaning, as such. Meaning continues to unfold, so to speak, beyond the arbitrary closure that makes it, at any moment, possible. It is always either over- or under-determined, either an excess or a supplement. There is always something "left over."

It is possible, with this conception of "difference," to rethink the positioning and repositioning of Caribbean cultural identities in relation to at least three "presences," to borrow Aimé Césaire's and Léopold Senghor's metaphor: *Présence Africaine, Présence Européenne,* and the third, most ambiguous, presence of all – the sliding term, *Présence Americaine.* Of course, I am collapsing, for the moment, the many other cultural "presences" that constitute the complexity of Caribbean identity (Indian, Chinese, Lebanese, etc.). I mean America, here not in its "first-world" sense – the big cousin to the North whose "rim" we occupy – but in the second, broader sense: America, the "New World," *Terra Incognita.*

Présence Africaine is the site of the repressed. Apparently silenced beyond memory by the power of the experience of slavery, Africa was, in fact, present everywhere: in the everyday life and customs of the slave quarters, in the languages and patois of the plantations, in names and words, often disconnected from their taxonomies, in the secret syntactical structures through which other languages were spoken, in the stories and tales told to children, in religious practices and beliefs in the spiritual life, the arts, crafts, musics and rhythms of slave and post-emancipation society. Africa, the signified which could not be represented directly in slavery, remained and remains the unspoken unspeakable "presence" in Caribbean culture. It is "hiding" behind every verbal inflection, every narrative twist of Caribbean cultural life. It is the secret code with which every Western text was "re-read." It is the ground-bass of every rhythm and bodily movement. *This* was – is – the "Africa" that "is alive and well in the diaspora."[6]

When I was growing up in the 1940s and 1950s as a child in Kingston, I was surrounded by the signs, music and rhythms of this Africa of the diaspora,

which only existed as a result of a long and discontinuous series of transformations. But, although almost everyone around me was some shade of brown or black (Africa "speaks"!), I never once heard a single person refer to themselves or to others as, in some way, or as having been at some time in the past, "African." It was only in the 1970s that this Afro-Caribbean identity became historically available to the great majority of Jamaican people, at home and abroad. In this historic moment, Jamaicans discovered themselves to be "black" – just as, in the same moment, they discovered themselves to be the sons and daughters of "slavery."

This profound cultural discovery, however, was not, and could not be, made directly, without "mediation." It could only be made *through* the impact on popular life of the post-colonial revolution, the civil rights struggles, the culture of Rastafarianism and the music of reggae – the metaphors, the figures or signifiers of a new construction of "Jamaican-ness." These signified a "new" Africa of the New World, grounded in an "old" Africa: a spiritual journey of discovery that led, in the Caribbean, to an indigenous cultural revolution; this is Africa, as we might say, necessarily "deferred" – as a spiritual, cultural and political metaphor.

It is the presence/absence of Africa, in this form, which has made it the privileged signifier of new conceptions of Caribbean identity. Everyone in the Caribbean, of whatever ethnic background, must sooner or later come to terms with this African presence. Black, brown, mulatto, white – all must look *Présence Africaine* in the face, speak its name. But whether it is, in this sense, an *origin* of our identities, unchanged by four hundred years of displacement, dismemberment, transportation, to which we could in any final or literal sense return, is more open to doubt. The original "Africa" is no longer there. It too has been transformed. History is, in that sense, irreversible. We must not collude with the West which, precisely, normalizes and appropriates Africa by freezing it into some timeless zone of the primitive, unchanging past. Africa must at last be reckoned with by Caribbean people, but it cannot in any simple sense be merely recovered.

It belongs irrevocably, for us, to what Edward Said once called an "imaginative geography and history," which helps "the mind to intensify its own sense of itself by dramatising the difference between what is close to it and what is far away."[7] It "has acquired an imaginative or figurative value we can name and feel."[8] Our belongingness to it constitutes what Benedict Anderson calls "an imagined community."[9] To *this* "Africa," which is a necessary part of the Caribbean imaginary, we can't literally go home again.

The character of this displaced "homeward" journey – its length and complexity – comes across vividly, in a variety of texts. Tony Sewell's documentary archival photographs, "Garvey's Children: the Legacy of Marcus Garvey" tell the story of a "return" to an African identity which went, necessarily, by the long route through London and the United States. It "ends," not in Ethiopia but with Garvey's statue in front of the St Ann Parish Library in Jamaica: not

with a traditional tribal chant but with the music of Burning Spear and Bob Marley's "Redemption Song." This is our "long journey" home. Derek Bishton's courageous visual and written text, *Black Heart Man* – the story of the journey of a *white* photographer "on the trail of the promised land" – starts in England, and goes, through Shashemene, the place in Ethiopia to which many Jamaican people have found their way on their search for the Promised Land, and slavery; but it ends in Pinnacle, Jamaica, where the first Rastafarian settlements were established, and "beyond" – among the dispossessed of twentieth-century Kingston and the streets of Handsworth, where Bishton's voyage of discovery first began. These symbolic journeys are necessary for us all – and necessarily circular. This is the Africa we must return to – but "by another route": what Africa has *become* in the New World, what we have made of "Africa": "Africa" – as we re-tell it through politics, memory and desire.

What of the second, troubling, term in the identity equation – the European presence? For many of us, this is a matter not of too little but of too much. Where Africa was a case of the unspoken, Europe was a case of that which is endlessly speaking – and endlessly speaking *us*. The European presence interrupts the innocence of the whole discourse of "difference" in the Caribbean by introducing the question of power. "Europe" belongs irrevocably to the "play" of power, to the lines of force and consent, to the role of the *dominant* in Caribbean culture. In terms of colonialism, underdevelopment, poverty and the racism of color, the European presence is that which, in visual representation, has positioned the black subject within its dominant regimes of representation: the colonial discourse, the literatures of adventure and exploration, the romance of the exotic, the ethnographic and traveling eye, the tropical languages of tourism, travel brochure and Hollywood and the violent, pornographic languages of *ganja* and urban violence.

Because *Présence Européenne* is about exclusion, imposition and expropriation, we are often tempted to locate that power as wholly external to us – an extrinsic force, whose influence can be thrown off like the serpent sheds its skin. What Frantz Fanon reminds us, in *Black Skin, White Masks*, is how this power has become a constitutive element in our own identities.

> The movements, the attitudes, the glances of the Other fixed me there in the sense in which a chemical solution is fixed by a dye. I was indignant; I demanded an explanation. Nothing happened. I burst apart. Now the fragments have been put together again by another self.[10]

This "look," from – so to speak – the place of the Other, fixes us, not only in its violence, hostility and aggression, but in the ambivalence of its desire. This brings us face to face with the dominating European presence not simply as the site or "scene" of integration where those other presences that it had actively disaggregated were recomposed – re-framed, put together in a new

way; but as the site of a profound splitting and doubling – what Homi Bhabha has called "this ambivalent identification of the racist world ... the 'Otherness' of the Self inscribed in the perverse palimpsest of colonial identity."[11]

The dialogue of power and resistance, of refusal and recognition, with and against *Présence Européenne* is almost as complex as the "dialogue" with Africa. In terms of popular cultural life, it is nowhere to be found in its pure, pristine state. It is always-already fused, syncretized, with other cultural elements. It is always-already creolized – not lost beyond the Middle Passage, but ever-present: from the harmonics in our musics to the ground-bass of Africa, traversing and intersecting our lives at every point. How can we stage this dialogue so that, finally, we can place it, without terror or violence, rather than being forever placed by it? Can we ever recognize its irreversible influence, whilst resisting its imperializing eye? The enigma is impossible, so far, to resolve. It requires the most complex of cultural strategies. Think, for example, of the dialogue of every Caribbean filmmaker or writer, one way or another, with the dominant cinemas and literature of the West – the complex relationship of young black British filmmakers with the "avant-gardes" of European and American filmmaking. Who could describe this tense and tortured dialogue as a "one way trip"?

The Third, "New World" presence, is not so much power, as ground, place, territory. It is the juncture-point where the many cultural tributaries meet, the "empty" land (the European colonizers emptied it) where strangers from every other part of the globe collided. None of the people who now occupy the islands – black, brown, white, African, European, American, Spanish, French, East Indian, Chinese, Portuguese, Jew, Dutch – originally "belonged" there. It is the space where the creolizations and assimilations and syncretisms were negotiated. The New World is the third term – the primal scene – where the fateful/fatal encounter was staged between Africa and the West. It also has to be understood as the place of many, continuous displacements: of the original pre-Columbian inhabitants, the Arawaks, Caribs and Amerindians, permanently displaced from their homelands and decimated; of other peoples displaced in different ways from Africa, Asia and Europe; the displacements of slavery, colonization and conquest. It stands for the endless ways in which Caribbean people have been destined to "migrate"; it is the signifier of migration itself – of traveling, voyaging and return as fate, as destiny; of the Antillean as the prototype of the modern or postmodern New World nomad, continually moving between center and periphery. This preoccupation with movement and migration Caribbean cinema shares with many other "Third Cinemas," but it is one of our defining themes, and it is destined to cross the narrative of every film script or cinematic image.

Présence Americaine continues to have its silences, its suppressions. Peter Hulme, in his essay on "Islands of enchantment"[12] reminds us that the word "Jamaica" is the Hispanic form of the indigenous Arawak name – "land of

wood and water" – which Columbus's renaming ("Santiago") never replaced. The Arawak presence remains today a ghostly one, visible in the islands mainly in museums and archeological sites, part of the barely knowable or usable "past." Hulme notes that it is not represented in the emblem of the Jamaican National Heritage Trust, for example, which chose instead the figure of Diego Pimienta, "an African who fought for his Spanish masters against the English invasion of the island in 1655" – a deferred, metonymic, sly and sliding representation of Jamaican identity if ever there was one! He recounts the story of how Prime Minister Edward Seaga tried to alter the Jamaican coat-of-arms, which consists of two Arawak figures holding a shield with five pineapples, surmounted by an alligator. "Can the crushed and extinct Arawaks represent the dauntless character of Jamaicans. Does the low-slung, near extinct crocodile, a cold-blooded reptile, symbolise the warm, soaring spirit of Jamaicans?" Prime Minister Seaga asked rhetorically.[13] There can be few political statements which so eloquently testify to the complexities entailed in the process of trying to represent a diverse people with a diverse history through a single, hegemonic "identity." Fortunately, Mr Seaga's invitation to the Jamaican people, who are overwhelmingly of African descent, to start their "remembering" by first "forgetting" something else, got the comeuppance it so richly deserved.

The "New World" presence – America, *Terra Incognita* – is therefore itself the beginning of diaspora, of diversity, of hybridity and difference, what makes Afro-Caribbean people already people of a diaspora. I use this term here metaphorically, not literally: diaspora does not refer us to those scattered tribes whose identity can only be secured in relation to some sacred homeland to which they must at all costs return, even if it means pushing other people into the sea. This is the old, the imperializing, the hegemonizing, form of "ethnicity." We have seen the fate of the people of Palestine at the hands of this backward-looking conception of diaspora – and the complicity of the West with it. The diaspora experience as I intend it here is defined, not by essence or purity, but by the recognition of a necessary heterogeneity and diversity; by a conception of "identity" which lives with and through, not despite, difference; by *hybridity*. Diaspora identities are those which are constantly producing and reproducing themselves anew, through transformation and difference. One can only think here of what is uniquely – "essentially" – Caribbean: precisely the mixes of colour, pigmentation, physiognomic type; the "blends" of tastes that is Caribbean cuisine; the aesthetics of the "cross-overs," of "cut-and-mix," to borrow Dick Hebdige's telling phrase, which is the heart and soul of black music. Young black cultural practitioners and critics in Britain are increasingly coming to acknowledge and explore in their work this "diaspora aesthetic" and its formations in the post-colonial experience:

> Across a whole range of cultural forms there is a "syncretic" dynamic
> which critically appropriates elements from the master-codes of the

dominant culture and "creolises" them, disarticulating given signs and re-articulating their symbolic meaning. The subversive force of this hybridising tendency is most apparent at the level of language itself where creoles, patois and black English decentre, destabilise and car-nivalise the linguistic domination of "English" – the nation-language of master-discourse – through strategic inflections, re-accentuations and other performative moves in semantic, syntactic and lexical codes.[14]

It is because this New World is constituted for us as place, a narrative of dis-placement, that it gives rise so profoundly to a certain imaginary plenitude, recreating the endless desire to return to "lost origins," to be one again with the mother, to go back to the beginning. Who can ever forget, when once seen rising up out of that blue-green Caribbean, those islands of enchantment? Who has not known, at this moment, the surge of an overwhelming nostalgia for lost origins, for "times past"? And yet, this "return to the beginning" is like the imaginary in Lacan – it can neither be fulfilled nor requited, and hence is the beginning of the symbolic, of representation, the infinitely renewable source of desire, memory, myth, search, discovery – in short, the reservoir of our cinematic narratives.

We have been trying, in a series of metaphors, to put in play a different sense of our relationship to the past, and thus a different way of thinking about cul-tural identity, which might constitute new points of recognition in the dis-courses of the emerging Caribbean cinema and black British cinemas. We have been trying to theorize identity as constituted, not outside but within repre-sentation; and hence of cinema, not as a second-order mirror held up to reflect what already exists, but as that form of representation which is able to consti-tute us as new kinds of subjects, and thereby enable us to discover places from which to speak. Communities, Benedict Anderson argues in *Imagined Communities*, are to be distinguished, not by their falsity/genuineness, but by the style in which they are imagined.[15] This is the vocation of modern black cinemas: by allowing us to see and recognize the different parts and histories of ourselves, to construct those points of identification, those positionalities we call in retrospect our "cultural identities."

> We must not therefore be content with delving into the past of a people in order to find coherent elements which will counteract colonialism's attempts to falsify and harm . . . A national culture is not a folk-lore, nor an abstract populism that believes it can discover a people's true nature. A national culture is the whole body of efforts made by a people in the sphere of thought to describe, justify and praise the action through which that people has created itself and keeps itself in existence.[16]

Notes

1 Taken from J. Rutherford (ed.) (1990), *Identity: Community, Culture, Difference*, London: Lawrence & Wishart, pp. 222–37.
2 Frantz Fanon, "On national culture," in *The Wretched of the Earth*, London, 1963, p. 170.
3 *ibid.*, p. 176.
4 Christopher Norris, *Deconstruction: Theory and practice*, London, 1982, p. 32.
5 *idem, Jacques Derrida*, London, 1987, p. 15.
6 Stuart Hall, *Resistance Through Rituals*, London, 1976.
7 Edward Said, *Orientalism*, London, 1985, p. 55.
8 *ibid.*
9 Benedict Anderson, *Imagined Communities: Reflections on the origin and rise of nationalism*, London, 1982.
10 Frantz Fanon, *Black Skin, White Masks*, London, 1986, p. 109.
11 Homi Bhabha, "Foreword" to Fanon, *ibid.*, pp. xiv–xv.
12 In *New Formations*, 3, Winter 1987.
13 *Jamaica Hansard*, 9, 1983–4, p. 363. Quoted in Hulme, *ibid.*
14 Kobena Mercer, "Diaspora culture and the dialogic imagination," in M. Cham and C. Watkins (eds), *Blackframes: Critical perspectives on black independent cinema*, 1988, p. 57.
15 Anderson, *op. cit.*, p. 15.
16 Fanon, *Black Skin, White Masks*, p. 188.

2

FIRST DIASPORIST MANIFESTO

R.B. Kitaj

Diasporist painting, which I just made up, is enacted under peculiar historical and personal freedoms, stresses, dislocation, rupture and momentum. The Diasporist lives and paints in two or more societies at once. Diasporism, as I wish to write about it, is as old as the hills (or caves) but new enough to react to today's newspaper or last week's aesthetic musing or tomorrow's terror. I don't know if people will liken it to a School of painting or attribute certain characteristics or even Style to it. Many will oppose the very idea, and that is the way of the world.

My embarrassment at pressing upon my dubious pictures[1] and upon you the case of the Jews, against the advice of wiser heads, begins to feel less uncomfortable. It is, of course, a universal art, something which speaks to the world, to the common reader, which every painter desires, as religions and poetry wish to speak of and to our world. The world being what it is, like our art, it's a poor listener and it remains divided, but artists at least tend to gentler, less killing divisions. For a while, I will presume to bore you with pictures of an imperilled world you may know only as imperfectly as I do, if at all . . . or I should say – pictures of part of my world just now. My case is built on a cliché which may also be an insightful art lesson. It is that the threatened condition of the Jews witnesses the condition of our wider world. It is a radical witness. One hundred and fifty years ago, Heine warned that where books were burned, human beings would be. Keep in mind that art and life get quite conjoined (art-time) in our modern tradition and sometimes blur. Later, when we are dead, the art is (life-less?) alone in the room.

For the moment, Diasporism is my own School, neither particularly unhappy practice nor proud persuasion. I would simply say it is an unsettled mode of art-life, performed by a painter who feels out of place much of the time, even when he is lucky enough to stay at work in his room, unmolested through most of his days. His Diasporism, to the extent that it marks his painting, relies on a mind-set which is often occupied with vagaries of history, kin, homelands, the scattering of his people (if he thinks he may have a people), and such stuff. Is that not a general meaning of Diaspora? More particular meanings may leave deeper marks or even scars on painting. It's not for me to

spell out the quite various Diasporic conditions proliferating everywhere now, except to say that Jews do not own Diaspora; they are not the only Diasporists by a long shot. They are merely mine. As if they were not in enough trouble right now, as usual, the Israel-Diaspora problem is as difficult to contemplate as the more usual problem of Jewish survival itself. Keening to seismic readings now that Israel is reborn, the awful historical problem of Jewish political impotence is lessened, but I would greatly fear the consequences if most Jews were concentrated in the Holy Land, where it would be easier than ever to finish them off in a place the size of Greater Indianapolis, with a bomb or two! Being Jews though, there's energy enough left over, while enduring siege by a billion enemies, to argue the very finest points among ourselves concerning the question of Diaspora – not uninteresting arguments you can look up your-self, which I won't rehearse here except to say that the Jewish problem, which never seems to go away (*pace* George Eliot), gave birth, about a hundred years ago, to a serious Palestine-Diaspora equation which was to have delivered a "normalcy" to the bloodied Jews and which now looks as elusive as the Messiah and the End of Days.

Since this is a manifesto, albeit not a very aggressive one (I haven't read Breton or Lewis or Marinetti and such since I was 18), I want it to be some-what declarative because I think art and life are fairly married and I think I owe it to my pictures to put their stressful birth with some idiosyncratic pre-cision.

What I owe to my pictures, I guess I owe to my readers, mostly to those few attentive or curious enough to interest themselves in the peculiar genesis of these disputed works I call Diasporist.

Like an aging bear, I am not often brave or cunning. I try to proceed from my cave with caution because I tend to blot my copybook, as the English say. Out I come at the wrong season, when the world is bemused daily by Jews and their Holocausts, past and pending. As if that were not enough, I just read in an art column that the time for manifestos has passed. So I thought I'd write one, the Belated Bear stumbling forward, brandishing his paintbrush, into the tunnel at the end of the light . . .

In my time, half the painters of the great Schools of Paris, New York and London were not born in their host countries. If there is nothing which peo-ple in dispersion share in common, then my Diasporist tendency rests in my mind only and maybe in my pictures . . . but consider: every grain of common ground will firm the halting step of people in dispersion as surely as every proof of welcome has encouraged emigrés before in cosmopolitan centers. Rootedness has played its intrinsic and subtle part in the national art modes of Egypt, Japan, England, Holland and the high Mediterranean cultures and city-states. I want to suggest and manifest a commonality (for painting) in disper-sion which has mainly been seen before only in fixed places; but, not unlike painters who leave those centers or those modes, such as Cézanne, who left Paris behind for his epochal old-age style at home, or Picasso who left

(classical) Cubism in the lurch, Diasporists also exchange their colors, for instance, to the extent that they begin to really feel at home somewhere, or practice within a School, or indeed, refuse what I say here . . .

If a people is dispersed, hurt, hounded, uneasy, their pariah condition confounds expectation in profound and complex ways. So it must be in aesthetic matters. Even if a Diasporist seems to assimilate easily to prevailing aesthetics, as he does in most currents of life, the confounding, uneasy side of his nature may also be addressed, that deeper heart, as magical as anything the Surrealist or Mystical-Abstractionist ever sought within himself. I can only posit a new aesthetic for myself (to recreate myself) because I don't want to become a mouthpiece for the traditions of general art, and because some things in dispersion (ancient and modern) have come of age now for me. As the quasi-Diasporist Gauguin said, "I wish to establish the right to dare anything."

Aside from the always still endangered Jews (in a Masadic Israel and in Diaspora), there are other resounding Diasporists – Palestinians prominent and suffering among them. Israel Zangwill (1864–1926) placed the Armenians at "the pit of Hell," and in 1920 bowed before their "higher majesty of sorrow." There is a Black African Diaspora as terrible and outstanding as any other, which has disturbed my thoughts since early boyhood. Murderous Stalinism and Pol Potism must have all but unsung Diaspora trails of their bloody own. What is left of these dispersed peoples finds as little peace as Ahasuerus himself. If the art of these Diasporists, as they emerge from historical fog, is not touched by their separate destinies, God help them. He has so often not.

Like most human events, Diasporism is not clear-cut, hard or fast (many movements in art are not), neither in its usual and historic explications nor in the meanings I have begun to feel for myself as a painter. As a Diasporist painter, like the Realist, the Cubist, the Expressionist and other painters, I would resist exacting codification (rightly). Nor can I speak cogently for even more complex and speculative realms of the painter's make-up, for "internal exile," the condition of the self-estranged sexual Diaspora and such. The Diasporist appears among emigrés and refugees, among the heirs of Surrealism, Naturalism, Symbolism and other aesthetics, among the home-grown, among nationalists and internationalists, pariahs and patriots, in every polyglot matrix, among the political and religious as well as those who do without politics and religion or are uncertain. *In the end, the Diasporist knows he is one*, even though he may one day settle down and sort of cease to be one. Many do not settle and that is a crux which will affect and, I think, effect the art. If human instincts for kin and home are primordial, as they so often seem, the Diasporic condition presents itself as yet another theater in which human, artistic instinct comes into play, maybe not primordial (?) but a condition, a theater to be treasured. As I write these words, I also know that if Diasporists become treasured, their theater will close, and open under a new sign and name, maybe with a curse upon it.

Diasporism is my mode. It is the way I do my pictures. If they mirror my

life, these pictures betray confounded patterns. I make this painting mode up as I go along because it seems more and more natural for me, so natural that I think I've been a Diasporist painter from the start without knowing and then slowly learnt it in a twilit period, until it began to dawn on me that I should act upon it. Diasporist painting is unfolding commentary on its life-source, the contemplation of a transience, a *Midrash* (exposition, exegesis of non-literal meaning) in paint and somehow, collected, these paintings, these circumstantial allusions, form themselves into secular *Responsa* or reactions to one's transient restlessness, un-at-homeness, groundlessness. Because it is art of some kind, the act (of painting) need not be an unhappy one. Although my Diasporist paint-ing grows out of art, as for instance, Cubism or Surrealism did, it owes its greatest debt to the terms and passions of my own life and growing sense of myself as a Diasporist Jew. I have spent half my life away from my American homeland, that most special Diaspora Jews have ever known. Until now, I've only rarely painted there and I set down these first exilic ruminations still from a bittersweet abroad, but written in my homesick, Americanist tense, haunted by the music of Diaspora.

I've always been a Diasporist Jew, but as a young man I was not sure what a Jew was. I was unaware that such questions were debated within Jewry, even in the Knesset itself. Jews were Believers, I thought, and I assumed you were whatever you believed in, that if you became a Catholic or an atheist or a Socialist, that's what you were. Art itself was a church, a universalist edifice, an amazing sanctuary from the claims and decrepitude of modern life, where you could abandon self and marry painting. My friend Isaiah Berlin says: "A Jew is a Jew like a table is a table." Now, that interests me greatly, but the thing was blurred in my youth. This was, I learned later, a classic assimilationist pose. My maternal grandfather had been a Socialist Bundist in Russia, on the run from the Czarist police. He passed on his religious skepticism to my mother, who brought me up as a freethinker with no Jewish education. Ours was a house-hold full of secular Diasporists who seemed to be Jews only by the way. It would be many more years before I learned that the Germans and Austrians who did what they did in that time, when I was playing baseball and cruising girls, made no distinctions between Believers or atheists or the one and a half million Jewish infants who had not yet decided what they were when they got sent up in smoke. One-third of all Jews on earth were murdered in my youth. It is well known that a Silence fell upon our world for some years after what Winston Churchill called "probably the greatest and most horrible crime ever committed in the whole history of the world." It was *the* break with tradi-tional evil, its own archetype, someone said. The classic texts on the Holocaust are fairly recent and as I got around to them and the paradox of Jewishness began to enthrall me, the Diasporist painter in me started to grow alert, after a numbing, morbid period. The mystery of dispersion now seems to me as *real* as any located School known to art. I didn't know it at first, but I had stumbled upon a tremendous lesson, taught long ago by many conflicting

personalities both Jewish and Gentile (Sartre, etc.), by such absorbing figures as Ahad Ha'am (1856–1927), that it is Jewishness that condemns one, not the Jewish religion. It became reasonable to suppose that Jewishness, this complex of qualities, would be a presence in art as it is in life. In Diaspora, life has a force of its own. So would Diasporist painting, never before particularly associated with pariah peoples. For me, its time has come at last.

Diaspora (dispersion in Greek) is most often associated with Jews and their 2,000 year old scattering among the nations (longer by other accounts). What the Jews call *Galut* (Exile in Hebrew), had become a way of life (and death), consonant with Jewishness itself, even though Israel is reborn. I am one of those who are possessed by the consonance of art and life. Some are not. I think that memories, events and beliefs are sacred dreams for painting and so the mode of my life is translated into pictures. In translation there is not ultimate accuracy, only an illusion of truth, as in art. Because neither Diaspora nor Israel can live really happily ever after anyway (or so it increasingly seems) and a normative co-existence replaces the "normalcy" once wished upon the state, many of us who make our lives in dispersion follow *its* peculiar, various, often very homelike (America), very complex destinies where, as someone put it, Jews have achieved emancipation without auto-emancipation. The compelling destiny of dispersion is one's own and describes my Diasporism, which describes and explains my parable-pictures, their dissolutions, repressions, associations, referrals and sometime difficulty, their text-obsessions, their play of differences, their autobiographical heresies, their skeptical dispositions, their assimilationist modernisms, fragmentation and confusions, their secular blasphemies, their longing allegiance to the exact art-past which corresponds to the historical moments when Jews became free to pursue a life in art (I mean from the late nineteenth century on).

Diasporist art is contradictory at its heart, being both internationalist and particularist. It can be inconsistent, which is a major blasphemy against the logic of much art education, because life in Diaspora is often inconsistent and tense; schismatic contradiction animates each day. To be consistent can mean the painter is settled and at home. All this begins to define the painting mode I call Diasporism. People are always saying the meanings in my pictures refuse to be fixed, to be settled, to be stable: *that's* Diasporism, which welcomes interesting, creative misreading; the Zohar says that the meaning of the book changes from year to year! And now as I come to life again after 50, the room in which I paint becomes a sort of permissive *cheder* (room, the room or school where one studies) in which art becomes what I *think*, dramatizing my mind's life, while the ancient religion itself whispers its Covenantal, mythic, Midrashic, ethical, exegetical, schismatic, Zaddik-ridden, arguments. There is a traditional notion that the divine presence itself is in the Diaspora, and, over one shoulder, *Sefirot* (divine emanations and "intelligences" according to Kabbalah) flash and ignite the canvas towards which I lean in my orthopedic back-chair, while from my subconscious, from what can be summoned up

from mind and nerve, and even after nature, other voices speak more loudly than the divines, in tongues learned in our wide Diaspora. These are the voices I mostly cleave to. Listen to them. They will tell you what a Diasporist has on his mind (Michelangelo said you paint with your mind) as he strokes his canvas.

The voices speak nervously about things unheard in painting (or long forgotten) – of *ethnie*, of historical memories and cultures, of ancestry myths and of heroes. Abraham's journey from Ur becomes, in the name of "good" picture-making (at my own easel), Joe Singer's secret lives, escapes, deaths and resurrections, reconstructed from Diasporic myths which began when I did in 1932 and will die with me – or live on, as for instance Daumier's Ratapoil has, as Cézanne's mountain has. Those art models were not only radical patterns representing spatial enquiry (which they also are) but profound *ethnie* (belonging to Paris, Provence, shared history). Yes, Cézanne's mountain represents shared *tribal* (French) history – the history of a bitter old Provençal genius wrestling with his art angel on his own sacred southern ground. That's what I want to be, a tribal remembrancer, wrestling with my Diasporic angel; I feel a great affection for this emancipating muse wherever I am at my painting. She is my favorite model. She suggests my frail entitlements and shaky destinies and let's-pretend art aspirations.

One of the most recent of my hundred negative critics wrote in his review of my 1986 exhibition that it was "littered with ideas." Heavens to Betsy, I hope that's true. My poor Diasporist mind urges me to wander among ideas without rest, always the false-scholar, which is often how we painters make our mark. The pursuit of ideas, both religious and secular, at any cost, is often attributed to Jews by both well-wishers and doubters. Hitler is said to have accused the Jews of inventing conscience. Ideas and painting are inseparable. The Diasporist pursuit of a homeless logic of *ethnie* may be the radical (root) core of a newer art than we can yet imagine . . . those of us who think we can relate our past experience of Diaspora to a present understanding of it in painted, hopefully universal, pictures which may speak to many people.

Speaking of homeless logic, I must declare or confess my most complex credential – one of the outstanding facts of my life and Diasporic condition: utterly American, longingly Jewish, School of London, I spin my years away from both my heartlands, up to now anyway (age 54). I suppose a case could be made for a Jewish heartland of the mind (the case of this text in fact), rather than Jerusalem or even New York. But the Americanist credential has another pedigree, surely touched upon by James, Cassatt, Sargent, Pound, Whistler, Epstein, Eliot, Stein and all my other forebears. Joyce and Lawrence were early hero-exemplars (art and life) and must have suffered/enjoyed a same confusion, but it is not my intention to drag all that expatriate weight across my present Diasporist musing and open up the membership. What did Groucho say? Something like he wouldn't want to join a club that would let people like him in?

In one of its self-definitions, Diasporism, *my* sort of Diasporism, has been lived and acted out in the free, Western, privileged, uninhibited, uncensored, permissive, élitist cloud-cuckoo lands of Modernism. Diasporism in art has been largely Assimilationist and Modernist, played on a diffuse stage with few constraints. Assimilationism is the prevailing mode in the art of our time. Young people are taught that they must strike chords which agree with *art* ("advanced" or not) without much regard to origin, milieu or creed – and so they may in our very few democracies. My own Diasporist mode resists (gently) the absolute wisdom of assimilationism in art. I would rather find the energy to do for Jews at least what Morandi did for jars. Then I could take summers off like he did and paint landscapes or something. The Diasporist in me would deny neither painting, as it asks to be continued, nor the themes and obsessions which quicken my mind and heart. Looking back before my own time, I'd like to identify a First *Aliyah* (ascent) in Diasporic painting, which, in *its* time, accorded with a faith in Modernism and which was assimilated to it more than to any idea of one's origins. These Diasporists, aside from those Jews who ascended to Paris, may include honorary Jews like Mondrian, Picasso, Beckmann, Hofmann, the Surrealists and the Bauhaus people, many of whom escaped the Enemy of the Jews, often to find refuge among Diasporist Jews themselves, especially in New York. Painters like Picasso, Bonnard, Matisse and Munch who did not have to flee, were touched and encouraged throughout their lives by what may even be called a (Jewish) Diasporist aura of friends, collectors, dealers, writers, audience, explainers and colleagues, some of whom were to go up the chimneys (another ascent in Diasporist destiny). Although Diasporism in refugee Gentiles may be my own speculative construct, it is very real for Jews.

And what is real for Jews is real for Jewish painters. I suspect that even those who go out of their way to isolate art from the imagined merits or demerits of being Jewish are, in the very doing, anointing art with the troubled wand of Jewish Diasporism. To my mind, something instinct with one's culture enters into one's art. And so the lost and soon to be murdered world of East European Jewry cultured the art of many Jewish painters, even as they assimilated to the powerful charms of the new Modernism. We know that from the School of Montparnasse. These early modern Diasporists lived and worked outside my own experience. The Kingdom of Death they left in the Pale, and the bittersweet Paris of their brief freedom is not for me to reconstruct. Nor is the amazing American sanctuary from 1900 to the present moment, where Diasporism achieved its Golden Age according to many people, and Diasporist painting reached its *second* modern coming (in my little history lesson). Before 1900 doesn't concern me here because Jews were only just preparing to arise from a Diasporic sleep of dreams and one-third of them would (in the last days of humanity) unknowingly sleepwalk into an oven. After 1900 begins to touch my own pictures, first of all because my Yiddish- and Russian-speaking grandparents fled to America. So did my father. Then, after the Anschluss, so did my

stepfather Kitaj and, after the war, my grandmother Kitaj. I am not only a Diasporist but a Biographical Heretic, among other things, and so I have a peculiar faith and interest in the influence not only of past art acting on one's pictures – everyone agrees about that – but also of one's youth, upbringing, friends, milieux. Can anyone doubt that we are fatally rooted in the first part of our life? I am given to my time in art as any painter is. It *tells* in our pictures. Our pictures speak our particular culture and the languages of general as well as tribal cultures which interest us most. That picture-speech is uttered through personality, which is something perceived in its very achievement, like all cultural stuff. I'm not content that the vivid marriage of forms and contents in painting be known aside from our particular, even singular cultures and predicaments. I like to think this cultural marriage drama may be seen to be done up in pictures. Picasso said it: "It is not sufficient to know an artist's works. It is also necessary to know when he did them, why, how, under what circumstances."

Post-Holocaust Diasporism then. I can't speak for the Jews or Gentiles of the Abstract School of New York and their explainers, Diasporists though many were, except to express a hunch that they kept to only *some* avenues of their creativity, large scale though it was, nor for any of my comrades in what I have called (in *The Human Clay*, 1976) the School of London, some of whom are Diaspora Jews and some of whom may wander in a sexual Diaspora. I will only say there is no doubt in my mind that this Second Diasporic Aliyah (pray God will forgive me this impertinent usage), roughly from Rothko to Auerbach, has been touched by its destiny, a destiny which is *driven* and driven to remember (like some great art before), the worst thing imaginable.

Diasporism didn't exist in painting until I invented it, but it has antecedents, like Surrealism had in Dada and Symbolism, and Abstractionism had in, say, theosophy and ornament. Since we artists tend to create our precursors, as Borges said, Diasporist painting now, for me, began in the great art of the West which nourishes all painters, including those of the briefly fluttering congeries of modernist styles, Yiddishkeit and doomed café freedoms which ended at Drancy and the Eastern railheads. Using the Hebrew term, the present Pope, John Paul II, just said: "This is *still* the century of the Shoah." Indeed, my own Diasporism turns on my century still, both in the sense the Pope meant and, as a painter, in the cosmopolitan (and early Diasporist) moments in a modern art which would live on and flourish, after Paris, mainly in the English-speaking world, my world. For the Diasporist Jew and Gentile (as for the Israeli) it is a world in the making and fraught with danger and mystery. For me, art is in the making in *that* world. Some years ago, I thought this might be a period I would pass through, but Diasporism, one's Jewishness itself, changes all the time. Any exciting life of the mind will keep changing one's art. The more I throw in my lot with the Jewish destiny or cultural tribe or nation or whatever it is, and the closer I get to my own death, the more a vision of Diasporic art draws me forward.

41

If any curious people have followed this stuff of mine thus far, my gentle manifesto is also a primitive and belated answer to those who have written to me during recent years asking for advice I could only rarely give. I don't want to enlist them as Diasporists – Jewish or otherwise. My tendency is to throw these few crumbs down at the feet of our modern art and run like hell into hiding.

Notes

1 The illustrations that accompany the text can be found in R.B. Kitaj (1989) *First Diasporist Manifesto*, London: Thames and Hudson, pp. 19–49.

Part II

DIASPORIC IDENTITY IN THE NINETEENTH CENTURY

3

MARY EDMONIA LEWIS'S *MINNEHAHA*

Gender, Race, and the "Indian Maid"

Juanita Marie Holland

Mary Edmonia Lewis's bust of *Minnehaha*, created during the early years of her successful career as an expatriate American sculptor in Rome and now in the collection of the Detroit Institute of Arts, is one of five works by the artist illustrating Henry Wadsworth Longfellow's epic poem *The Song of Hiawatha*. Lewis's portrayal of Minnehaha is that of an idealized Indian princess whose beads and feather adorn her neoclassical Caucasian features, an interpretation which fits comfortably within the stereotypical conventions that informed contemporary portrayals of Native American women.[1] But it is precisely the stereotypical qualities of this piece, as well as those found in Lewis's other Native American subjects, that are rendered both more potent and more ambiguous by the identity of its creator.

Lewis (1843 – after 1911) was part of a group of expatriate American women sculptors, including Sarah Clampitt Ames (1817–1901), Louisa Lander (1826–1923), Emma Stebbins (1815–1882), Margaret Foley (1827–1877), Florence Freeman (1836–1876), Anne Whitney (1821–1915), Blanche Nevin (1838–1925), Vinnie Ream Hoxie (1847–1914), and Harriet Hosmer (1830–1908). Hosmer was probably the most famous and successful of this group of artists, who lived and worked in Italy in the second half of the nineteenth century. They adhered to the conservative academic traditions of mid-century neo-classical sculpture and came to Italy for classical inspiration, cheap sources of marble, and a more liberal atmosphere where they might work freely in a medium traditionally perceived as masculine.[2]

For Lewis, however, her parentage was seen as more remarkable than her decision to work in a medium traditionally deemed a pursuit for male artists. Her father was African-American, her mother Native American and, according to Lewis, much of her childhood was spent in upstate New York among her mother's people, the Ojibwa (also called Chippewa). This conflation of ethnic identities elicited very revealing responses from her public, patrons, and

45

acquaintances and determined Lewis's own artistic choices. She shrewdly uti-
lized both aspects of her heritage to skillfully navigate the maze of racism and
sexism that defined her reception as a woman sculptor of mixed ancestry. As a
black woman, she was able to use the abolitionist fervor of mid-century
Boston as a springboard for her career and as a continuing source of sculptural
subject matter and patronage. But it was as the Indian lass that her public most
easily accepted and approved of her, and this gave her the exotic edge so nec-
essary for public recognition. Lewis's aggressive and remarkable shaping of her
Native American identity into a public persona was as carefully crafted and
presented as any of her marble pieces.

Documenting the facts of Lewis's life has proved an elusive task for histori-
ans. The colorful biographical anecdotes published about her, often affirmed
and further embroidered by Lewis herself, are quite often at odds with what
little has been discovered about her youth. Most historians accept the proba-
bility that Lewis's mother was from New York state and was of part Chippewa
descent, although no clear documentation exists. Marilyn Richardson's
research has placed Lewis's older brother Samuel, her mother, and her Afro-
Haitian father in Newark, New Jersey, by 1840.[3] Both parents had died by
1847, and Samuel placed his sister with a Captain S.R. Mills while he went to
California to prospect for gold. Samuel continued to care for his sister, sending
money back east and making trips to visit her. Sometime in the 1850s, he
enrolled her in a Baptist abolitionist school in McGrawville, New York. It is
unclear how long she remained there, but the school closed in 1859, and by
that year Lewis had enrolled in Oberlin College in Oberlin, Ohio.[4]

With the help of abolitionist supporters at the college, she had moved to
Boston by 1863 and was introduced to prominent anti-slavery activist and
publisher William Lloyd Garrison, and feminist abolitionist Lydia Maria Child.
Learning of Lewis's ambition to become a sculptor, they arranged for her to be
tutored by artist Edward Brackett (1818–1908), the only formal training that
Lewis received. From 1863 to 1865, she worked as an artist in the Studio
Building, fashioning portrait busts and medallions of black and white anti-
slavery leaders and heroes. The sale of copies of her bust of Colonel Robert
Gould Shaw, martyred Civil War leader of the all-black Massachusetts 54th
Regiment, earned her enough to finance a trip to Europe in 1865.

Loosely allied with the community of like-minded women artists who
found better opportunities and markets for their work in Italy, Lewis remained
in that country for the remainder of her life, enjoying financial and artistic
success with European and American patrons through the 1880s. Outside of
the standard neo-classical fare – copies of famous Italian sculptures, religious
and classical groups and single figures, and putti – Lewis is best known for her
work celebrating the Emancipation Proclamation, her portrayal of characters
from Longfellow's *Hiawatha*, and her 1876 *Death of Cleopatra*, exhibited at the
Philadelphia Centennial. She traveled back to the United States several times
to exhibit her work, but information about her life after the 1880s is scarce.

Although Roman documents place her in Italy as late as 1911, the exact date and place of Lewis's death are still unknown.

The various permutations of Lewis's life story which appeared in the popular press provide a glimpse into the mythic constructs of Indian womanhood that became the artist's public persona. Although contemporary accounts of Lewis's activities had such titles as "The Negro Sculptress" and mentioned her African parentage, they usually went on to discuss her life and career almost wholly in terms of her Indian ancestry.[5] Lewis herself is quoted as preferring her Native American ancestry: "My mother's people never submitted to slavery; and I honor them for that." Rather than seeing in Lewis a blend of cultures, most interviewers clearly differentiated between her two heritages. One remarked that Lewis "has the proud spirit of her Indian ancestor, and if she has more of the African in her appearance, she has more of the Indian in her character."[6]

One reason for the public's preference for the Native American aspect of her background might have been that Lewis did not easily fit some of the deeply embedded stereotypical perceptions of African-American women popular in white American society, such as the tragic mulatta or hardy slave woman.[7] In post-Civil War America, African-American women, once safely defined in their relationship to slavery, began to assume unsettling new roles. African-American women who were free, talented, and successful outside their "proper" spheres of activity (such as teachers and nurses to their race) became troubling and uncontrollable presences. Such threatening aspects of Lewis's identity could be more easily defused by placing her within the stereotypes of Native American women.

Certainly, the emphasis on Lewis's Native American ancestry reflected the white fascination with Indian life as exotic lore from America's past. Lewis's accounts of her Native American experience reveal her willing participation in the construction of her identity as an Indian maid. "My mother," she said in one interview,

> was a wild Indian, . . . born in Albany, of copper color and straight black hair. There she made and sold moccasins. My father, who was a negro, and a gentleman's servant, saw her and married her. . . . Mother often left her home, and wandered with her people, whose habits she could not forget, and thus we her children were brought up in the same wild manner. Until I was 12 years old, I led this wandering life, fishing and swimming and making moccasins.

When she was sent by her brother to a Baptist abolitionist white school in the mid-1850s, Lewis claimed, "[I] was declared to be wild, – they could do nothing with me."[8] Another published account, a pamphlet entitled "How Edmonia Lewis Became An Artist," also chronicles her rise from noble savagery to lofty civilized pursuits. "Born in a wig-wam," her idyllic childhood

was a "happy life . . . indeed a wild, roving one – hunting, fishing, and making moccasins," but she had to "bid farewell to her Chippewa dress" for the "civilized dress" required at school.[9]

Probably the most potent popular tale concerning Lewis, one recounted by the artist herself, was the story of her introduction to the art of sculpture. As told in an 1871 version, Lewis had had little opportunity for education until she came to Boston in the early 1860s. Walking the city's streets one day, she was awestruck by the sight of a statue of Benjamin Franklin. As the story goes, this young girl

> was filled with amazement and delight. She did not know by what name to call the "stone image," but she felt within her the stir of new powers. "I, too, can make a stone man," she said to herself, and at once went to visit Lloyd Garrison . . . and asked him how she should set about doing it.

Lewis reaffirmed this account in an interview after the successful exhibition of her *Death of Cleopatra* at the 1876 Philadelphia Centennial, allegedly claiming that "at that time I knew nothing of art, and did not even know the big bronze monument was a statue. I had no idea what a statue was; but a certain fascination seemed always to direct my steps to that one spot, and I became almost crazy to make something like the thing which fascinated me."[10] Almost all contemporary accounts of her life repeat this story in one version or another.

Lewis often emphasized the wild and untamed nature of her Ojibwa experience, contrasting it with the new life of sophisticated art and culture she had chosen in "civilization." She also declared she liked her Indian lifestyle of crafting baskets and embroidering moccasins "a great deal better than I do your civilized life. . . . I would not stay a week pent up in cities, if it were not for my passion for art." When Lydia Maria Child, Boston feminist, abolitionist, and Lewis's most important patron, asked Lewis how she came to sculpture, Lewis replied, "I don't know. My mother was always inventing new patterns for moccasins and other embroidery; and perhaps the same thing is coming out in me in a more civilized form."[11] But Lewis's claim of ignorance of the concept of sculpture prior to arriving in Boston is difficult to accept. In 1862 while at Oberlin, Lewis completed a drawing, entitled *The Muse Urania*, probably copied either from an engraving or a plaster cast of the original Roman sculpture. She would have seen the copy in one of her Oberlin art classes, and it is unlikely that the concept of statuary as an art form was never discussed there.

Although she was college-educated, fluent in both English and Italian, and a shrewd businesswoman, most of her interviewers perpetuated an image of this adult artist as a kind of gifted child, describing her as "naive in manner, happy and cheerful, and all unconscious of difficulty . . . because obeying a great impulse she prattles like a child, and with much simplicity and spirit pours forth all her aspirations."[12] In general, the public was loath to see women

artists in forceful terms, and artists like Lewis and her colleague Harriet Hosmer were characterized by the press as childlike in their demeanor, having had wild and "tomboyish" childhoods. For Lewis, implications of power were defused by her identification as a naive savage; public descriptions of the white sculptor Harriet Hosmer achieved the same effect by concentrating on her childlike ways and small stature. Both Hosmer and Lewis were described as "mannish" and unconventional dressers, but any questions of gender identification were resolved by their depiction as playful child-women with a chaste dedication to their art.[13]

This public image of Lewis is remarkable in that it differs from descriptions of her found in the private writings of patrons and colleagues. It is these personal observations, untouched by the necessities of public propaganda, that give a very different picture of the artist. Lewis's patron Lydia Child, who was often annoyed at Lewis's stubborn refusal to follow her advice, once wrote of her, "whether the little lady has genius or not, she certainly is largely endowed with one element of success, for her perseverance is unconquerable. What she undertakes to do she will do, though she has to cut through the heart of mountains with a penknife. . . . I besought her not to undertake to work in marble for two or three, or even four years to come . . . but she went on all the same, and thought my advice very unkind. She is in a hurry to play wear the laurels before she has earned them." In another example, Sarah Shaw (the mother of Col. R.G. Shaw) said that she had no patience with Lewis's "overwhelming vanity."[14]

Fellow sculptor Anne Whitney, in an acid commentary on Lewis's multiple identities composed after Lewis had approached her for assistance in Boston in 1864, wrote:

> Lo! The poor Indian! Edmonia is very much of an aboriginal, grateful, vengeful, a little cunning, and not altogether scrupulous about the truth when dealing with those she doesn't love, open, kind, and liberal as day with those she does. I like her in spite of her faults, and will help her all I can. I wish she were a little less of an aborigine about the ordering of her wigwam.[15]

Correspondence between Lewis and her patrons reveals the shrewd business sense and aggressive marketing techniques she used to secure her niche in a competitive market. No gentle maiden artist, Lewis could pursue her objectives quite fiercely.[16]

Will, ambition, pride, and stubborn intelligence were the qualities most often remarked upon when Lewis was described in private. But the public perception of Lewis as the gifted, savage child was a more comfortable image for her white public. White supporters of the rights of Native Americans and African-Americans often still thought of these groups as downtrodden primitive peoples who, although not currently the equals of whites, could be

elevated to a higher level of humanity through Christianity and education. Even Child's public appeal for Indian rights was based on the belief that "every . . . tribe on earth is capable of being softened and refined if brought under the right influences."[17]

Certainly, this proud, intelligent, and aggressive woman could only be accepted and embraced with adoring fascination by the public if she were seen as the idealized Indian maiden who reverently approaches the altar of Western civilization. Examining popular conceptions of Native American womanhood helps to further delineate and explain the need for such a carefully crafted public perception. As Rayna Green points out in her study of Native American women, "The Pocahontas Perplex," the Indian woman commonly had two possible identities in American society. She could either be a Pocahontas-like figure, the cherished noble princess who renounces her heritage to save the white man and embraces his culture, or the negative image of the squaw, often portrayed as fat, indolent, alcoholic, and a prolific breeder, who satisfies the lusts of white men.[18] As reflected in popular novels, folk tales, poems, and songs, these were common perceptions of Native American women. They served to reassure the white population with codified images that reaffirmed the superiority of the dominant culture, much like the mammy, pickaninny, and minstrel images that were popular depictions of African-Americans.

An undeniably talented and intelligent woman who was accepted and endorsed by abolitionist and artistic circles, Lewis could hardly be cast in the bawdy folk song image of a drunken squaw. Rather, her public sought in her the more romantic and non-threatening image of the Pocahontas legend, echoed so clearly in the tale of Lewis's discovery of sculpture. Here, art and education, rather than John Smith, are the object of Lewis's love and the reasons that cause her to throw over her Indian life and don the trappings of civilization. Like Pocahontas's converted loyalties at the sight of John Smith, Lewis was transformed by the figure of Benjamin Franklin in stone. It is the artistic aesthetic of white culture that seduced Lewis, affirmed in her public declarations that, after her Oberlin education, "I thought of returning to wild life again; but my love of sculpture forbade it."[19]

The popularity of Lewis's mythic biography, stressing her idyllic Indian childhood, as well as her sudden and startling love affair with Western art, her conversion to Catholicism,[20] and her willing embrace of the "civilized" life, reflects the affection held by Americans and Europeans for casting Lewis in the Pocahontas mold. And although she was not a royal Indian princess, Lewis's nobility was God-given, expressed in the gifts of artistic talent bestowed upon her.[21]

Lewis's Native American subjects certainly reflected her canny understanding of the power and importance of the mythic Indian in white American culture. Given the popularity of Lewis's tales of her Indian childhood with the public, one might assume that some of her sculptures of Native American

themes would recount her exotic childhood among the Ojibwa. On the contrary, no surviving work or documentation exists to indicate that her sculptures depict any aspect of her Indian childhood. Instead, Lewis apparently chose to portray in all her works with Native American themes a series of events from Henry Wadsworth Longfellow's enormously popular epic poem of the Native American culture-hero, Hiawatha.[22] *The Song of Hiawatha* recounts the life of an Ojibwa leader born on the shore of Lake Superior. Hiawatha served his people by bringing them skills for agriculture and hunting, vanquishing supernatural enemies, and promising peace. Longfellow's work, widely read and admired, not only became a familiar aspect of American culture, but also inspired a number of painters, sculptors, and illustrators, including Thomas Eakins (1844–1916), Augustus Saint-Gaudens (1848–1907), Thomas Moran (1837–1926), Albert Bierstadt (1830–1902), and Currier (1813–1888) and Ives (1824–1895).[23] Lewis's five documented works illustrating this poem probably make her the most prolific sculptural interpreter of *The Song of Hiawatha*. The only other contemporary creator of a significant number of images based on the poem was the team of Currier and Ives, whose several editions of seven popular prints also capitalized on the public's fascination with Longfellow's poem. Cynthia Nickerson has noted similarities in Lewis's work that suggest she was influenced by the first two Hiawatha prints published by Currier and Ives. She also notes the similarity in genre-type subjects and in size to John Rogers's popular sculptural groups, of which Lewis certainly would have been aware.[24] Lewis manifested a shrewd understanding of her market from the earliest days of her career as a sculptor. Her first works appealed to the strong anti-slavery sentiments in Boston and reflected abolitionist themes, and she marketed these early works in moderately priced mediums accessible to a wide range of patrons. Lewis would certainly have been aware of the popularity of Longfellow's poem during her years in Boston, the time when she began to craft her public identity as Indian maid.

In her first year in Italy, Lewis began sculpting scenes from the poem. In 1866, a visitor to her studio in Rome described the work commonly titled *The Old Arrowmaker and His Daughter*, which depicts Minnehaha and her father just before their first meeting with Hiawatha, and a group described as "Hiawatha and Minnehaha going through the forest to find a new home," probably the work later identified as *Hiawatha's Marriage* or *Hiawatha's Wedding* (private collection).[25] *Hiawatha's Wooing* (1866, location unknown) depicts "Minnehaha seated making a pair of moccasins and Hiawatha by her side with a world of love and longing in his eyes."[26] Individual portrait busts of *Hiawatha* and the museum's *Minnehaha*, both dated 1868, complete the list of extant works by Lewis inspired by Longfellow's poem.

Although one critic said of Lewis's depictions that "the Indian type of features is carefully preserved and every detail of dress, Etc. is true to nature,"[27] when compared with contemporary images of Ojibwa men and women, Lewis's Native Americans are clearly more evocative of the sentimental visions

of Indian life safely set in the distant past that were cherished by Anglo-Americans. In its depiction of Caucasian standards of female beauty, Lewis's version of Minnehaha embraces standard neo-classical conventions used by popular sculptors like Eratus Dow Palmer (1817–1904) in *Indian Girl, or the Dawn of Christianity* and Hiram Powers (1805–1873) in *The Last of the Tribes*. Although Lewis's depiction of Minnehaha's father in the *Old Arrowmaker*, with his sinewy body and wrinkled face, strives for a more realistic portrayal of age and, perhaps, ethnographic accuracy, the busts of Minnehaha and Hiawatha are classically idealized noble savages.

The concepts of the Native American as both noble savage and a member of a vanishing race were essential to the agenda of westward expansion: subduing a primitive people was justified by the gifts of Christianity and progress that white civilization would bring. The decline of native peoples was seen as romantic but inevitable and necessary before civilization's onslaught.[28] In *The Song of Hiawatha*, Longfellow echoed popular sentiments about the potential to civilize the Indian savage, hoping that his intended audience would

> believe that in all ages / Every human heart is human / That in even savage bosoms / There are longings, yearnings, strivings / For the good they comprehend not.[29]

In sculpture, physical attributes such as "well-formed heads, with high foreheads and prominent [Roman] noses" conjured up images of Roman physique and virtue for nineteenth-century audiences. These features were used to connote the noble and intelligent savage who either is welcomed into civilization or marches grandly into the sunset as his age ends and that of the white man begins.[30] Although Lewis's hesitant handling of the full torso in *Hiawatha's Wedding* falls short of the ideal, the heads of her young couple certainly exhibit these heroic features; Minnehaha's gaze is softened by a demure half-smile, and any exoticism hinted at by her costume is effectively neutralized by the white marble.

In addition to following the aesthetic conventions of the noble savage, the narrative moments Lewis chose from *The Song of Hiawatha* – peaceful artisanship, courtship, and marriage – would have been reassuring images, especially in the context of the often violent displacement of Native Americans from their lands that was integral to America's western expansion.[31] As also illustrated by the peaceful Indian encampment in Albert Bierstadt's *Wolf River*, Native Americans were portrayed as a safely neutralized quantity, metamorphosed into thrilling tales of barbarous or noble savages yet at the same time considered to be remnants of a distant past, never to return. Sculptor Ferdinand Pettrich's 1856 *Dying Tecumseh* (National Museum of American Art, Washington, D.C.) and Tompkins H. Matteson's 1847 painting. *The Last of the Race* (New York Historical Society, New York) reflect this need to depict the Indian peoples nobly acquiescing to the inevitable course of "civilization."

The Song of Hiawatha and the images that illustrated it reaffirmed this idea:

Minnehaha dies during the course of the story, and Hiawatha, rather than save his people from Anglo-American domination, leaves them, just as the white man and Christianity arrive, with a vague promise that he will return. Lewis's own manipulation of these concepts certainly indicates her awareness of their value to her public acceptance and artistic success. While other sculptors renditions of Native Americans also expressed the popular stereotypes comfortable to white viewers, it was Lewis's self-proclaimed identity as a Native American that made her renditions so powerfully appealing. What better confirmation of the validity of Anglo-American beliefs about Native Americans than to have them expressed by a very member of that group? One reviewer described Lewis's renditions of Longfellow's characters as "poetic, simple, and natural," and went on to exclaim that "no happier illustrations of Longfellow's most original poem were ever made than these by the Indian sculptor."[32] Lewis's Native American subjects have often been characterized as an expression of pride in her own heritage, but her choice to illustrate her expression of Native American identity solely through the fictional characters created by a white American author, must have arisen from a more complex motivation than simple pride in her heritage.

It should be noted, however, that there is little documentation, other than these anecdotal accounts, of any actual links between Lewis and the Ojibwa. No mention of her Native American heritage appears prior to her arrival in Boston. Considering all the facets of her public identity – her willingness to embroider a colorful but vague Indian past with no examples of Ojibwa culture or language in any of her accounts, that all of her Indian subjects are based on Longfellow's epic tale presented in neo-classical garb – it does seem likely that Lewis created or greatly embellished her Indian past to enhance the public's interest in her life and work. Certainly, it was more convenient for the public to award this headstrong, talented, ambitious, and successful woman their adoration in her suitably modified Native American persona – a last vestige of a dying race, Christian, asexual, non-threatening, and a perfect example of the evolutionary process deemed necessary by Western civilization for all primitive peoples. Lewis's depictions of themes from *The Song of Hiawatha*, like her crafted identity, were the natural outgrowth of her sophisticated reading of American prejudices and the presumptions held about Native American peoples, as well as her awareness of the narrow boundaries within which she could succeed at her career. Her public persona and her works, both carefully created, reveal her determination not to become a passive victim of stereotype; instead, she reshaped the limitations of those stereotypes into a remarkable act of empowerment.

Notes

This article is taken from the more thorough discussion of Lewis's manipulation of African-American, Native American, and gender stereotypes in "Mary Edmonia Lewis

and the Hierarchy of Gender and Race," chapter three of the author's "Co-Workers in the Kingdom of Culture: Edward Mitchell Bannister and the Boston Community of African-American Artists, 1848–1901" (Ph.D. dissertation, Columbia University, 1995). The author is indebted to scholar Marilyn Richardson, Watertown, Massachusetts, who is currently completing a book on the life and career of Mary Edmonia Lewis (University of Massachusetts Press), and who graciously shared her research, which helped form the direction of this study.

1 See, for example, Hiram Powers's *The Last of the Tribes,* Joseph Mozier's *The Indian Girl's Lament* (whereabouts unknown, photograph reproduced in W. Gerdts, *American Neo-Classic Sculpture,* [New York, 1973]), and *Pocahontas* (1877, collection of Hirschl and Adler Galleries, New York), or Erastus Dow Palmer's *The Indian Girl, or The Dawn of Christianity.*

2 These artists were part of a larger circle of European and American artists and writers living in Italy, including artists Hiram Powers (1805–1873) and William Wetmore Story (1819–1895), famed American actress Charlotte Cushman (1816–1878), and poets Robert (1812–1889) and Elizabeth Barrett (1806–1861) Browning. Author Nathaniel Hawthorne (1804–1864) apparently used several of these women as inspiration for the female sculptor in his novel *The Marble Faun* of 1859. Many of the artists' studios were popular stops on the fashionable grand tours undertaken by America's élite; they were often listed in local guidebooks, and patrons would routinely order works from the artists to be shipped back to America.

3 Harry Henderson and Romare Bearden (*A History of African-American Artists: From 1792 to the Present* [New York, 1993] 54, notes 4 and 5) cite circumstantial evidence that Edmonia was born in the Niagara region of upstate New York to a mother who was Mississauga Chippewa and had married "a colr [sic] man named Lewis." But the dating of their documentation seems to contradict Edmonia's birth date and her age when she entered Oberlin College. Also see M. Richardson, "Edmonia Lewis's *The Death of Cleopatra*: Myth and Identity," *The International Review of African American Art,* Summer 1995: 18–19.

4 While at Oberlin, Lewis was charged with poisoning her two white roommates. Although acquitted, she was viciously beaten by a vigilante mob and endured suspicion and hostility from students and teachers after returning to classes, see G. Blodgett, "John Mercer Langston and the Case of Edmonia Lewis: Oberlin, 1862," *Journal of Negro History,* 53 (July 1968): 201–18.

5 H.W., "A Negro Sculptress," *The Athenaeum,* no. 2001 (March 3, 1866): 302, and L. Gay, "Edmonia Lewis, the Colored Sculptress," *Editors Sunday Mercury,* (Washington, D.C.: Vertical File on Edmonia Lewis, Moorland Spingarn Research Center, Howard University, n.d..): 23.

6 L.M. Child, "Letter from Mrs. Lydia Maria Child: A Plea for the Indians, No. II," *National Anti-Slavery Standard,* April 18, 1868, and L.C. Bullard, "Edmonia Lewis," *The Revolution,* April 20, 1871.

7 See H.V. Carby, *Reconstructing Womanhood: The Emergence of the Afro-American Woman Novelist* (New York, 1987), and B.M. Doriani, "Black Womanhood in Nineteenth-Century America: Subversion and Self-construction in Two Women's Autobiographies," *American Quarterly* 43, 2 (June 1991): 199–221.

8 H.W. 1866 (note 5).

9 "How Edmonia Lewis Became An Artist," undated pamphlet (Washington, D.C.: Evans-Tibbs Collection Archives, Edmonia Lewis Vertical File).

10 Bullard 1871 (note 6), and Gay (note 5).

11 L.M. Child, letter published in *The Liberator,* February 19, 1864, and again in the *National Anti-Slavery Standard,* February 27, 1864.

12 H.W. 1866 (note 5). An 1871 interviewer also noted that "her manners are child-like, simple, and most winning and pleasing," see Bullard 1871 (note 6).

13 J.S. Kasson, *Marble Queens and Captives: Women in Nineteenth-Century American Sculpture* (New Haven, 1990), 142–147. Albert Boime, (*The Art of Exclusion: Representing Blacks in the Nineteenth Century* [Washington, D.C., 1990], 236, n. 30) cites an 1873 description of Lewis that stated, "Her appearance is masculine and her voice hard and gruff."

14 L.M. Child to H. Sewall, June 24, 1868 (Boston: Robie-Sewall Papers, Massachusetts Historical Society), microfiche 69/1841 (courtesy of the Marilyn Richardson Research Files, Watertown, Mass.), and Child to Shaw, (1870?), (Cambridge, Mass.: Houghton Library, Harvard University), BMS kAm 1417 (105).

15 A. Whitney to A. Manning, August 9, 1864 (Wellesley, Mass.: Whitney Archive, Wellesley College Library) cited in E. Tufts, "Sculpture," in *American Women Artists 1830–1930* (Washington, D.C.: National Museum of Women in the Arts, exh. cat., 1987), 107.

16 For example, once she had decided to sculpt a bust of Henry Longfellow, Lewis was so determined that she stalked her subject through the streets of Rome to catch his likeness until Longfellow's brother assisted her efforts by persuading the poet to sit for her, see Tufts 1987 (note 15), 107. For additional letters, see J. Holland, "Mary Edmonia Lewis and the Hierarchy of Gender and Race," in "Co-Workers in the Kingdom of Culture: Edward Mitchell Bannister and the Boston Community of African-American Artists, 1848–1901" (Ph.D. diss., Columbia University, 1995) 45–51, notes 129–148.

17 Child 1868 (note 6). Child's "Plea for the Indian" was first published in the *National Anti-Slavery Standard*, April 11 and 18, 1868, and reissued as a pamphlet later that year.

18 R. Green, "The Pocahontas Perplex: the Image of Indian Women in American Culture," *The Massachusetts Review* 16, (1975): 699–714. In the popular version of the Pocahontas story, Pocahontas saved the life of John Smith by putting herself between him and her father's men. Later she married John Rolfe, converted to Christianity, was renamed Lady Rebecca, and moved with her husband to England.

19 H.W. 1866 (note 5).

20 She converted to Catholicism in 1868, and at some point was visited in her studio by Pope Pius IX, see L.R. Hartigan, *Sharing Traditions: Five Black Artists in Nineteenth-Century America* (Washington, D.C.: exh. cat. 1985), 94, and "An Unplaced Artist," *The Peoples' Advocate* (Washington, D.C. December 4, 1880): 1. In the medium of sculpture, Erastus Dow Palmer's *The Indian Girl, or Dawn of Christianity* as well as Joseph Mozier's *Pocahontas* illustrated the transformative and overwhelming effects of Christianity upon the noble savage. Lewis's ambitions as a neoclassical sculptor and her devout embrace of Christianity affirmed, like those images, beliefs about the proper course for American Indians, and in particular the ability of the Native American woman to be saved and civilized through Christianity. See W.H. Gerdts, "The Marble Savage," *Art in America* (July/August 1974): 64–70.

21 "[It was] God's gift . . . of unconquerable energy, as well as genius . . . [that enabled] her to rise above all prejudices of race or color, and command the respect and honor of all true lovers of art," quoted in Evan-Tibbs (note 9).

22 Indeed, the only documented plans by Lewis for an Indian sculptural subject that was not drawn from *The Song of Hiawatha* further illustrate her understanding of the potency of these mythic stereotypes. In 1868, Lewis expressed a wish to do a statue of Pocahontas (see L. M. Child to H. Sewall, July 10, 1868 [note 14]), although no evidence exists that it was ever completed.

23 Longfellow's *The Song of Hiawatha*, published in Boston in 1855, sold 30,000 copies within a few months of its publication and continued to sell well in a number of editions for years afterward. For other works of art inspired by the poem, see C. Nickerson, "Artistic Interpretations of Henry Wadsworth Longfellow's *The Song of Hiawatha*, 1855–1900," *American Art Journal* (Summer 1984): 49–77.

24 Ibid.: 64.

25 "Artistic," *Boston Commonwealth*, June 16, 1866. *The Old Arrowmaker and His Daughter* has until now been given a date of 1872. It illustrates the lines from Longfellow's poem: "At the doorway of his wigwam/Sat the Ancient Arrowmaker, / In the land of the Dacotahs,/ Making arrow-heads of jasper, / Arrowheads of chalcedony. / At his side, in all her beauty, / Sat the lovely Minnehaha, / Sat his daughter, Laughing Water, / Plaiting mats of flags and rushes; / Of the past the old man's thoughts were, / And the maiden's of the future" in Tufts 1987 (note 15), 108.

26 Bullard 1871 (note 6).

27 Ibid.

28 Elizabeth Johns (*American Genre Painting: The Politics of Everyday Life* [New Haven, 1991], 63–64) has discussed how representations of Indians by white American painters expressed both European stereotypes of the noble primitive, as well as American fears of the barbarous savage; these images served to promulgate, for fascinated Eastern audiences, the idea of Native Americans as a vanishing race.

29 H.W. Longfellow, *The Song of Hiawatha*, in E. Wagenknecht, *Henry Wadsworth Longfellow, His Poetry and Prose* (New York, 1986), 102.

30 J. Schimmel, "Inventing 'the Indian'," in *The West As America: Reinterpreting Images of the Frontier, 1820–1920*, W.H. Truettner, ed., (Washington, D.C.: National Museum of American Art, exh. cat., 1991), 151.

31 Nickerson (1984 [note 23]: 59) also suggests that Lewis's portrayals from *The Song of Hiawatha* reflected Lewis's attempt to widen the canon of acceptable ideal figures in neoclassical sculpture. Gerdts (1974 [note 20]: 70) has speculated that Lewis's interest in Hiawatha and Minnehaha's marriage, representing the union of two previously warring tribes, might have expressed her hopes for national unity after the Civil War.

32 Bullard 1871 (note 6).

4

PISSARRO'S PASSAGE

The Sensation of Caribbean Jewishness in Diaspora

Nicholas Mirzoeff

Camille Pissarro (1830–1903) often talked about recording sensation as the goal of his art. He would immediately supplement this idea, as in this 1883 comment that: "Impressionism should be only a theory of pure observation, without losing either fantasy, liberty or grandeur, in short everything that makes an art great without puffery."[1] Sensation thus includes psychic, political and aesthetic dimensions beyond the purely optical. Pissarro further argued, speaking of his relationship with Cézanne but by extension of all the Impressionists, that: "We were always together but what cannot be denied is that each of us kept the only thing that counts, the unique *sensation*," suggesting that sensation was individual not universal.[2] In this chapter, I want to suggest that such observation referred not only to opticality but also to what we now call identity.

Specifically, I will seek to demonstrate that Pissarro's Jewishness helps us understand his work and further to understand Jewishness from a secular standpoint. This is not a domestic dispute of interest to Jews alone. One could argue that secular Jewishness, centered around such figures as Marx, Freud and Einstein, was as constitutive of modernism as the work of Cixous, Derrida, and Levinas has been to poststructuralism and postmodernism. Further, the understanding of the interconnections between culture and ethnicity cannot be restricted to people of color, leaving "white" people as an ethnic-free zone. So what does secular "Jewish" art look like? Art is typically described as Jewish if it fulfills a liturgical Jewish function or represents religion iconographically, that is to say, by rabbis and menorahs. Perhaps the most obvious example of such Jewish art is that of Marc Chagall. Yet what is represented here is not Jewishness but Judaism, specifically the orthodoxy of Eastern Europe, which is denoted here as, to quote Roland Barthes, "something simple, literal, primitive: something true." Jewishness, on the other hand, is not so much denoted as connoted. Connotation is a secondary meaning generated by association, which, as D.A. Miller points out, "enjoys, or suffers from, an abiding deniability."[3] At all stages in this project I have

been informed, regarding Pissarro's Jewishness, that "there is nothing there," to quote one distinguished professor from the Hebrew University of Jerusalem. But the connotations of Jewishness cannot be so easily disposed of in the life of a man so dominated by the Jewish themes of diaspora, family and work, in a period during which the "Jewish question" was increasingly inescapable in European life.

Further, Pissarro's "there" was not the by-now standard European/ Ashkenazi Jewishness but Caribbean Sephardic Jewishness from the then Danish island of St Thomas. What did it mean to be a Caribbean Jew in European diaspora in the second half of the nineteenth century? Caribbean Jews were as much Caribbean as they were Jewish, with the result that European Jews sent missionaries in the mid-nineteenth century to instruct them in orthodoxy. The standard assertion that Pissarro's work is not Jewish because he did not represent traditional Jewish iconography thus fails to consider his very untraditional Jewishness. Caribbean Jewishness was created during the period of plantation slavery by the triangular process of what Cuban critic Fernando Ortiz called transculture, an often violent interaction between cultures that generates a third, hybrid neo-culture from fragments of the originally encountering cultures.[4] Sephardic Jews arrived in Jamaica with Christopher Columbus and by the mid-seventeenth century they had settled throughout the Protestant islands of the region, fleeing the persecution of the Spanish Inquisition in both Europe and Latin America. By 1680, there were more Jews in Bridgetown, Barbados, than there were in London. In the first difficult years of settlement, Jews were welcomed as necessary additions to the flimsy European presence, constantly at risk from disease and war. But as an indigenous planter population developed – those whom the English called Creoles – they increasingly came to resent the Jews as competitors and as aliens. Creole anti-Semitism led to discriminatory taxation, limits on Jewish slave ownership and compulsory militia service on the Sabbath. Local British Assemblies justified their actions because of the "great ease and indolence" of the Jews, by which they meant their failure to plant and trade in slaves.[5] In 1739, white Barbadians burnt down the Bridgetown synagogue during an anti-Semitic riot. In short, having failed to "Europeanize" the Jews, the planters sought to "Africanize" them, a task finally accomplished by nineteenth-century race science.

As a result, some Jews came to sympathize with the enslaved Africans, creating a radical tradition that was the source of Pissarro's own famed radicalism. Jewish merchants traded with the enslaved Africans, and supplied the Jamaican Maroons with essential gunpowder during their successful revolt of 1730–38. In the 1750s, Jamaican Jews campaigned unsuccessfully for voting rights, one of the first civil rights campaigns. When the French Revolution did emancipate the Jews in 1791, the echoes soon reached the Caribbean. David Nassy, a failed Jewish planter turned *philosophe*, published a book in Surinam calling for Jewish emancipation, arguing for "equal rights [and] equal privileges" in the

spirit of the Universal Declaration of the Rights of Man.[6] In the early nine-teenth century, Jews from Curaçao were prominent supporters of Simon Bolivar's freedom struggle in Latin America, giving financial aid, sheltering refugees and sending volunteers to fight in the revolutionary armies. Pissarro himself witnessed the successful slave revolt in St Thomas in 1848 and a simi-lar later victory in Venezuela.

By the late eighteenth century, it made sense to refer to Caribbean Jewishness, a distinct interpretation of the tradition shaped by local conditions, but split into two distinct factions. One, known demeaningly as the "Smouse" Jews (a term created by slave traders), advocated the relaxation of almost all religious law, claiming the right to marry Gentiles while remaining Jewish. Given that many had died at the hands of the Inquisition for the slightest trace of Jewish observance, this was no hollow claim. Pissarro's famous marriage to the gentile Julie Vellay was by no means incompatible with his continuing to view himself as Jewish. Mainstream Caribbean Jews contested this secular minority but their position was not orthodoxy. Rather, it was described by one Jamaican rabbi as "reason with faith," a blend of Jewish monotheism and Enlightenment rationalism.

The St Thomas Jewish community in which Pissarro grew up was trans-formed by immigration in the early nineteenth century from other islands, especially Curaçao. In Curaçao, Sephardic Jews maintained widely extended families and distinguished themselves from the other Europeans by wearing different clothing.[7] They spoke Papiamento, the Creolized language used by Africans. The closeness between Curaçao Africans and Jews was epitomized in the local Jewish funeral practice of placing the corpse on a bier for a day after death,[8] a flagrant breach of European Jewish tradition, derived from Kongo funeral practices.[9] On St Thomas, a group of Jewish doctors set up a hospital to care for Africans who fell ill during the Middle Passage where many were healed.[10] In typically transcultural fashion, Pissarro was educated alongside African students by Protestant missionaries at the only school on St Thomas. The similarities between the colonial conditions of Africans and Jews that motivated Jewish radicalism were also observed by Africans, like the freed slave turned writer Olaudah Equiano who believed that Africans were originally Jews. By the mid-nineteenth century, interaction between the different com-munities on St Thomas was well advanced. Indeed, a Dutch missionary wrote in 1852 that "the most kindly feelings exist between [the Jews] and the rest of the community." For some white observers, such interaction was extremely disturbing. The American journalist John Bigelow reported to his readers from Jamaica in 1850 that: "I had never seen a black Jew before, and I was astonished to find how little the expression of the Israelitish profile was effected by color."[11] The racialized equation between Africans and Jews that had been a staple of planter belief since the seventeenth century was now transposed from culture to biology. Pissarro thus grew up in a culture where racial interaction, political radicalism and racial prejudice were equally common. It was this

complex inheritance, rather than his cursory reading of anarchist tomes, that caused his passionate advocacy of political and cultural equality.

Pissarro himself had a highly ambivalent attitude to his background. On the one hand, he sometimes would sit *shiva* or observe the holiday of Yom Kippur and he gave help to young Jewish artists late into his career. On the other, he married "out" and never depicted any overtly Jewish subject in his art. This "double-consciousness" extended even to his name. On his birth certificate, he was recorded as "Jacob Pizarro, son of Abraham Pizarro and Rachel Petit."[12] In daily life, of course, he went by Camille Pissarro, son of Frédéric, a change that prevented French Jewish journalists from including his work in their reviews of Jewish artists at the Salon. The counterpoint between these two named identities was the recurring force behind Pissarro's repeated artistic and personal crises.

Pissarro and the Caribbean

Pissarro's artistic career began with drawings and sketches of scenes of local life in St Thomas and later in Venezuela with the Danish artist Fritz Melbye. After his arrival in France in 1855, he began to work these subjects into finished oil paintings of Caribbean and Latin American subjects. Both drawings and paintings present aspects that were to be typical of his entire artistic career. It was common for European and American artists to use Latin America as an example of an exotic, primitive wilderness. For example, the American Frederick Church depicted the *Andes of Ecuador* (1855) on a dramatically grand scale as an Eden untouched by "civilization." Pissarro's early scenes of St Thomas were far less Romantic, seeming to show the influence of photography in his choice of views and portraits. This self-consciously modernist strategy of depicting everyday life without allegorical overtones was by no means as straightforward as might at first appear. While anthropological and colonial photography presented Caribbean peoples as specimens, Pissarro explored Western ambivalences towards such subjects.

It is, then, less surprising than it might at first appear that Pissarro's early Caribbean drawings, and the paintings derived from them, centered on African women. For these were not *plein air* works in unconscious anticipation of the Impressionist tradition but drawings of the Pissarro family's daily life. Jewish families in the region customarily employed an African woman known as the "Yaya" to raise their children. Although colonial life depended on the labors of such women, European men were very uneasy about the resulting cultural miscegenation. The Caribbean Jewish philosophe David Nassy typically complained that Jewish women in Surinam were "continually chatting in Negro English, surrounded by black women."[13] Men who identified themselves as Europeans did not recognize themselves in their wives and especially not in their children. As W.E.B. Du Bois famously said in the year of Pissarro's death: "It is a peculiar sensation this double consciousness, this sense of always looking at oneself through the eyes of others."[14]

Other Caribbean drawings suggest that Pissarro's cross-diaspora identity was a conscious, even inescapable, aspect of his adult life. Pissarro often sketched an African boy called Frédérick David, for example in an 1852 portrait and in a drawing of the same year. The boy has Pissarro's father's first name, making it possible that he was Camille's half-brother, cousin, or even son. One account of St Thomas observed: "Many female house-slaves, when they get the chance . . . offer themselves in intercourse and seduce many of our young European males from the best families."[15] Indeed, all histories of the island stress that it was commonplace, as in all the Caribbean colonies, to see European men with African or mulatta mistresses. Both Gentile and Jewish men were involved in such relationships that they nonetheless vigorously denounced in print as in this early nineteenth-century account: "the majority of the white men, whether married or single, live publicly with *mulattas*, women who surpass all others in the art of reviving the blasé senses of an old libertine and in ruining the richest proprietors."[16] Yet while one might have expected Pissarro to depict the alluring mulatta, just as Manet was to paint Baudelaire's mistress Jeanne Duval, only one such work – an oil sketch – is known. Rather than return to the familiar "scandals" of colonial miscegenation, Pissarro placed himself in the erotic landscape of the black Caribbean population. In his drawing "Lovers Meeting" of 1852, Pissarro represented one of the quietly accepted social mechanisms of black Caribbean life. It shows two women working at their laundry. Unless we assume that they are the lovers referred to, no meeting seems to be taking place. In fact it was a commonplace ruse for black women to linger at such spots in order to meet their lovers, away from the gaze of the plantation overseers. Pissarro drew a scene that a white person was not supposed to have seen. As this drawing suggests, the recording of sensation in Pissarro's early work does not necessarily imply that he literally witnessed the scene depicted. He repeatedly sketched this scene of a woman dawdling at the wash in increasingly romanticized format, suffusing his work with a subtextual eroticism.

Performing identity

Nowhere is this confluence of observation and sexuality more apparent than in his 1853 drawing in Venezuela, known as "The Dance at the Inn." At the time of composition, slavery was still in force but was soon to be abolished in March 1854. This cabaret scene is replete with ethnic and sexual tension in a manner that was to be sublimated or displaced in his later work. At the center of the sepia drawing are dancing figures, fully absorbed in the music. Abolition is in the air. So too cross-cultural sexual experience, as evidenced by the couple embracing in the door to the left, for these cabarets were notorious sites of sexual debauchery. Strikingly, the dancers are wearing white masks, as can most easily be seen in the man at extreme left wearing a top hat. In Venezuela, with its famously hybrid population, the ethnicity of the dancers is unknowable. All this abandon is set in relief by the disproportionately large figure of an

African man at center right. He bends over two small children in a paternal gesture that also seems to suggest great sorrow. He is the first father figure in Pissarro's work and one of the last, excepting the self-portraits. The family group are deep in shadow in counterpoint to the well-lit dancers creating a moral as well as visual distinction. Indeed, their unlikely presence suggests that Pissarro intended his drawing to be more than simple observation. Given its large scale (36 by 53 centimeters), it may well have been a first sketch towards an intended full-size History painting that was never realized. Taken as a whole, the cabaret puts into question gender and ethnic identity, while also raising political issues. It recognizes that in the colonial Caribbean, identity was quite literally performative.[17] All "dances and plays" were ineffectually forbidden to enslaved Africans on St Thomas, following the uprising of 1733 during which Africans controlled the island for over six months.[18] Although the plantation owners rightly believed that slave discontent was marshaled and coordinated through music and performance, St Thomas had its own theater that received touring companies.[19] Even after the abolition of slavery, a key area of civil rights activism for Africans, Jews and "mulattos" in the Caribbean concerned the desegregation of theaters. Interestingly, Pissarro himself performed in a "Great Venetia Festival with Chorus and Lyrical and Dramatic Scenes" in Caracas on December 8, 1853.

Following his arrival in France in 1855, Pissarro recast Caribbean performativity in the modernist vocabulary of photography. He thus worked up an 1853 sketch of a Venezuelan water carrier into an 1856 oil painting that imitated the manner of Latin American *cartes-de-visite* of the period. For certain cartes featured a series of "picturesque" scenes of everyday life that often included a full-length photograph of a water carrier. Pissarro's painting further resembled these cartes in its placement of the woman close to the frame, excluding any background, and her direct, smiling address to the spectator. That is not to say that issues of identity now disappeared from his work but that they were reformulated. In his *Two Women Chatting by the Sea, St Thomas* (1856) (Figure 4.1), a complex dynamic of gender, identity and diaspora is being worked out. At first it seems a quiet rural scene. Two African women dominate the foreground, pausing in conversation on their journey. In the background, other women can be seen at the water's edge. In the immediate aftermath of the 1848 slave revolt, this picture was full of possible meanings in the Caribbean context. There were over 2,000 African women enslaved in Charlotte Amalie, capital of St Thomas, considerably outnumbering the men. While many were domestic servants, women also served to unload and coal the steamers that plied the port. The women in the foreground of Pissarro's painting are clearly journeying traders.[20] Of all the many Africans on St Thomas and neighboring St Croix, these women had the greatest freedom of movement. It was widely believed that they had in fact distributed instructions for the insurrection of July, 1848. The Danish governor Von Scholten reported that:

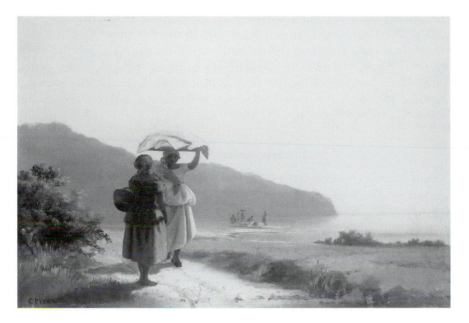

Figure 4.1 Camille Pissarro, *Two Women Chatting by the Sea, St Thomas*, 1856. National Gallery of Art, Washington D.C. Collection of Mr and Mrs Paul Mellon.

> Women . . . do the same work that men do and their physical build and size render them formidable adversaries in a fight. Throughout the disturbances, they were more aggressive, vengeful and altogether more violent than the men.[21]

Pissarro's painting thus showed the leaders of a successful slave revolt to a Parisian public that had just experienced its own 1848 revolution, one of whose achievements had been the abolition of slavery. His painting is not an explicit manifesto. Rather it forces the spectator to choose what he or she believes is represented. While few French people knew about the events in St Thomas, all were aware of debates over the status and humanity of Africans relative to Europeans. In offering the spectator what Richard Brettell has called an "insistent and clearly intentional ambivalence towards his subject-matter,"[22] Pissarro forces us to make an ethical choice. Are these women simply enjoying a break from hard physical labor? Or are they idling away the day and refusing to work, as the opponents of abolition maintained was endemic to all Africans? Or are they even engaged in plotting the overthrow of colonial slavery? The artist captures the moment of ambivalence in the colonial gaze and asks his audience to make an ethical decision as to what it is they see. It is this focus on the necessity of ethics that gives a consistently Jewish dimension to Pissarro's work. While ethics have been central to the Jewish tradition from

the Talmud on, I am using the term in the fashion of the Franco-Jewish philosopher Emmanuel Levinas. Levinas argued that the sense of self can only be sustained via a prior engagement with the Other, a process he called alterity. For Levinas, the defining moment of alterity is visual. It comes in the exchange of looks from face to face, from artist to spectator that creates a moment in which the passive observer is forced to make a choice and becomes a witness.[23]

Pissarro as an Israelite

Pissarro's career is evidence of the difficulty of that choice. After 1860, he tried to work as if he were a fully assimilated French Jew, an *Israélite* rather than the supposedly less refined Eastern European *Juif*. Both terms were perceived as ethnic classifications, rather than referring to religion, which was often designated as *hébraïque*, or Hebrew. As Jews in France sought to become what Aron Rodrigue has called "not . . . a 'lesser' Jew but simply a 'different' Jew, a distinctive, modern Jew," Pissarro formulated his own modern, secular Jewishness.[24] In his well-known 1865 canvas *L'Hermitage*, the meeting between women that dominated his St Thomas canvas has been retained but in attenuated form. Two women speak in the foreground of a village scene. One woman appears to be middle-class, shading her face from the sun with a parasol, while her partner in conversation is darker-skinned from working in the fields. Here the encounter is between women of different classes, a difference that is signified through skin color. Its diminished place in the painting seems to evoke Pissarro's sense of being overwhelmed by the European landscape. Even his palette of colors was more restrained, tending to brown, green and gray, always further mixed and blended. At the same time, his embrace of landscape and the rural economy was part of his continuing rejection of his father's commercial world. In the next twenty years, Pissarro carefully constructed a French artistic identity, only to see it collapse due to a combination of family crisis and rising anti-Semitism.

In the Impressionist circle, he alternated between playing the role of group patriarch and perceiving himself to be an outsider. In a diaspora version of what Freud later called the family romance, the younger artists who had rejected the paternal embrace of the French art system found a more appealing father figure in Pissarro, whom they nicknamed Abraham or Moses. In turn, the Caribbean artist clearly reveled in the role. The writer Octave Mirbeau, writing to Lucien Pissarro, directly evoked this mutual fantasy: "I loved your father as if he was my own, the ideal charming father that I would have dreamed of having at the start of my life."[25] Yet Mirbeau was later to suddenly end his friendship with Pissarro, re-enacting the Oedipal break and revealing that the surrogate son is paradoxically a stronger subject position than that of the surrogate father.

In 1873, Pissarro painted his first major self-portrait in precisely this image

of the Jewish patriarch.[26] At the time he was only 43, yet he depicts himself as a much older, bearded man, evoking Michelangelo's Moses. The self-portrait has often been seen as a pendant to his *Portrait of Paul Cézanne* (1874), painted when the two often worked together. It was during this period that Cézanne sublimated the violent sexuality of his earlier work into what was to become his characteristic landscape style, often working alongside Pissarro. He readily accepted the junior role: "Pissarro was like a father to me, he is a man to turn to for advice and something like the Good Lord."[27] The two portraits are the site of a cornucopia of sublimation and transference. They are similar in size, composition and pose, creating a father and son diptych to replace the problematic relations both artists had with their real fathers. Each was the son of a wealthy businessman whom they had rejected to seek acceptance in the Parisian art world, and yet they often lacked belief in their success. The homosocial, quasi-Oedipal tie between the two artists was tellingly evoked by Cézanne's comment that they both made "painting with real balls."[28] At the same time, the two portraits can also be seen as depicting both halves of Pissarro's diasporic double-consciousness. Pissarro painted only some unidentifiable landscape sketches in the background to his own self-portrait, emphasizing at once his rejection of his own father's commercial world and his doubled diaspora as a Caribbean Jew in Europe. By contrast, Cézanne's portrait is filled with cultural and political references, seeming to indicate that he has a national identity unavailable to the Jewish artist. On the left, behind Cézanne's right shoulder, is a representation of André Gill's famous caricature of Adolphe Thiers, satirizing the self-proclaimed liberator of Paris.[29] To the right, is a cartoon portrait of Gustave Courbet, still under interdiction at the time for his presumed involvement with the Commune, who appears to be haranguing Cézanne. The portrait places Cézanne on the radical left of French politics as a logical consequence of his avant-garde artistic practice, a position that really belonged to Pissarro. Yet, for all this artistic and cultural grounding, the figure of Cézanne lacks certainty, keeping his hat and coat on indoors, with his hands clasped nervously together. There is a certain "Jewishness" to the portait, as if it anticipates R.B. Kitaj's description of Cézanne as "arguably an internal exile . . . unwilling and unable not to irritate his art and his neighbours, like a Jew."[30] It is as if the Pissarro portrait is of the Caribbean Jacob, while the Cézanne shows the immigrant Camille. While "Camille" looks meekly out to the middle-distance, "Jacob" engages our gaze with a stern patriarchal regard that suggests his greater claim to artistic authority. As a pair, the portraits set in motion some striking oppositions around the diasporic double consciousness at the ambivalent center of Pissarro's practice.

Perhaps due to this elaborate role-playing, Pissarro never felt entirely secure about his position in the Impressionist group. In 1878, aged 48, he was sufficiently depressed to assert that "my work carries on without consequences, without gaiety, without spirit and as a result I must abandon art."[31] His ethnicity was undoubtedly a significant component of such self-doubt. In July 1885,

he described to Monet an abrasive encounter with Edmond Renoir, the painter's brother: "It seems that I am an intriguer of the first rank, without talent, a self-interested Jew, trying underhand things to supplant both you, my friend, and Renoir. I was really very hurt." Here the vulnerability of the surrogate father comes to the fore. What Freud later termed the "deferred obedience" due to such surrogates crumbled in the face of competing professional and personal hierarchies. At once the connotation of Pissarro's Jewishness shifted register so that Moses the law-giver was now seen as Moshe the "self-interested Jew [*Juif*]." Like many a victim of such encounters, Pissarro was led to wonder about his attacker's motivation:

> Here is a boy that I hardly know . . . I never think of him; yet he has found a way to hate me with a passion. Is it fraternal love that inspired this evil? . . . Is it because I am an intruder in the group?[32]

Remarkably, Pissarro still perceived himself as an outsider among the Impressionists nine years after their first exhibition and thirty years after his arrival in France. Certainly, Renoir was fully capable of anti-Semitism, informing the dealer Durand-Ruel in 1882 that: "The public doesn't like the smell of politics and at my age I do not wish to be a revolutionary. To remain with the Jew Pissarro is the revolution."[33] For Pissarro at least, the Impressionist circle was far from the perfect intellectual community now celebrated in endless exhibitions and publications.

Pissarro hoped that being an Impressionist artist would allow him to at once be an acculturated Jew, a political radical and the center of an artistic community. In the early years, this surprising mixture held together around a common sense of battling the political and cultural establishment. However, the Impressionists also claimed the dubious cachet of race science for their work. The pro-Impressionist critic Jules Laforgue claimed that:

> The Impressionist eye is, in short, the most advanced eye in human evolution. No longer an isolated melody, the whole thing is a symphony, which is living and changing, like the "forest voices" of Wagner, all struggling for existence in the great voice of the forest.[34]

Laforgue thus directly connected the Impressionist style to racial theories of Northern, that is to say Aryan, superiority. As early as 1869, the Jewish critic Isidore Cahen had seen the connection between the Impressionist style and so-called Northern race theory. He dismissed the Impressionist influenced *Après déjeuner* by the Jewish artist Henri-Michel Levy as "Wagner in painting," referring to Wagner's notorious anti-Semitism: "Wagner has thus sought to excite the passions of the crowd, to exploit the prejudices of the masses; now in these cases, the first resource of the mediocrity is to attack the Jews."[35] For both Laforgue and Cahen, the racial aspect of Impressionism lay not in what

was literally denoted by the paintings but in the connotations of technique. Far from being a neutral or uncontested term, sensation was the locus of ethnic difference in modern painting. The practice of Impressionist painting inevitably entailed a certain unease in Pissarro as he sought to limit what could not in fact be contained, the free play of connotation invoked by visual sensation.

"Our diseased eyes"

As radical anti-Semitism flourished following the publication of Edouard Drumont's *La France Juive* in 1886, it was no longer possible for Pissarro to elide the connotations of ethnicity by a common artistic purpose within the Impressionist group. While Pissarro sustained his belief that Jewishness was not a race, that very belief would soon necessitate a pro-Dreyfus stance. In turn, this position would alienate him from Degas, Renoir and Cézanne. It is usually said that Pissarro kept the spheres of politics and art as separate as the Victorian division of masculine public and feminine private. However, the very possibility of color vision and its artistic representation had become strongly charged with issues of race, and hence politics. In 1883, the acerbic critic Joris-Karl Huysmans accused the Impressionists of suffering from Daltonism, one of the terms then in use for the newly-discovered affliction of color-blindness. Most dismissed the criticism, but Pissarro was aggrieved,[36] declaring in a series of letters that the Impressionists were attacked everywhere:

> If in London, we are reproached for our lack of finish, here we are reproached for our diseased eyes, "the malady of painters who see blue." Even Huysmans in his book deplores this affliction of the visual organ as a corrective.[37]

Anti-Semitic rhetoric had long accused the Jews of defective color vision, whether in terms of their supposedly gaudy clothing or their lack of achievement in the fine arts. Pissarro thus perceived Huysmans' comment as a personal attack, although race is again connoted in the excessive use of blue pigment, rather than in any representational form.

Color-blindness was first identified by John Dalton (hence Daltonism) in the late eighteenth century but remained a curiosity until the invention of railways and steamships made it imperative to be able to detect color-blindness in the industrial workforce. Doctors had accordingly recorded the incidence of color-blindness and devised tests to diagnose it, but failed to determine any cause. In the 1880s anthropologists combined the old anti-Semitic prejudice with race science to provide a racial origin for the complaint. In 1877 the German philologist Hans Magnus concluded from a study of color in the Greek poet Homer that Greeks of the period had in

fact seen in black and white. Color-blindness could thus be explained in hereditary terms as "a type of atavism."[38] This idea was given dramatic support by the British prime minister and noted classical scholar, William Gladstone, whose study of the *Odyssey* found only "thirty-one cases in nearly five thousand lines, where Homer can be said to introduce the element or the idea of colour."[39] He concluded that the Greeks perceived color as in a black and white photograph, relying on the perceived "whiteness" of Greek sculpture, like the then recently discovered Venus de Milo, which we now know to have in fact been brightly colored. Gladstone's prestige brought widespread attention to Magnus' theory, which was soon debated in the French Anthropological Society. In the discussion, Paul Topinard demanded a study of the racial difference of color vision that would be properly anthropological, a desire that was soon granted.[40] In the French translation of Magnus' work, Jules Soury further asserted that "the Hebrews could only distinguish a small number of colours,"[41] inaccurately claiming that the book of Genesis mentioned only green. It was easy to conclude that as the Jews were held to have intermarried since Biblical times, modern Jews would also have defective color vision. The Jewish anthropologist Joseph Jacobs carried out research in London designed to counter such attacks but in this instance he concluded that color-blindness was indeed "the most marked characteristic" of the Jews, an especial defect of Sephardic Jews like Pissarro at 13.4 percent. The cause of this problem was "the long continuance of Jewish life found in the cities, where so much less colour and especially so much less green is to be met with."[42] It was therefore the answer to the question, why have there been no great Jewish artists? This rather casually performed research became a standard of race science literature from its publication in 1885 to the First World War. Pissarro's strong reaction to Huysmans' accusation was both appropriate and remarkably prescient.

In his later career, Pissarro's work concentrated precisely upon this relationship between perception, drawing and color. Rather than being a retreat from the politics of culture, it was a sustained engagement with the question of Jewish identity in the fin-de-siècle. His attention to the connotations of color was a direct contestation of the locus of ethnic difference in nineteenth-century art criticism. It did not come easily. His first response was to adopt the *pointilliste* technique of Georges Seurat in 1886, which sought to create a scientific approach to painting. The neo-Impressionists applied the color theories of Chevreul and Rood to their artistic practice, seeking to produce work exactly in accord with the operations of the eye. This practice was more a development of Academic theory than a radical rejection of traditional practice. Charles Blanc, director of the Ecole des Beaux-Arts, noted that "colour is a mobile, vague, undefinable element" and recommended Chevreul's theory as a means of dealing with it.[43] Indeed, ever since the Renaissance, artistic theory had warned of the dangers of color – seen as "feminine" – and the need to

control it with (masculine) intellectual constructs. Vasari warned artists that the "disagreeable discordance" of color could only be controlled when "the intelligence of the painter has by the harmony of his colours assured the excellence of the design."[44] In similar fashion, neo–Impressionism sought to place "feminine" color under the firm "masculine" discipline of science. In the racialized context of the period, color was not only feminine, it was exotic, Oriental and racially Other.[45] Pissarro was the only member of the original Impressionist group to adopt these would-be scientific procedures, for they seemed to offer a way out of his dilemma. The very definition of nineteenth-century science was objectivity, and if pointilliste technique was scientific, then the race of the practioner ceased to be an issue.

Pissarro's passage

As an artist obsessed with the recording of individual "sensation," Pissarro could not long remain satisfied with the constraints of pointillisme. As early as September 1888, he wrote to Lucien: "the dot is weak, without consistency, diaphanous, more monotonous than simple, even in Seurat, above all in Seurat." Instead, he now sought to produce an art that he termed the "passage," which he tried to explain as follows:

> I am at present looking for some substitute for the dot; so far I have not found what I want, the actual execution does not seem to me rapid enough and does not follow sensation with enough inevitability; . . . the fact is I would be hard put to express my meaning clearly, although I am completely aware of what I lack.

If he could not define it in words, he sought to realize it in the extended late series paintings. Significantly, these works concentrate upon cityscapes for the first time in his career, precisely the arena that was supposed to render the Jew color-blind.

However, Pissarro was first to undergo a crisis of confidence throughout 1889 in which the ethical choices he had put to his audiences came home to roost. This was a year in which an undistinguished anti-Semitic Salon painting entitled *The Jew* was on the front cover of the leading French art magazine, a year in which the Dutch Jewish artist Josef Israels produced his ambiguous picture *One of the Ancient Race*. Israels' Jew might be the object of pity for the fallen Jewish race or of scorn for the degenerate. At this charged moment, just as Pissarro embarked on the difficult task of changing his artistic style away from pointillisme, he began to suffer from an eye condition. This confluence of artistic difficulty with the very type of illness predicted by race science led him to believe that his problems were, as he wrote to his niece Esther Isaacson:

> A matter of race, probably; until now, no Jew has made art here, or rather no Jew has sought to make a disinterested art of sensation; I believe that this could be one of the causes of my bad luck . . . I cause too much surprise and break too much with acquired habits.[46]

Pissarro had been led to question whether the anti-Semites were right and that his race was in some way impeding his efforts to create an "art of sensation" or perhaps causing the weakness in his eyes.

Shortly after this letter was written, Pissarro's mother Rachel died on 30 May, 1889. In addition to the usual disruption caused by such loss, he was soon plunged into a fierce row with his brother Alfred over the inheritance derived from their father's estate. When Alfred insisted on legal niceties that denied him any share, Pissarro retorted: "In my opinion, this is a matter of conscience."[47] Pissarro asserted an ethical Jewishness in response to the Mosaic laws of inheritance, only to be confronted by rejection within his own family. He who had been known as Moses now sought to defy the law in the name of ethics. Despite Pissarro's assertion of a paternal role in the Impressionist group, his own father continued to dominate him even from the grave, creating a crisis of confidence and identity. At this time he carried out a series of drawings, *Turpitudes Sociales*, for his niece Esther Isaacson, showing the excesses of capitalism. The drawings are rather simplistic cartoons, given that Esther was a woman of 32 who associated with William Morris and other leading English socialists. Like so many others, Pissarro now blamed Jewish bankers such as the Rothschilds for the miseries of the day. In his explanatory letter accompanying the volume, he described Jewish bankers as "monsters" worthy of Dante's *Inferno*.[48] In rebelling against his father the successful businessman, Pissarro came to use the verbal and visual language of anti-Semitism. We should not equivocate: the drawings were intentionally composed to illustrate the standard themes of anti-Semitic literature at a time of personal crisis for the artist.

What is more remarkable is that Pissarro was able to recover from such a profound setback to create the great series of late paintings that so fully explore the ambivalences of the passage. The passage evokes travel, displacement and circulation, with undertones of both sexuality – a *maison de passage* was a brothel – and race, in the sense of passing. For Pierre Missac,

> [t]he notion of passage is plural – polyvalent as we say these days. It refuses to take refuge in the mirage of the proper noun, and thus gives the word, which can be a noun at times (passage, passerby) and a verb at times (pass) a function that can be modified easily and that evokes the arbitrariness and vicissitudes of allegory.[49]

In "passage" connotation is allowed its necessary freedom of movement. One might say that the sensation of passage was the sensation of diaspora. In refocusing his art on sensation, Pissarro's late work achieved the synthesis of an

ethical viewpoint and the exploration of modernity that he had been seeking throughout his career. Like Marcel Proust's character Swann, Pissarro discovered:

> Perhaps too in these last days, the physical type that characterizes his race was becoming more pronounced in him, at the same time as a sense of moral solidarity with the rest of the Jews [*Juifs*], a solidarity which Swann seemed to have forgotten throughout his life, and which, one after another, his mortal illness, the Dreyfus case and the anti-Semitic propaganda had reawakened. There are certain Jews [*Israélites*], men of great refinement and social delicacy, in whom nevertheless there remain in reserve and behind the scene – finally to make their entry at a given hour of their life, as in a play – a cad and a prophet. Swann had arrived at the age of the prophet.[50]

If Swann was motivated by his illness, Pissarro was forced to recognize his Jewishness by his eyes, that instrument which artists often hold to be divine but had been revealed to be all too human.

In the first instance, "passage" refers to the use of gradated color, a triangulation of the binary complementary color contrasts used by the neo-Impressionists that one might call the transculturation of color, the counterpoint to racialized color theories. Pissarro did not simply return to his earlier Impressionist technique of the patch of color but created a swirling, heavily worked paint surface that ignored the conventions of both Academic and Impressionist art. Rather than the chalky, dry brushstroke of the 1870s and 1880s,[51] the late works were created mixing wet paint into wet, blending color on the surface of the canvas, using a pastel palette with added white.[52] The paint is worked thickly in the manner of Van Gogh, while the glimpses of uncovered canvas anticipate Jackson Pollock more than they recall Monet. These paintings display a remarkable technical skill and innovation but they are not simply formal exercises. For color could not be a neutral issue in a period when race and national identity were the central issues of the day. Art theorists were very much aware of the difficulties of handling color. Félix Bracquemond explained in 1885 that: "[i]n order to master this fugitive element, . . . art isolates color; the intensities of light . . . provide the means to visualize color."[53] It is as if Pissarro's rejection of the pure aesthetic of neo-Impressionism allied him with color, that refugee in the cold, northern light.[54] One might say that in the nineteenth century color is to Jewish as light is to Gentile. As neo-Impressionist Paul Signac observed, Pissarro had rejected "the violent purity of tints which hurts his eye."[55] The search for purity was over. Pissarro now embraced the mixed, the blended, the miscegenated, even at the cost of admitting a "Jewish" weakness of the eye. He found a new confidence in doing so, telling Lucien in 1891 that: "I firmly believe that something of our ideas, born as they are of the anarchist philosophy, passes into our works which

are thus antipathetic to the current trend."[56] If there is here an element of the "fantasy" that Pissarro had evoked as part of sensation, that is only to say that connotation is in the eye of the beholder. The passage thus allowed a movement of ideas from the political to the cultural, not through subject matter alone but through the painter's very mark on the canvas. This movement evoked a sense of the changed modernity of the 1890s with its hectic urban environment. Rather than the photographic style of his early work, Pissarro now sought to capture a sense of movement just like the newly invented cinema. In the 1890s, modernity itself became cinematic, "the juncture of movement and vision: moving pictures."[57] Likewise, Pissarro's concern was now to find a "rapid execution" for the passage, rendered in his 1898 canvas *La Place du Théâtre Français* (Figure 4.2) as a swirl of figures, carts and buses in a flat modernist space created by the top-down view. While the locale was a part of Haussmann's Paris, Pissarro believed that these new techniques made such scenes "completely modern."[58] The mix of people in the urban environment is evoked by the mixed color in the paint itself in which the outline of figures blend into one another. The scene, like all his late work, is a moment of passage in the literal sense, as people move through liminal spaces, such as squares, bridges and boulevards. These border zones are haunted by the ghost of Paris

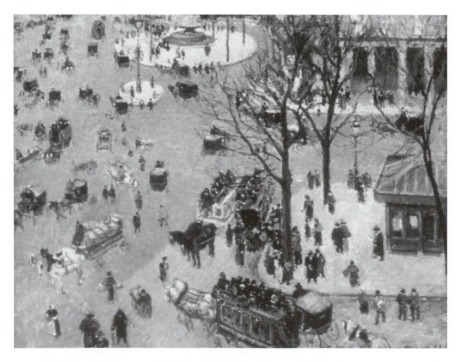

Figure 4.2 Camille Pissarro, *La Place du Théâtre Français*, 1898. Courtesy Los Angeles County Museum of Art, Los Angeles, CA.

past, represented by the Baudelairean *crépuscule* and the ghost of Paris future, namely Walter Benjamin's evocation of the *passage*. In this sense, the passage works evoke the triangular movement of transculturation for the spectator. They are scenes of circulation and movement, the statement of a diaspora artist exploring the meaning of his exile. Reviewing his exhibition of that year the critic Gustave Geoffroy saw the power of this new work: "Cities have a particular physiognomy, passing, anonymous, busy, mysterious, which must tempt the artist . . . The melée of vehicles and passers-by [*passants*] swirls around, passes by, mingles, with a prodigious sense of the rhythmic movement of crowds. Time and again, this visible social combat in the anxious comings and goings of the street is noticed and summed up by Pissarro."[59] For Geoffroy, Pissarro's passage – note how often he used the term – was inextricably artistic, modern and political, the artist's stated goal.

In the same year 1898, at the height of the agitation over the Dreyfus case, Pissarro found himself in a curiously complex moment of passage: "Yesterday going to Durand's at five o'clock on the boulevards, I found myself in the middle of a group of little thugs, followed by hooligans, crying 'Death to the Jews, down with Zola!' I passed tranquilly through the middle of the group, and they did not even take me for a Jew!"[60] Jacob Pizarro could now pass among the anti-Semitic mob as Camille Pissarro, while working on art that he believed to be politically radical and giving whole-hearted support to the Dreyfusards. Those who accused him of defective eyesight could not even see the Jew in their midst. The Jew in the heart of the metropole was the stuff of anti-Semitic nightmares. Pissarro stood the old chestnut on its head and made the passage of a Caribbean Jew across modern Paris the very subject of his work.

Notes

1 Cited by Anne Thorold, *The Letters of Lucien to Camille Pissarro 1883–1903* (Cambridge: Cambridge University Press, 1993), p. 11.

2 Emphasis original. Quoted by John Rewald, *The History of Impressionism*, 4th edition (London: Secker and Warburg, 1973), p. 294.

3 D.A. Miller, "Anal *Rope*," in Diana Fuss (ed.), *Inside/Out: Lesbian Theories, Gay Theories* (New York: Routledge, 1991), p. 124. I have borrowed Miller's citation of Barthes' *S/Z* (New York: Hill and Wang, 1974), p. 7.

4 Fernando Ortiz, *Cuban Counterpoint: Tobacco and Sugar* (Durham: Duke University Press, [1947] 1995), pp. 93–107.

5 Frank Cundall, *The Governors of Jamaica in the Seventeenth Century* (London: The West India Committee, 1936), p. 132, orthography modernized.

6 Quoted in Sigmund Seligmann, "David Nassy of Surinam and his 'Lettre Politico-Theologico-Morale Sur les Juifs'," *Publications of the American Jewish Historical Society*, Vol. 22, 1914, p. 31.

7 Cornelis Ch. Goslinga, *The Dutch in the Caribbean and in the Guianas 1680–1791* (Assen, Maastricht and Dover NH: Van Gorcum, 1985), p. 236.

8 Francis P. Karner, *The Sephardim of Curaçao: A Study of Socio-Cultural Patterns in Flux* (Assen: Van Gorcum, 1969), p. 19–25.

9 Sterling Stuckley references a lecture by Robert Farris Thompson to this effect,

Slave Culture: Nationalist Theory and the Creation of Black America (New York: Oxford University Press, 1987), p. 12.

10 Isidor Paiewonsky, *Eyewitness Accounts of Slavery in the Danish West Indies* (New York: Fordham University Press, 1989), p. 52.

11 John Bigelow, *Jamaica in 1850, or the Effects of Sixteen Years of Freedom on a Slave Colony* (New York: George P. Putnam, 1851), p. 15.

12 Janine Bailly Herzberg (ed.), *Correspondance de Camille Pissarro*, 4 vols, (Paris: Editions de Valhermeil, 1980–91) [hereinafter BH], tome 1, no 110 (14 Oct 1882), p. 168. Pissarro was worried about proving his identity to the French authorities in order to make it possible for his son Lucien to evade French military service and wrote to his uncle Albert Petit in St Thomas to obtain a notarized clarification of his given name and the orthography of his family name.

13 David de Isaac Cohen Nassy, *Essai Historique sur la colonie de Surinam . . . Avec l'Histoire de la Nation Juive Portugaise et Allemande y Etablie*, 2 vols (Paramaribo, 1788), Vol. II, p. 60.

14 W.E.B. Du Bois, *The Souls of Black Folk* (New York: Bantam, 1989), pp. 2–3.

15 Paiewonsky, *Eyewitness Accounts*, p. 120.

16 André-Pierre Ledru, *Voyage aux Iles de Ténérife, La Trinité, Saint Thomas, Sainte Croix et Porto Rico*, 2 vols (Paris: Arthur Bertrand, 1810), vol. II, pp. 8–9.

17 Antonio Benítez-Rojo, *The Repeating Island: The Caribbean and the Postmodern Perspective*, 2nd edition (Durham: Duke University Press, 1996), pp. 11–12.

18 John P. Knox, *A Historical Account of St Thomas, West Indies* (New York: Charles Scribner, 1852), p. 70.

19 Charles Edwin Taylor, *Leaflets from the Danish West Indies: descriptive of the Social, Political, and Commercial Condition of these Islands* (Westport CT: Negro Universities Press 1970 [1888]), p. 53.

20 Felix V. Matos-Rodriguez, "Street Vendors, Pedlars, Shop-Owners and Domestics: Some Aspects of Women's Economic Roles in Nineteenth-Century San Juan, Puerto Rico," in Verene Shepherd, Bridget Brereton and Barbara Bailey (eds), *Engendering History: Caribbean Women in Historical Perspective* (Kingston, Jamaica: Ian Randle, 1995), pp. 176–93.

21 Quoted and translated in Neville A.T. Hall, *Slave Society in the Danish West Indies: St Thomas, St John and St Croix*, ed. B.W. Higman (Baltimore: Johns Hopkins University Press, 1992), p. 226.

22 Richard Brettell, *Pissarro and Pontoise: The Painter In a Landscape* (New Haven: Yale University Press, 1990), p. 60.

23 Emmanuel Levinas, *Difficult Freedom: Essays on Judaism*, trans. Seàn Hand (London: Athlone Press, 1990), p. 8. See also Eunice Lipton's essay in this volume for a similar use of Levinas.

24 Aron Rodrigue, *Images of Sephardi and Eastern Jewries in Transition: The Teachers of the Alliance Israélite Universelle, 1860–1939* (Seattle: University of Washington Press, 1993), p. 11.

25 Octave Mirbeau, *Correspondance avec Camille Pissarro*, ed. Pierre Michel and Jean-François Nivet (Paris: Du Lérot, 1990), p. 14.

26 John Rewald describes how Pissarro "inspired complete confidence because in his actions and in his views he resembled the just of the Bible," *The History of Impressionism*, p. 206.

27 Quoted by Joachim Pissarro, *Camille Pissarro* (New York: Abrams, 1993), p. 105.

28 J. Pissarro, *Pissarro*, p. 95.

29 Albert Boime, *Art and the French Commune* (Princeton: Princeton University Press, 1995), p. 121.

30 R.B. Kitaj, *First Diasporist Manifesto* (London: Thames and Hudson, 1989), p. 73.

31 BH, vol. I, no 63, p. 120.

32 BH, vol. 1, no 279, p. 338.
33 Albert Boime, *Art and the French Commune: Imagining Paris After War and Revolution* (Princeton: Princeton University Press, 1995), p. 123.
34 Quoted in Linda Nochlin (ed.), *Impressionism and Post-Impressionism 1874–1904: Sources and Documents*, (Englewood Cliffs NJ: Prentice-Hall, 1966), p. 17 (translation modified).
35 Isidore Cahen, "Le Judaisme dans les Arts: Le Salon de 1869," *Archives Israélites* (15 June, 1869): 335–8.
36 Paul Smith, " 'Parbleu': Pissarro and the Political Colour of an Original Vision," *Art History*, vol. 15, no. 2 (June 1992), p. 235–6.
37 BH, no 148, 13 May, 1883, p. 206.
38 Hans Magnus, *Histoire de l'évolution du sens des couleurs*, trans. Jules Soury (Paris: C. Reinwald, 1878),
39 William E. Gladstone, "The Color Sense," *The Nineteenth Century*, vol. 1 (September 1877): 383.
40 *Bulletin de la Société d'Anthropologie*, vol II (17 Apr., 1879), p. 330.
41 Magnus, *Histoire*, p. xvii.
42 Joseph Jacobs, *Studies in Jewish Statistics, Social, Vital and Anthropometric* (London: D. Nutt, 1891), pp. 83–4.
43 Charles Blanc, *Grammaire des Arts du Dessin* (Paris: Jules Renouard, 1867), pp. 595 and 598–9.
44 Quoted by Patricia L. Reilly, "The Taming of the Blue: Writing Out Color in Italian Renaissance Theory," in Norma Broude and Mary D. Garrard (eds), *The Expanding Discourse: Feminism and Art History* (New York: Icon, 1992), p. 90.
45 Nancy Leys Stepan, "Race and Gender: The Role of Analogy in Science," *Isis*, vol. 77, 1986, pp. 261–77. For a discussion of race in nineteenth-century art theory, see Nicholas Mirzoeff, *Silent Poetry: Deafness, Sign and Visual Culture in Modern France* (Princeton: Princeton University Press, 1995), pp. 154–62.
46 BH, II, 525 (1 May 1889), p. 270.
47 BH, II, 546 (1 October 1889), p. 302.
48 BH, II, 559 (December 1889), p. 321.
49 Pierre Missac, *Walter Benjamin's Passages*, trans. Shierry Weber Nicholsen (Cambridge MA: MIT Press, 1995), p. 1.
50 Quoted by Michael Sprinker, *History and Ideology in Proust: A la Recherche du Temps Perdu and the French Third Republic* (Cambridge: Cambridge University Press, 1995), p. 116.
51 Anthea Callen, *Techniques of the Impressionists* (London: Orbis, 1982), pp. 88–91.
52 Michael Milkovich, *Homage to Camille Pissarro: The Last Years, 1890–1903* (Memphis, TN: Dixon Gallery, 1980), p. 19.
53 Quoted by Anthea Callen, *The Spectacular Body: Science, Method and Meaning in the Work of Degas* (New Haven: Yale University Press, 1995), p. 122.
54 See Anthea Callen, *The Spectacular Body* (New Haven: Yale University Press, 1995), pp. 114ff for a discussion of color and colonialism.
55 Camille Pissarro, *Letters to His Son Lucien*, ed. John Rewald and Lucien Pissarro (Mamaroneck, NY: Paul P. Appel, 1972), p. 135 n.1.
56 Christopher Lloyd, *Camille Pissarro* (New York: Rizzoli, 1981), p. 135.
57 Leo Charney and Vanessa R. Schwarz, "Introduction," *Cinema and the Invention of Modern Life* (Berkeley: University of California Press, 1995), p. 6.
58 Lloyd, *Pissarro*, p. 127.
59 Quoted by Kathleen Adler, "Camille Pissarro: city and country in the 1890s," in Christopher Lloyd (ed.), *Studies on Camille Pissarro* (London: Routledge and Kegan Paul, 1986), p. 104.
60 BH, vol IV, 1503, pp. 434–5.

5

THE BODY OF ALFRED DREYFUS

A Site for France's Displaced Anxieties of Masculinity, Homosexuality and Power[1]

Norman L. Kleeblatt

By the end of the nineteenth century, racist concepts – through both text and image – had developed a standard, somewhat paradoxical picture of the male Semite. It was simultaneously threatening and repulsive. This image identified a stout, paunchy, hunched, and disheveled body with fleshy face, tightly curled hair, large nose and protruding lips.[2]

None of these exaggerated physiognomic descriptions fits the first Jewish officer on the French army's general staff, Captain Alfred Dreyfus. Dreyfus's erect, trim, and orderly military physique; his light, straight hair, small nose and blue eyes represented the very antithesis of this nineteenth-century stereotype of Jewish men. An 1889 photograph of Alfred Dreyfus taken when he received his commission as Captain is a bit dramatic and idealized. It, along with the group photograph from his graduating class at the Ecole Militaire, demonstrates certain facts about Dreyfus's physiognomy. His military garb and manner hint at the extent to which his life and career sought to follow the dictates of assimilation, a concept central to the aspirations of France's Jewish community at the time.[3]

Alfred Dreyfus was accused of treason against the French Republic on October 15, 1894. In particular, he was charged with selling military secrets to Germany, France's powerful and most feared enemy. The machinations around his court-martial, conviction, public degradation; his incarceration on Devil's Island, his retrial, reconviction, governmental pardon and eventual rehabilitation in 1906, became known as the Dreyfus Affair. In fact, during these events it was proven that another French officer, Major Walsin Esterhazy, was the culprit. This series of incidents constituted the single most significant political event in France during the last decade of the nineteenth century.

Increasing outbreaks of political anti-Semitism followed the defeat of France by Germany at the end of the Franco-Prussian War in 1871. They became

intensified by France's numerous recessions during the last quarter of the nine-
teenth century and, in particular, the collapse of the Catholic-backed bank, the
Union Génerale, in 1881. In addition to these political and economic misfor-
tunes, a veritable landoffice business developed in pseudo-science and science.
They encompassed phrenology and criminology as well as the newly emerg-
ing and still highly contested fields of neurology and psychology. All spawned
both overt and subliminal racist and sexist theories and, not least, a *nouvelle
vague* in anti-Semitic imagery. These ranged from such populist images as
Emile Courtet's *Les qualités du Juif d'après la méthode de Gall (Jewish Virtues
According to Gall's Method)* (Figure 5.1) which appeared in the rabidly anti-

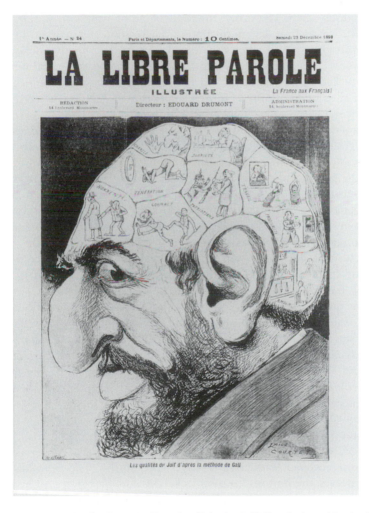

Figure 5.1 Emile Courtet. 'Les Qualités du Juif d'après la méthode de Gall', *La
Libre Parole*, 23 December 1893. © The Jewish Museum, New York.

Semitic journal published by Edouard Drumont, the self-proclaimed rabbi of anti-Semitism, to more artistic ventures such as Toulouse Lautrec's 1892 poster for Victor Joze's novel, *Reine de Joie (Queen of Pleasure)*[4] and Jean-Louis Forain's *Artiste et Juifs (Artist and Jews)*.[5] The undetectable bodies of assimilated Jews, such as that of Alfred Dreyfus, presented a serious threat to the French societal myths propagated by racist theories. Assimilated Jews challenged the very authority of the finely honed and deeply ingrained Jewish stereotype. In essence, the army exploited Alfred Dreyfus to prove that dormant, typecast Jewish features and behavior could be reinscribed onto the body of a Jew who virtually could pass for Gentile. As treasonous criminal, Dreyfus could help exemplify that beneath every Jew – no matter how assimilated his appearance – lurked a sinister alien. The army's method of proof was both simple and highly visible: degradation and incarceration. These strategies worked to the army's ends particularly well when the degradation became highly public and the incarceration extravagantly symbolic. In turn, France's partisan and unregulated press picked up the narrative and reinvested it with even more legible signs that the alien body of Alfred Dreyfus, this highly suspect Jew, was responsible for France's various political and social ills.

On the days immediately following Dreyfus's conviction, a debate raged in the Chamber of Deputies concerning the re-introduction of the death sentence for the "treasonous" convict. This option was championed by none other than the prominent Socialist leader Jean Juarès. Several years later, he would become one of the most ardent Dreyfusards. Juarès's political clout eventually would help turn the tide in the call for a revision.[6] The notion of keeping Dreyfus alive, but manipulating a public event akin to execution, deporting him, and controling and disciplining his Jewish body, made sense in the trajectory of signs and symbols that Dreyfus's body would come to represent. The highly public ceremony of the degradation was held in the courtyard of the Ecole Militaire on Saturday, January 5, 1895. Cries of "Death to the Jews, Death to the Traitor, Death to Judas!" were heard outside the ancient walls.[7] The ceremony was held conspicuously on the Jewish Sabbath. So was that of the 1951 execution of Ethel and Julius Rosenberg, yet another symbol of control over the Jews and what might be considered their odd and "foreign" rites. Dreyfus was literally stripped of his rank. Maurice Paléologue, an important chronicler of the Affair aptly described his first-hand observation of the scene:

> A warrant officer of the Garde républicaine, a giant of a man, Sargent-Major Bouxin, approached the condemned man as he stood there motionless and, with angry gestures, tore off the braid from his cap and sleeves, the buttons from his jacket, his shoulder-straps, all his marks of rank, and threw them in the mud. When Dreyfus's uniform had been reduced to tatters, the giant took his saber and scabbard and broke them over his knee. The fearful ordeal seemed interminable.[8]

This event provided the press with the opportunity for graphic commentaries. *Le Traître, Dégradation d'Alfred Dreyfus (The Traitor: The Degradation of Alfred Dreyfus)*, from *Le Petit Journal, Supplément Illustré* (Figure 5.2) is one example. However, this seemingly neutral image of the "ceremony" does not accurately reflect the violent anti-Semitism of the paper's editorial content. Dreyfus's degradation is usefully examined in light of Michel Foucault's notion that while earlier, premodern forms of physical torture and "execution" had been supplanted by more modern, "humane" punishments, the degree of social control intensified. The scene here bore the same old-fashioned theatricality as did executions in the era of absolutism and the reign of the guillotine

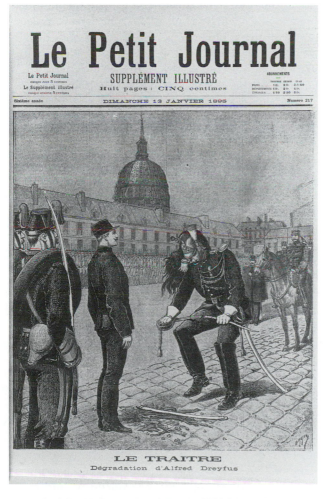

Figure 5.2 'Le Traître, Dégradation d'Alfred Dreyfus', *Le Petit Journal, Supplément Illustré*, 13 January 1895. Musée de la Presse, Paris.

during the Revolution.[9] In Foucault's own words, "The function of public torture and execution was to reveal the truth; and in this respect it continued, in the public eye, the work of the judicial torture conducted in private."[10] Given all the preparation for this symbolic event, Dreyfus's cries of protestation, the horrible and prolonged post-degradation revue along the ranks of the assembled soldiers who got to see "justice in action,"and finally Dreyfus's dispatch into a tightly confined Black Maria wagon, one can rest assured that, at very least, mental torture was dauntlessly substituted for the physical torments of yesteryear.

Shortly after the degradation, phrenological diagrams were immediately superimposed on Dreyfus's head by the likes of caricaturist Alfred le Petit (Figure 5.3). It showed a mild exaggeration in comparison to the previously seen generalized phrenological view by Courtet. Its hyperbole is underscored through a comparison with the prisoner photograph of Dreyfus's benign and rather attractive countenance (Figure 5.4). Le Petit's pseudo-phrenological caricature mirrored precisely the invective of the clerical newspaper *La Lanterne* which described the body of the degradee two days after the events. It used these words:

> The physiognomy is intelligent, the figure is fine, despite his 8-day growth of beard, he is a somewhat serious type, a rough-hewn genius. But, the mouth has a mischievous expression under the blond mustache, the chin indicts a formidable abstinence, and under the *pince-nez*, the clear blue eyes speak of the ruse and the falseness of his character.[11]

In essence this amalgam of physical flattery and mental damnation revealed for *La Lanterne*'s reading public the alien that lay just beneath the surface of the "passing" Jewish officer.

Documentary photographs of criminals and their body parts were fabricated into a pseudo-scientific regimen in the hands of Alphonse Bertillon. Bertillon was the head of the identification bureau of the judicial police at the time of The Affair. His expert testimony on the handwriting of the infamous *bordereau* helped convict Dreyfus. He had established an elaborate system for measuring, documenting and photographing criminals. This was part of increasingly professionalized systems of criminology in the 1880s and 1890s. Bertillon's filing system and purportedly accurate procedure for gathering data on the bodies of criminals became so internationally renowned that it was exhibited at the 1892 Chicago Columbian exhibition. His explanation concerning the veracity of his identification of Dreyfus's handwriting on the *bordereau* suggests the lengths to which Bertillon's pseudo-scientific mind would go to construct damning hypotheses. He was determined to find reason to implicate Dreyfus in the authorship of the document, despite earlier expert investigation rejecting this supposition. (Allow me to spare you further details.)

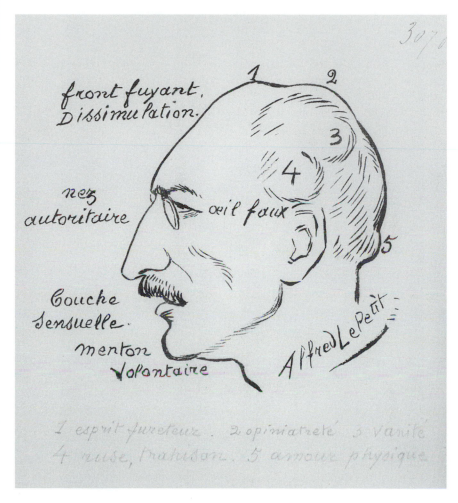

Figure 5.3 Alfred le Petit, 'Dreyfus jugé par son crâne et par sa physionomie' *c.* 1898–99. Artine Artinian Collection.

Figure 5.5[12] represents the tangled diagram Bertillon used to analyze the *bordereau* and reflects the complex measuring and photographic operation in his systems. Even Jean Casimir-Périer, the President of the Republic at the time of Dreyfus's arrest, thoroughly discounted Bertillon's validity. Casimir-Périer considered Bertillon not odd but mad, and recognized that he "used such unintelligible jargon, talked such grotesque gibberish that I thought I was in the presence of a lunatic escaped from Salpétrière or Villejuif."[13] Nevertheless, Bertillon convinced the military court of Dreyfus's guilt as well as selling his system of identification to major urban police departments in the US, a central archive in Washington DC and throughout Canada.[14]

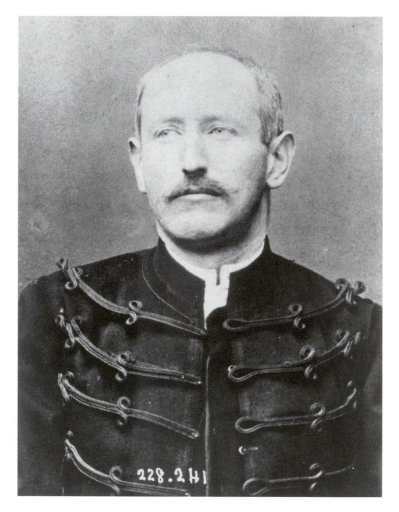

Figure 5.4 Police identification photograph of Alfred Dreyfus (after degradation), 1895. © The Jewish Museum, New York, 1990. Gift of Mr and Mrs Herbert D. Schimmel.

In his astute article on the criminal body, Allan Sekula has observed that the control of the criminal's body, especially as seen in the working methods of Bertillon, "necessitated a massive campaign of *inscription*, a transformation of the body's signs into a text."[15] This documentary technique for the military prison photograph of Dreyfus was not made using Bertillon's method.[16] However, the partially frontal photograph and printed verso readied for documentation derived from the necessity to formulate such signs of guilt onto military prisoners as well as civil criminals. Dreyfus's own diaries describe the moment of manufacture of this photograph: "At the Central Prison, in my

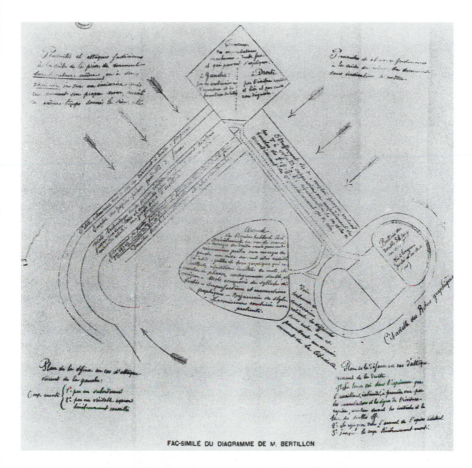

FAC-SIMILÉ DU DIAGRAMME DE M. BERTILLON

Figure 5.5 Bertillon, Redan Drawing. National Gallery of Canada.

torn and stripped uniform, I was dragged from hall to hall, searched, pho-
tographed, and measured."[17] How odd and ceremonial such procedures: he
had already been imprisoned for over two months. In this case his loss of mil-
itary standing demonstrated Dreyfus's deficiency, a sure symbol of his dishonor
and the efficacy of the degradation ceremony. This image along with the
inscription *trahaison* next to the line for *motif* on the verso assured, at least the
military inspectors who viewed this photographic document, that their former
suspect was guilty. In essence, the degradation served to strip from Alfred
Dreyfus any recognizable military signs of strength and courage,[18] and ulti-
mately to eviscerate his – and by symbolic extension any other – Jewish body
from the signs of rank of French military officer.

Consequently, this document of the "treasonous" former captain, with all its
appropriate signs of military rank conspicuously lacking, affirmed the racist
theories about the physical inability of the Jew to serve in the army.[19] The

notion of the Jew as criminal had become part of the psychiatric writing on forensic pathology. This photograph further validates such research as well.[20] Dreyfus had already been dubbed an "incomplete officer,"[21] the photograph would further emphasize another deficiency which had become a major element in the racist mythology surrounding the Jewish male: a deficiency in virility. This was attributed in part to the ritual practice of circumcision and its ultimate connection with the claim that the Jewish male was effeminate.[22]

Nascent photo-journalism was still unable to provide suitable press images of the degradation, even though photographs of the events in Rennes during Dreyfus's retrial less than five years later began to appear with considerable frequency. An amateur shot of the degradation and the only known existing photograph of the event, reveals the great distance and concomitant indecipherability of the figures and events portrayed in this operatic "execution" (Figure 5.6). Illustrators and caricaturists, however, were able to embellish the details into highly focused images such as the childish caricatural illustration from *Le Petit Journal*. Drumont's *La Libre Parole* would show the ultimate overpowering of the convict by a French hulk. In this case, Drumont himself becomes the personification of the mighty, virile Frenchman.[23] The image shows the total submission of the now-downsized, Jewish-featured German traitor replete with a miniature Prussian helmet. With the highly publicized

Figure 5.6 Unknown, "A l'école militaire", 5 January 1895. Collection of Robert J. Maguire.

breaking of a simulated sword by the giant officer, the degradation was exaggerated in caricature so that it could be read, using the most elementary psychoanalytic symbolism, as emblematic of Dreyfus's decimated manhood. This contradictory notion of the effeminate, yet dangerous, Jew would foster another image four years later. In the 1899 caricature, Marianne, symbol of France, unsuccessfully attempts to scrub a thoroughly emasculated Dreyfus who now stands more like a figure of Venus than that of a former army captain. Ultimately, no amount of mother's milk, a symbol of French genealogical connection and fertility, with which Marianne struggles at her frustrating task, can cleanse this evidently "dirty" Jew. Such notions of the effeminized Jew became standard in the rhetoric of racist literature during the fin-de-siècle.[24] Following Robert Nye's study on honor, impotence and male sexuality in nineteenth-century medicine, the association of effeminization with a male Jewish scapegoat may have countered Frenchmen's anxieties about their own masculinity and fertility.[25]

His degradation accomplished, Dreyfus was deported to Devil's Island, a former leper colony off French Guyana. Such deportation had been limited to political criminals under the Empire. But with the new influx of vagrants and the extent of vagabondage in Paris in the mid-1880s, deportation to Guyana and New Caledonia became an option for these so-called lesser criminals whose main crime was their threat to the French urban economy. The signs of Dreyfus's deported body thus were bound up with both "high" and "low" notions — if you will — of criminals, with incurable and communicable illness and, following the lines of Church teaching prior to the Enlightenment, with the devil himself.[26]

The "incompleteness," "feminacy," and "deficiency" that had been inscribed upon or extracted from Dreyfus's body were symbolic validations of the problems Jews posed to society in general and to the military in particular. Only 17 months prior to Dreyfus's being accused of treason, in May 1892, Drumont's *La Libre Parole* had begun its crusade against what he regarded as the considerable number of Jewish officers in the military. Drumont considered them potential traitors and claimed that "in an enormous majority of French soldiers there existed a sentiment of repulsion towards the sons of Israel."[27] His anti-Semitic tabloid was coincidentally the first to leak the news of Dreyfus's arrest. Within less than two years, while Drumont had not accomplished his fundamental goal of abolishing Jews from the army, at least he had helped produce a symbol supporting his reckless claims. There is a striking similarity between Drumont's invective against Jews in the French army and that surrounding the issue of gays in the American military 101 years later.[28]

The fear of the German military and the repugnance of his image had become closely inscribed in popular iconography at least since the Franco-Prussian War of 1871. That a particular image of a German officer could continue to incite passions is attested to with the near scandal that surrounded the appearance of Toulouse-Lautrec's poster *Babylone-Allemagne* in 1894, the very

year of Dreyfus's arrest (Figure 5.7). In it an erect German officer with a supercilious bearing follows three others up the street, all the while oblivious to both the French sentry and the couple who gaze peripherally at the procession. We see the horse from below and behind, Lautrec's visual pun which basically labels the rider a "horse's ass," or "un cul de cheval." The author whose book this was meant to promote, Victor Joze, actually asked Toulouse-Lautrec to withdraw the poster. The German ambassador had taken offense and the combination of the anti-German book and the disparaging stereotype in the poster nearly caused an international incident.[29]

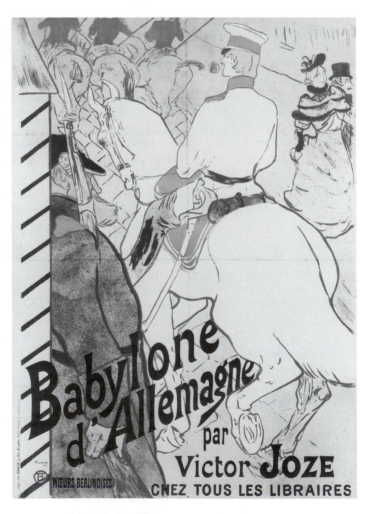

Figure 5.7 Henri de Toulouse-Lautrec, *Babylone d'Allemagne*, 1894. The Museum of Modern Art, New York. Gift of Abby Aldrich Rockefeller. Photograph © 1998 The Museum of Modern Art, New York.

The notorious *bordereau* was found in the offices of the German military attaché in Paris, Lieutenant Colonel Maximilien von Schwartzkoppen, as part of a sting operation on the part of French intelligence. This site of discovery of the document that convicted Dreyfus provides additional indicators about the fears of the French military concerning the Jews among them, as well as their anxieties about their own individual virilities and institutional strengths. Von Schwartzkoppen was the visible symbol and personification of the great might of France's most feared enemy; and his wastepaper basket was a potential source for information about Germany's military secrets. The purported maid for the German military attaché, Mme. Bastian, routinely emptied this receptacle every evening on her way home from work and deposited the contents at the office of French intelligence.

The tale of Mme. Bastian is re-told continually in the voluminous bibliography that has appeared since the Affair. But it was only upon publication of Jean-Denis Bredin's *The Affair*, first printed in Paris in 1983, that the additional content of Mme. Bastian's huge haul of correspondence came to light. Rummaging through the archives of the Ministry of War nearly 90 years after the initial accusation of Dreyfus, Bredin discovered a sizeable group of love letters that are hotter sexually than affectionately. This was the professional and personal correspondence between none other than the German military attaché, Lieutenant Colonel Maximilien von Schwartzkoppen, and the Italian military attaché Major Allesandro Panizzardi! Here are some excerpts from this correspondence:

> "Dear Maximilien, am I still your Alexandrine? When will you come bugger me? A thousand salutations from a girl who loves you. Alexandrine." Or "My darling, all yours and on the mouth" and "Yes little red dog, I shall come for your pleasure." Some were not just amorous. Take for instance: "I am transmitting a copy of the old firing tables for the 80 cannon and the 95 cannon. All yours. Good day, bugger," and others containing salutations such as "my dear little war dog" and closings such as "your devoted war bitch."[30]

Yes, in looking for military secrets among their enemies, the French Intelligence Office had uncovered a homosexual affair between the military envoys of two of their arch rivals. Historian Annelise Maugue argues that "while the [French] official discourse on homosexuality was changing, the old attitudes still prevailed, and for many homosexuality was seen as both criminal and immoral."[31] Surely the French army, an institution known at the time for its retrograde, right-wing, and even Royalist ideas, and the bureaucrats who rigged the evidence against Dreyfus, must have shared such presumptions. The question remains: did French Intelligence delight in discovering that the agents of their military rivals were, according to the psychological theories of the age, either of intermediary gender or, more profoundly, the woman in the

man? Or, did they reason that if the representatives of their more powerful enemies were less than men, how might this reflect on the masculinities of the individual members of their own admittedly weaker army?[32]

There was no way they could censor such behavior, not only because foreign diplomats carried requisite immunity from French civil law but also because France herself had no laws with which to prosecute any homosexual, even a French citizen.[33] Coincidentally, this surface tolerance of homosexuals by the French civil code would make it possible for Oscar Wilde to find refuge in Paris following his trial for homosexual offenses in London during the very same year of Dreyfus's degradation. Furthermore, the exposing of such personal and damning information found among foreign diplomats could have contributed to the dreaded military confrontation France's army most feared.

Thus, a conflation of signs and symbols, images and stereotypes occurred within the threatened masculinities of the French Intelligence and War bureaus. The only possible course of action was to find a scapegoat who could literally be sent out to the wilderness bearing all the sins and fears of the French army. A Jew as scapegoat would consolidate signs of the "foreign" with signs of the "effeminate." In essence, Dreyfus's victimization served as a transference of the threatened manhood and power of the French military. As archetypical Jew, a secure stereotype and carefully researched specimen for the medical science of the time, Dreyfus could displace the homosexual. This is especially true considering the virtually embryonic knowledge and then only recent coinage of the term "homosexuality." Similarly the notion of the homosexual male as diseased was just beginning to replace the older idea of the homosexual as criminal.[34] So the reinscribed body of Alfred Dreyfus, the "passing" Jewish soldier, offered a surrogate for the "passing" homosexual and military bodies of Schwartzkoppen and Panizzardi. As homosexuals and foreigners, these two men may have been ultimately even more threatening, and certainly less controllable, than French Jews.

Yet, France's army was not the only one to buy into the conflicted logic of Jewish stereotype and threatened male virility. The anxiety of Jews themselves to these societal stereotypes was remarkable, and once again Dreyfus serves as an exemplary model. During his adolescence, he grappled to overcome his frail physique, he struggled to become an equestrian, and eventually he succeeded in becoming a model French soldier, at least for a short moment.[35] These efforts may easily be read as his bid to counter the common perception of Jews as a physically weak "race."[36] Dreyfus's zeal to become the able-bodied, assimilated Jew, immediately foreshadowed the development of the concept of a muscular type of identified Jew that Zionism would advocate.

Established by Theodore Herzl, a Viennese correspondent posted in Paris in the 1890s, the Zionist movement developed as his reaction to the anti-Semitic violence he observed during the Dreyfus Affair. The notion of the "muscle Jew" promoted by Herzl's close colleague, Max Nordau, a physician and critic,[37] became a necessity as these founders of Zionism realized the need for

virile men to build a new nation, architecturally and agriculturally, and not least, to be able to defend its borders. Oddly enough, Nordau's notion of the "muscle Jew" also might be perceived as a deployment of concerns about societal perceptions of his own sexuality, masculinity and virility – both real and symbolic. His 1893 tome, *Entartung*, is his damnation of the degeneracy of fin-de-siècle art, music and literature. Among other things, he ridiculed the Wagner cult, the novels of Zola, Symbolist and Impressionist painting and the Pre-Raphaelites. Nordau argues against the depravity and effeminacy of recent culture, what he considered a "vice that looked to sodom and lesbos."[38] His ideas were hotly contested in both America and Europe.[39] In this defensive posture against the degeneration and effeminacy of current culture, he falls prey to the same social and pseudo-scientific stereotypes that would continue to define both Jews and homosexuals through the late nineteenth and early twentieth centuries. In his book, *Degeneration*, he claims:

> Degeneracy betrays itself among men in certain physical characteristics, which are dominated by "stigmata." Such stigmata consist of deformities, multiple and stunted growth in the first two halves of the face and cranium, and the imperfection in the development of the external ear.

Nordau continues to note that his mentor, Cesare Lombroso – another anxious nineteenth-century Jew – "links these stigmata with born criminals."

Paradoxically, the masculine construction of Zionism, the nationalist movement theorized by Herzl and Nordau in reaction to the reinvigorated anti-Semitism born of the Dreyfus Affair, might be seen as evolving from the same anxious attitudes towards masculinity and the male Jewish body. And even more ironic is the direct line of correspondence between Nordau's theorization of decadence and the censorship of degenerate art in Nazi Germany forty years later.

Notes

1 A version of this paper was originally presented at the College Art Association 83rd Annual Conference in San Antonio, Texas, January 1995. Sander Gilman was also working on a paper on Dreyfus's body at the time I began my work on this topic. His paper titled "Dreyfus's Body, Kafka's Fear" was presented in Berlin in early May 1994. Although I was not able to attend that conference, I thank Sander Gilman for sharing his text with me. I also would like to thank Mira Goldfarb, Curatorial Assistant at The Jewish Museum, and Anita Friedman, a former colleague, for help with certain details of the research and preparation of the initial presentation.

2 For further examples of these types of visual images see Eduard Fuchs *Die Juden in der Karikatur*, Munich, Albert Langen 1921, still the classic historical compilation of images. Late 19th century French anti-Semitic imagery formed a significant part of the illustrated material in Norman L. Kleeblatt *The Dreyfus Affair: Art, Truth and Justice*, Berkeley, Los Angeles, London, University of California Press, 1987. Sander

Gilman's aforementioned *The Jew's Body*, New York and London, Routledge, 1991, deals with a combination of the nineteenth- and twentieth-century anti-Semitic textual and visual representations of Jews.

3 Michael Marrus, *The Politics of Assimilation: The French Community at the Time of the Dreyfus Affair,* Oxford, Clarendon Press, 1980.

4 Kleeblatt, p. 71, figure 10 (cat. 62).

5 Kleeblatt, p. 54, figure 3, (cat. 47).

6 Jean-Denis Bredin, *The Affair: The Case of Alfred Dreyfus*, translated by Jeffrey Mehlman, New York, George Braziller Inc., 1986, p. 98.

7 Maurice Paléologue, *An Intimate Journal of the Dreyfus Case*, New York, Criterion Books 1957, trans. by Eric Mosbacher, p. 52.

8 Paléologue, pp. 52–3.

9 Michel Foucault, *Discipline and Punish: The Birth of the Prison*, London, Peregrine Books, trans. by Allen Lane, 1977, pp. 9–15.

10 Foucault, p. 44.

11 *La Lanterne*, 7 January 1895, no. 6470. This author's translation.

12 I thank Anne Thomas, Curator of Photography at the National Gallery of Canada, Ottawa and her colleague Hazel Mackenzie, Art Documentation and Storage Officer, for making this image available to me.

13 Paléologue, p. 42.

14 Allan Sekula, "The Body and the Archive," *October* 39 (Winter 1986), pp. 34, 35.

15 Sekula, p. 33.

16 I thank Allan Sekula for discussing the photograph of Alfred Dreyfus with me. The photograph is in the collection of The Jewish Museum, originally purchased at a public auction in Argenteuil in 1986. This photograph was purchased in a lot together with a Bertillonage photo of Louis Gregori, the man who attempted to assassinate Dreyfus at the internment of Zola's ashes at the Pantheon. The photographs had been stolen from the préfecture of police by an archivist who seems to have helped himself to photographs of murderers, prostitutes, autopsies, as well as the photos of Dreyfus and Gregori. The print had been in the possession of the archivist's family. Some statute of limitations seemed to have lapsed through which the police archives no longer seemed to have rights to the material.

17 Alfred Dreyfus, *Five Years of My Life: The Diary of Captain Alfred Dreyfus*, New York, Peebles Press, 1977. Introduction by Nicolas Halasz, p. 67.

18 Foucault, p. 135.

19 Sander L. Gilman, *The Case of Sigmund Freud: Medicine and Identity at the Fin de Siècle*, Baltimore and London, Johns Hopkins University Press, 1993, pp. 31–2. For Jewish response to these charges see also p. 119.

20 Gilman, *The Case of Sigmund Freud*, p. 170.

21 Bredin, p. 63.

22 Gilman, *The Jew's Body*, New York and London, Routledge, 1991, pp. 76, 91, 175, 176.

23 Kleeblatt, p. 156, plate 6.

24 Gilman, *Difference and Pathology: Stereotypes of Sexuality, Race and Madness*, Ithaca and London, Cornell University Press, 1985, pp. 150-63.

25 Robert A. Nye, *Crime, Madness and Politics in Modern France: The Medical Concept of National Decline*, Princeton, NJ, Princeton University Press, 1984.

26 Nye, pp. 59–61.

27 Quoted from Bredin, p. 29.

28 For examples of the arguments around gays in the military around the time of President Bill Clinton's inauguration see James T. Bush, "Dialogue: Gays in the Military: Cancel Reagan's Ban," *New York Times*, January 14, 1993, p. A23 and quotations from Camp Lejeune in the same newspaper on January 28, 1993.

29 Gerstle Mack, *Toulouse Lautrec*, NY: Alfed A. Knopf, 1938. 287. Also Götz Adriani, *Toulouse-Lautrec: The Complete Graphic Works, A catalogue Raisonné*, Thames and Hudson, London, 1988. 96–97.

30 Bredin, pp. 49–50. Note Schwartzkoppen's bisexuality.

31 Annelise Maugue, *L'identité masculine en crise au tournant du siècle, 1871–1914*, Paris, Editions Rivages, 1987, pp. 99, 135.

32 Catherine Gallagher and Thomas Laqueur, eds, *The Making of the Modern Body: Sexuality and Society in the Nineteenth-Century*, Berkeley, Los Angeles, London, University of California Press, 1987, p. 112. Since my initial research for this paper, a great deal of work has been published on the subjects of homosexuality in France (Jeffrey Merrick and Bryant T. Ragan, Jr., eds, *Homosexuality in Modern France*, New York and Oxford, Oxford University Press, 1996, for example) and homosexuality and Jews (Adrian Rifkin, "Parvenu or Palimpsest: Some Tracings of the Jew in Modern France," *The Jew in the Text: Modernity and the Construction of Identity*, New York, Thames and Hudson, 1995, pp. 276–91, for example).

33 This contrasts with the stringent laws in Germany and England at the time.

34 Maugue, p. 99.

35 Michael Burns, *Dreyfus, A Family Affair 1789–1945*, New York, Harper Collins, 1991, pp. 59–83.

36 Gilman, *The Jew's Body*, pp. 40, 52–3, and *The Case of Sigmund Freud: Medicine and Identity at the Fin de Siècle*, The Johns Hopkins University Press, 1993, p. 142.

37 Gilman, *The Jew's Body*, pp. 53–4. Also see Max Nordau, *Zionistische Schriften*, Cologne, 1909, pp. 379–81.

38 Max Nordau, *Degeneration*, New York, Howard Fertig, 1968 (English Edition).

39 For George Bernard Shaw's rebuttal to this work, see Shaw, "The Sanity of Art: An Exposure of the Current Nonsense about Artists being Degenerate," *Major Critical Essays*, London, Constable and Company, 1932; St. Clair Shores, Michigan, Scholarly Press, 1976. For the American reaction see Linda L. Maik, "Nordau's Degeneration: The American Controversy," *Journal of the History of Ideas*, vol. 50, no. 4, pp. 607–23. See also Gilman, "The Mad Man as Artist: Medicine, History and Degenerate Art," *Journal of Contemporary History* 20, 1985, pp. 575–97.

Part III

ENGENDERING DIASPORA

6

DIASPORA AND HYBRIDITY
Queer Identities and the Ethnicity Model

Alan Sinfield

"It's as if we were an ethnic grouping" – Peter Burton writes in *Gay Times* (April 1995). The idea goes back, at least, to *The Homosexualization of America* (1982), where Dennis Altman observes that gay men in the United States have since the 1970s adopted an "ethnic" mode of identification: "As gays are increasingly being perceived as a minority in the best American tradition, it is hardly surprising that they have come to claim a political role based on this fact."[1]

Ethnicity is not the only framework through which we have envisaged same-sex passion. As Eve Sedgwick points out, we have operated, together and incoherently, two ideas: minoritizing and universalizing. In the former, lesbians and gay men constitute a fairly fixed minority, as an ethnic group is supposed to do; in the latter, virtually everyone has a potential for same-sex passion.[2] Hence the ongoing argy-bargy about how "widespread" homosexuality is: it depends how the question is put. If "it" is defined so as to require an acknowledged identity and a gay "lifestyle," research will find few instances. If "it" is any intense same-sex bonding or the occasional occurrence of any same-sex act, then research will find hardly anyone to be immune.

Thinking of lesbians and/or gay men as an ethnic group is a minoritizing move, and it runs counter to the constructed and decentered status of the subject as s/he is apprehended in current theory. Nonetheless, very many lesbians and gay men today feel, intuitively, that the ethnicity model best accounts for them. This is partly because, as Steven Epstein suggests, we have constituted ourselves in the period when ethnicity, following the precedent of the Black Civil Rights movement, has offered the dominant paradigm for political advancement. It has become "the default model for all minority movements," Michael Warner remarks.[3] So we too claim our rights: that is what ethnic groups do. The culmination of this tendency is Simon LeVay's belief that he is doing us all a good turn by locating a part of the brain that is different in gay men, because this will enable US gays to claim recognition in the courts as a minority having immutable characteristics.[4] So North American lesbians and gays can get to be as well-off as the Indian peoples.

In other quarters, the ethnic model is under new kinds of question. In a review of Marjorie Garber's book, *Vice Versa: Bisexuality and the Eroticism of Everyday Life*, Edmund White begins by remarking: "In the United States, where so many political factions are linked to ethnic identity, homosexuals have been astute in presenting themselves as something very much like a racial or cultural identity." But White concludes by wondering "whether I myself might not have been bisexual had I lived in another era." The post-Stonewall drive to *be gay* limited him: "I denied the authenticity of my earlier hetero-sexual feelings in the light of my later homosexual identity."[5]

It is not, altogether, a matter of deciding how far we want to go with ethnic-ity-and-rights; the dominance of that model is not incidental. For it is not that existing categories of gay men and lesbians have come forward to claim their rights, but that we have become constituted *as gay* in the terms of a discourse of ethnicity-and-rights. This discourse was active, and apparently effective, else-where in the political formation, and afforded us opportunity to identify our-selves – to *become ourselves*. This has meant both adding to and subtracting from our potential subjectivities. As Didi Herman puts it, rights frameworks "pull in 'new' identities . . . people are forced to compartmentalize their complex sub-jectivities in order to 'make a claim'."[6] Again: "The person who takes up a post-Stonewall gay identity feels compelled to act in a way that will constitute her or himself as a subject appropriate to civil rights discourse," Cindy Patton observes.[7] Gay men and lesbians *are*: a group, or groups, claiming rights.

There are drawbacks with envisaging ourselves through a framework of eth-nicity-and-rights. One is that it consolidates our constituency at the expense of limiting it. If you are lower-class, gay lobbying and lifestyle are less conve-nient and may seem alien. If you are young, the call to declare a sexual iden-tity imposes the anxiety that exploration of your gay potential may close your options for ever. And if you are a person of color, the prominence of a mainly white model makes it more difficult for you to negotiate ways of thinking about sexualities that will be compatible with your subcultures of family and neighborhood.

Also, fixing our constituency on the ethnicity-and-rights model lets the sex-gender system off the hook. It encourages the inference that an out-group needs concessions, rather than the mainstream needing correction; so lesbians and gay men, Herman observes, may be "granted legitimacy, not on the basis that there might be something problematic with gender roles and sexual hier-archies, but on the basis that they constitute a fixed group of 'others' who need and deserve protection."[8] Initially in Gay Liberation, we aspired to open out the scope of sexual expression for everyone, in the process displacing the oppressive ideologies that sexuality is used to police. By inviting us to perceive ourselves as settled in our sexuality, the ethnicity-and-rights model releases others from the invitation to re-envision theirs. "At best, a minority group analysis and a civil rights strategy pertain to those of us who already are gay," John D'Emilio argues. "Our movement may have begun as the struggle of a

'minority,' but what we should now be trying to 'liberate' is an aspect of the personal lives of all people – sexual expression."[9]

Correcting the exclusiveness of lesbian and gay identities was one goal of "Queer Nation." "Queer," Michael Warner writes, "rejects a minoritizing logic of toleration or simple political interest-representation in favour of a more thorough resistance to regimes of the normal."[10] Henry Abelove reads "nation," in "Queer Nation," as an aspiration, in the tradition of Henry David Thoreau's *Walden* (a gayer book than is generally acknowledged), not to join, but to *become* "America" – *the* nation.[11] The problem for Queer Nation was the scale of that aspiration: relatively few people were ready for it. In many small-town and rural circumstances, being gay is quite a struggle; the last thing you want is someone from a city telling you that you don't measure up because you can't handle "queer." Like many vanguard movements, Queer Nation was a minority within a minority.

The Castro and the White House

The ethnicity-and-rights model encourages us to imagine a process whereby, win some/lose some, we all advance gradually towards full, democratic citizenship. However, "citizen" has never meant "inhabitant." It always counterposes some others who are present but not full citizens – at best, visitors, but usually also racial, ethnic and sexual minorities, slaves, criminals, the lower classes, women, children, the elderly. In our Enlightenment inheritance, the nation is an unstable construct, and ideas of citizenship are deployed, typically, in a hegemonic process whereby outsiders are stigmatized and potential deviants jostled into place.[12] The corollary of the "Citizens' Charter," propagated by the UK Conservative Government in the early 1990s, is the harassing of people who try to live outside a narrow norm.

Discussion of citizenship in the United Kingdom usually invokes T. H. Marshall, who in 1947 analysed modern constitutional history as a broad progress – from class hierarchy, towards equal rights of citizenship. Civil rights – of property, speech and religion, justice before the law – developed in the eighteenth century, Marshall says; political rights (mainly the franchise) were achieved during the nineteenth and early twentieth centuries; and, lately, in the 1940s, social rights were being added – "the components of a civilised and cultured life, formerly the monopoly of a few, were brought progressively within the reach of the many."[13] Marshall's analysis reflects the optimistic, egalitarian climate at the end of the Second World War, when an apparatus of welfare benefits was installed to ameliorate the worst consequences of capitalism, effectively relegitimating the British state through an ideology of fairness and consensus. In this framework, even homosexuals became a "social problem" requiring a benign state solution; the Wolfenden Report was commissioned in 1954 to find one, and in 1967 its proposals became the basis of the current law.[14]

The UK version of citizenship positions out-groups as petitioning for con-cessions, which appear analogous to the welfare granted to the unfortunate. In the USA, where a constitution professes to guarantee rights to all citizens, it is more a matter of asserting a claim. "Each time there is a major defeat of gay rights in the voting polls of middle America, gays take to the streets of San Francisco chanting 'Civil Rights or Civil War'," Manuel Castells notes.[15] This threatens, metaphorically, a repeat of the founding revolt of the United States, or perhaps of the war that freed Black slaves. Either way, it wouldn't work in England because our civil war means differently (probably the dominant meaning is upper-class incompetence versus vulgar fanaticism; this is echoed, still, in perceptions of the two main parliamentary parties today). However, gay activism in Britain often adopts an "American" rhetoric, because it seems more determined and dignified. (In fact, I think, British images of male gayness are generally dependent on North American examples – to a far larger extent than British people realize.)

The US ideology of rights, as Epstein says, "functions typically through appeals to the professed beliefs of the dominant culture, emphasizing tradi-tional American values such as equality, fairness, and freedom from persecu-tion;" it implies the goal of "gaining entry into the system;" it appeals to "the rules of the modern American pluralist myth, which portrays a harmonious competition among distinct social groups."[16] How far that myth is to be trusted is a question far wider than queer politics: it is about how much we expect from the institutions through which capitalism and heteropatriarchy are reproduced.

The ethnicity-and-rights model aspires to two main spheres of political effectivity. One is a claim for space within which the minority may legiti-mately express itself. For gay men, classically, this was the Castro district of San Francisco. Manuel Castells, in a moment of exuberance in the early 1980s, saw there a recovery of the merchant citizenship of the Italian Renaissance:

> We are almost in the world of the Renaissance city where political freedom, economic exchange, and cultural innovation, as well as open sexuality, developed together in a self-reinforcing process on the basis of a common space won by citizens struggling for their freedom.

Castro gay leaders spoke of a "liberated zone."[17]

However, if it is hard to achieve socialism in one country, as Trotsky insisted against Stalin, it is even less likely that sexual liberation can work in one sector of one, capitalist, city. Castells observes how inter-communal hostility devel-oped in and around the Castro, as gentrification (also known as "gay sensibil-ity") raised property values and squeezed out other, mainly Black and Latino, minorities.

The clashing of competing interests is endemic to the ethnicity-and-rights model. When ACT UP intruded on the Roman Catholic service of Cardinal

O'Connor in New York, Douglas Crimp reports, it was said that they had "denied Catholic parishioners their freedom of religion." Similarly in Britain, Rachel Thomson notes, Department of Education and Science circular 11/87 declares: "It must also be recognized that for many people, including members of religious faiths, homosexual practice is not morally acceptable."[18] One interest group is used against another. Castells observes: "each player defines him/herself as having to pursue his/her own interests in a remarkable mirror image of the ideal model of the free market."[19] However, the free market, we should know, does not generally present itself in "ideal" form. Generally, it sets us all at each other's throats.

The second sphere where the ethnicity-and-rights model aspires to political effectivity is through the organs of the state. In *Close to the Knives* David Wojnarowicz propounds an urgent critique of US political, religious and judicial systems (that aspect of his book is left out of Steve McLean's 1994 film, *Postcards from America*). However, alongside that Wojnarowicz manifests an underlying vein of surprise that gay rights have not been acknowledged; he is shocked to read of a Supreme Court ruling (presumably *Bowers v. Hardwick*), that it is "only people who are heterosexual or married or who have families that expect these constitutional rights."[20] Lamenting the suicide of his friend Dakota, Wojnarowicz asks: "Man, why did you do it? Why didn't you wait for the possibilities to reveal themselves in this shit country, on this planet?" (p. 241). Despite his indictment, Wojnarowicz still expects Uncle Sam to come up trumps eventually. A persistent leitmotiv in *Close to the Knives* is that if only President Reagan would pay attention to AIDS, we would begin to get somewhere with it. Wojnarowicz writes:

> I imagine what it would be like if, each time a lover, friend or stranger died of this disease, their friends, lovers or neighbors would take the dead body and drive with it in a car a hundred miles an hour to Washington d.c. and blast through the gates of the white house and come to a screeching halt before the entrance and dump their lifeless form on the front steps.
>
> (p. 122)

It is as if recognition in official quarters would not only help resource a campaign to alert gay men to HIV and AIDS; not only legitimate the campaign; but somehow magic away the epidemic.

In comparable fashion, Larry Kramer's persona in *The Normal Heart* (1985) throws his energy into getting the attention of city hall, the mayor, and the *New York Times* newspaper. In 1995 Kramer says in an interview with Lisa Power that he has been

> accepting and facing . . . that all these myths I have swallowed about humanity and America and "one voice can make a difference" – these

things that we're all taught, that democracy works and all – turn out to be bullshit when you're gay or you have AIDS or are a member of a minority or whatever the reason.

"That was a surprise?" the interviewer asks, "curiously."[21]

Is homosexuality intolerable? – that is the ultimate question. One answer is that actually lesbians and gay men are pretty much like other people but we got off on the wrong foot somewhere around St Paul; it just needs a few more of us to come out, so that the nervous among our compatriots can see we really aren't so dreadful, and then everyone will live and let live; sexuality will become unimportant. That scenario is offered by Bruce Bawer, who calls himself a conservative, in his book *A Place at the Table*. He believes US gay men can rely upon "democracy" to gain "acceptance," because "to attempt to place restrictions on individual liberty and the right of others to pursue happiness is, quite simply, un-American."[22] What Bawer calls "subculture-oriented gays" impede this process by appearing radical and bohemian.

The other answer is that homophobia contributes crucially to structures of capital and patriarchy, and that lesbian and gay people offer, willy-nilly, a profound resistance to prevailing values in our kinds of society. The point may be figured through a distinction which Shane Phelan draws, between ethnicity and race. While ethnicity has enabled a discourse of rights and incorporation, race (despite the formative moment of Black Civil Rights) has proved less pliable. People deriving from Europe, Phelan observes, have been assimilated, but "Race in the United States has been the mark of the unassimilable, the 'truly different'."[23] Racial difference is doing more ideological work, and hence is more – perhaps ultimately – resistant. Which is closer to the situations of lesbians and gay men?

We cannot expect to settle this question. However, it would be rash to suppose that the criminalizing and stigmatizing of same-sex practices and lifestyles is an incidental kink in an otherwise reasonable structure; that the present system could, without cost, relinquish its legitimations and interdictions. Consider: parents will repudiate their offspring because of gayness. Something very powerful is operating there.

In my view, the pluralist myth which legitimates the ethnicity-and-rights model affords useful tactical opportunities, but it is optimistic to suppose that it will get us very far. Nevertheless, I will argue eventually that we cannot afford entirely to abandon a minoritizing model because we cannot afford to abandon subculture.

Diaspora, hybridity, and the doorstep Christian

Meanwhile, in another part of the wood, theorists of "race" and "ethnicity" have been questioning how far those constructs offer a secure base for self-understanding and political action. Stuart Hall traces two phases in self-

awareness among British Black people. In the first, "Black" is the organizing principle: instead of colluding with hegemonic versions of themselves, Blacks seek to make their own images, to represent themselves. In the second phase (which Hall says does not displace the first) it is recognized that representation is formative – active, constitutive – rather than mimetic. "'Black' is essentially a politically and culturally *constructed* category," Hall writes, "one which cannot be grounded in a set of fixed transcultural or transcendental racial categories and which therefore has no guarantees in Nature."[24] In similar vein, Henry Louis Gates Jr calls for a "thorough critique of blackness as a presence, which is merely another transcendent signified."[25]

In respect of European and American – *diasporic* – Black peoples, this may seem merely a necessary move: after forced migration, forced miscegenation and all kinds of economic and cultural oppression it must be hard to isolate an uncontaminated Africanness. "Our task is not to reinvent our traditions as if they bore no relation to that tradition created and borne, in the main, by white men," Gates declares (p. xxiii). "Diaspora" (a Greek, biblical term, denoting the captivity of the Hebrews in Babylon and, latterly, the worldwide dispersal of Jewry) usually invokes a true point of origin, and an authentic line – hereditary and/or historical – back to that. However, diasporic Black culture, Hall says, is defined "not by essence or purity, but by the recognition of a necessary heterogeneity and diversity; by a conception of 'identity' which lives with and through, not despite, difference; by *hybridity*." Alluding to the improvisatory virtuosity of Black jazz musicians, blues singers, rappers, dubbers and samplers, Hall writes of "the process of unsettling, recombination, hybridization and 'cut-and-mix' " arising out of "diaspora *experience*."[26]

Hall is inclined to celebrate hybridity; I mean to question that. But two immediate qualifications are appropriate. First, many non-white cultures are neither diasporic nor notably hybrid; those of Africans born and living in Africa, for instance. In his book *After Amnesia*, G.N. Devy invokes an Indian tradition that preceded a relatively slight Western imperial intrusion and continues through and beyond it – not as a static past, but a "never-ending transition."[27] Second, it is quite hard to envisage a culture that is not hybrid; Lévi-Strauss specifies *bricolage* as the vital process through which cultures extend themselves, and Hall deployed the concept a while ago, with white youth cultures mainly in view.[28]

With these provisos, it still makes intuitive sense to regard diasporic Black cultures as distinctively hybrid. Paul Gilroy in his book *The Black Atlantic* offers the image of a ship, situated in mid-Atlantic – in continuous negotiation between Africa, the Americas and Western Europe. "Because of the experience of diaspora," says Gates, "the fragments that contain the traces of a coherent system of order must be reassembled."[29] He discusses myths of the trickster, myths which embody a self-reflexive attitude to Black traditions, prizing agility and cunning at adaptation and insinuation in African-American culture, rather than an authentic African heritage.

The argument for hybridity has not gone unchallenged. Molefi Kete Asante in his book *Afrocentricity* acknowledges that African genes have been mixed with others, but

> it is also a fact that the core of our collective being is African, that is, our awareness of separateness from the Anglo-American experience is a function of our historical memory, the memory we have frequently denied or distorted. Such experiences are rooted in our ancestral home and defined by social and legal sanctions of four hundred years in America. Regardless to our various complexions and degrees of consciousness we are by virtue of commitments, history, and convictions an African people.[30]

Of course, anti-essentialist Black commentators do not mean to abandon "commitments, history, and convictions." "The past continues to speak to us. But it no longer addresses us as a simple, factual 'past' ," Hall declares.[31] bell hooks writes: "There is a radical difference between a repudiation of the idea that there is a black 'essence' and recognition of the way black identity has been specifically constituted in the experience of exile and struggle."[32]

In practice, it is not easy to keep tradition and hybridity together in the same frame. Gates, for instance, sounds *just a bit* essentialist when he argues that a distinctively Black pattern can be uncovered in the hybrid history that we know: "The Black tradition has inscribed within it the very principles by which it can be read." To be sure, these principles cannot be securely discerned – "To reassemble fragments, of course, is to engage in an act of speculation, to attempt to weave a fiction of origins and subgeneration." Nonetheless, Gates believes he can "render the implicit as explicit" and "imagine the whole from the part."[33] He needs to do this partly because the idea of hybridity implies *at least some* identifiable element of Blackness in the mix, and partly because the thought that African-Americans may have nothing that they can call their own is intolerable.

Recognition that race and ethnicity might be constructed, hybrid and inse-cure, but yet necessary, has obvious resonances for lesbian and gay cultural politics, and may help us to think about ourselves. For gay subculture, certainly, is hybrid; to the point where it is difficult to locate anything that is crucially gay – either at the core of gayness, or having gayness at its core. What about drag, then? Mostly – from pantomime and music hall to working-men's clubs and film and television comedy – it is consumed by straight audiences. Drag plays with gender boundaries, and all sorts of people are interested in that. The disco scene, perhaps? Well yes, except that a standard feature is the latest diva calling down God's punishment on people with AIDS. The ancient Greeks, maybe? Well, the organizing principle of their sexual regime seems to have been that a citizen (male) may fuck any inferior – women, slaves, boys. That is the stuff heroes are made of, but hardly sexual liberation. Camp then? Since Susan

Sontag's defining essay of 1964, it has appeared to be anybody's, and now it is co-opted into "the postmodern." There is art and literature: surely gay men are justly famed for our achievement there? Yes, but we have been allowed to produce quality culture on condition that we are discreet — thereby confirming our unspeakableness. Decoding the work of closeted homosexual artists, I have argued elsewhere, discovers not a ground for congratulation but a record of oppression and humiliation.[34] Opera even — since "The Three Tenors" were offered as a curtain-raiser for the World Cup Final in 1994 — now correlates with football rather than, in Wayne Koestenbaum's title, *The Queen's Throat*.

When Frank Mort writes of "a well-established homosexual diaspora, crossing nation states and linking individuals and social constituencies," we know what he means. However, as Warner remarks, there is no remote place or time, not even in myth and fantasy, from which lesbians and gay men have dispersed.[35] Our hybridity is constituted differently. Indeed, while ethnicity is transmitted usually through family and lineage, most of us are born and/or socialized into (presumptively) heterosexual families. We have to move away from them, at least to some degree; and *into*, if we are lucky, the culture of a minority community. "Home is the place you get to, not the place you came from," it says at the end of Paul Monette's novel, *Half-way Home*.[36] In fact, for lesbians and gay men the diasporic sense of separation and loss, so far from affording a principle of coherence for our subcultures, may actually attach to aspects of the (heterosexual) culture of our childhood, where we are no longer "at home." Instead of dispersing, we assemble.

The hybridity of our subcultures derives not from the loss of even a mythical unity, but from the difficulty we experience in envisioning ourselves beyond the framework of normative heterosexism — the *straightgeist* — as Nicholson Baker calls it, on the model of *zeitgeist* (compare Monique Wittig on "the straight mind").[37] If diasporic Africans are poised between alternative homelands — in mid-Atlantic, Gilroy suggests — then lesbians and gay men are stuck at the moment of emergence. For coming out is not once-and-for-all; like the Africans, we never quite arrive. Now, I am not proposing any equivalence between the oppressions of either race or sexuality — anyway, there is not one oppression of either race or sexuality, there are many. But, while in some instances race and ethnicity are not manifest, for lesbians and gay men passing is almost unavoidable.[38] It rehearses continually our moment of enforced but imperfect separation from the *straightgeist*. You can try to be up-front all the time — wearing a queer badge or T-shirt, perhaps — but you still get the telephone salesperson who wants to speak to the man of the house or to his lady wife. Or the doorstep Christian who catches you in only your bathtowel, bereft of signifiers. The phrase "coming out," even, is not special to us. It is a hybrid appropriation, alluding parodically to what debutantes do; the joke is that they emerge, through balls, garden parties, and the court pages of *The Times*, into centrality, whereas we come out into the marginal spaces of discos, cruising grounds and Lesbian and Gay Studies.

This implication in the heterosexism that others use has advantages. It allows us to know what people say when they think we aren't around. And at least we can't be told to go back to where we came from, as happens to racial minorities in Britain. Conversely though, it makes us the perfect subversive implants, the quintessential enemy within. We instance what Jonathan Dollimore calls a "perverse dynamic": we emanate from within the dominant, exciting a particular insecurity – "that fearful interconnectedness whereby the antithetical inheres within, and is partly produced by, what it opposes."[39] The lesbian or gay person is poised at the brink of a perpetual emergence, troubling the *straightgeist* with a separation that cannot be completed, a distinction that cannot be confirmed. It makes it hard for us to know, even to recognize, ourselves. It is a kind of reverse diaspora that makes our subcultures hybrid.

Hybridity and dissidence

I was set on to this phase of work by a passage in Philip Roth's novel *Operation Shylock* (1993), where it is remarked how Irving Berlin, a Jew, wrote "Easter Parade" and "White Christmas":

> The two holidays that celebrate the divinity of Christ – the divinity that's the very heart of the Jewish rejection of Christianity . . . Easter he turns into a fashion show and Christmas into a holiday about snow. Gone is the gore and the murder of Christ – down with the crucifix and up with the bonnet! *He turns their religion into schlock.* But nicely! Nicely! So nicely the goyim don't even know what hit 'em.[40]

Hybrid, diasporic Jewish culture is preferred to the arrogance that typifies the ethnically-authorized state of Israel. Jews belong in central Europe, it is suggested, and the brief dominance of the Nazis should not be allowed to wipe out centuries of Jewish-European, hybrid civilization: "The time has come to return to the Europe that was for centuries, and remains to this day, the most authentic Jewish homeland there has ever been, the birthplace of rabbinic Judaism, Hasidic Judaism, Jewish secularism, socialism – on and on" (pp. 31–2). The boldness of this conception challenges other subcultural formations to review their own traditions and their relations with other cultures. However, hybridity is, so to speak, a mixed blessing.

Because the prime strategy of ideology is to naturalize itself, it has been tempting to suppose that virtually any disruption of symbolic categories or levels is dissident. This can lead to the inference that hybridity is, in its general nature and effects, progressive. Thus Homi Bhabha:

> hybridity to me is the "third space" which enables other positions to emerge. This third space displaces the histories that constitute it, and sets up new structures of authority, new political initiatives, which are

inadequately understood through received wisdom. . . . The process of cultural hybridity gives rise to something different, something new and unrecognisable, a new area of meaning and representation.[41]

On this argument, virtually *any* instability is progressive; the problem, Bhabha suggests, lies with left politics "not being able to cope with certain forms of uncertainty and fixity in the construction of political identity and its pro-grammatic, policy implications." We should be welcoming opportunities for "negotiation" – to "translate your principles, rethink them, extend them." In fact, since Bhabha has just said that "all forms of culture are continually in a process of hybridity," it would seem that everything that happens is potentially progressive, and only the dreary old (new) left is holding us all back.[42] Well, we have to work, of course, with the situations that global capitalism and its local conditions visit upon us, but this sounds indiscriminately stoic.

Bhabha's case for hybridity is related to his argument that the "mimicry" of the colonial subject hovers, indeterminately, between respect and mockery; that it menaces, through "its *double* vision which in disclosing the ambivalence of colonial discourse, also disrupts its authority." Judith Butler makes a com-patible case for cross-dressing, suggesting that it "implicitly reveals the imitative structure of gender itself – as well as its contingency."[43] Bhabha and Butler are proposing that the subtle imperfection in subaltern imitation of colonial dis-course, or in the drag artist's mimicking of gender norms, plays back the dom-inant manner in a way that discloses the precariousness of its authority.

Now, symbolic disjunction may indeed disturb settled categories and demand new alignments. However, I fear that imperialists cope all too conveniently with the subaltern mimic – simply, he or she cannot be the genuine article because of an intrinsic inferiority; and gay pastiche and its excesses may easily be pigeon-holed as illustrating all too well that lesbians and gay men can only play at true manliness and womanliness. To say this is not to deny resistance; only to doubt how far it may be advanced by cultural hybridity. The Stonewall queens insti-gated Gay Liberation not because they were camp or wore drag – there was nothing new about that; but because they fought the police.

We have supposed too readily that to demonstrate indeterminacy in a dom-inant construct is to demonstrate its weakness and its vulnerability to subver-sion. That is optimistic. To be sure, the ideologies of the British and US states exhort us to credit the stabilizing virtues of our political institutions and cul-tural heritage. But in actuality, as Marx tells us, capitalism thrives on instability:

> Constant revolutionizing of production, uninterrupted disturbance of all social conditions, everlasting uncertainty and agitation distinguish the bourgeois epoch from all earlier ones. All fixed, fast-frozen rela-tions, with their train of ancient and venerable prejudices and opin-ions, are swept away, all new-formed ones become antiquated before they can ossify.[44]

Capital ruthlessly transforms the conditions of life: industries are introduced and abandoned; people are trained for skills that become useless, employed and made redundant, shifted from town to town, from country to country.

It is easier than we once imagined to dislocate language and ideology; and harder to get such dislocations to make a practical difference. Hybridity has to be addressed not in the abstract, but as social practice. Kobena Mercer posits a dialectic between dissidence and incorporation. He takes a difficult instance – the straightened hairstyle favoured by African-Americans in the 1940s:

> On the one hand, the conk was conceived in a subaltern culture, dominated and hedged in by a capitalist master culture, yet operating in an "underground" manner to subvert given elements by creolizing stylization. Style encoded political "messages" to those in the know which were otherwise unintelligible to white society by virtue of their ambiguous accentuation and intonation. But, on the other hand, that dominant commodity culture appropriated bits and pieces from the otherness of ethnic differentiation in order to reproduce the "new" and so, in turn, to strengthen its dominance and revalorize its own symbolic capital.[45]

Hybridity, this instance says, is both an imposition and an opportunity. Which of these will win out depends on the forces, in that context, against us, and on our resourcefulness. "Once 'camp' is commodified by the culture industry, how do we continue to camp it up?" Danae Clark asks. "The only assurance we have in the shadow of colonization is that lesbians *as lesbians* have developed strategies of selection, (re)appropriation, resistance, and subversion."[46]

Going West

An instance. The record "Go West" was made by the Village People in 1979. David Drake, in his play *The Night Larry Kramer Kissed Me* (1992), recalls the Village People, as apprehended by the 8-year-old David when he bought Mommy their record "YMCA" for Christmas. "They're fairies!" his sister exclaims.

> But they don't look like fairies on the record cover. They look really tough – really cool. There's a Cowboy and an Indian and a Policeman and an Army Guy and a Motorcycle Guy – and he looks really tough. . . . So, why are they called Village People? Do they all like live in the same small town or something? . . . Boy, if I was big and tough like the Village People, Cliffy sure wouldn't mess with me. He'd be the one getting chased through the woods.[47]

In "Go West" the excessively butch manner of the Village People – a comic version of the macho style that was being cultivated by gay men in 1979 –

alludes also to the nineteenth-century US drive to dominate the subcontinent. "Go west, this is our destiny," the song runs, using typical imperial motifs; "Together, we'll find a place/To settle where there's so much space." The joke depends upon the hybridity of gay culture: the trappings of "manly" pioneering had become part of the fantasy paraphernalia of the gay leatherman.

The Village People were pastiche: they depended on the thought that even manly gay men are not all that manly. In the tradition of camp self-mockery (at least we know we are silly), they exhibited that thought to the mainstream record-buying public. Yet, at the same time, it was "coming true," for gay men were redefining the idea of "going west" – they were making a subcultural colony in the Castro district. "I couldn't live on one of those gold-and-white prairies alone," the narrator declares in Andrew Holleran's *Nights in Aruba* (1983) – "The West in the end meant only one thing: San Francisco. Everyone in the little band went to San Francisco."[48] "Now if we make a stand,/We'll find our promised land" ("Go West"). It did look rather like a ghetto – a sign of ethnic oppression – and legitimate civic representation proved difficult and dangerous to attain. But in comparison with living in the *straightgeist* it seemed like a diasporic return. "There where the air is free,/We'll be what we want to be." "Go West" celebrated an attainment on the ethnicity-and-rights model, even while recognizing, through camp self-mockery, that gay men could not achieve more than a hybrid, self-cancelling, pastiche relation to the pioneer values that are supposed to constitute "America."

The Pet Shop Boys' remake of "Go West," produced in the entirely different circumstances of 1993, is fraught with nostalgia. There is a manly, *Oklahoma*, male chorus, but it is exaggerated only in the way that such choruses generally are, and it alternates with Neil Tennant's plangent tones. Suddenly, if you listen, the words all mean differently. "Go west, sun in winter time/Go west, we will feel just fine." We went west, but it went terribly wrong. Our friends fell ill and died, and an entirely new phase of stigmatization was legitimated. "Together, we will fly so high,/Together, tell all our friends goodbye." In the two voices – the manly choir and Tennant – the aspirations of the 1970s confront the distress of the AIDS emergency. This is not my reading alone; it's what Neil Tennant said in an interview with Andi Peters on BBC2 on 1 October 1993.

Even so, HIV and AIDS in gay districts of San Francisco and other cities have called forth resources beyond what we had believed ourselves capable of. "Together, we will work and strive." The choir builds in purposefulness, claiming eventually the heroic dimension that in 1979 had seemed mere pastiche. "Together, your hand in my hand."

In the Pet Shop Boys' version, the camp disjunction, between manly, "American" values and gay style, is redistributed within the subculture; the hybridity is *within* gay experience and speaks to a gay agenda. This is how subculture should work. There is an element of gay affirmation, but "Go West" – through the typically subcultural process of reinvesting an earlier textual

moment – may evoke for gay men a difficult part of our experience, inviting us to work through it again, reassessing complicated and emotive histories, decisions and affiliations. To be sure, little of that is heard by mainstream record-buyers, probably, but why should that matter? They may listen if they wish, but they have plenty of records of their own.

As with another Pet Shop Boys' song, "Being Boring," I recall precisely when and where I first heard the remake of "Go West." So you can imagine how angry and betrayed I felt when I saw the video. This is set outside the Kremlin, with a lot of men marching around in vaguely kinky "uniforms," encouraging some listeners to hear in the music an allusion to the Russian national anthem. Peters, in the television interview, observed that the video "changes the meaning." Tennant's response – that Russia is trying to move in a Western, capitalist direction – did not address the implicit question. What I had appreciated as a specifically gay treatment had been abruptly hybridized. Even at the moment when it promises to come out from the protection of the pastiche, gay work is vulnerable to appropriative pressures. Our culture is indeed hybrid, but it is not a source of strength.

Am I being sentimental? Of course the Pet Shop Boys want their record to chart; the effect I have been admiring is expensive to produce, and there is not a gay cultural apparatus capable of circulating it. But then, the Pet Shop Boys have not wanted, as Tennant has put it, to be seen as "kind of joining a club, the president of which was Jimmy Somerville"; the reason he did not discuss homosexuality publicly before 1994, Tennant says, "was that it seemed more interesting not to."[49] Whatever his purposes, we may remark that marginal cultural producers are liable to be seduced by the legitimation of mainstream approbation – a doomed project, since you can't correct the stigma of being gay by being successful as a musician, politician, academic, or whatever *in straight terms*.

Of course, everyone must make their own decisions about where they want to get to and how they are going to do it; the outcome of those decisions is the balance, in the world, between dissidence and incorporation. If the latter tends to prevail, it is facilitated by the hybridity which troubles explicitly gay work in mainstream media. Fortunately, subcultural viability does not depend on the authentic intention of producers: from Plato, through Shakespeare, Wilde, Proust, Tennessee Williams and Freddie Mercury, we are accomplished at (re)appropriating compromised material.

Subcultural work and the post-gay

The argument thus far: lesbians and gay men have understood themselves on the model of ethnicity, but this provides only a doubtful political opportunity and, anyway, ethnic identities are hybrid. This has been regarded as an advantage, but the example of "Go West" suggests otherwise.

Hybridity may or may not disconcert the system. My case is that being

always-already tangled up with it makes it hard for lesbians and gay men to clear a space where we may talk among ourselves. We used to say that we were silenced, invisible, secret, Now, though our subcultures are still censored, there is intense mainstream investment in everything that we do, or are imagined as doing. We are spoken of, written of, and filmed everywhere, but rarely in terms that we can entirely welcome. In the face of such pressures and opportunities, my case is that we need various but purposeful subcultural work – with a view neither to disturbing nor pleasing the *straightgeist*, but to meeting our own, diverse needs.

The dominant ideology constitutes subjectivities that will find "natural" its view of the world: hence its dominance (that is an Althusserian axiom). Within that framework, lesbians and gay men are, ineluctably, marginal. "They had the power to make us see and experience *ourselves* as 'Other'," Hall remarks of colonial regimes.[50] Subcultures constitute *partially alternative subjectivities*. In that bit of the world where the subculture runs, you may feel, as we used to say, that Black is beautiful, gay is good. It is through such sharing – through interaction with others who are engaged with compatible preoccupations – that one may cultivate a workable alternative subject position. In Ken Plummer's formulation, "As gay persons create a gay culture cluttered with stories of gay life, gay history and gay politics, so that very culture helps to define a reality that makes gay personhood tighter and ever more plausible. And this in turn strengthens the culture and the politics."[51]

The nearest equivalent to a queer diasporic experience, Simon Watney remarks, is "the sense of relief and safety which a gay man or lesbian finds in a gay bar or a dyke bar in a strange city in a foreign country."[52] Considered as a model for the good society, a gay bar lacks quite a lot, but for a gay man it is a place where he is in the majority, where some of his values and assumptions run. Of course, it is an artificial security, as he knows all too well from the risk of street aggression as he enters and leaves. But, by so much, it is a place of reassurance and sharing – and this holds also for all the trivia of our subcultures.

Subculture is not just good for morale, though; it does not, particularly, require positive images; and it doesn't occur only, or specially, in bars and the like. Lesbian and gay subcultures are the aggregate of what lesbians and gay men do, and that includes music, fiction, poetry, plays, film and video, cultural commentary. They are where we may address, in terms that make sense to us, the problems that confront us. We may work on our confusions, conflicts and griefs – matters of class, racial and inter-generational exploitation; of misogyny, bisexuality and sado-masochism; of HIV and AIDS.

For it is dangerous to leave the handling of these matters within the control of people who, we know, do not like us. Wojnarowicz and Kramer wanted to catch the attention of the president and the mayor, but it is gay subculture that has taught us about safer sex. Wojnarowicz and Kramer, through their work, have been vastly more use to us than the city or the state. At a poignant

moment in Oscar Moore's novel, *A Matter of Life and Sex*, the protagonist proclaims his "contempt for having to die of a gay disease when he had stood so firmly outside the gay scene, standing on the touchline with his back turned" (he prefers to imagine that being a call-boy is not a part of "the gay scene").[53] He has it precisely the wrong way around; as Jeffrey Weeks puts it, "it was the existence of strong lesbian and gay communities and identities which provided the essential context for combating the virus: in providing social networks for support and campaigning, in developing a grammar for safer sex, in promoting a language of resistance and survival." Watney links the fact that the French have the worst HIV epidemic in Western Europe with the fact that they have no gay press.[54]

Richard Rorty has tried to distinguish a wrong and a right kind of multiculturalism. It is admirable that Black children should learn about Frederick Douglass, Harriet Tubman and W. E. B. Du Bois, he says, but this may lead to "the dubious recommendation that a black child should be brought up in a special culture, one peculiar to blacks." Rorty doesn't want Black children to feel that "their culture is not that of their white schoolmates: that they have no share in the mythic America imagined by the Founders and by Emerson and Whitman, the America partially realized by Lincoln and by King."[55] Like Wojnarowicz, he is waiting "for the possibilities to reveal themselves in this shit country." The consequence of thus crediting the prevailing ideology is that Rorty makes subculture sound like an optional extra. Rather, it is an indispensable resource, for the alternative is the continuing dominance of *straightgeist* accounts of ourselves. In Roth's *Operation Shylock*, despite the sharp look at the state of Israel and the arguments about hybridity, the (somewhat unexpected) conclusion, as I read it, is that Jewish people cannot risk abandoning the last-ditch refuge which Israel represents.

Am I proposing a "gay ghetto," then, in which we must all think the same? There is no question, in practice, of this. First, working through our differences will produce an enhanced awareness of diversity. For instance, native American gays may be drawing their own thoughts from "Go West." A common feature in attacks on gay subculture is a dual denunciation: (1) it makes everyone the same, (2) gays have nothing in common but their sexuality. In between these propositions, any possibility for a political movement seems doubly disqualified: we are, at once, too limited and too various to make any legitimate common purpose. In fact, I would go further: gay sexuality is not such a great cohesive force either; it too is diverse; there are different kinds of gayness. Our apparent unity is founded in the shared condition of being *not-heterosexual* – compare "people of color," whose collocation derives from being not-white. Gayatri Spivak advises a "strategic essentialism," and Weeks writes of identities as "necessary fictions," but lesbians and gay men find even an artificial coherence hard to sustain.[56] However, that should not inhibit subcultural work. Notheterosexual, like not-white, is a real-world political category, and its indeterminacy makes subcultural work the more productive and necessary.

Second, there is no new, allegedly-empty world in which to "settle where there's so much space." A gay congressman is still a congressman, a lesbian business still a business; a queer professor is still a professor. Subculture in the West today is not a matter of side-stepping hybridity, but of maintaining any space at all that is not entirely incorporated, in which we may pursue our own conversations. Indeed, it is subordinated groups that have to be bilingual and mainstream groups that need not bother. "Marginal people know how they live and they know how the dominant culture lives. Dominant culture people only know how they live," Sarah Schulman remarks.[57] Gays need to be able to read the language of straights so we can take evasive action when they get vicious.

The problem, rather, is this: I have been writing "we." Insofar as "we" address "our" problems today and work through "our" history and "our" culture, in the face of inevitable hybridizing pressures, "we" suppose a minority awareness. Despite all the arguments I assembled initially about the damaging consequences of the ethnicity-and-rights model, a project of subcultural work leads us back towards a version of that model. For, as bell hooks writes, it is with reason that subordinated peoples hold on to ideas of genetic innateness, cultural purity, and other essentialist notions: "The unwillingness to critique essentialism on the part of many African-Americans is rooted in the fear that it will cause folks to lose sight of the specific history and experience of African-Americans and the unique sensibilities and culture that arise from that experience."[58] It is to protect my argument from the disadvantages of the ethnicity model that I have been insisting on "subculture," as opposed to "identity" or "community": I envisage it as retaining a strong sense of diversity, of provisionality, of constructedness.

For it should not be supposed that our post-Stonewall lesbian and gay identities, and their heterosexual corollaries, are the last word. In the 1970s and 1980s, to declare yourself "gay" was such a strenuous project that to blur the effect by adding that sometimes you were straight after all seemed too difficult, too confusing, and scarcely plausible. Now, though, there are more than a few signs that some young people are not daunted by that kind of pressure; for them (because of the gains of the Stonewall generation), same-sex experience is not such a big deal. And some gay activists, who can hardly be accused of running scared, have been venturing beyond gay identities. To be sure, proclaiming that whatever most of us thought we were doing is passé because it's "post-" is an easy way for the trend-setter to make a mark. However, we may be entering the period of *the post-gay* – a period when it will not be so necessary to define your sexuality. That's fine by me, but it won't suit a lot of people that I know. How far it is going to get most of us, and how fast, is by no means easy to anticipate (compare 1960s "melting pot" predictions on race?).

If we cannot afford to abandon minority awareness, then, our subcultural task will have to include a reappraisal of its nature and scope. We have to

develop a theory and a politics that will help us to tolerate permeable boundaries. We need to draw upon the experience of elderly gays. We have to maximize opportunities for lesbian and gay alliances, and to explore sexualities that the gay movement has treated as marginal – bisexuality, transvestism, transsexuality. We need to speak with gay people who proclaim themselves to be "straight-acting" and who demand and promise discretion in contact ads. We must be ready to learn from the different kinds of "gayness" that are occurring in other parts of the world, and among ethnic and racial minorities in Western societies. For it would be arrogant to suppose that the ways we have "developed" in parts of North America and Northern Europe of being lesbian and gay constitute the necessary, proper, or ultimate potential for our sexualities.

One inference from anti-essentialist theory should be that we cannot simply throw off our current constructions. We are consequences of our histories – those that have been forced upon us and those that we have made ourselves – and we have to start from there. The notion of gay ethnicity is intuitively powerful and therefore we have to remain in negotiation with it. At the same time, it is because we believe that culture constructs the scope for our identities that we may believe those identities to be contingent and provisional, and therefore may strive to revise our own self-understanding and representation. Subcultural work is our opportunity to support each other in our present conditions, and to work towards transforming those conditions. "Together, we will learn and teach" – "Go West."

Notes

1 Peter Burton, *Gay Times*, 199 (April 1995), p. 24; Dennis Altman, *The Homosexualization of America* (Boston: Beacon Press, 1982), p. 29.
2 Eve Kosofsky Sedgwick, *Epistemology of the Closet* (Hemel Hempstead: Harvester, 1991), p. 85, and pp. 84–90.
3 Steven Epstein, "Gay politics, ethnic identity," in Edward Stein (ed.), *Forms of Desire* (New York: Routledge, 1992), p. 255; Michael Warner, "Introduction," in Warner (ed.), *Fear of a Queer Planet* (Minneapolis: Minnesota University Press, 1993), p. xvii. See also Martin Duberman, *About Time*, revised edition (New York: Meridian, 1991), pp. 404–5, 458–9.
4 See Simon LeVay, *The Sexual Brain* (Cambridge, Mass.: MIT Press, 1993); Alan Sinfield, *The Wilde Century* (London: Cassell, and New York: Columbia, 1994), pp. 177–84.
5 Edmund White, "Gender uncertainties," *The New Yorker*, 17 July 1995, 79–81, reviewing Marjorie Garber, *Vice Versa: Bisexuality and the Eroticism of Everyday Life* (New York: Simon & Schuster, 1995).
6 Didi Herman, "The politics of law reform: lesbian and gay rights struggles into the 1990s," in Joseph Bristow and Angelia R. Wilson (eds), *Activating Theory* (London: Lawrence & Wishart, 1993), pp. 251–2.
7 Cindy Patton, "Tremble, hetero swine," in Warner (ed.), *Fear of a Queer Planet*, pp. 173–4.
8 Herman, "The politics of law reform," in Bristow and Wilson (eds), *Activating Theory*, p. 251.
9 John D'Emilio, *Making Trouble* (New York: Routledge, 1992), p. 12.

10 Warner, "Introduction," in Warner (ed.), *Fear of a Queer Planet*, p. xxvi.

11 Henry Abelove, "From Thoreau to queer politics," *Yale Journal of Criticism*, 6, no. 2 (Fall, 1993), 17–28, pp. 25–6.

12 See Hans Mayer, *Outsiders*, trans. Denis M. Sweet (Cambridge, Mass.: MIT Press, 1982), p. 18.

13 T.H. Marshall, *Citizenship and Social Class* (Cambridge University Press, 1950), p. 47. See Alan Sinfield, *Literature, Politics and Culture in Postwar Britain* (Oxford: Blackwell, 1989), pp. 13–21.

14 See Alan Sinfield, "Closet dramas: homosexual representation and class in postwar British theater," *Genders*, 9 (1990), 112–31.

15 Manuel Castells, *The City and the Grassroots* (London: Arnold, 1983), p. 163.

16 Steven Epstein, "Gay politics, ethnic identity," in Stein (ed.), *Forms of Desire*, pp. 279, 282. See Herman, "The politics of law reform," in Bristow and Wilson (eds), *Activating Theory*, p. 251; Jo Eadie, "Activating bisexuality: towards a bi/sexual politics," in Bristow and Wilson (eds), *Activating Theory*, pp. 164–5.

17 Castells, *The City and the Grassroots*, pp. 162, 138–9.

18 Douglas Crimp with Adam Rolston (eds), *Aids DemoGraphics* (Seattle: Bay Press, 1990), p. 138; Rachel Thomson, "Unholy alliances: the recent politics of sex education," in Bristow and Wilson (eds), *Activating Theory*, p. 228.

19 Castells, *The City and the Grassroots*, p. 171.

20 David Wojnarowicz, *Close to the Knives* (London: Serpent's Tail, 1992), p. 81. See Dennis Altman, *AIDS and the New Puritanism* (London: Pluto, 1986), ch. 8: "A very American epidemic?"

21 "Happy as Larry," Lisa Power interviewing Larry Kramer, *Gay Times*, 203 (August 1995), p. 49.

22 Bruce Bawer, *A Place at the Table* (New York: Simon & Schuster, 1993), p. 139.

23 Shane Phelan, *Getting Specific* (Minneapolis: Minnesota University Press, 1994), p. 60.

24 Stuart Hall, "New ethnicities," in James Donald and Ali Rattansi (eds), *"Race," Culture and Difference* (London: Sage, 1992), p. 254.

25 Henry Louis Gates, Jr, *The Signifying Monkey* (New York: Oxford University Press, 1988), p. 237.

26 Stuart Hall, "Cultural identity and diaspora," in Jonathan Rutherford (ed.), *Identity: Community, Culture, Difference* (London: Lawrence & Wishart, 1990), p. 235; Hall, "New ethnicities", in Donald and Rattansi (eds), *"Race," Culture and Difference*, p. 258.

27 G.N. Devy, *After Amnesia* (London: Sangam Books, 1992), p. 56.

28 Stuart Hall, "Deviance, politics, and the media," in Paul Rock and Mary McIntosh (eds), *Deviance and Social Control* (London: Tavistock, 1974), p. 293.

29 Paul Gilroy, *The Black Atlantic* (London: Verso, 1993), p. 4; Gates, *The Signifying Monkey*, p. xxiv.

30 Molefi Kete Asante, *Afrocentricity* (New Jersey: Africa World Press, 1988), p. 27.

31 Hall, "Cultural identity and diaspora," in Rutherford (ed.), *Identity: Community, Culture, Difference*, p. 226.

32 bell hooks, *Yearning* (London: Turnaround, 1991), p. 29.

33 Gates, *The Signifying Monkey*, pp. xxiii–xxiv.

34 See Alan Sinfield, *Faultlines* (Oxford University Press, 1992), pp. 294–9.

35 Frank Mort, "Essentialism revisited? Identity politics and late twentieth-century discourses of homosexuality," in Jeffrey Weeks (ed.), *The Lesser Evil and the Greater Good* (London: Rivers Oram, 1994), p. 202; Warner, "Introduction," in Warner (ed.), *Fear of a Queer Planet*, p. xvii.

36 Paul Monette, *Half-way Home* (New York: Crown, 1991), p. 262. See also Gregory Woods, *This Is No Book* (Nottingham: Mushroom Publications, 1994), p. 79.

37 Nicholson Baker, "Lost youth," *London Review of Books*, 9 June 1994, p. 6; see Monique Witig, "The straight mind," in Wittig, *The Straight Mind and other essays* (Hemel Hempstead: Harvester, 1992), p. 28.

38 Cf. Sagri Dhairyam, "Racing the lesbian, dodging white critics," in Laura Doan (ed.), *The Lesbian Postmodern* (New York: Columbia University, 1994), p. 31; Avtar Brah, "Difference, diversity and differentiation," in Donald and Rattansi (eds), *"Race," Culture and Difference*, pp. 128–9; Sedgwick, *Epistemology of the Closet*, pp. 76–82.

39 Jonathan Dollimore, *Sexual Dissidence* (Oxford: Clarendon, 1991), p. 33.

40 Philip Roth, *Operation Shylock* (New York: Simon & Schuster, 1993), p. 157. See Alan Sinfield, *Cultural Politics – Queer Reading* (Philadelphia: University of Pennsylvania and London: Routledge, 1994).

41 Homi Bhabha, "The third space," in Jonathan Rutherford (ed.), *Identity: Community, Culture, Difference*, p. 211.

42 Bhabha, "The third space," pp. 216, 211. Cf. Ania Loomba, "Overworlding the 'Third World'," *Oxford Literary Review*, 13 (1991), 164–91; Benita Parry, "Signs of our times: a discussion of Homi Bhabha's *The Location of Culture*," *Third Text* (Winter 1994).

43 Homi K. Bhabha, *The Location of Culture* (London: Routledge, 1994), p. 88, and see pp. 111–21; Judith Butler, *Gender Trouble* (London: Routledge, 1990), p. 137.

44 Karl Marx, *Manifesto of the Communist Party*, in Marx, *The Revolutions of 1848*, ed. David Fernbach (Harmondsworth: Penguin, 1973), p. 70.

45 Kobena Mercer, "Black hair/style politics," *New Formations*, 3 (Winter 1987), 33–54, p. 49.

46 Danae Clark, "Commodity lesbianism," in Henry Abelove *et al.* (eds), *The Lesbian and Gay Studies Reader* (New York: Routledge, 1993), p. 199.

47 David Drake, *The Night Larry Kramer Kissed Me* (New York: Anchor, 1994), pp. 29–30. Altman seems to miss the point when he remarks: "The long-haired androgynous look of the early seventies was now found among straights, and the super-macho image of the Village People disco group seemed to typify the new style perfectly" (Altman, *The Homosexualization of America*, p. 1).

48 Andrew Holleran, *Nights in Aruba* (1983; Harmondsworth: Penguin, 1991), p. 116.

49 Interview in *The Guardian Weekend*, 15 July 1995, p. 17.

50 Hall, "Cultural identity," in Rutherford (ed.), *Identity: Community, Culture, Difference*, p. 225.

51 Ken Plummer, *Telling Sexual Stories* (London: Routledge, 1995), p. 87. See also Pat Califia, *Public Sex* (Pittsburg: Cleis Press, 1994), p. 21.

52 Simon Watney, "AIDS and the politics of queer diaspora," in Monica Dorenkamp and Richard Henke (eds), *Negotiating Lesbian and Gay Subjects* (New York: Routledge, 1995), p. 61.

53 Oscar Moore, *A Matter of Sex and Death* (Harmondsworth: Penguin, 1992), p. 234.

54 Jeffrey Weeks, *Invented Moralities* (Cambridge: Polity, 1995), p. 98; Watney, "AIDS and the politics of queer diaspora," in Dorenkamp and Henke (eds), *Negotiating Lesbian and Gay Subjects*, p. 63.

55 Richard Rorty, "A leg-up for Oliver North," *London Review of Books*, 20 October 1994, pp. 13, 15.

56 Gayatri Chakravorty Spivak, *In Other Worlds* (New York: Methuen, 1987), p. 205; Weeks, *Invented Moralities*, ch. 3. See Gilroy, *The Black Atlantic*, p. 102, and Chris Woods, *State of the Queer Nation* (London: Cassell, 1995).

57 Sarah Schulman in an interview with Andrea Freud Loewenstein (1990), repr. in Betsy Warland (ed.), *Inversions* (London: Open Letters, 1992), p. 219.

58 hooks, *Yearning*, p. 29. See further Alan Sinfield, " 'The moment of submission': Neil Bartlett in conversation," *Modern Drama*, 39, no. 1 (Spring 1996).

7

NOMADIC CULTURAL PRODUCTION IN AFRICAN DIASPORA

Margaret Thompson Drewal

"Tradition" in Yoruba is *asa*. Innovation is implied in the Yoruba idea of tradition. The verb *sa*, from which the noun *asa* is derived means to select, to choose, to discriminate or discern. . . . [The] ability to reconcile opacity and difference and open-ness in an unending movement of metonymic engagements might explain the success and popularity of Yoruba culture in the New World where it has greatly contributed to cement and creolize African and non-African cultures despite a social cli-mate of intolerance and invitation to mimetism. As the Yoruba themselves believe and say emphatically:
[*Oruko to wu ni laa je lehin odi*]
(Outside the walls of your birthplace, you have a right to choose the name that is attractive to you.)

(Olabiyi Yai 1994 : 13–14)

[A]s we think about worlds that might one day become think-able, sayable, legible, the opening up of the foreclosed and the saying of the unspeakable become part of the very "offense" that must be committed in order to expand the domain of linguistic survival. The resigni-fication of speech requires opening new contexts, speaking in ways that have never been legitimated, and hence producing legitimation in new and future forms.

(Judith Butler 1997 : 41)

In this essay, I examine a hybrid, nomadic practice embodied primarily by people of color in the African diaspora. Known in some circles, particularly in New York, as "Yoruba reversionism," this practice is an active resigni-fication in Judith Butler's sense that has created a new context of legitimate speech and action as an insurrection against dominant authority. Diviner and scholar of

115

Yoruba religion, John Mason, recognizes the power of this kind of nomadic participatory practice:

> we often hear the word syncretism used when discussing Black religion. But, I would suggest that with closer scrutiny it will be discovered that Blacks compromised little in the maintenance of their culture. Instead they might be viewed as waging a transcultural war that today, in many places where Blacks find themselves, would be extremely difficult to ascertain who won or is winning.
>
> (Mason 1985b:6)

Mason is suggesting that wherever blacks were taken as slaves, they made an indelible imprint on the dominant culture they were forced to serve.

To win the transcultural war is to transform dominant culture's very identity. In the end, hegemony persists, but as Raymond Williams (1980 : 38, 45) observed, the internal structures of hegemony have to be renewed, recreated, and defended continually, and, just as they can be challenged, they can also be modified. Practitioners of Yoruba religion are participants in dominant culture. Many are college educated with upper-middle-class jobs and lifestyles so – a practitioner told me – a delivery man can walk two goats on leashes into an expensive co-op building on Roosevelt Island and manage to get away with it. Why? Because location in the dominant culture simultaneously empowers the individual to interfere in it. Indeed, Yoruba religion in New York puts into practice all the educational processes for transmitting what Williams calls *selective tradition* (1980 : 39), that is, social training within the immediate and non-traditional extended family, the practical definitions and organization of work within the practice, and reinforcement at an intellectual and theoretical level. These practical reinforcements produce the practice as a discursive formation. From a Yoruba perspective, as well as from that of contemporary social theory, action is linked to power (Giddens 1982 : 38–9, 1986 : 14–16). In Yoruba, this idea inheres in the term *aṣẹ*, a generative force, that practitioners understand as "the power to bring things into existence," or "the power to make things happen." That is in essence what performing is all about. The concept has endured west of the Atlantic. It is the *axe* of Brazilian Candomblé, the *aché* of Cuban Santería, and the *aṣẹ* of New York's Yoruba reversionist movement.

If, as Pierre Bourdieu suggests, *habitus* is "embodied history, internalized as a second nature and so forgotten as history" (Bourdieu 1990 : 56), then what cultural nomads perform is *active re-membering*, that is, a conscious material reassembling of a remembered past. In the case I examine here, practitioners recuperate an other's embodied past (drawn from Yoruba traditions of south-western Nigeria) and radically internalize it as an alternative ontology and epistemology, deploying it in the practice of everyday life. But rather than being structurally grounded as in Bourdieu's formulation of *habitus*, Yoruba religious practices are heterogeneous ensembles of acquired, embodied knowl-

edges that, when performed in combination, reconstitute and transform them-
selves and social situations. In a critique of Bourdieu, Judith Butler argues:

> To the extent that Bourdieu acknowledges that this *habitus* is formed
> over time, and that its formation gives rise to a strengthened belief in
> the "reality" of the social field in which it operates, he understands
> social conventions as animating the bodies which, in turn, reproduce
> and ritualize those conventions as practices. In this sense, the *habitus* is
> formed, but it is also *formative*: it is in this sense that the bodily *habitus*
> constitutes a tacit form of performativity, a citational chain lived and
> believed at the level of the body. The *habitus* is not only a site for the
> reproduction of the belief in the reality of a given social field – a
> belief by which that field is sustained – but it also generates *dispositions*
> which "incline" the social subject to act in relative conformity with
> the ostensibly objective demands of the field.
> The body, however, is not simply the sedimentation of speech acts
> by which it has been constituted. If that constitution fails, a resistance
> meets interpellation at the moment it exerts its demand; then some-
> thing exceeds the interpellation, and this excess is lived as the outside
> of intelligibility. This becomes clear in the way the body rhetorically
> exceeds the speech act it also performs. This excess is what Bourdieu's
> account appears to miss or, perhaps, to suppress: the abiding incon-
> gruity of the speaking body, the way in which it exceeds its interpel-
> lation, and remains uncontained by any of its acts of speech.
>
> (Butler 1997 : 155)

Butler regards bodily *habitus* as a "tacit form of performativity" in J. L. Austin's
sense, and she distinguishes speech acts from the body in so far as the latter cannot
be fully controlled by the former. Thus, "speech is bodily, but the body exceeds
the speech it occasions" (155–6). According to Stanley Jeyaraja Tambiah:

> It was quite evident to Austin that, while he focused on the role of
> speech in illocutionary acts, the utterance was not the sole thing nec-
> essary if the illocutionary act was to be deemed to have been per-
> formed, and also that *actions other than speech*, whether physical or
> mental, were entailed for the full realization of the performance.
> Indeed it is even possible at the other extreme to enact a performa-
> tive act without uttering words at all – a hypothetical example would
> be the establishment of blood brotherhood by the physical exchange
> of blood (without the exchange of words).
>
> (Tambiah 1985 : 79–80)

Tambiah thus understands Austin's notion of "saying is doing" to be more
encompassing than Butler. He therefore includes two other features of ritual

performativity: multimedia, which he suggests experientially intensifies the performance, and "*variation* in lexical usages, in the structure of the site of aspersion, and in the *scale* of the ceremonies (their magnificence, their duration, the number of the officiants participating, the pace of the staging, and so on)" (1985 : 128, 156–7). The latter, following Charles Saunders Peirce, constitute the *indexical* features of ritual that mark the system of interpersonal relations among participants. Tambiah's proposition about the performativity of ritual is very useful here, but in the end he settles on a meaning-centered approach, based on a refinement of information theory, rather than an action-centered approach that can take into account human agency. If illocutionary acts always already include bodily action, as Tambiah reads Austin, then privileging speech over the body, the sedimentor over the sedimented, is simply another problematic binary in which one term is hierarchically dominant. Butler's way out of this bind is to assert that "the body rhetorically exceeds the speech act it also performs" (155). But it is unclear to me precisely how this works operating theoretically within the conceptual confines of "performativity."

At this point I would like to reclaim performance as a powerful concept and invert one of Butler's earlier assertions (1993 : 234) to claim: one would err to reduce performance to performativity. Butler's mistake belies an anti-theatrical prejudice that relegates performance to a "bounded act" (1993 : 234). In so far as "performance" is a bounded event in Butler's estimation, it conceals its history and the processes of normalization that reiteration produces in the very formulation of practices. Butler's stated and unstated assumptions about performance warrant her posing performativity as the more encompassing explanatory model. The only insurrection against dominant social conventions in that case is one of misappropriation or expropriation of society's performatives. Thus Butler states:

> In such bodily productions resides the sedimented history of the performative, the ways in which sedimented usage comes to compose, without determining, the cultural sense of the body, and how the body comes to disorient that cultural sense in the moment of expropriating the discursive means of its own production. The appropriation of such norms to oppose their historically sedimented effect constitutes the insurrectionary moment of that history, the moment that founds a future through a break with the past
>
> (Butler 1997 : 159)

Butler used performativity initially to examine gender and sexuality as social constructions sedimented in the body (*Gender Trouble* and *Bodies That Matter*) and later to address hate speech (*Excitable Speech*). But performativity does not account for the capacity of performers to embody skills and techniques alien to normative social conventions. Nor can it explain bodily excess. Hence, Butler's only recourse is to posit as the primary means for social change social

actors' false or wrong invocations as *reiterations* and their misappropriation and expropriation of performatives (see Butler 1997: 147, 158–9).

But it is precisely the contestatory capacity of performers to embody skills and techniques completely alien to normalized social conventions, an active remembering of that forgotten history, that unmoors performance and performers from constrained contingency and liberates the body for insurrection without recourse to either misappropriation or expropriation. Techniques of the body are not limited to embodied sedimentations of the history of state apparatuses. They may exceed the conventional through repetition with critical difference and/or they may stand apart from official social conventions altogether.

I have defined and theorized performance elsewhere as the practical application of embodied skills and techniques to the task of taking action (Drewal 1991: 1). Implicit in the concept of embodiment is that techniques and styles are forged, refined, and reiterated to constitute performance practices. They are in this way deployed to take action. Acquired, in-body techniques need not enact structures of domination or systems of unreflexive, mechanical reproduction as in the Foucaultian sense of the subjugated body (Foucault 1979). Rather techniques of the body may also operate as resources for negotiation that knowledgeable agents deploy critically in performance either for complicity or resistance. While I agree that actions are never fully volitional or conscious (Shoshana Felman, cited by Butler 1997: 10), at the same time, once performance becomes a conscious and self-reflexive act it carries agency. That is why practitioners of Yoruba religion say quite explicitly that practice is not contingent on belief. The "doing" itself is transformational. Practitioners of Yoruba religion specifically view their practice as resistant to dominant ideology and as an alternative life style for self-determination. Performance participants can self-reflexively monitor their behavior in the process of the doing (Giddens 1984:5–6). This essay is an attempt to account for the production of discursive agency through ritual conventions forged from heterogenous ensembles of embodied knowledges and ways of operating to improvise on new, foreign, and oppressive conditions.[1] Some of these bodily knowledges include: the practice of herbalism; divination; drumming; ritual language; songs for the òrìṣà; culinary arts; ritual symbols and action; and intimate knowledge of the deities (including their roads, colors, foods, visual symbols, histories, rhythms, songs and dances, and their modes of operation and being in the world).[2] This partial listing only hints at the complexity of bodily knowledges required for the practice. Divination in and of itself is based on a systematic and extremely complex body of knowledge. All of these practices have illocutionary force; they have aṣẹ, the power to bring things into existence. In this essay, I focus only on one dimension of the practice, the performance of ritual parties known as *bembe*.

Yoruba religion in New York City constitutes an invisible, alternative culture that operates within the larger socio-political system. Economically

self-sustaining, it has generated its own complex network of producers and consumers. Practice of the religion requires the services of professional specialists, such as diviners, and a wide variety of ritual paraphernalia – shrine objects and items of dress, herbs, minerals, and animals. A growing number of artisans are responding to these needs by creating hand-made items for shrines and ceremonies, including ritual pots, *soperas* (soup tureens), sculpture, fans, musical instruments, embroidered cloth, beadwork, iron implements, brass castings, pastries, and decorated cakes.

Although my primary resources have been in New York, the practice is dispersed throughout the United States. It continued without break in time from Yorubaland to Cuba to New York.[3] From the early 1960s, it began to expand rapidly with the large influx of Cuban practitioners into New York and Miami and the emergence of the Black Nationalist movement. The first two African-American priests of the religion were initiated in Cuba in 1959. One – Serge King (alias Oba Oseijeman Adefunmi) – established Oyotunji village in South Carolina. The other, Christopher Oliana, remained in New York and trained protégés such as the scholar, practitioner, and educator John Mason, who shared this history with me. Initiated in 1970, Mason, like many practitioners, can trace his lineage back to Yorubaland. Thus his godfather, Oliana, was trained in Matanzas, Cuba, by Tomasita Romeiro (alias Igbinleti – a Yoruba name), who had been trained by a Yoruba diviner named Obadimeji. Obadimeji had been brought to Cuba as a slave in the late nineteenth century and reportedly died at the age of one hundred and twelve. From my own knowledge of Yoruba culture, I can infer that Obadimeji, a praise epithet meaning "King-Becomes-Two," was a priest of the deity Sango or Aganju, his brother, who in Yorubaland bear this very praise name.

While the religion is open to scholarly inquiry at one level – and indeed practitioners like Mason and others research the topic and read the scholarship written by both insiders and outsiders – the religious network manages to make the religion inaccessible as a curiosity by screening outsiders informally and prohibiting all photographs, tape recordings, and filming. Making the religion inaccessible to curiosity-seekers protects its anonymity and decreases the possibilities for appropriation, exploitation, reproduction, and incorporation into the dominant culture either as sameness or as spectacle (see Hebdige 1979 on this process).

Participants in this movement use essentially three kinds of sources in their practice of "Yoruba reversionism." One is Afro-Cuban practice learned both in Cuba and also transmitted by Cuban immigrants. Practitioners also consult Yoruba-speaking people in New York, who are steeped in Yoruba practice. Another major source is the writing of ethnographers who have worked in Yorubaland and Cuba. This body of literature is diverse, uneven in quality, and presents itself as authoritative. It is however expropriated and subjected to practitioners' own processes of evaluation and interpretation.

In this latter category are the books of William Bascom, particularly *Ifa*

Divination: Communication between Gods and Men in West Africa and *Sixteen Cowries: Yoruba Divination from Africa to the New World* (1969, 1980). These works provide an extensive corpus of Yoruba divination verses translated into English. Practitioners interpret the import of these verses (known as Odu) already translated into English and adapt and apply them to the New York context. The verses supplement the Cuban sets of verses they have learned. As John Mason put it, "Odu never changes – only as other elements impact against it." As people venture outside prescribed boundaries, he asserts, the way the light shines on Odu changes its reflection. In other words, meaning changes with changing conditions and contexts. This provides for a wide margin of interpretation and adaptation.

The scholar who has had the greatest impact on the entire Yoruba movement in the United States is Robert Farris Thompson. Adepts of the religion read Thompson's publications and attend his public lectures as well as his classes.[4] In addition, Thompson is sought out as a speaker by African-American groups, such as the Caribbean Cultural Center in mid-town Manhattan, the Studio Museum in Harlem, and the Yoruba Theological Archministry in Brooklyn. Not only do Thompson's words ring true to African-Americans, but his style of presentation adds another greatly admired dimension.

Thompson's verbal facility – his use of black English; his language play, including punning; and his free visual associations – is likened by Mason to the improvisations of a jazz musician. Mason claims he has modeled his style of presentation on Thompson's, particularly the way Thompson structures his lectures, integrates visual material, and makes free associations verbally and visually. Thompson is a verbal artist who gives poetic form to values important to African-Americans. Even more so than his scholarship – cast as a kind of praise poetry (*oriki*) in tribute to black culture – Thompson's appeal is in his oral performance for a people who have traditionally respected the power of words and the ability to perform them (Peek 1981; Davis 1985).

This kind of nomadic poaching on a variety of sources resonates strongly with Yoruba precepts. From a traditional Yoruba perspective, traveling is the *modus operandi* for the pursuit of knowledge about everyday life (see Drewal 1992). As Olabiyi Yai points out, the Yoruba word *ìtàn*, translated as "history," implies the notion of dispersal, and therefore diaspora consciousness. More specifically, he explains,

> etymologically *ìtàn* is a noun derived from the verb *tàn. Tàn* means to spread, reach, open up, illuminate, shine. The verb *tàn* and the derivative noun *ìtàn* are polysemic and integrate at least three fundamental dimensions. First, there is the chronological dimension through which human generations and their beings, deeds, and values are related. Second, there is the territorial or geographical dimension through which history is viewed as expansion (not necessarily with

121

the imperial connotations that have become the stigma of that con-
cept in the English language) of individuals, lineages, and races
beyond their original cradle. In that sense it is important to observe
that the Yoruba have always conceived of their history as diaspora. The
concept and reality of diaspora . . . is rationalized in Yorubaland as the
normal or natural order of things historical. . . . The third dimension
of *ìtàn* . . . is the discursive and reflexive dimension of the concept.
Tàn is therefore to discourse profoundly on the two dimensions
earlier mentioned.

(Yai 1994 : 108)

The *modus operandi* of historiographical discourse and the search for truth and
knowledge by Yoruba peoples is diasporic in its very conceptualization.

Diasporic ritual parties

Large number of practitioners get together to socialize in the contexts of ini-
tiations and improvised ritual parties known as *bembe*. The object of a *bembe* is
to "bring down" the Yoruba deities to celebrate them. This is accomplished
through altered states of consciousness, when deities mount the heads of their
priests, who transform into their deities. And although *bembe* are sacred in this
sense, participants also perceive them as parties – that is, social gatherings in
honor of the deities held for collective enjoyment and productive work with
the deities. Indeed the deities themselves come to party with the other invited
guests and dance. As John Mason put it,

In order to coax the òrìsà from their homes in fire, water, earth and
sky we must engage and entertain them and move them to either
laugh or cry. If necessary we make them mad, we play with them,
insult them, play the dozens as it were, and then apologize when they
arrive fuming. We dance so well and the music is so hot/cool/sweet
that they rush to cut in and strut their stuff. We are actors, people of
action who are not mindless in our renegotiation of history.

(Mason 1992 : 31)

These improvisations are the performer's interpretation and transformation of
embodied skills and techniques. Improvisation is at once an interpretive strat-
egy for negotiating the present as well as the embodiment of tried and true
skills and techniques that have withstood the test of history, albeit a reterrito-
rialized history. Improvisations are thus synthesizing practices of applying
embodied knowledge to new situations.

Bembe ritual parties are integral to the practice of Yoruba religion in its
Cuban and American manifestations.[5] Through dance the effort, qualities and
modes of operation of the deities are sedimented in the bodies of practition-

ers. They are experienced materially by the body dancing and also visually in the dancing bodies of others. Practitioners perform *bembe* on the anniversary of an initiation, or a deity may specially request a *bembe* through divination or from a mounted priest during a prior *bembe*. In the latter case, it is the deity who makes the request. The host invites friends, most of whom are involved directly in the religion. Practitioners value certain guests for their ability to manifest certain aspects of the deities whose attendance they most desire at the ceremony. If the *bembe* is in honor of the deity of thunder, Sango, it is desirable that his brother Aganju and his wives Oya, Oba, and Osun attend. When in a few cases deities do not mount their American priests, it is common for the host priest to hire a trance specialist devoted to his or her own deity for the occasion. It is the job of the specialist to bring down, or manifest, the host's deity.

The American *bembe* I attended were heterogenous. The participants were from mixed cultural backgrounds, a combination of Latinos – Cubans, Puerto Ricans, and others –, people from the Caribbean – especially Jamaicans –, African-Americans, and those who are neither Latino nor Black, including participants of both Christian and Jewish backgrounds. At one *bembe*, Chinese Cubans, considered by Cubans to be particularly powerful in spiritual matters, were also involved.

Reflecting their heterogeneity, many *bembe* were conducted in three languages. Practitioners sang the incantations in Yoruba to invoke the deities and bring them down. Yoruba survived as a ritual, and a vernacular language among West African slaves taken to Cuba during the late nineteenth century. In New York, they continue to use Yoruba as a ritual language. Most participants, however, cannot translate the songs and incantations, although they have a general sense of their meaning and can differentiate between them and associate them with particular deities. This situation is likely to change with the 1992 publication of John Mason's book *Orin Òrìsà: Songs for Selected Heads* that records and translates songs for the deities, many collected in Cuba, transcribed in Yoruba, and translated into English.

The deities themselves, that is, the mounted priests of the deities, spoke either Spanish or English to advise other priests and visitors. The concept of "mounting" is a direct translation from the Yoruba monosyllabic action verb *gun* (to mount). Those who were knowledgeable in Yoruba integrated it into their pronouncements. Attendants stood by to translate the deities' words of advice and perlocutions into English for non-Spanish-speaking American participants. At one *bembe* in Brooklyn on April 27, 1986, the deity of deep water, Yemoja, spoke English through an interpreter who translated it into Spanish for the Cuban singer who had originally invoked Yemoja in Yoruba. Yemoja spoke English with a Nigerian accent, making her otherness felt more strongly. The deities' pronouncements were, strictly speaking, perlocutionary acts. Thus the receiver is supposed to heed the words of the deity and put them into practice in everyday life. Ordinary verbal exchanges among participants were

in English and Spanish as well as admixtures of both, often with Yoruba words and phrases woven in.

The particular mixture of people at any *bembe* can give it a very distinctive flavor or quality. There are *bembe* that are predominantly white, that is, made up of participants who consider themselves neither Black nor Latino. There are also gay *bembe*. Those devotees who consider themselves "straight" often puzzle over why the religion seems to attract homosexuals, both male and female. More often than not, *bembe* integrate homosexuals and heterosexuals in a single ceremony.

The deities themselves are also highly differentiated, reflecting further the heterogeneity of their devotees. A host of personified natural forces called *ocha*, or *òrìṣà* in Yoruba, make up the religious system. Through divination, individuals learn the particular deities "around" their heads. As in Yorubaland, deities differ according to their personalities, their concerns, their modes and qualities of action, their special feast days, their colors, their favorite foods, their praise poetry, and their ritual paraphernalia. In addition, each deity is defined further at more refined levels of distinction by "roads" (*ona* in Yoruba) or aspects that suggest more specific dimensions of their personalities. Only one named aspect, or road, of a deity manifests itself in the body of a medium. The vain female riverain deity Osun, for example, can manifest as Osun Aparo (the antagonistic Osun) or as Osun Pansaga (The Stream is a Prostitute; *pansaga* is the Yoruba word for prostitute) and so on.

Nomadic engenderings

Complicating matters further, certain "roads," or manifestations, of female deities are male, while certain manifestations of male deities are female. Whenever practitioners perform a *bembe* to bring down the host's deity, they expect other deities to visit, depending on the mediums attending the ceremony. Like secular parties, *bembe* are distinctive to a large extent because of the particular mix of their participants and the combinations of deities who mount them on any given occasion. Each *bembe* thus takes on its own unique character.

Practitioners personalize deities and prepare them for specific individuals. Thus there is a strong sense of ownership in the religion. As one priest put it, "my Obatala will not be like anybody else's Obatala." Through divination – a highly interpretive process, as I have suggested – the deity identifies itself and specifies its relationship to the person. This initiates the interpellative process to incorporate the person into the practice. The individual then "makes *ocha*" according to these specifications. Moreover, a person who has "made *ocha*" – "made Aganju," for example – speaks of "my" Aganju and alternatively of the time, "when I was made." Thus, making *ocha* is simultaneously "making" oneself. This expresses the strong link between the initiate and the deity, for, as in Yorubaland, initiation is a re-birth.

During initiation, medicine for empowerment of the deity is literally sedimented in the head of the priest through inoculations and medicinal paint on top of the shaved head of the initiate (known in Yoruba as *sin gbere*, "to incise inoculations").[6] When a new initiate is first possessed by his/her deity, according to John Mason

> special medicine is placed in incisions cut in the tongue, which gives the *òrìsà* the ability to speak. This enables them to give instruction by teaching new songs, prescribing the making of ebo (sacrifice), directing the dance by calling for certain rhythms to be played, answering questions posed by troubled devotees, and dictating the proper course for community activities.
>
> (Mason 1992:27)

This ritual is called *àse l'enu*, "power has a mouth." It empowers the priest to speak the deity.

Priests of the religion celebrate their birthdays on the day they were initiated, rather than on the day their mothers gave birth to them. They receive new names that identify them with their deity. I mentioned Obadimeji earlier. At this level, people are conscious of constructing their realities. It is the personalized deity who mounts. Likewise, the priest personalizes her/his deity in the deity's permanent shrine created in the home and in the more temporary *plaza* constructed especially for *bembe*. When a particular deity becomes manifest in several priests simultaneously, no two manifestations are exactly alike.

Certain deities have special affinities with other deities. Some deities are husband and wife; some are the offspring of others; others are siblings. This model of family ties is enacted among priests who group together in "houses" led by a godmother and a godfather, a structure derived from the Cuban *cabildos*, or self-help organizations that developed in the seventeenth century in response to the condition of slavery. Some deities have special affinities because of their particular associations with water or earth. Sango and Oya often come together because of their association with storms – the thunder and the whirlwind respectively. When two friends become Sango and Oya, they simultaneously become husband and wife. In the *bembe* I attended, the relationships of participants to each other did not usually coincide with those of their deities. As identities were transformed, participants' relationships to each other were also transformed in the process, if only temporarily.

Performances not only involved transformations of participants into deities, but simultaneously involved transformations of the genders of both heterosexuals and homosexuals. Thus male deities possessed women as well as men, just as female deities possessed both men and women. This is also true of Yoruba practice in West Africa and Brazil (Drewal 1986, 1989). The gender of the deity around a priest's head sanctions that priest's behavior. In contrast to

125

female impersonators who play on an opposition of illusion and reality (Newton 1979:100–1), priests literally transform their gender identities when their deities mount them, in what scholars have called possession trance. Thus, instead of fronting for an inner, stigmatized self in Esther Newton's terms, the mounted priest foregrounds that self and gives cosmic significance to the gender transformation, elevating it to divine status. Or from another angle, perhaps the religion attracts gay and lesbian practitioners precisely because the practice itself implicitly understands gender is a social construction. Being mounted by a deity engages homosexuals and heterosexuals alike in the same discourse on gender. Although these transformations of gender *reiterate* dominant binary gender codes as analyzed by Butler (1990, 1993), they do so with difference. The *òrìsà* system, in Butler's terms, expropriates normative gender codes and performs them in non-conventional ways in an unconventional context. These gender transformations are not parodies in the same sense as drag or camp (see Meyer 1994), but rather through dance and music intensify the effort qualities of the deity and her/his modes of taking action. The back-and-forthness of the gender transformations denaturalizes the relation between sex and gender. Thus mounted, priests implicitly contest their historically sedimented gender effects (Butler 1997:159). They perform *Otherwise*.

Both heterosexual female and lesbian priests become "male" in possession trance. Moreover, they carry that gender identity with them in everyday life, not necessarily through cross-dressing (though some lesbian and gay priests cross-dress), but rather in ways of behaving conventionally gendered "male." For example, Sango is considered a hot male deity, a warrior king whose attack is analogous to the strike of lightning and resounding thunder. Sango personalities tend to be impetuous, outgoing, aggressive, forceful, demanding and commanding, and love to party. Drumming and dancing the movements associated with a deity sediment these behaviors in the body, and dancers can then refine them and inflect them meaningfully with more precise bodily stylistics. Priests can often identify the deity around another person's head through reading the kinds of behaviors I've just described. Although Sango is gendered male, both lesbian and heterosexual women and gay and transexual men embody Sango's *modus operandi*. It is at this level that priests transgress gender norms. Their ways of operating cross the gender divide, even as their clothing may reiterate the normative heterosexual standard. Sango is operational in everyday life in the quality of his action, not in the clothes he wears.

In conversation with a priest of Aganju (wilderness), nephew of Sango, associated with the power and force of the volcano and the battering ram, the woman told me it would be senseless for her to go into direct confrontation with another Aganju. The battle would be fierce, but they would eventually lock horns in a stalemate. While this self-perception positioned her in a power relation operationally with other Aganju priests, it also spoke reams about how she operates in confrontation with priests other than Aganjus. Aganju is a very complex deity with a multitude of traits, including architect, ferryman, and

animal tamer (see Mason 1992 : 168–9). I use this example because the Aganju priest herself keyed on that dimension of Aganju's power. Women embody behaviors associated normatively with men and vice versa. In short, identification with a deity (initiated through the sedimentation of the deity in the head of the priest) overrides and confounds normative gender distinctions and appropriate gendered behaviors.

The *ocha* system provides a framework for interpersonal understandings outside ritual contexts. For, just as the deities reflect the personalities of their priests or mediums when they come to party, priests in everyday life reflect their deities.[7] Indeed a deity's personality traits not only sanction her or his priest's ways of operating, but are considered personally effective. In this way, behavior in ritual penetrates and spills over into mundane life, and vice versa. Priests often narrate situations when they discovered for the first time that a co-worker was a priest of a particular deity. Such discoveries inform priests how to deal with each other successfully outside the contexts of ritual – in the workplace, for example. Or, perhaps more accurate, religious practice in these ways permeates all of life.

Nomadic visual and kinetic production

Held primarily in private, middle-class homes at the formal invitation of a host, who is also a priest of a Yoruba deity, *bembe* last from about two o'clock in the afternoon to nine in the evening. Practitioners have organized themselves into houses based on a model of kinship.[8] Developed from the Cuban self-help organizations known as *cabildos*, each house has a god-mother and godfather who have initiated a host of godsons and goddaughters to form an extended family unit. Seniority is based on how long one has been a priest.

Before the guests arrive, the host constructs a temporary shrine or throne for the deity known as a *plaza* (Figures 7.1 and 7.2). Earlier that morning the host makes blood sacrifices to the deities in preparation for a communal feast with the guests. The host and some friends cook the meat of the sacrificial animals according to traditional recipes that are favorites of the deities to be honored. The *plaza* is a specially constructed environment built within a room in the larger environment, yet clearly marked off from it. People stand just on the outside edges of the *plaza*, but are careful not to step into its space. In it is placed the deity's *așé*, enclosed in a container. The *plaza* at once seats and represents the deity.[9] As a collage of natural, handmade, and mass-produced objects – of colors and textures – a *plaza* transforms the entire area around it, introducing the deities directly into the performance space. Simultaneously it attests to the expense and decorative flair of the host. Artists such as Juan Boza (himself a practitioner, now deceased) transported the *plaza* format from shrine to art installation that migrated into museum and art gallery exhibits (Figure 7.3) (see also Lippard 1990:62, Figure 5). In this installation Sango

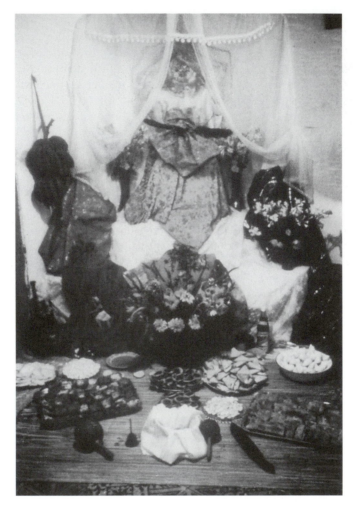

Figure 7.1 Plaza and throne for Osun, deity of rivers, streams and all sweet water. Photograph courtesy of Ivor Lynn Miller.

manifests as Santa Barbara. Such art installations expropriate the form and symbols of the deities, but are not prepared shrines.

A *plaza* for Obatala, for example, considered the eldest among Yoruba deities, the creator of human beings, is predominantly white, the color of the birth caul (Edwards and Mason 1985: 33–6). In one Obatala *plaza*, the host draped the entire corner of the room in white cloth and covered it with a canopy. In the center – the focal point of the shrine – was the seat, or throne, of the deity (*asiento*): a tall, slender pedestal wrapped in white lace that elevated a covered white soup tureen (*sopera*) containing Obatala's *aṣé*, the site of the blood sacrifices. A profusion of white strands of beads, each accented with a

128

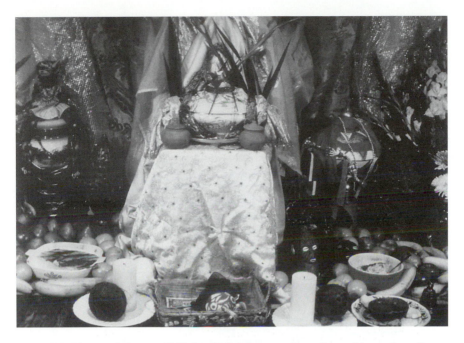

Figure 7.2 Plaza and throne, 1990, by Cuban-born artist and practitioner Juan Boza,
NY. Photograph courtesy of Ivor Lynn Miller.

few red ones, ornamented the baking dish. The background of the *plaza* was
entirely white on white.[10]

The host also inserted other key items into the white space, referring to the
deities expected to visit the ceremony. On the left side hung a small cloth,
deep blue in honor of the goddess of the sea, Yemoja; on the right was a yel-
low one for the river goddess Osun, who is associated with brass. In the very
corner, at the center, hung another bright cloth, red hot for the temperamen-
tal deity of thunder and lightning, Sango. A small shrine for the divine mes-
senger, Elegua (also Elegba), was placed beneath Obatala's on the floor. It was
a bowl containing a cone-shaped cement mass with cowry eyes. Around it in
the bowl were some of Elegua's favorite morsels – pieces of candy wrapped in
brightly colored paper. Flanking Elegua at the far sides were two thick 12-inch
white candles, both lit, and beyond them two white vases containing assorted
white flowers, including baby's breath and gladioli. They carried through the
white theme to the floor of the *plaza*.

The floor also overflowed with some of Obatala's favorite foods, similarly
light in color – pears, pineapples, bananas, rolls of bread, and sweet egg
meringues. For the deity of thunder and lightning, Sango, the host added
apples and oranges, providing a touch of color in a way similar to the red beads

129

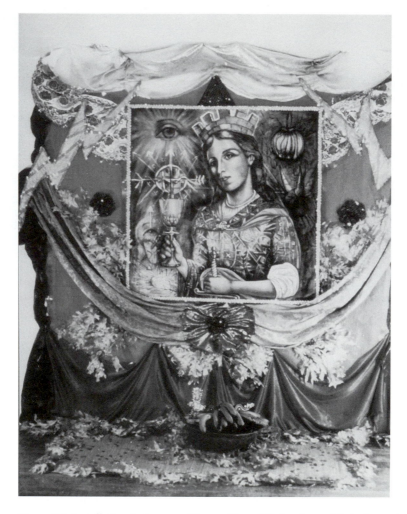

Figure 7.3 Installation in honor of Sango (Santa Barbara), modeled after a throne or plaza by painter and sculptor Juan Boza, Brooklyn, NY, December 1990. Photograph courtesy of Ivor Lynn Miller.

set off against white ones. There was also a huge rectangular cake decorated with white icing and red flowers.

At the end of each *bembe* I attended, the guests ate a communal meal prepared from the deity's sacrificial foods, including those on the shrine.[11] The host served food to everybody present. This meal had the quality of a cooldown period in the performance process (Schechner 1985 : 18–19). People were tired. After up to five hours of dancing and singing, they tended to sit quietly as they ate, scattered around the perimeter of the room in a loose circle. Neighbors sometimes spoke softly between themselves, but the primary

concerns were eating and resting. As guests left, members of the house distrib-
uted to them all the fruit and candy on the *plaza*. Taking away food was tak-
ing away part of the ceremony itself to be ingested later.

The idea was to clear the *plaza* by the end of the *bembe*. Thus, during the
dancing and drumming as the deities arrived to party, the host presented them
with brightly colored cloths from the shrine. This act established a direct link
between the constructed shrine environment and the manifested deities. The
deities prostrated themselves flat on the floor in front of the *plaza* to salute the
host's deities. Then they put on the cloth presented to them and danced in it.
The host might also hand a deity an object from the shrine – a fan for Osun
or a carved thunder axe staff for Sango – which the deity will then dance
with.[12]

After the *bembe*, those who had been possessed took the cloth home with
them to place on their own shrines. The cloth takes on meaning through its
participation in the ritual action. As decoration for the guest priest's shrine, the
cloth then serves as a memento of the priest's participation in a friend's *bembe*.
The accumulation of such cloths on a shrine is an index of a priest's social
relationships and his or her ability to manifest a deity. Evidences of the social
relationships constructed by the ritual action thus survived the performance.

There was an inverse relationship between the *plaza* and the ritual being
performed in close proximity to it. Both underwent transformation during the
performance process. Items from the *plaza* moved into the adjoining space of
the performance, where they were re-contextualized. As deities and other
guests depleted the *plaza*, the ritual itself in a sense swelled.

As in secular parties, guests arrived and left sporadically. Some dressed all in
white, while others wore everyday garb that ranged from casual to semi-
formal. The music and invocations began when the drummers arrived and set
up their instruments. They invoked each deity systematically one by one with
three songs each as the participants stood respectfully still and attentive facing
the drums. Following the invocations, participants danced as the drummers
and singers worked their way through the order again. This time their inten-
tion was to bring the deities down for the party.

The *bembe* I attended were so packed with people it was difficult for guests
to maneuver through the rooms in the houses. And it was always hot, except
in the rare cases where there was air-conditioning. Most participants tended to
orient themselves toward the drum ensemble so that their backs were to the
plaza. They stayed in close physical proximity to each other, within about 18
inches. There was not much choice except to leave the room altogether.

Percussion music automatically established an aural context, even outside
the immediate physical space of the performance. Music functioned on one
level as a kind of aural matrix that bound the events together. For 200 dollars,
a host could hire a drum ensemble, a small chorus, and a lead singer. Their pri-
mary role was to invoke deities by chanting the incantations particular to
them. The chorus ensured the response part in a call–and–response format in

case the guests at the ceremony did not know the particular invocations the lead singer chanted. It also took the strain of continuous singing off the lead singer and allowed her/him to take breaks while a chorus member substituted. The musicians interacted with each other establishing a polyrhythm.

Musicians at once used rhythmic codes associated with specific deities and performed operations on them. In this way each musician added his or her own aural comments to the emerging whole. The chanters then contributed their own line on top of the drummed rhythms. As Thompson (1966:91) has suggested, this musical mode of interaction is "a communal examination of percussive individuality." The particular choice of songs was up to the lead chanter. Sometimes the chanter, supported by the musicians, directed attention to mounted priests by singing a deity's special incantations loudly into their ears. This took them deeper into trance.

The crowdedness, the heat, and the driving drum rhythms and singing provided a unique sensory context for the action. The visual power of the *plaza* added another dimension. Strictly speaking, the participants were at once guests and performers. Thus a primary role of a guest at these sacred parties was to sing the response part in the call-and-response format, to dance, and, in some cases, ultimately to manifest a deity. The lead singer initiated the invocations – one to two lines – the participants picked them up and sang. While the drumming continued throughout the evening, the invocations were more sporadic. They were directed to specific deities they wanted to become manifest.

Abiding by the rhythmic structure of the music, the performing guests individually engaged the music qualitatively in their own ways. They thereby performed tactical operations on the rhythmic structure the musicians presented. There was a great range of improvised interpretations performed spontaneously by participants on the rhythmic structure of the music. There was no spatial uniformity.

At one *bembe*, for example, three women priests side by side suddenly formed themselves into a uniform group amid soloists by simply synchronizing and harmonizing their movements. Collectively they concentrated on the music and each other simultaneously. The temporary, spontaneously-constituted group – on count 1 of a 4-count phrase – swung their right shoulders and body weight forward into a quarter turn to face left, simultaneously plunging their torsos forward forcefully from the hips and drawing their elbows out in the frontal plane. Another priest, maintaining a different style, stood erect and transferred his weight in tiny steps forward and back as if he were starting to walk and then changed his mind. Others, rather than stepping in place, crossed one foot behind the standing one to step diagonally backward on count 2 before stepping back in place on count 3, so that the pattern traveled side to side instead of forward and back. This rhythmic phrase, filtered through different bodies, was in honor of Sango. Each deity has her or his own sets of rhythmic phrases, greatly multiplying the range of possibilities for interpretation.

132

Within the musical structure, participants' movements varied qualitatively. Their energy levels, flow, size of steps and gestures, orientation of bodies in the space, use of body parts, direction of steps, gaze of the eyes, temporal and physical punctuation, posture, and other elements of personal style all varied. While some participants collectivized, forming themselves spontaneously into smaller groups within the larger context, others differentiated themselves from each other by playing independently on, and with, basic rhythmic and stepping patterns.

Just as the drummers directed the dancers musically, dancers also occasionally stimulated the drummers, who in turn focused on and followed a particular dancer. This usually happened spontaneously when a particularly adept dancer emerged from the background of other bodies. In this way the musicians foregrounded the dancer through their music. Particularly inspired dancers confronted the drummers directly by dancing right up in front, squarely facing them. With the shift in the drummers' attention onto an individual dancer, their relationship to the whole shifted simultaneously.

Participants exercised several options in relating to the scene. Most chose to sing or dance, or both. Others stood still and silent, left the room entirely and came back, or interacted personally with a deity or another priest, irrespective of the music. For the deities it was the same although, when still and silent, they often posed and postured with hands on hips and torsos tilted sideways.

This kind of play back and forth between the drummers, the singers, and the dancers was itself transformational. It generated a discourse at another level which surmounted that going on among the drummers alone. The participants' focus of attention and their relationships to each other were in continual flux. Sometimes drummers focused on a particular dancer, momentarily disengaging the rest of the group. Deities occasionally interrupted dancing participants, forcing them to disengage the music and redirect attention to the deity. These shifts were not at all uniform, systematic, or simultaneous. Rather, as a group, they were very spontaneous, individualistic, multidimensional, and multifocal.

The deities circulated freely through the dense crowd to greet people individually. Their gaze was particularly intense, but shifted continually from individual to individual. Participants got the deity's attention through establishing eye contact. Occasionally a deity would force other mediums into trance through a kind of contact possession by focusing attention on them, grabbing them physically, and holding on. The contacted medium then whirled around in disequilibrium, falling and grabbing until he or she also went into trance. Sometimes the lead singer would interfere to prevent the full manifestation of the deity by talking the medium and blowing into each ear to clear the head. Once deities had arrived, they often set off chain reactions, and there was a certain amount of power in so doing.

The altered state of consciousness constituted the most dramatic transformation in social relationships. Priests resisted trance because the onset, as one

practitioner described to John Mason, is an unpleasant feeling of something creeping into one's mind. Another priest described to me how, when her deity comes, her heart begins to pound so hard it feels as if it is going to break through her chest. She said it is a frightening experience.

In the *bembe* I attended, when a deity finally "caught" someone, the transitional period was elaborated. There was a period of disequilibrium when a priest lost balance, stumbled, and fell into people. Much physical contact resulted, mostly unexpected. But participants considered it dangerous for the medium if by-standers interfered in any way with the process. Those standing nearby, including me, could feel the deity's struggle to "mount" a priest. In some cases, people standing only a few yards away were unaware because this initial stage was so subtle. Sometimes several priests entered trance simultaneously, scattered around the room.

An extended period of resistance followed initial disequilibrium. A priest tried to withdraw from the activity to quiet down and clear his head. Often priests stopped dancing, retreating to the nearest side wall, stood erect, breathed deeply, and batted their eyes or dropped their jaws to try to clear their heads. Some put their fingers in their ears to block out the invocations. Practitioners think the chanted verses, and not the drumming *per se*, induce trance. To try to avoid deities mounting them, sometimes priests charged out of the room. Usually, when a priest attempted to resume participation, the deity struck again hard and quick. Elbows, arms, and heads flew out insensitive to by-standers. Yet in all of this there were identifiable personal styles.

In one instance, the priest's head thrust repeatedly forward and back at a frantic pace. She grabbed for anyone and everyone standing nearby. Trying to straighten up, she shook her head side to side as if to break the other impulse. She blinked her eyes, alternately closing them tightly and opening them wide, staring straight ahead as if trying to regain a sense of sight. Dropping her lower jaw, she opened her mouth wide, as if to pop her ears. Each time the deity caught her again and threw her head forcefully forward and back, and she continued to resist. Some priests were successful in averting trance, but more often they did not. The altered state of consciousness means a temporary loss of self; most priests claim they cannot recall the experience after the initial sensation of an altered state. Practitioners say the spirit of the deity displaces that of the individual.

Priests visibly conveyed their interactions with the deity, which read as a kind of tug of war the deity finally won. The ideas of "mounting" and "riding," combined with the priest's resistance, seemed to allude to a rider trying to break in a horse.[13] The elaborated transition was critical to the transformation, particularly because there is a great deal of suspicion in the religion that participants do not always enter trance but are simply "acting-out." One skeptical, yet uninitiated, participant suggested to me 99 percent of the trances are phoney. From most participants' points of view, however, that figure is highly exaggerated.

Because of their divine status, deities, when they come down to party, have a certain amount of social license in interacting with other guests. At one *bembe*, participants told me, Sango mounted the head of a woman priest and then stormed over to a woman wearing a red dress in his honor. He succeeded in ripping it off her with one downward yank. The host of the party quickly announced, "everybody close your eyes!" At another *bembe*, Sango playfully smeared molasses in guests' faces, getting it all over their clothes as well. He also demanded money from some guests, which they were obliged to hand over. Once, too, an elderly woman mounted by the male trickster deity, Elegua, wore a red cloth tied over his shoulder, a straw Panama hat, and smoked a big stogey. As Elegua puffed on his cigar, he went around the room pinching women on the butt. Although smoking a cigar is common to Elegua iconography, pinching buttocks was the tricksterish invention of *that* particular Elegua. The mounted priests improvise their actions spontaneously. Some behaviors become part of a priest's repertoire. Such deeds can be provocative and engaging. They took the guests by surprise and precipitated interaction.

Deities also gave prophetic advice to individuals who wished to approach them. One female water deity known as Yemoja circled her index finger up in the air as she told a young woman she must try to help *all* the people around her. Yemoja went on to assert that the woman worked very hard but she never satisfied herself with what she had done. The implication was that if she helped others instead of thinking of herself, she would find more satisfaction. This Yemoja advised another woman that she worried too much and it was making her tense inside. "Free your mind," Yemoja told her. To one drummer, she said, "You are part of Yemoja's family. You can never abandon us." And to another, she insisted, "I will not allow you to misbehave."

During these pronouncements, a deity may request an individual to perform a *bembe* in his or her own, or another deity's, honor. John Mason told me deities can also invent new dance steps when they come, or even instruct people to perform differently. Some prophecies become trademarks for the individual's deity who professes them. I asked my friend what one Sango had said to him: "what *that* Sango always says to me," he replied, " 'kill your enemies.' " No one seemed to take him seriously because of the obviously absurd content of the pronouncement, reflecting Sango's role as warrior according to oral tradition.

Practitioners often judge the authenticity of the trance state based on what the deities have to say. Priests have told me if the deity says something meaningful to the guest, they assume the trance to be authentic. If, on the other hand, the guest doubts the trance prophecy, there is always the option of consulting a diviner on the matter to get a second opinion. If divination does not bear out the trance prophecy, the guest can disregard the priest's advice on the grounds that he or she was just "acting-out," as opposed to being in a true trance state. When priests continually fail to be persuasive, they can get reputations for faking trance.

Bembe performances

On March 23, 1986, in a middle-class section of the Bronx, a priest of Obatala hosted a *bembe* in her deity's honor. The majority of the participants were Puerto Rican, together with some African-Americans. Thus, when the deities arrived, most of them spoke Spanish, which was translated into English for non-Spanish speakers. Three Obatalas came down simultaneously. Then the masculine deity of thunder and lightning Sango mounted the head of a lesbian Puerto Rican priest, who had come to the *bembe* dressed in men's clothes – red pants and striped shirt, Sango's colors.

The priest's transformation into the deity was particularly elaborate, express-ing at once the deity's struggle to mount and the priest's resistance. This Sango was particularly forceful in his actions. A young African-American man leaned over to an elderly gentleman standing next to me and asserted, "That's the best Sango I've ever seen!" Sango did not dance much. Rather he paced back and forth agitatedly, stopping suddenly, rearing back with his torso, head tilted back, hands on hips, and yelping, "auh, auh!" before turning around and pac-ing once again. Those people who wished to consult him approached and greeted him.

As a teenage Puerto Rican woman approached Sango, he wiped the sweat from his closed eyes with both hands and then rubbed it on the closed eyes of the girl. He then wiped his whole face down with his right hand and then wiped the girl's face from top to bottom, continuing this time down her neck, her collar bone, and over her breasts. The girl stood frozen on the spot, look-ing startled as she stared ahead wide-eyed until Sango had finished. Sango is known as a womanizer and letch, but this interaction took on another dimen-sion when performed by a lesbian medium. The ambiguity was striking.

This particular *bembe* ended with dispatching the troublesome deity Esu from the house (an act known as *despacho* in Spanish). Most of the guests rec-ognized what was happening as a *despacho*, but they did not know precisely why it was needed. Everybody was told to cover their heads. All those who were bareheaded were given paper towels to lay on top of their heads. Guests put their hands over their heads while they waited to receive paper towel. The host wanted to prevent trouble from coming down on anyone's head until Esu had been dispatched.

A man was then "washed with fruit." The host put a selection of fruit taken from Obatala's *plaza* into a large enamel basin. As the man stood just in front of the drums, the host picked up two handfuls of fruit and rubbed him down from head to toe repeatedly until she had used all the fruit. A couple of priests then wrapped the fruit in a cloth inside the basin and carried it outside the house, at once taking away bad fortune.

In another *bembe* for Sango in a Brooklyn home on Sunday, April 27, 1986, the participants were exclusively African-Americans. The lead singer however was Cuban. This time the deities spoke English, which had to be translated

into Spanish for the singer. The participants in a *bembe* performed on May 4, 1986, on the edge of Brooklyn, near Jamaica, Queens, were very mixed. There was a Chinese Jamaican priest in the group. The singers were American, along with the lead drummer, who was of Puerto Rican descent. The other guests were primarily Cuban and Jamaican; the group also included both homosexuals and heterosexuals.

At this *bembe*, there was a problem in bringing down the deities. They were slow in mounting and, when they arrived, the priests being mounted kept averting a full trance state. The participants tried to figure out the source of the problem. The singers complained to the drummers that they were not following up the incantations properly in their music so they never achieved the level of intensity needed to bring down the deities. Drummers are expected to be flexible so, when a deity begins to mount a priest, they can quickly redirect their music and follow a different track in order to stimulate that particular deity.

From the drummers' point of view, on the other hand, the singers did not know exactly when they should begin to sing in relation to the music. The singers, they said, were not synchronized properly with the *clavé* beat, and therefore threw off the timing of the whole. Some of the Cuban participants commented privately that the accent the American musicians gave to the rhythms was different from the way they were accustomed to performing it. Consequently, they claimed, this gave the music a different quality and threw off their dancing. It may be they, too, were picking up on the unconventional relationship between the *clavé* and the singing.

At no time was it ever suggested the *bembe* failed because Osun did not descend. It failed no more so than any other kind of party when certain invited guests did not show up. What seemed more significant was the host provided well for all her guests, including the deities. As in other parties, people commented on the amount, the variety, and the quality of the food the host served.

The *bembe* for Yemoja on May 18, 1986, was organized by a group of devotees rather than an individual. It was a catered affair held in a spacious rented hall in Brooklyn. Two Yemojas descended to party. Participants took one off and dressed her in traditional Yoruba dress – a loose fitting scoop-necked white blouse known as a *buba* and a deep blue wrapper made of handwoven strip cloth (*aso oke*), imported directly from Yorubaland. Yemoja spoke with a Nigerian accent, although the priest is American. They took the second Yemoja off and dressed her in a formal, pale blue satin gown. In addition, Osun, Elegba, and Obatala also visited. The first Yemoja remained as the guests were served food. While they were eating, she visited around the tables and spoke with guests.

The interactional activity of participants creates the dynamics of *bembe*, which transforms relations, roles, and power structures. This activity is multidimensional, characterized not only by shifts in roles and relationships of

participants, but also by continually shifting foci among participants within the broader focus of the ritual frame.[14]

Conclusion

This religious system is not a dogmatic, mindless reproduction of some past. Rather, it involves choice, and thus it is continuously re-interpreted, re-invented, and re-created anew, at the same time acting on and responding to the changing world, for as Raymond Williams has observed,

> tradition ("our cultural heritage") is self-evidently a process of delib-erate continuity, yet any tradition can be shown, by analysis, to be a selection and reselection of those significant received and recovered elements of the past which represent not a necessary but a *desired* continuity.
>
> (Williams 1982:187)

The way practitioners conceptualize and verbalize their practice and transmit it in the performance of *bembe* is fluid and nomadic.

Diaspora performance provides a model that collapses binary distinctions between spectator and spectacle in which participants are at one and the same time both spectators and spectacles, and in which roles and positions of the participants are continually in flux. It is also a model that encompasses that which remains unseen or invisible as part of its ethos. And finally it attributes agency to the performers, rather than to some disembodied eye of a distanced critic. Indeed critique is part and parcel of the performance negotiation itself and never at a remove from it.

In these nomadic performance practices, knowledge is produced through embodied techniques and skills in collaboratively improvising spectacle and is shared unevenly among participants. There is power from practitioners' points of view in the performer's ability "to bring things into existence," "to make things happen," or in other words to participate in the construction of social reality through human agency. Practitioners value difference, or rather repeti-tion with infinite distinction, rather than fixity in the performance. The per-formances construct nomadic subjectivities among participants within the spectacle itself in the give and take of the collaboration, where subject and object positions are in flux or collapse. And there is an explicit understanding that reality is only partially visible, a perspective I might add Foucault under-stood all too well and devoted his life to revealing (see Halperin 1995).

In *Excitable Speech*, Butler counters Bourdieu's *habitus* with a notion of "constrained contingency" and the indeterminacy of interpellation. Thus,

> what breaks down in the course of interpellation, opening up the possibility of a derailment from within, remains unaccounted for.

Bodies are formed by social norms, but the process of that formation runs its risk. Thus, this situation of constrained contingency that governs the discursive and social formation of the body and its (re)production remains unacknowledged by Bourdieu. This oversight has consequences for his account of the condition and possibility of discursive agency.

(Butler 1997 : 156)

Butler's critique of Bourdieu is for me precisely the point where performativity gives way to performance and the possibility of contestation and derailment. Through the practice, the religious system interpellates practitioners, literally hailing them into being and sedimenting a bodily stylistics through ritual performance that then carries over into the practice of everyday life (Butler 1997 : 153). In these ways, the practice defines, orders, and classifies an alternative social world within a larger world. Practitioners thus constitute themselves both socially and discursively, albeit within their own ranks. They are fully conscious they are engaged in a radical re-membering of an occluded history alien to state apparatuses. They take charge of the interpellative process and produce "the material existence of an ideological apparatus" of their own choosing (Althusser, quoted by Butler 1997 : 25) as an alternative way of life.

Acknowledgments

I would like to thank John Mason, Valerie Mason, Henry John Drewal, Olabiyi Yai, Robin Poynor, Nicholas Mirzoeff, and Ivor Lynn Miller for their careful readings and comments on earlier drafts of this essay. Any shortcomings are my own.

Notes

1 The material for this chapter comes from several kinds of sources: 1) conversations with John and Valerie Mason and their friends on numerous occasions while simply hanging out – at home, restaurants, Central Park, exhibitions, performances, etc.; 2) attendance at six *bembe*, sacred parties for the Yoruba deities; 3) Mason's publications (1985a & b; Edwards and Mason 1981, 1985); 4) six lectures on divination given by Mason from March to May 1986, at the Caribbean Cultural Center in Manhattan; 5) visits to *botanicas* around the city, and 6) extensive field research in Yorubaland itself from 1970 through 1986.
2 For more insight on the songs and drumming, see John Mason (1992), and on the culinary arts, see Edwards and Mason (1981) and Mason (1985b).
3 Slavery ended in Cuba only in 1886.
4 One artist/priest, for example, uses plates of Yoruba sculpture shown in Thompson's publications as models for her own sculpture that she creates for use on religious shrines. Of course, the uninformed would not recognize the artist's intent. Therefore, her works have different meanings as well as uses for insiders and outsiders.

5 The meaning of the word *bembe* is obscure. In Yoruba, *bembe* is a type of drum based on the English snare drum. However this is not the type of drum used in *bembe* performance. I am particularly grateful to John Mason, diviner and priest of Obatala, and Valerie Mason, also a priest of Obatala, for taking me to four *bembe*, for discussing them with me and patiently answering my questions. Any mistakes are my own.

6 For a fuller treatment of the preparation of the head in Africa and the diaspora see H. J. Drewal and Mason (1997).

7 On the relationship between the priest's personality and that of the deity in Brazilian Candomblé, see Lepine (1981). And, for a comparison of these notions about personality between Brazil and Yorubaland, see Drewal (1989).

8 For a detailed account of the social organization of religious practice based on a model of kinship relations, see Steven Gregory's work (1987).

9 The site where the deity's vital force sits is often referred to as the throne, or as the *asiento* in Spanish.

10 In another Obatala *plaza*, the host placed a rhinestone tiara on top of the *sopera* and attached to each upward projecting tip a red tail feather of the West African gray parrot. White turtle doves were spaced regularly on the ruffles that formed the outside borders of the environment.

11 Gary Edwards and John Mason (1981) have published some of these recipes in a cookbook designed for the religious community and published under the auspices of the Yoruba Theological Archministry.

12 For an examination of the relationship between shrines and performance in Yorubaland, see Drewal (1986).

13 In Yorubaland, Brazil, and Haiti, as well as among pre-Islamic possession troupes of the Hausa, mediums are called literally the "horses" of the gods.

14 The transformation from deity back to priest is private. Deities tell attendants when they want to leave. Uncompleted transformations, when the priest does not enter trance fully, may be reversed in everyone's presence.

References

Bascom, William (1969), *Ifa Divination: Communication between Gods and Men in West Africa*. Bloomington: Indiana U.P.

Bascom, William (1980), *Sixteen Cowries: Yoruba Divination from Africa to the New World*. Bloomington: Indiana U.P.

Bourdieu, Pierre (1990), *The Logic of Practice*. Trans. Richard Nice. Stanford, CA: Stanford U.P.

Butler, Judith (1990), *Gender Trouble: Feminism and the Subversion of Identity*. New York and London: Routledge.

Butler, Judith (1993), *Bodies That Matter: On the Discursive Limits of "Sex."* New York and London: Routledge.

Butler, Judith (1997), *Excitable Speech: A Politics of the Performative*. New York and London: Routledge.

Davis, Gerald L (1985), *I Got the Word in Me and I Can Sing It, You Know: A Study of the Performed African-American Sermon*. Philadelphia: University of Pennsylvania Press.

Drewal, Henry John and Mason, John (1997), "Ogun and Body/Mind Potentiality: Yoruba Scarification and Painting Traditions in Africa and the Americas." In *Africa's Ogun: Old World and New*. Second, Expanded Edition. Ed. S. Barnes, 332–52. Bloomington: Indiana U.P.

Drewal, Margaret Thompson (1986), "Art and Trance among Yoruba Shango Devotees." *African Arts* 20(1):60–7, 98–9.

Drewal, Margaret Thompson (1989), "Dancing for Ogun in Yorubaland and in Brazil." In *Africa's Ogun: New World and Old*, ed. S. Barnes, pp. 199–234. Bloomington: Indiana U.P.

Drewal, Margaret Thompson (1991), "The State of Research on Performance in Africa." *African Studies Review* 34(3):1–64.

Drewal, Margaret Thompson (1992), *Yoruba Ritual: Performers, Play, Agency*. Bloomington: Indiana U.P.

Edwards, Gary and Mason, John (1981), *Onje Fun Òrìṣà – Food for the Gods*. Brooklyn, NY: Yoruba Theological Archministry.

Edwards, Gary and Mason, John (1985), *Black Gods – Òrìṣà Studies in the New World*. Brooklyn, NY: Yoruba Theological Archministry.

Foucault, Michel (1979), *Discipline & Punish: The Birth of the Prison*. New York: Vintage Books.

Giddens, Anthony (1982), *Profiles and Critiques in Social Theory*. Berkeley: University of California Press.

Giddens, Anthony (1986 [1984]), *The Constitution of Society: Outline of the Theory of Structuration*. Berkeley: University of California Press.

Gregory, Steven (1987), "Afro-Caribbean Religions in New York City." In *Caribbean Life in New York City: Sociocultural Dimensions*, eds C.R. Sutton and E.M. Chaney, pp. 307–24, New York: The Center for Migration Studies of New York, Inc.

Grosz, Elizabeth (1994), *Volatile Bodies: Toward a Corporeal Feminism*. Bloomington: Indiana U.P.

Halperin, David M. (1995), *Saint Foucault: Towards a Gay Hagiography*. New York and Oxford: Oxford U.P.

Hebdige, Dick (1979), *Subculture: The Meaning of Style*. London and New York: Methuen.

Lepine, Claude (1981), *Os Estereotipos da Personalidade no Candomble Nago*. In *Oloòrìṣà: Escritos sobre a religiao dos orixas*, coordinated and translated by C.E.M. de Moura, pp. 11–31. Sao Paulo: Editora AGORA, Ltda.

Lippard, Lucy R. (1990), *Mixed Blessings: New Art in a Multicultural America*. New York: Pantheon Books.

Mason, John (1985a), *Four New World Yoruba Rituals*. Brooklyn, NY: Yoruba Theological Archministry.

Mason, John (1985b), *Santa Comida*. Exhibition Catalog. NY: EXIT ART.

Mason, John (1986a), Lecture, Caribbean Cultural Center, New York City, 4 March.

Mason, John (1986b), Lecture, Caribbean Cultural Center, New York City, 15 April.

Mason, John (1992), *Orin Òrìṣà: Songs for Selected Heads*. Brooklyn, NY: Yoruba Theological Archministry.

Meyer, Moe (ed.) (1994), *The Politics and Poetics of Camp*. New York and London: Routledge.

Newton, Esther (1979 [1972]), *Mother Camp: Female Impersonation in America*. Chicago: University of Chicago Press.

Peek, Philip M. (1981), "The Power of Words in African Verbal Arts." *Journal of American Folklore* 94, 371: 19–43.

Schechner, Richard (1985), *Between Theater & Anthropology*. Philadelphia: University of Pennsylvania Press.

Tambiah, Stanley Jeyaraja (1985), *Culture, Thought, and Social Action: An Anthropological Perspective*. Cambridge and London: Harvard U.P.

Thompson, Robert Farris (1966), "An Aesthetic of the Cool: West African Dance." *African Forum* 2(2):85–102.

Williams, Raymond (1980 [1973]), "Base and Superstructure in Marxist Cultural Theory." *Problems in Materialism and Culture*, pp. 31–49. New York: Verso.

Williams, Raymond (1982), *The Sociology of Culture*. New York: Schocken Books.

Yai, Olabiyi (1994), "In Praise of Metonymy: The Concept of 'Tradition' and 'Creativity' in the Transmission of Yoruba Artistry over Time and Space." In *The Yoruba Artist: New Theoretical Perspectives on African Arts*, eds R. Abiodun, H. Drewal, and J. Pemberton, pp. 107–15. Washington, D.C.: Smithsonian Institution Press.

8

BLACK SKIN, WHITE KINS
Metamodern Masks, Multiple Mimesis

Moyo Okediji

In diaspora forms, metamodernism is the neo-spiritual hard drive of a virtual
modem-and-mouse world at peril.[1] Inclusive of myriad variants of distanc-
ing, metamodernism fosters not only the somatic, but also the psychic and
other mythic forms of diasporas.[2] Televising the Egungun idiom among the
Yoruba of West Africa illustrates vividly this motif.[3] As its heavily loaded mul-
timedia body gracefully glides to the provocative percussion of ancestral
rhythms, as it twists and sometimes turns and tumbles, as it mumbles incan-
tations and thunderously rumbles with rapture, the televised Egungun mas-
querade – as it carries with dignity its elaborate multi-colored,
poly-patterned costume – casually takes the infinitely fluid community for its
amorphous amphitheater. It is a metamodern art form, in which mythic pat-
terns embellish and redefine contemporary icons and ideas, using votive and
esthetic materials that are unconventional, or transforming conventional
material with novel techniques and mediations.[4] Its Egungun musical perfor-
mance and choreographic motions annually lend structural, spiritual and aes-
thetic form to the town. For an entire season after the performance, despite
the television tapings, audiences excitedly remember and recall the "exact"
route forged by the masquerade meandering through the adobe buildings,
darting across narrow laterite streets, the "sold-out" performance colored by
an excited milling crowd.

Now and then, the masquerade steps bold and slow inside the homes of
prominent community elders for some closed door rituals – who cares if it's
really to invigorate the ancestral spirit with palm wine behind closed doors –
and down slows the drumming outside. Suddenly, out darts the Egungun, reju-
venated, and the crowd scatters, terrified children screaming excitedly, nubile
women wriggling seductively, mobile men leaping assertively, marketing their
macho, while drummers intensify the tempo and volume of the rhythm, and
once again, the Egungun is on its cartographic mission, gyrating, mapping out
the postmodern secular territory with sacred compasses (Figure 8.1). Here,
symbolized by the mask, comes the return of Gothic proportions, when the

143

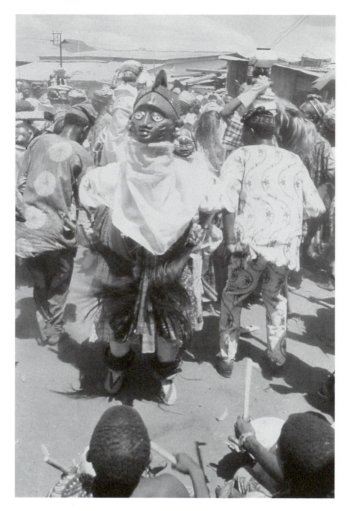

Figure 8.1 Isola Oloye, *Egungun Gelede*, 1975. Photo: Henry Drewal.

postmodern succumbs to theory and speculations, yielding to the mythic and metamodern.

Possessed, the Egungun masker defines a route that, as people remember it, as they talk about it, becomes the form of the town for an entire season. It is not a permanent form, but an ephemeral boundary, shifting from year to year, sometimes from mouth to mouth, because different people often remember it differently: while an eye-witness insists on a particular route, another reads it as a contrasting road, often arguing with the television recordings as inaccurate, partial or biased. Does it matter that everybody constructs the memory differently? Wherever the performance takes the masquerade, or wherever the mas-

querade takes the performance, wherever its footsteps are planted on the ground, is a formidable, dreadfully sacred ground, among a people for whom every space is intense and invocatory in the first place. At that point of route definition, at the moment of performance, the masquerade is not the self, but the divine Other. The masker, the fellow physically inside the mask, carrying the burden? Vacant. In diaspora land.

The spirit of the ancestors, known as the Egungun, visits the Yoruba world annually. Occupying a space formally known in the West as the Slave Coast, Yoruba elements contributed approximately one quarter of the enslaved population to the New World. To console and bless the world of the Yoruba, to replenish its resources and heal its wounds, fertilize its soil and celebrate its harvest, the Egungun masquerade descends regularly, in a vehicle of dance and music, in a festive mood. But, as the Yoruba people say, "*Eniyan lo wa ninu eku, leku fi n jo*," the ancestral mask dances with human legs. Out of its own orbit, distanced from the other world from which it descends, the Egungun metaphorically colonizes and inhabits the frame of the masker, who is driven out and must abandon his physical self for the Egungun to possess, appropriate and distance him as an other.

How does a masker vacate, diasporate, while carrying the mask? How does a physical body become a metabody, how does the flesh turn slave-god? The aggregate personality of the ancestors that descends annually in the Egungun energy is too intense to share the same form with mere mortals such as the mask carrier. The more powerful force eliminates its human host, since it inhabits the human body of the mask carrier to manifest itself. This inhabitation and elimination is a form of colonization at the optimistic end of the spectrum and death at the other. Since matter, even when banished, killed or fiscally alienated, cannot be destroyed, where does that humanity go, roam? To the diasporas. There, its fractured postcolonial body is a metaphor for a different dance of decorporeality, of acoloniality – of diasporas – such as those orchestrated in the work of Howardena Pindell and Adrian Piper, two African–American female artists, who have used their bodies as metamodern sites, like the Egungun masquerade. This is the nexus of trans-atlantic crossroads, where the biggest of female masquerades transfigure, in diasporation, to share the same ancestral spirits with the hosts of Africa.

Here, also, the masking canon shares the burden, this time the Divine Ones' burden, akin to the white man's burden that fueled the triangular trade, enslavement and the black diaspora. In the Divine Ones' body, the ancestors have come, condescended to the realms of humans, for the sole benefit of humans, to give blessing to human wishes, to heal their injuries and comfort their troubled and confused minds with divine assurances. But in order to fulfil this divine injunction, a sort of divine burden, the gods must ritually seize the human body, possess, banish and kill it. Consider the praisename of a household divinity, Ogun:

Olominile
Fejewe
Olasonile
Fimokimo bora

He has water in abundance
But bathes in [human] blood
He has garments in surplus
But wears [camouflage/war-time] palm fronds

The gods are not and could not be human, as the above chant demonstrates. Humans bathe with water, and not blood. But these divinities do not ask to be judged with mortal standards because they embody immortality, beyond mortal grasp. The gods are like they are because they are gods, and if they were otherwise, we would have no use for them. And, remember, they carry the Divine Ones' burden, a definite responsibility, even if it must entail the dislocation and diasporation of certain different selves into Othernesses.

Where do we find the dramas of those diasporated in the process of possession by the gods? In the metamodern forms of the land of diasporas, in the Americas, in occidental black art. Not merely in their *jonkonu* masques,[5] because that merely produces further trances of diasporation. It is much more rewarding, when mapping this diaspora, to open the historic pages of individual black bodies, especially of the black female artist's back that claims to carry the totem pole. There will we not only find the penetrating sanctions of the gods, effected in pursuit of Divine burdens, but also rituals of full seasons, survival and desires, forceful and more urgently signified and painfully poignant than the largely collective dramas of the gods. There we truly find diasporation in its multiple affects. Hidden under a huge mask of history, distanced by geography, gender and sexual agencies, the politics of diasporation assumes an aesthetic costume, to dance the masque of alienation. A dance of death to defy mortality and celebrate negrophilia, this necrophilic choreography teases and monumentalizes immortality with its multiple projection of virtual nomadism over factual alienation. It is a site where black bodies must embrace and negotiate space with white kinship simply in order to survive, where diaspora conditions conquer cultural death with negrophilic positions and proportions, with an Aryan meta-aesthetics.

Within that diaspora we encounter the work of Howardena Pindell. For her, diasporation goes beyond the physical exodus, embracing a metaphysical dissolution that allows for all forms of self-recomposition, of re-memory and re-membering. This re-molding of self, this measure of self-formation, beyond its paramedium iconography, is a matter of self-defence and preservation. It is an epic struggle against death. Radiating that space of self-definition as mask forms – in Pindell's work – is a framing of multiple mimesis, plotting the character of the painter/performer as female, colored, feminist, individualist. It is a mask of defiance, fashioned into an artistic pattern that is bitterly poignant

with the pills of translations wrought by diaspora conditions, as different from home. As in home is where the art is.

Pindell, therefore, still remembers Africa as some form of home. She sees herself as a black woman. And if home is where the art is, then, for her, Africa is the mother of art, to whom she must return periodically to replenish her stock, as Leonardo returned to ancient Greece and Rome. She constantly bridges the physical and emotional distance between Africa and America with mimetic mediations and meditations, actual and astral travels, thereby directly and indirectly tapping into what is for her a primary home source of inspiration.

Pindell's work, since the beginning of the 1980s, has been largely autobiographical. That genre of self-celebration shifts the focus to her individual body as the site of a bitter struggle and the prize/price of negotiation. In psychic terms, in mythopoeic dimensions, she becomes an *arugba*, the woman who carries sacrifices from the world of mortality to the gods, the person who must walk alone through the white terror of blind light to deliver the messages of her people to the Others, a physical and psychic test of endurance that she constantly faces. She often blends into the sacrifice itself, integrating her body fluids into the composition, so that you cannot separate her from her work. Thus, like an oracle, her back supports the sacrificial detritus emanating from the postindustrial, postcommunist, neo-colonial world. As that potion affects black female visual sensibility, it affects her. As she sees it as a means of psychic revelation, she uses her *arugbaism* as a sensor with which she psychicly feels and relates, deploying her art as a humanitarian vector, like a metamodern priestess.

Her masking takes place within her autobiographical works, where she mimes the images of her own representation, by manipulating certain psychosomatic resonances of color, movements and sound energies that intensify her mind and sense of perception. Her choice of diasporation as a masking form allows her to banish herself into a metapsychic terrain of displacement, beyond the geographical distancing from Africa. It is this second level of diaspora that translates Pindell's vision to the aggravated grade of multiple diasporation and multiple mimesis.

The concept of multiple diasporation implicates a measure of fragmentation, a fracture of self, recovered in the form of art, a tragic, metabody art. This fracturing triggers an organic explosion, like the blasting of the acacia pod, its seeds scattered out to the world, diasporated. The seeds readjust themselves wherever they land and try to root, initiating another season of life. It is a self-generated struggle, autobiographical as in Pindell's work, in which she multiplies her own body mimetically, somatically sowing her seeds and elements. This self-invention, this algebra of elements and principle of design signifies a discovery of wholeness, a tap-rootedness, in a universe animated by constant flux, as in the swirl of the Egungun's garment, a perpetual diasporation of distancings.

In diasporation is a form of distancing that ordinarily involves a physical

journey from a native to a strange land. In metamodern aesthetics, however, the mythic dimension provides a virtual tangent to fly off from. The distancing need not be limited to the physical any longer. It may assume a metaphysical or virtual transposition, for example, in self-portraiture where artists distance the self in image forms as representations, thus (dis)placing the self into an other space. This banishment of self (as image) into a strange place is a transportation from factual to fictive reality — or from life to death — an enabling process that may empower artists. When this spatial suicide or virtual emigration occurs in artists who are already perceived as living in diaspora, whether as Jews, blacks, whites or Asians, through the devices of multiple mimesis, it creates a state of double diasporation. The complexity of multiple diasporation is provoked when this train of mobilization confronts — and is further distanced by — factors of race, gender, class or sexuality, as in Pindell and Piper, the two female African-American artists whose works are explored in this chapter.

Any form of portraiture is not merely a copy, but a diaspora commitment in the metamodern aesthetics. The portrait duplicates the body and delegates the duplicate into a mythic Other, or metabody, that is frequently as important, sometimes more relevant than the self. Colonial authorities have long realized that the portrait is as important as the portrayed body. Portraits of colonial rulers are strategically positioned in public places in the colonies. The bust of the Queen of England, Elizabeth II, still adorns Canadian coins. She lives at home in Britain, but her busts are committed to the diaspora, where she continues to rule, not in absentia, but in iconic diasporation. Similarly, my own portrait, in the form of passport photographs, has proven more important to bank officials, police officers and immigration control personnel, than my physical presence. It is not enough for me to present my body physically. I must prove that my body is really mine, that I am what I am, with the use of these tiny portraits that corroborate my existence. These mimetic passport photographs split me into two halves, and until these officials unite my body *in situ* with that in the iconic diaspora, they are unable to recognize, acknowledge or assist me. It is that loss of self, in a pseudo-suicide, and self-reborn, with the use of a photographic mimesis, a virtual diasporation, that forms the plot of an apartheid-inspired tragicomedy, Athol Fugard's *Sizwe Banzi Is Dead*. My own mimesis, my passport photograph, begins to haunt, taunt and tease me, because at some point, it stopped miming me. At the point when the immigration/police/health/school official looks from the passport to my face, then back to the passport, I, not the photograph, am the reference material; I am the one miming the photograph, and not merely vice versa. I mime the photograph that is a mime of me, in a complex coding of relationships, of multiple mimesis, that begins to respect no center as the ultimate point of origin or reference. Everything mythologizes itself as a portrait, an icon, thus I become a mere portrait, a mime of myself.

Artists use their own self portraits, their iconic diasporations, in different

ways. For Vincent van Gogh, it was partly a means of providing mental stability to a physical body. For Picasso, it was partly a colonial enterprise, a means of penetrating other geographic and gendered bodies. For Pindell and Piper, it is a way of multiplying their physical diasporation from Africa with an iconic diasporation, to produce a multiple, more formidable sense of distancing, that enables them to perform rituals beyond the means of their basic bodies.

The painter in this group, Howardena Pindell, is a New York artist who uses images as a means of constructing a constantly shifting and mutating identity for herself, following her amnesia after sustaining head and body injuries in a 1979 car accident. Her autobiographical work is a mapping of the perpetual motion and departures that subject her self-representation to relentless transgressions, and no final arrival. This virtual nomadism enables her to apprehend, appropriate and artistically translate political and religious experiences that might otherwise be geographically and culturally alien to her. As Yoruba people say, *Oruko to wu ni laa je leyin odi*: you are free to rename yourself, should you choose, in diaspora. Renaming is a form of distancing, a departure from previous identities and recognitions, further multiplying the geographical distance of the land of diaspora.

Constantly renaming her work, re-inventing herself in autobiographical language, Pindell projects painting as a site of multiple diasporation consisting of ceaseless symbolic emigrations signifying her (disguised) self-portraits. Diasporally masked in *Autobiography: Fire: Sati* (1986–7) (Figure 8.2), she emigrates to Indian widowhood to symbolically incinerate her body image, protesting against the practice of *sati*.

Pindell's symbolic suicide in *Autobiography: Fire: Sati* demonstrates how an artist could exercise autophilia and autocide in the same gesture, with the use of masking, of distancing, of diasporation, multiple mimesis. And this hydra-edged sword is a Janus-headed dragon that would necessarily haunt the artist. First, her intervention is welcome. To place anybody in such a horrendous situation that she would have to jump into her deceased husband's burning funerary pyre, as in *sati*, is abusive. One could understand Pindell's concern, her voluntary symbolic suicide to protest the practice, her willingness to take a position on the issue, her courage to stake her art on it, "die" for it.

Sati is an outlawed ancient practice performed in some sections of society that Pindell found appalling during her visit to India. What first shocked her was the realization that she had not hitherto heard of the practice, and how few people outside of India knew about *sati*. Resolved to use her art to bring some attention to *sati*, she decided to do a painting entitled *Sati*, based on the Hippocratic element of fire. The work, because it alludes to fire, one of the four natural elements of the ancient world, is essentially therapeutic, a self-directed therapy, projecting Pindell's autobiographic interests as a self-healing process. After all, as the Yoruba people say, *Bi ina ba jo ni, jo omo eni, tara eni laa koko gbon danu*: if one should combust simultaneously with one's child, one must douse the fire on one's body first, before attempting to douse the fire

Figure 8.2 Howardena Pindell, *Autobiography: Fire: Sati*, 1986–7.

consuming the child. Tough situation. It is here, in Pindell's painting, that boundaries dissolve, that autophilia intertwines with autocide, forming a multiplication of interests, a crossroads of desires, an intensification of chromatics to its torturous point of explosion into fiery hues.

The painting *Autobiography: Fire: Sati* picks a dramatic moment, when the victim's body, Pindell's own symbolically sacrificed body, is already on fire. It is burning, and through the brilliant forks of leaping tongues of flame, layered in multiple sheets of pyre-hot fire, her arms thrashing to the luminous dissolution of tepid rhythms, she throws her body into the final tango with death, a grimacing end where conjugal love burns and melts down into lies, and culture

ruptures and dies with every *sati* ritual performance. It is the awesome beauty of betrayed death, of romantic suicide, of autocidal autophilia that Pindell maps here in her *sati* painting. Where does betrayal commence and love lie in this work? It is not clear, just as you are not really sure whether there is actually anybody inside the fire, despite the artist's claim. There seems to be some movement, but leaping flames are always playing tricks with perception. And if the artist is still with us, how could she also claim to be inside the fire at the same time? Diasporation or *Isuju*, in Yoruba mythology. Multiple identities that allow for multiple mimesis and multiple appearances simultaneously. Even though she is burning in her *sati* iconic diaspora, she is still able to stand with us to debate the intensity of the experience, and the passion it excites as a cathartic choreography. She knows it. She is an insider to a different kind of *sati* that burns her in the United States, as a person of color, and as a woman. But in India, even though she is a woman, she is not a total insider/insider. She is empathetic, but she remains a spectator, and all her iconic diasporation to *sati*, all her sympathy for the victims, is still from the outside. As a woman, she is inside. In the *sati* iconic diaspora, she remains an outsider, in virtual nomadism. *In toto*, she is an insider/outsider.

It is here that she incurs the wrath of the absolute insider, the insider/insider, who is sick of being tagged with *sati*. Pindell would understand this position, being a black American woman shackled with myriad representations and stereotypes including the Welfare Mammy, Aunt Jemima, Jezebel, Abortion Abuser, AIDS Whores, and Junkies. The Indian woman must confront the horrified foreigner and take a stand on *sati*, for or against. If she has been educated, the horrified foreigner expects her to take a stand against *sati*, to share in the outsider's indignation for the practice, in fact to apologize, on behalf of her culture, for the gynocide, console the outsider for going through the ordeal of hearing about *sati*, and commit herself to its eradication. In some white feminism, the diatribe goes, *sati* is the symbol of ultimate evil, and no sin, present, past, or future, seems as abominable. The battle against *sati* must, therefore, be waged like a holy war, and any weapon brought into the service against *sati* is demonstrably justified. It is within this discourse that Pindell's *Autobiography: Fire: Sati* radiates, challenges and is challenged.

The discourse complicates as it rolls along, because, as Frantz Fanon stated many years ago, the "native" is always amused when the "master" expresses concern for the native's plight. What does the oppressor know or care about compassion for others? There seems to be a silent masking going on, surreal and frightful, a sordid diasporation of reality, when suddenly some Western liberationist feminists recognize and are devastated by the plights of Indian women. Where it is practiced, various levels and kinds of *sati* exist, including the deprivation of food and medicine for the young, old and sick, provoked by the exploitation and economic imbalance defining contemporary global economic and political interaction. Or what exactly are the benefits in the manifestos of feminism, ask African feminists, if Western women are not going to

acknowledge and address their complicity with the global oppressive deploy-
ment of hemispheric power politics?

Irritated by the piousness of Western feminism, Geeta Patel poses the riddle:
"What's the difference between a welfare queen and a burnt bride? Nothing,
both have been taken care of by the state." It gets more colorfully landscaped:

> Sitting across a plastic table cloth, worn smooth as buffed nails, she
> leaned delicately into the question, "Did you leave, because, unh,
> Indian women get burnt ... you know like ... umm ... *sati?*"
> Embarrassment flushed me into a short silence. What if our Punjabi
> waiter I had casually established ascendance over overheard my
> response? What would he think of me? Would he agree with my rep-
> resentations? ... From tourist-guide to burnt-bride/native infor-
> mant, with a short hiatus as an intellectual peer discussing the politics
> of the conference we attended together. Trapped and immobile, I
> fought to extricate myself from the fire.[6]

This is the sort of sarcastic response that Western feminism may elicit from an
Indian woman when the issue of *sati* ignites. But for Pindell, it is not merely
another exotic tourist postcard. It is part of her own journey toward realizing
and healing herself. Her postcards, collected from her various travels all over
the world, strategically deployed as memory stimulators, following her amne-
sia. She would dismember stacks of postcards, cut them into bits and pieces,
and then re-member these pieces meticulously, not to form the initial pictures,
but to create new experiences. She knows that she is a symbol of the burning
woman, always on fire, like Ogun the Yoruba god of metals, always cutting new
directions, always opening up new frontiers. It is therefore not surprising that
she is one of the few black women artists in America to cross the racial barrier
and receive a lot of exposure locally and internationally. But she was not let
into the system until she confronted it headlong, documented and published
her research into the systematic exclusion of women of color from art exhibi-
tions by the mainstream galleries and museums.[7] Her talent and drive have
taken care of the rest.

Pindell's *sati* therefore transcends the American tourist's exotic fascination
with native difference. It represents her diasporized self as the perpetual trans-
gressor, the artist, the maiden who must carry the human sacrifice, through the
tunnel of creation, from mortals to their divinities. And who in so doing, must
die, because it is a journey from which nobody returns, a one-way traffic that
ends within itself, leading nowhere from which one could then depart. By the
means of self-portraiture, within an autobiographical idiom, Pindell casts her
own image into that diaspora, and manipulating the license of distancing,
bride-burns her own body. She torches herself, and people ask, Why is she
burning? Why does she act, react, transact differently from the others? She
burns, she says, because it is her own body, her own life that is being decon-

structed and misconstructed by the pyres of *sati* in everyday life, on a regular basis, on the streets, where s/he is first black then a wo/man. In diasporation, in picture formulation, in autobiographical art, it is a mere painting. As a black woman, she burns in reality on the streets of American public opinion, stereotyped between the Whore, Welfare Mammy and Aunt Jemima, born of racial discrimination and gender subordination.

Not so easily categorized is Adrian Piper. Video and performance artist, Piper, who teaches philosophy at Wellesley College, once ritually and regularly transgressed outside her native female boundaries, using crossgender performance stunts. She demonstrates how she would dress arrogantly like a young black man, strut down the street and elaborately claim her space. She would sit in the bus with her legs wide open, to give enough room for her male genitalia to maneuver itself. She gawked at girls, made a scene on the streets, looked incurably cool and wobbled with a cat's gait, generally projecting a tense profile of the carefree young black male in heat, free to comb the curbs, jobless, angry.[8]

It was for her an empowering act. She enjoyed the attention that society lavishes on men, especially young men of the vapidly dating age. She was no longer the slight anonymous woman, one of the many young anonymous women milling about the streets, wearing anonymous apparel, purchased in anonymous stores from anonymous persons wearing anonymous smiles.[9] She also noticed how white women shrank away from her in horror, how they fled across deserted streets, became mortified in elevator rides as they frantically clutched their bags and purses, taking her for a black man. Many white men refused to catch her eyes, walked away from her, made nervous movements, or scowled at her in utter discomfort. Because for her it was an act of mimesis, mere drama, performance art, those reactions thrilled her, but she felt pity for the black men who really go through the experience on a daily basis. She similarly pitied those whites who really feel terrorized by the presence of blacks, because that problem is real and incapacitating for those who seem to have it.

She claims that the fluid transgender attire gave her a wider mode of expression than the more restrictive monogender gear, that the boundary-crossing mode of experience is nearer her natural sensibility than an either/or choice. Currently, she wilfully departs from the terrains of both black and white racialities, entrenching her image in a transom exile she describes as the Gray Experience. Her parody, *Self-portrait Exaggerating My Negroid Features*, is a racially tensioned transmutation of her own image, demonstrating her permanent symbolic shuttle between two races, within neither of which she could fully settle. Is this a type of negrophilia that must dialectically reverberate from an essentially necrophilic, negrocidal age? But what other type of aesthetic do you expect from a site in which the same individual could be given two birth certificates, one proclaiming him black, the other white?

Self-portrait Exaggerating My Negroid Features is particularly worrisome because it stands reasoning on its head. Its logic proceeds in the opposite

direction. The "normal" behavior is to accentuate Caucasian features and pass. In the African–American culture, there is a hierarchy of shades, in which the lighter implies the better, the more Caucasian the prettier. In other words, the darker the skin, the uglier, the further from the Caucasian kins. The ebony dark body of a female African negro, therefore, becomes the embodiment, the most expressive manifestation of the complete reversal of all that is exalted in a Eurocentric world. Yet it is to that negated African form and aesthetics that Piper appeals here. *Self-portrait Exaggerating My Negroid Features* signifies one for too long silenced, so that when the gag is removed, or when her cries soak through the cruel twists of the gagging rag, and leaks with a leap into the free wind, it explodes into a deafening roar. Yet the voice transcends pathological Aryan negrophilia and its lurking negrocidal corollary, because it is choreographed into the mimetic patterns of the struggles of a distanced race, regaining its grace in the strange landscapes of diaspora. Like a Yoruba masquerade, Adrian Piper wears the body of another character and thus transforms her native body, manifesting herself in an iconic somatic diaspora. Her newly acquired body in that portrait is both the actual black diaspora in America, and the iconological diaspora of her own making, in a mythic exile.

When in *Self-Portrait as a Nice White Lady* (1995) (Figure 8.3) she seemingly wears an opposite mask, her work diasporates into some portentous house of mirrors. Here Pindell invites the audience no longer to view the objects directly, but within the distortive scope of other's reflections. In the picture that appropriates icons as disparate as imperial coin portraiture and comic-strip pop culture, Piper reflects on the reflection of a young black male as he looks at a white lady. What one sees is a Magrittian disclaimer that astutely insists that what the audience really saw was not a white lady. If anything, it was a troubled male's reading of the mind of what he thought was a white woman, but is in fact a black woman masking herself as white because she is ordinarily considered white and not black, in a cultural hierarchy that prioritizes the former over the latter.

But how could she claim to know what a young black male sees when he looks into the eyes of a respectable white lady? As a veteran insider/outsider, one who has been there on the street as a black male, even if only in her performance arts, Piper grafittis her credentials on the streets of diaspora mimes from the inner cities of New York, to the suburbia of Wellesley. Her work, *Self Portrait as a Nice White Lady*, becomes another site of diasporic transmutations, where she mythically crosses over to a self-made Caucasia, using a montage of mimes, satire and irony as a vehicle to the iconic sojourn.

Settlement is the negation and complement of diasporation. It is from the settled root that the diaspora shoots, the diaspora becoming the animated bordering of the settled stock, from which the self extends into Otherness. From which the black skin claims white kins. But without a real or imagined settled bulk, you cannot extricate a diaspora. And all diasporas will sooner or later

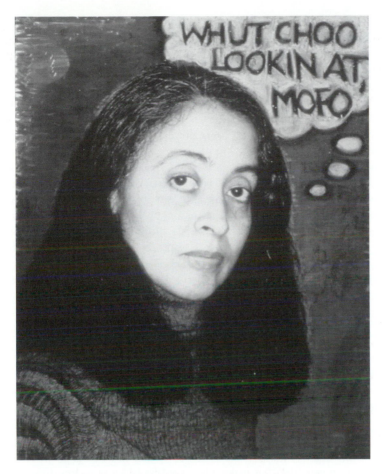

Figure 8.3 Adrian Piper, *Self-Portrait as Nice White Lady*, 1995.

root into settlements even though it would always remain a displaced space, and the distanced folks would always remain nomadic at heart. Because at the core of every diaspora is a space of nostalgia, acknowledged or suppressed, a Zionism, a longing for exodus, to return, replicate and celebrate home. At the same time, there is always a reluctance to retrace the steps of diaspora, to retreat, because it connotes defeat to return home. The advance guard, a romantic concept of distancing, wants to keep pressing on, to attenuate into a perpetual study in constant diasporation, to keep penetrating the frontiers, moving forward in the jungles and wildernesses, remapping geography, like the masquerade dances in the village streets remapping the season. The masquerade wants to keep dancing on, wants to fully fling itself with rhythmic abandon into the seduction of the percussion timbres. But a silent voice calls the Egungun, "Softly, softly, spirits of the ancestors must move with awe-inspiring

dignity, not gambol like an urchin. And, weather wise, don't you think it's time to return home?"

Thus the Egungun spirit tears Piper between diaspora and home, so that at some point it no longer matters, it is no longer clear, which is home and which diaspora. What counts is the nomadism, the flux, the "shuttle in the crypt," which weaves several yards, which keeps the engine warm, the blood flowing, the system keyed. What matters is commitment and resilience. That is why she often fully flings her body into the dance, ignoring entirely the caution about ancestral masques and dignified steps. She leaps and flies when the spirit and intellect so demand, as her recent political and personal protest demonstrates. Before it became popular for politicians to bash cigarette companies, she abruptly withdrew her work from an important exhibition in California when she discovered that the major sponsor of the exhibition was a cigarette company. She would only agree to show pictures of her parents – when the exhibitors approached her to reconsider her decision to withdraw from the show – both of whom had died of cigarette-related illnesses. She follows her heart and head: why dance when you don't want to sweat? Even a masquerade sweats, but its costume covers it all, therefore however long it stays away from home, the masquerade always looks fresh.

But a masquerade must return home. A masquerade is only a visitor, and cannot choose to reside for ever in human diaspora, regardless of how exciting the percussion music is. That is the bane of the Gray, the aesthetic of the bridge. Always in perpetual diasporation, distanced from both black and white, the gray isolates, dislocates itself while at the same time unifies black and white. The bridge is nothing but a hyphen between two bodies, as in African-American. By itself it is a nobody. But to function as a bridge, it must experience isolation because it must *appear to be* truly impartial, in perfect harmony with both sides, to truly convey the traffic between the two extremities. It is a necessary form of isolation that ironically engenders a sense of bonding with a greater humanity informed by the best (and the base) of both parties.

As one who has mingled with both black and white, who has identified with both and who potentially faces rejection from both, only she knows what it truly means to carry a double consciousness. She says she understands when dark skinned blacks think that she is privileged, because it is true that the paleness of her skin accords her certain opportunities not often open to darker skinned people. She readily understands when whites are uncomfortable with her, because she does not behave as a loyal member of the Aryan community, pass for white, shut up and enjoy the benefits. As one with one leg in different terrains, who transcends all boundaries, who symbolically crosses physical and psychic barriers, who does not belong within traditional borders, who constantly fluctuates across all cells of race, gender and class, Piper is in a cosmological diaspora theater. Her *Self-portrait Exaggerating My Negroid Features* and *Self Portrait as a White Lady* become an iconic diasporation that further distances her experience of physical diaspora, translating it in multiple terms.

Inside the iconic diaspora, she feels safe to remake herself, build a shell of melanin for her body where she feels insufficiently endowed, remove the melanin with a sweep of her brush at her will, and, like the Yoruba divine sculptor, Ajala, remake her own head, flattening her aquiline nose, thickening her lips, Aryanizing her body and Caucasianizing her visage.

Ajala, in Yoruba mythology, is the clay sculptor who makes the *Ori*, or human head, from which everybody must choose before traveling from the other world (Old World) to this world (New World). Ajala is a debtor and a drunk, and frequently hides from his creditors because he is unable to settle his bills.[10] Despite his creative skill and dedication to art, his pathetic personal life makes him a shoddy artist, who is so distracted that he occasionally forgets to fire his clay heads in the kiln, and when he fires them, sometimes removes them in biscuitware stages, underfired. Occasionally, he forgets and leaves them in the kiln for too long, so they crack. Most of his heads are properly fired, but there is hardly any way of telling the good heads from the bad, because only Ajala knows the difference. Since Ajala is a debtor and is always in hiding, however, he is never around to guide people who come to his studio, on their way from the Old to the New World, to choose a head. Many people, therefore, end up choosing the wrong heads when they arrive at Ajala's studio, and must repair these heads, or face the unpleasant consequences of using inadequate, anemic unfired/underfired heads, or overfired and cracked heads. But there is always room for rebuilding your head, should you decide that what you have is not what you want, or that you wish to experiment with other heads. Using this metamodern principle based on freedom, Adrian Piper iconically remade her own head, injecting more negroid blood into her veins, accentuating the black of her skin, without denying her white kins, all effected ritually and psychically using iconic diasporation devices of form and by mimesis.

Piper's diaspora spirit is made manifest in her video, *Cornered*, as well as in her drawing, *Self-Portrait Exaggerating My Negroid Features*. The provocations for her virtual nomadism began while she was a kid: black boys in the black neighborhood where she grew up in Harlem called her "paleface," while white boys didn't date her because she was black. She shared the story of her class teacher who asked her (Piper's) parents whether they did not tell her (Piper) that she was a negro – since she kept wanting to use the white bathrooms when the kids went on excursions. She also shared the experience of the slightly tipsy mother of her first boyfriend, who told Piper that she (mother) was too liberal to mind that her son was running around with a little negro girl; that it was in fact kind of cute.

Piper claims not to have the "black experience" because the color of her skin was too white. Black kids thought that she was not black enough to claim to be black, so they always excluded her from activities designed for blacks. Neither has she the white experience, because her social status as black excludes her, even though the color of her skin, her ordinary appearance,

includes her. Her father had two birth certificates, one identifying him as white, the other negroid. She does not need a birth certificate, because there was none that could adequately accommodate her line. Like her progenitor, she requires several birth certificates to describe her, and as soon as one certificate is presented, it becomes necessary to show the others. Thus her shuttles, diasporations, constant motion, nomadism, from one race to the other, as she hyperbolizes in her negroid self-portrait, complements the picture where she masks as white.

Valiant as the two pictures stand, they also mask and manifest the anxiety of a mind that seems pigeon-holed by a society seeking easy modes of classification. At any one time, she is always defined in terms of race, white or black, whenever people look at her, they see whatever they want, whether white or black, depending on what she chooses to represent at particular moments. Since her esthetics includes a philosophical curiosity about the nature of mankind, she explores the volatile field of racial interaction, deploying visual stimuli. People have lost their individual identities, she seems to conclude, and have herded together into different races. Her work asks: why can't people speak neither of black nor of white? Why must it always be exclusionary as either/or? These same questions baffle Loraine O'Grady, whose exploration of misogyny similarly provokes issues of masking and diasporation. For O'Grady, it is an inclusionary issue of both black and white. For Piper, it is both and neither.

The black and white crack is a strange fault to fall into, within a society that demands absolute manichean positions. Blackness is one of Piper's virtual passports and depending on the circumstances, she is judged by it, she represents it, signifies it. But at the same time, whiteness is her right by her look: she appears Caucasian to the ordinary eye. Cornered by the society that would like to pin her down to black or white rather than black and white, she also corners the society by diasporating, by masking back and forth between the races, by being an unstable and destabilizing racial entity, portending the future of the human race as formed now. It is apocalyptic for racism, emblematic for metamodernism.

Her video performance, *Cornered*, is an iconoclastic metaphor of that struggle, as she puts society to task to define what race exactly is. She does not hide the fact that she has her back against the wall. That is both the literal and metaphoric imagery of the video. The camera claustrophobically pins her against the wall, corners her into one of the four angles of the room, where she eloquently but calmly takes her stand. Pushed so deeply into the bowel of the wall, there is the sense in which it appears she is being hunted and haunted, and is finally captive. Thus she seems to speak under provocation, under interrogation, even though the bodies of these interrogators are not visible on the screen.

In the course of the interrogation, it becomes clear that she turns the table. She totally seizes the conversation and turns it into a monologue. She takes the

voice away from the aggressor, whose only weapon of offence remains the staring eye, symbolizing the camera, signifying violence, the monocular gun, the aimed phallus.[11] And now she is in full control of the rapist, who has frozen in the middle of the offense. She does not lose her calm. Is she smiling sometimes in the same shot in which she appears to be crying? She produces a severe Gothic picture using the female television anchor idiom, with its almost religious iconography, as her lips utter a strange message of racial indeterminacy, as she talks sometimes with traces of pain, sometimes of amusement. But unmistakable is the mask of abstraction that nothing could penetrate, violate any further. This is for her the very end of the corner. She has been driven as far as it is possible to go. And she remains inviolate, which is what turned the table: it is the rapist who blinks and gets cornered, pinned down, impotent, dared to rape, unable to escape from metamodern gravity.

She corners the camera with the last issue it does want to cover: a discourse on race. Purportedly, everyone knows that race is not a discourse, it is a disgust disguised as discourse to make it seem decent. It has proved a bomb-shell in the United States, a powerful conversation killer. That is why the camera cringes when confronted with a race discourse, something that quickly appreciates into a Piper monologue. Somebody said that the kind of smile Mona Lisa is wearing could only come from a woman following good sex. The kind of smile that Piper is wearing in *Cornered* emanates from a victim of attempted or actual rape, from a burnt-bride victim in the searing throes of intellectual *sati*. Certainly, to extend the Geeta Patel parable, there may not be much to choose between a card-carrying Western feminist and a burnt-bride of *sati*. Everyone is cornered, everyone on fire, every issue is burning. We witness the morbidity of the postmodern era and acknowledge the triumph of diasporation, of metamodernism. Everybody, does it not seem, is in one form of diaspora or the other: in some measure of distancing, of masking, renaming, reconstruction, re-membering, recollecting? We think often in terms of a black or a Jewish diaspora: the whites in America are in no less a state of diasporation than the blacks. Is the entire world, therefore, not undergoing the diaspora age? Like the Egungun masquerade, as diaspora people, do we not often manufacture and carry our own garbs across the chthonic realms of life via several continents, over several generations?[12]

Among a younger generation of artists, the above question, the issue of multiple diasporation provokes Renée Stout's work, where she uses art as a means of attenuating her diaspora identity, by drawing on the images of her real or imagined ancestors. Being metamodern in a neo-Gothic world, she dwells on atavistic connections. Diasporating from the physical to the metaphysical plane, she employs Nkisi art from among the Kongo as her transitional vehicle.

A painter turned sculptor/installation artist, Renée Stout is a Washington D.C. mixed-mediaist, whose mythological and multi-dimensional work often breaks boundaries between painting and sculpture. Her simulacral

self-representations distance her body in fetishistic rituals of self-diasporation. Symbolically returning to Africa by appropriating the Kongo Nkisi iconography, Stout banishes the image of her own body within the metaphysical realms of East African homeopathic aesthetics. Her *Fetish #2*, casts Stout's metabody image in an alienating pose that distances her from mortality, creating an empowering body within which her spirit feels free to sojourn, an exile from a racist, technologized society.

Fetish #2 is confrontational. It challenges the canon of Grecian beauty, perhaps because right from the beginning, the artist's autophilia causes her to concentrate on the specificities of her own body, and not on some external ideal of beauty. Diaspora existence is beautiful, she seems to say, and I embody it. Her embodiment of diaspora existence is as a woman, thus her work generates gender agendas and issues of sexuality, beyond the basic racial determinism.

Her diaspora body in *Fetish #2* is not only nude, but masked with fetishes that distance, transform and de-eroticize the flesh.[13] In this work by Stout, the multiplication of diasporation causes disorienting distancing. In a marriage between her own body and Kongo Nkisi fetishism, Stout diasporates herself, shows every part of her body, but without revealing any flesh. On the contrary, the nudity translates into a mask form, concealing rather than exposing her flesh, confronting us with her metapsyche, even as we stare at her metabody. The image leans on us aggressively, and we must retrace our steps to engage it, or to allow it to engage us. This metabody is a recollection of myriad sources and materials, including visual, literary and choral samplings, resolved into a complex three-dimensional assemblage that spectacularly diasporizes Stout's mortal body with transmortality. Metabodies cannot, should not promise immortality.

Metabodies signify the natural sense of loss accompanying the normalization, hence demise, of postmodernism and mythifications caused by the psychic migration, dislocations and relocations of metamodern figures – of diasporation. There is the sense of loss caused by the transgression away from native homeland. At the same time, the art results and benefits from this same condition of the diaspora. The Rastafarian yearning for Zion is only possible because the Rastaman is in Babylon. Without Babylon, there would be no Rasta.

Increasingly, Rastafarians are everywhere, and the motherlands, for many people, have turned into Babylons, while all creative spirits must live in diasporic metamodern conditions. It is nothing peculiar. Metamusic such as rap, as well as metapainting such as graffiti, all define the conditions of diaspora, of distancing, of metamodernism. Is it merely coincidental that Pindell, Piper and Stout often inscribe writing into their works – in the spirit of graffiti, or rap? Or is it part of the larger era of diaspora that is now upon us after we have finally passed the last posts of familiar culture, and now move into a metamodern art?

In the process of representing the selves as forms or metabodies, Pindell and

Piper, as well as Stout, through diasporic strategies, reveal and amplify other aspects of themselves that are invisible on their native bodies. Diasporation thus becomes a strategy releasing artists to reconstruct themselves according to their desires. This creative freedom seems to contradict the conventional perception of diaspora as a place of pain, discontent, anguish and confinement, beyond the tolerance or manipulation of the body in diaspora.

The concept of multiple diasporation enables a viewer to investigate the space of diaspora as a forum specifically created to free artists from the limitations not only of the native lands, but also of the native body. Based upon distancing techniques, especially that of masking, multiple diasporation gives full rein to formal or metabody experimentations that are either not possible, necessary or acceptable in motherlands or on natural human bodies.

The drive for diasporation is a necessary and natural instinct that has helped in the definition of metamodernism. Diasporation celebrates how artists/natives expand and transcend all boundaries, break the chains of the native flesh, and make masks that endow mortals with transmortality. Diasporation is itself a condition of strangeness. But it goes beyond the limbo of postmodern disorientation, and reintroduces the mythic, gothic dimensions of metamodernism.

In diaspora sites, there is no horizon. The scripts of diaspora landscapes draw a convocation, a return home, to metamodern mimesis, as modern masks. Even celebrated masquerades must not overstay their welcome in diaspora, before they return to their homelands. The trouble is, whenever the diasporating ancestral bodies return home, it is not home, never as they left it, since the world is always at peril. Unable to return to the modern from the postmodern, what remains of black diaspora culture is the metamodern, infused with the drama of postcolonial struggles, with its quasi-religious devotion to an aesthetics of salvation. Even home diasporates, so there is never any real homecoming, implying that the initial sense of departure is an illusional conspiracy between time and space, forming a synchronization that purports to redeem the perilous world.

Decipher, in conclusion, the Egungun masquerade, as it dances and creates space with the swelling whirls of its gyrations, while time beats rhythm with space. As it progresses steadily into the dance, distancing itself towards and into the landscape, it also knows that the Egungun is on a return journey home, because the dance is mounted on a borrowed body, using a borrowed time, in a land of diaspora. Using the portrait framings of borrowed bodies, Pindell, Piper and Stout appliqué black female life as a masquerade dance of the diaspora, where masked bodies perform their distancing away from home, in self-imposed forms of alienation. It is a metamodern display of multiple mimesis, using diaspora forms to salvage a world invariably at peril.

Notes

1 Metamodernism may be read as metamythic modernism, inclusive of and transcending all forms of modern myths, such as the metaphysical, geometric, gestalt, existentialism, postmodern, and late modern. While the modern scope covers a mere fraction of the activities of the twentieth century, the metamodern explores all forms of this era: for example, the physical and psychic relationships between the work of, say, the Yoruba sculptor Bamidele Arowoogun and Pablo Picasso, both of whom are temporal if not geographic contemporaries.

2 Somatic diaspora involves geographic migration while the mythic and the psychic does not entail any geographic movement, but relies on imagining and imaging the mind.

3 The Egungun is the Yoruba spirit of the ancestors that annually returns to the world of the living using the medium of the mask.

4 "Unconventional," that is, to the west, that has imposed itself as the manifestation of global conventions, rules and regulations.

5 *Jonkonu* refers to John Canoe, some legendary Caribbean masquerade form, apparently a survival of African culture in the diasporas.

6 Geeta Patel, "Killing the Other Off," unpublished, University of Iowa, undated.

7 See Howardena Pindell, "Art World Racism: A Documentation," *New Art Examiner*, March 1989, pp. 32–6.

8 Most of the information for this essay was collected in a series of discussions with the artist, between September 1995 and March 1997.

9 Anonymity, of course, is in the eye of the beholder.

10 Wande Abimbola, *Sixteen Great Poems of Ifa*, (Lagos: UNESCO, 1969).

11 Piper does not identify that by which she is cornered (the American society) as male. She does not exclude women.

12 If for many people, Africans, Jews, etc., diaspora migrations have been accompanied by violence, dislocation and distress, it must be so stated. There are others who have diasporated across continents and under less turbulent circumstances; while this is worth mentioning, it does not nullify the alienation experiences of those who enjoyed relatively painless diasporation.

13 See Wyatt MacGaffey and Michael Harris, *Astonishment and Power*, (Washington D.C. and London: National Museum of African Art), 1994.

DAUGHTERS OF SUNSHINE

Diasporic impulses and gendered identities

Irit Rogoff

I Introduction: The production of "belonging"

The Modern Myth of the Jew as pariah, outsider and wanderer
has, ironically enough, been translated into the post modern
myth of the Jew as "other", an other that collapses into the
equation: writing = Jew = Book. Such an exclusive address ulti-
mately obscures the necessity of mapping out a space in which
the Jew *was* native, not a stranger but an absolute inhabitant of
time and place.[1]

(Alcalay 1993 : 1)

Alcalay's "Jew as Pariah" transformed into the "Jew as Book" is writ masculine,
a metaphor extracted from material culture and conceived of in terms of the
universalizing and homogenizing stereotypes of abstracted scholarship; out of
time and out of place. The discussion I wish to pursue, that of European Israeli
feminine identity and its visual representations, is situated at the intersection of
the two states described by Alcalay, those of belonging and of displacement
and of their inevitable and mutual interdependence. It is an intersection in
which the desire for an emplaced belonging, enacted by European Jews in
Palestine and refracted through the edicts of Zionism, produced an internally
contradictory range of vehement, performative and highly gendered identities.
These produced identities would consequently serve an ideological purpose,
they would enable laying claims to land and writing histories for those claims.
Within visual culture many of them are writ feminine and distinctly
European; their tasks however defy the conventional codes of traditional fem-
inine activity – women laundering and breaking stones for road paving,
women posturing as soldiers and modeling swim wear, women making con-
temporary art from the gendered scraps of forbidden nostalgias. The images of
European women are equally conscripted into the fervor to produce and rep-
resent that elusive concept of belonging, mapped onto modern, European
bodies. At the same time they also act out a certain diasporic dissonance, a

diasporic desire for a much hankered after yet unachievable state of belonging that is written in their bodies and gestures, in the veiling and performing of their sexuality, in their physically embodied challenge to the indigenous bodies around them. The extreme contrast between the representation of active, productive, machine-like European feminine bodies and the representation of passive, silent immobile "Oriental" feminine bodies within the visual culture of Zionism, attests to this production of "belonging."

Supposedly these very Western images exist within the framework of a nationalist rhetoric in which they are nothing more than the feminine counterpart to the radical socialist project of Zionism. By this I mean that they are the assumed representations of actual social, material and cultural conditions and actions in which these women's bodies participated as part of the collective heroics of early Zionist activity in Palestine. It remains to be seen whether the conjunction of feminist theory, post-colonial analysis and the study of visual culture can serve to puncture the surface of such totalizing nationalist rhetorics and nationalist imagery in order to reveal their fundamental incoherences. While feminist theory insists on the importance of situated knowledge, the study of visual culture insists that images are the sites of identity constitution rather than a reflection of the cultural and material conditions of their making. Furthermore, the emergent arena of visual culture analysis recognizes the importance of the bearer of the gaze and the range of subjectivities through which specifically thematized gazes and their cultural imaginaries reconstitute meanings. Thus the combined insights of both of these theoretical models of cultural analysis might work to reconfigure the purposes to which these wishfully charged images of women in Zionism were put, isolating their protagonists out of any organic and naturalized relation to the land so as to be able to lay a claim to that very land.

That so much of Zionist Israeli culture should have paid so little attention to the cultures of Arab Jews whose histories of regional belonging have been so ancient and so complex, that these have not provided a model for the newly rewritten relation between a people and a place, attests to the resolutely European nature of this model of a diasporic homecoming of the imagination. An analysis that genders every component of this process from the ideological inscriptions of images to the gestural codes of performative bodies, might go some modest way towards dismantling the homogenizing aspects inherent in any modernist, totalizing, European ideology such as Zionism.

As a native Israeli I was taught to understand Judaism through the State of Israel, a moment of national coalescing that somehow also served as a rupture, or perhaps an assumed healing, within the paradigm of Judaism as pariahdom throughout the ages. Now I have begun to wonder about an inverse model, about the possibilities of reading Israel through the divergent histories of numerous Jewish communities outside of the State. Perhaps it raises the possibility of reading the State as a national discourse that mobilizes the desire to belong through a new definition, an outsider's definition of what and how it

means to belong. In adolescence, every story I heard, every picture I saw, every song I sang served that capacity of constructing a culture of belonging in which we were both actors and audience, simultaneously producing that belonging and culturally surveying it, being seduced by it. In a history so overdetermined by one overriding anxiety and one overriding concern, it is obvious that a totalizing set of ideological imperatives would sweep aside any consideration of what we today might term "difference" or of differentiated experiences. In fact, much of the purpose of producing a culture of belonging was to eradicate the concept of "difference" that had served to create the racial differentiation that marked European Jews as those outside the culture in their host countries, those who do not "belong." How would such a notion of difference, of feminine or sexual difference in particular, affect the scenarios of belonging which were being woven in the culture I was raised in? It seems increasingly clear to me that one cannot have a culture of belonging without maintaining a consciousness of "not belonging" against which it exists in a permanent state of defiance and self definition. On the one hand there was the historical model of the "unbelonging" of Jews in the so-called diaspora, and on the other the construction of a whole new category of "unbelonging" under the aegis of Zionism such as that of Arab Jews and Palestinians. If this grounding binarism is indeed characteristic of the culture I am trying to engage with, then it is imbued with a necessary nostalgia and desire for the "old world" that are essential to its project but cannot be consciously acknowledged, for they are the very heart of what the new State has set itself to replace. So many of the avenues one would ordinarily pursue within a less forbidden and a less overdetermined terrain have been closed to me through moralizing historical discourses, that a direct critique of Zionism via the terms it has set up and the paradigms it has determined are impossible, they would only sustain a true/false, right/wrong dichotomy. This is the reason I have ventured to examine the contradictory and conflicted desires of Zionist ideology through the representations of women within it.

Unacknowledged and unspoken ideological contradictions have always informed the ways in which cultures set up and represent femininity as a meeting point between rational and irrational discourses. Perhaps if I could gain insight into how the culture of belonging shaped the represented identities of women within it, I might also gain some perception of its own internal contradictions. Therefore what I am trying to do in this piece about European, privileged Israeli feminine identity and its relation to the diaspora it left behind, is not to define it in any way but to put together some of these elements of disruption, dislocation and narration and to see how they work one upon the other.

While it is both ideologically imperative and politically urgent to address the complexities of other, marginalized, non-European feminine identities within modern Israeli culture, such as those of Arab Jewish women or Palestinian women, this does not absolve us of the responsibility of examining

165

the actual identity formation of privileged positions. It is these Eurocentric cultural subject positions that have continued to dominate the popular imagination with regard to definitions of national identity and to determine all forms of otherness as inferior to themselves. Since the European Israeli identity does not question its own values or regard itself as anything but normative and universal there has been little opportunity to acknowledge its own profound internal contradictions or to problematize its extremely uneasy relation to the European cultures upon which it builds and draws for its own overall hybrid identity. By using categories of gender and Eurocentricity to read across fortified and barricaded narratives of nation we may be able to illuminate some of the inherent contradictions which have worked to mold dominant Israeli culture in relation to the European cultures that had rejected its own founding fathers.

The critical models that have helped me think through some of the issues raised in this essay have emanated primarily from the work termed critical analyses of colonialism and minority discourse. These have posited complex and elaborate analyses of both the cultural systems constructed by old world colonialism as well as of conditions of cultural and racial marginality and hybridity within the contemporary post-colonial world. At the heart of all of these discussions there are trajectories of cultural power relations between colonizers and colonized or between dominant hegemonic culture and emergent minority identities. The subject position I am attempting to deconstruct in this discussion however, cannot be fully or exclusively accommodated within this theoretical framework. While European, middle-class Israeli identity is undoubtedly a colonizing presence within the regional political map as well as within the internal ethnic map of the state, the feminine subject positions within it are simultaneously colonized and marginalized both in relation to dominant ideology and the ensuant internal contradictions of its own gender specific identity. The attempt to understand and locate such split subject positions – historically oppressed, inhabiting a performative ideological stance and functioning regionally as a local colonial power – has resulted in this instance in a somewhat fragmented and inconsistent form of theoretical bricolage. I have, in recent years, encountered far too many analyses in which the female component of colonial or colonizing powers was assumed to be cognate with and acting out of identical imperatives to its male counterparts, albeit through a different set of social institutions such as the domestic rather than the public sphere. Thus the ensuing fragmented account is offered in the feminist hope that it may ultimately be helpful in articulating an emergent set of contradictions which have been so firmly glossed underneath the rhetoric of western, progressive ideology.

How then can one attempt to understand the inherent tensions within this Israeli feminine identity as well as to disavow the authenticity and coherence that it has tended to claim for itself? Part of my intention in so doing is to suggest possibilities for a greater plurality of coexistent, fragmented voices and

identities within the geographical region of Israel/Palestine – identities that do not necessarily have to claim for themselves a fully representative coherence or authenticity and therefore do not have to masquerade as the sole legitimate representation of an indigenous population. If the conflicts and struggles between Israelis and Palestinians are to be understood as more than territorial but as a struggle over the possession of an authentic and locally rooted identity, then a major part of our attempt to critically address and understand these struggles must be invested in the claims which we make for our own identity. For as Adorno said, "It is part of morality not to be at home in one's home"[2] and it is in the name of (re)possessing this mythical home/land that much of the vehemently insistent nature of constructed Israeli identities has been mobilized.

It is equally important, to my mind, to address these issues within the arenas of culture, of a

> struggle [which] is an essential counterpart to political and economic struggle. Since cultural hegemony continues to play an invaluable role in the production of subjects who are compliant toward the economic and political domination of internal as well as external colonialism, and since it legitimates the acceptance of one mode of life and the exclusion – or extermination – of others, the function of cultural criticism and struggle is to contest continually the binary oppositions on which such legitimation is founded.[3]

For it is within the arena of radical culture, unlike those of party political rhetoric, that fragmentation of voices can occur, that modes of representation can be seen to engage in legitimate contestation with one another and that formal and stylistic disjunctures and experiments can be attempted to capture, to some extent, the "newly arrived at consciousness" of our incoherent selves. For in the words of Arif Dirlik,

> An authentically radical conception of culture is not only a way of seeing the world but also a way of making and changing it. . . . Culture is not a thing, to paraphrase E.P. Thompson, but a relationship. It is not merely an autonomous principle that is expressive of the totality constituted by these relationships, a totality that once it has been constituted, appears as a seamless web of which culture is the architectonic principle, exterior to the socio-political and logically prior to them. . . . Culture is an activity in which the social relations that are possible but absent, because they have been displaced or rendered impossible (or utopian) by existing social relations, are as fundamental as the relations whose existence it affirms.[4]

In attempting to introduce a dimension of sexual difference into the "possible but absent" social relations of Israeli identity, we may simultaneously be able to

extend the axis and historical dynamics of internal fragmentation as well as work towards a re-radicalization of culture.

II Narratives

A couple of years ago a friend and I were sitting astride the fortified outer walls of the ancient crusader city of Acre on the Northern Mediterranean coast of modern Israel. We were, as is our wont, ignoring the multicultural profusion around us; the Israelis and the Palestinians, the earnest pink-nosed English tourists with their Baedekers and the elegant, laconic French ones lolling about drinking local wine, for we were immune to such panoramas of difference, we had both been born into the newly-founded State of Israel, into a babble of immigrant cultures and tongues soon to become that most excruciating of cultural experiences, "The Melting Pot." Instead, as we dangled our feet towards the warm Mediterranean, we spoke of that most fascinating of all subjects; ourselves. "Our Tragedy," proclaimed my friend, "is that we believe we are the real Europeans, that those people out there in France, Germany, Spain are simply fraudulent parvenues who have usurped our rightful cultural place." "Look at you" he continued pointing an ironic crooked finger, "Ninth generation in Palestine, first generation of an independent Jewish state, the fulfillment of so many generations' dreams and hopes, and you spend your entire adult life immersed in the two cultures which have most oppressed your people in this century." He is referring to the fact that I did all my studies and lived for many years in Britain and that I work, when I can persuade myself to be geographically and historically specific, on modern German culture. Look indeed, but do not speak, for ours is the shared experience of a childhood in the shadow of the recent European holocaust of which no one could speak, an omnipresent legitimating narrative for every form of aggression and discrimination perpetuated by the State and the culture, which could not, would not be acknowledged in language.

At the same time in which this conversation was taking place I was reading a novel by Israeli author David Grossmann. The novel which is called *See Under: Love* defies any attempt at formal categorization or description; suffice it to say that it is a series of narrative voices, Israeli and European, past and present, which attempt to construct a language of the holocaust; lived, experienced, received, misunderstood, mythologized and abused. At the novel's center is a 9-year-old boy named Mommik growing up in Israel in the 1950s, the only child of two haunted survivors and living in the midst of other survivors whose utter disorientation is reflected in the confused babble of old and new tongues in which they communicate with the world, as if fearfully uncertain of who will be tuning in or of what they can speak clearly and what must remain coded and veiled. A secret society of mutes at the heart of the declamatory, and abrasively proud new nation. The following is a scene from Mommik's childhood section of the novel:

Bella sits at one of the empty tables of her grocery/café all day long reading *Women's Own* and *Evening News*, smoking one cigarette after another. Bella isn't afraid of anything, and she always says exactly what she thinks, which is why when the city inspectors came to throw Max and Moritz out of the storeroom, she gave them such a piece of her mind that they had a (bad) conscience for the rest of their lives, and she wasn't even afraid of Ben-Gurion and called him "The little Dictator from Plonsk," but she didn't always talk that way, because don't forget that like all the grownups that Mommik knew Bella came from **Over There**, a place you weren't supposed to talk about too much, only think about in your heart and sigh with a long drawn out krechtz, the way they always do, but Bella is different somehow and Mommik heard some really important things from her about it, and even though she wasn't supposed to reveal any secrets, she did drop hints about her parents' home **Over There**, and it was from her that Mommik first heard about the Nazi Beast. The truth is, that in the begining Mommik thought Bella meant some imaginary monster or a huge dinosaur that once lived in the world which everyone was afraid of now. But he didn't dare ask anyone who or what. And then when the new grandfather showed up and Mommik's mama and papa screamed and suffered in the night worse than ever, and things were getting impossible, Mommik decided to ask Bella again, and Bella snapped back that there were some things a nine year old boy doesn't have to know yet, and she undid his collar button with a frown saying it choked her just to see him buttoned up like that, but Mommik decided to persist this time and asked her straight out what kind of animal is the Nazi Beast, and Bella took a long puff of her cigarette and stubbed it out and sighed and looked at him and screwed her mouth up and didn't want to say, but she let it slip that the Nazi Beast could come out of any kind of animal if it got the right care and nourishment, and then she quickly took another cigarette, and her fingers shook a little and Mommik saw he wasn't going to get anymore out of her.[5]

The conjunction of these two narratives generated for me a series of speculations concerning diaspora and diasporic culture; traditionally in our Israeli context the diaspora referred to the various scattered communities of Jews who had been exiled by the Roman conquerors of the land of Israel in the first century A.D. and had scattered throughout the world. In attempting to reconstruct that land in the twentieth century, we, the second generation as it were, seem to have reversed that relationship and had become in turn a diaspora of the host cultures into which our ancestors had been exiled and from which they had been banished. Ours, then, was a complex culture founded in nostalgias for imaginary, mythical locations in which we could

function as oppositional marginals to the dominant order, as a constant disruptive "other" against which the center could define itself. A new cultural construct had begun to emerge amongst us and which viewed itself as the "diaspora's diaspora." This collapse of a clear historical order of center/diaspora relations led, in my mind at least, to the need to re-evaluate the relations between history and geography, between collective cultural narratives of "Over Here" and the signification of that which is "Over There." Mommik the self-styled spy and investigator eavesdrops whenever he can; "Mommik is so excited he forgets to shut his mouth! Because they are talking freely about **Over There**! It's almost dangerous the way they let themselves talk about it. But he has to make the most of this opportunity and remember everything, everything and then run home and write it down in his notebook and draw pictures because some things it is better to draw. So when they talk about certain places, **Over There** for instance, he can sketch them in this secret atlas he is preparing."

III Analyses

I am attempting to construct an argument concerning geography and identity that revolves around questions of displacement viewed by a former member of the Israeli intelligentsia who has herself undergone several displacements backwards to the cultures which were previously considered to be "diasporas." The argument I am trying to present here concerns a contemporary siting which I would call the "Diaspora's diaspora" and negates the very basic historical assumptions that an old people could conceivably have a genuine "new beginning." It seems to me that there are several dynamics between "home and exile in existence within the problematic interaction of collective cultural and gendered identities as set up within the modern Jewish state."[6] The dominant narrative of "return home" is problematic not only because of the legitimation it provides for territorial claims but also for the seamless naturalization of the concept of "home" that it puts forth as a cultural metanarrative.

Instead, I wanted to use the rather interesting conjunction of Judaism, femininity and modernity as an opportunity to speculate on the contemporary revisions and the internal contradictions of these supposedly progressive, egalitarian and ungendered intersections. As in all so-called "radical" societies, in Israel there was an imperative master narrative of struggle under which all other categories of potential difference and conflict were subsumed and trivialized. In the case of the modern Jewish State the dominant ideology of socialist Zionism presumed to speak for two categories of oppression, those of the Jews as an oppressed minority as well as for their transformation from marginal, reviled serfs into a revolutionary working class linked to an international struggle. In effect this was a transition from margins to center, countering traditional European anti-Semitism with its exclusions and persecutions of Jews with a participatory political project that aligned the Jews with other

oppressed elements in society within the context of an international move-
ment that transcended national or regional belonging and authenticity.

That these were to be transposed into the Eastern Mediterranean, into a
land already inhabited by a people with an equal set of claims to it, into a cul-
tural location that could not be more different from the underground radical
Socialist movements of Central and Eastern Europe at the turn of the century,
did not seem to overly worry the movement's ideologues. The supposedly
seamlessly progressive identity of this society is constituted out of a discourse
which is white, Eurocentric, bourgeois and masculine and assumes itself to be
the norm and the measure of what it is to be Israeli, while masking a huge
array of differences in internal and external injustices and discriminations
against Oriental Jews, local Arabs, Palestinians, not to mention those against
women. Given the prominence of Israeli and related affairs within the inter-
national media there is no need to go into a detailed critical analysis of this
supposed identity, for its internal incoherence is in fact constantly being
exposed through a variety of much reported policies and the fierce debates
which these generate both nationally and internationally.

For all of this criticism I am nevertheless a product of all of these uneasy
corollaries and find it necessary to try and unravel them in some potentially
interesting and questioning mode. This then is a position of cultural hybrid-
ity which produces the need to problematize the seamless rhetoric of con-
structed national identity through the transnational critical tools evolved
within my own generation's movements of resistance to hegemonic culture
and the categories through which it establishes itself as normative and index-
ical. Thus an examination of specific feminine identities within the modern
Jewish State can actually provide some useful insights into the overall pat-
terns of internal conflict and contradiction to which any form of Israeli
identity would by necessity be subject. To begin with, feminine identity is
positioned as filial, "the daughters of Zion" being a local variant of traditional
Jewish femininity, which holds a secondary position within the traditional
religious culture, as well as being linked to the actual land in some filial and
organic manner. But the subservient and secondary nature of this feminine
subject position is further exacerbated by the passive shouldering of the bur-
den of history. In a poem entitled "No License to Die," Esther Fuchs, a
young feminist poet and daughter of Holocaust survivors tells of her aborted
attempt at suicide:

Their faces as I was led away
on the stretcher

No *Gestapo*, no *Kapo* is upon
you are after all newly invented
A Bride of Sunshine
How dare you?

171

The forgiveness I beg –
They were in crematoria smoke
I have no license to die.[7]

Esther Fuch's poem speaks of the despair of attempting to actually possess an identity of one's own in a society in which collective trauma has served to simultaneously infantilize and bind one to duty, to make one responsible for the existence of a supposedly better world in which such a genocide could never occur. Within this trajectory, the concerns of women born long after the war had ended and the State of Israel had been founded could not be viewed as anything but self-indulgent desires aimed at a form of bourgeois, individual gratification. In my youth the culture abounded in sentences such as "you do not know the meaning of horror, of hard work, of suffering, of sacrifice, of loss, of victimization" etc., etc. We were meant to be "newly born" but at the same time we were supposed to provide a daily, conscious and, not least, a grateful reminder of the negation of the old world. Women, whose experiences, needs and desires had been completely subsumed under the rhetorical mantle of so much supposedly radical innovation and progress, seemed poised between two extreme models of femininity and identity, a radical European Socialist one that served as an oppositional stance to the world they had come from, and a passive timeless "Oriental" one that served as a mythologizing perception of the world they had immigrated to.

Being much preoccupied with visual culture and the ways in which images construct meanings and mediate power relations, I would like to examine some images derived from classroom textbooks and popular histories that circulate widely in modern Israel. These are officially circulating representations of fictive, idealized femininity functioning as binary opposites between which no actual identity could be formulated.

The earliest images show pioneer women who had immigrated from Eastern Europe at the turn of the century, performing both private and public chores, laundering the clothes and breaking up stones for the paving of roads and building of houses.[8] In each case there is a staged quality to the photographic narrative; in the image of the laundering there is an Arab man idly languishing against a post in the background as if to declare that the women are doing this menial labor for reasons of ideological conviction and refusing to have it done by the indigenous population of the land which could conceivably be hired to do so. In the stone breaking image the two women are focused on their work, while the numerous men stand about posing for the camera and unemployed. The fictions have to do with an attempt to disassociate the protagonists, the early pioneers, from the normative, exploitative codes of European colonialism in the Eastern Mediterranean and with the myth of gender equality in the early communal existence of the first waves of ideologically motivated "aliyah." Contemporary accounts however, alert us to the mythologized nature of this equality; Fania, a woman pioneer of the second

wave of immigrants and heroine of the novel set in the Rosh Pina pioneer set-
tlement in the 1880s, "Gey Oni" ("Valley of Strength"), complains: "Of all the
things that were said the one which constantly scorched her memory were
remarks casually made by the doctor, 'There are nine Biluyim in Gedera and
one woman' . . . as if she were not a person! Nine persons and one something
else."[9]

The dreamy, idealistic pioneer girls were within twenty years to become the
thickset, severe, bespectacled matriarchs of the Labour movement, political
hacks like Golda Meir who did little for the cause of women and conformed
in every way to the dominant, masculinist mode of party power politics.[10] As
the building of the fledgling community progressed, we find images of women
building houses, ploughing the land, working in light industry and in service
industries such as the telephone and electricity companies. They are focused
and attentive to their tasks, their bodies are veiled beneath layers of functional
clothing, their sexual identity negated, subjugating themselves to their duties.
They, through their disciplined bodies, have become work tools within a
socialist culture that valorized labor as the highest achievement and the great-
est agent of equality. It is important to understand how these bodies are used
to make claims to the land and to render those claims naturalized and organic.
These representations of women linked to the land posit a new relationship,
one in which the land is not owned or possessed as within the feudal or colo-
nial systems which immediately preceded it, but is served and nurtured and
made fertile. Thus both the land and its occupation are feminized through
internally linked dynamics of subordination, service and fertility. Their direct
opposites are the "Oriental" women, passive and quiet and self-absorbed,
clothed in cumbersome traditional clothes that bespeak the exact opposite of
the pioneer women's public physical work. Toting small babies or sitting in
traditional "Oriental" poses, they inhabit an arena of ahistorical timelessness, an
exotic Other against which the pioneer women's activities seem even more
extraordinary and their revision of traditional femininity even more radical.[11]
Not least, the fictive positioning of these women as passive and subdued served
as a legitimizing narrative for the imposition of a set of foreign cultural values
over the existing ones in the name of twentieth-century progress.

In the period leading up to the "War of Independence" and the establish-
ment of the state in 1948, we see a shift in the photographic construction of
femininity circulating within the culture. On the one hand there is an obvious
escalation in the real level of participation by women in underground and mil-
itary activities against the British Mandatory government and in preparation
for what seemed to be an inevitable conflict with the indigenous Palestinians
and neighboring Arab states, a participation dictated by demographic scarcity
since the Jewish population of Palestine numbered no more than 600,000 at
that point. The images, though, indicate another set of shifts, in the perception
of a femininity mobilized for a cause, dictated by circumstances rather than by
the severe strictures of ideological purity. If we examine the images of the

women arming the mountain of hand grenades, crouched in tortuous and implausible positions, of the woman being led away by the British soldiers with her arms on her head, or of the woman soldier with her arms on her hips in a confrontational pose apparently belied by a sweet and charming smile, a distinct pattern begins to emerge. The degree of physical confrontation and the far greater emphasis on gendering these bodies as female, on situating them as on display, begins the process of humanizing belligerence through an insistence on a new and self-consciously aggressive femininity. The difference in signification has as much to do with the shift from choice to necessity as it has to do with the cultural conventions of specific historical moments. More importantly, it is the moment at which the links with the two previously mentioned defining poles, the European and the Oriental, gets radically redefined in favor of a newly born construct, the "Israeli woman," who can be allowed neither the choices of the European woman nor the passivity of the Oriental one. The surface aggression masks a level of filial subservience, this time to the State and the dominant Zionist ideology.

Forty years on, the cycle of unceasing aggression, destruction, injustice and loss of life seems to continue without cease. The State of Israel, founded on a rhetoric of socialist equality, has been continuously shaken by accusations of racial discrimination against Sephardic Jews and by gnawing voices insisting on recognition for the Palestinians. The situation of women, who had started out as supposedly equal partners in the radical social experiment of Zionism, has remained sadly unevolved. There are few women in public life, feminism is a marginal and ridiculed movement, the traditional family dominates every aspect of life and dictates the circumstances and priorities of women's existence and possibilities, and most important, we can perceive an exceptionally acute crisis of identity. The identity which had been forged between the two extreme poles of European and Oriental has now receded back into those poles. The model in the Gottex advert conforms to every known cliché of the "Oriental beauty"; dark haired and dark skinned, her hair an unruly cloud of curls, her costume vaguely reminiscent of the harem, she is supposedly firmly situated in the specific geographical region.[12] The inherent contradiction between adopting a set of so-called Oriental aesthetic values and then negating them through the display of the nearly naked body and the provocative posture is one that perfectly represents the internal contradictions of Israeli feminine identity. The model on the cover of *Naamat* – a vaguely feminist mass circulation women's magazine in Israel linked to what was the Labour party daily paper *Davar* – is made up with a mask of glittering, sophisticated make-up that adheres to a European aesthetic of the remote and distant feminine.[13] Attempting to adapt to a region with which it is engaged in active daily warfare, dreaming nostalgically of lost European worlds, cloaking itself in a mantle of emancipatory rhetoric and living out a traditional and contradictory life, femininity in Israel is experiencing not just a crisis of identity but also a crisis of context.

IV Gendering diasporic nostalgia

These different representations have been circulating within the culture throughout this century as an increasingly coherent and solid mythical narrative. In recent years the internal contradictions of these gendered identities have become the focal point of a few, far too few, interrogations within visual and textual culture. The cool, analytical work of Sigal Primore, a young Israeli visual artist who has only recently begun to exhibit her work internationally, is to my mind one of the most interesting speculations on this split identity.[14] The imaginary setting of the work is a fiction of urbane, European culture centered around the world of opera houses and concert halls. With this she acknowledges the extraordinary symbolic and ideological centrality that classical music has in Israeli cultural life, which is flooded with orchestras, visiting musicians and apparently has one of the largest classical music concert-going publics in the world. Aside from the obvious historical reasons that make music the most international, transient and easily transportable of high cultural practices, it is also the one that supposedly transcends national cultural identities and thus can be appropriated as "our" cultural heritage, one that is exclusive to the European population of Israel and denotes their privilege without being obviously discriminatory. In Primore's work we see the entire gamut of romantic narratives associated with the world of high musical culture; violin cases lined with velvet are echoed by reduced scale evening gowns of glistening taffeta and velvet in glowing jeweled colors, all alluding to an acculturation of women's bodies and a recognition of the seduction and sexual allure of high culture. The extreme artificiality, the emphasis on identity as a form of staged theatrical production is investigated through the endlessly intricate play with concert hall balconies, parapets and walkways which immediately bring to mind the opera house paintings of Renoir and Mary Cassat.

Primore's work articulates a perception of identity as a feminized cultural spectacle. It is a complex cultural gaze in which subtle intersections of a longed-for mythologized heritage and a remote and privileged femininity intertwine and define one another, as in Central European novels of the 1930s such as those by Vicki Baum, in which spectacles of high culture (opera houses, cafés, grand hotels) supposedly masked internal differences and struggles. There is an acknowledgment of the simultaneity of insidership and outsidership, of the conjunctions of heady and rapturous cultural experience and of the staging of desire through that experience. In a work entitled "The Bride and The Echo" we see a photo of a generic European opera house. Empty and cavernous, it draws us into its vast spaces through the promise of opulence, romance and fulfilled desire that it holds forth to our cultural imaginations. It is surrounded by plywood cutouts of female images holding out some printed sheafs of paper, perhaps music manuscripts, perhaps romantic scenarios. Superimposed over the entire image we find the slick, cold metalic image of Duchamp's bride from the "Large Glass" narrative of the "Bride Stripped Bare

175

by her Bachelors, Even." This image by Duchamp stands in as the referent for all that is "modern," European, technologically constituted and progressive. In one single artistic referent, the entire contextual, geographically located world of the Near East and the Levant can be dismissed and denied. The invocation of Duchamp has less to do with his actual work than with reception and its position as groundbreaking and paradigm-shifting modernist work. In Duchamp's mechanized speculation on human sexuality in the crisis of modernism, the bride in the upper part of the work is being anchored down by the "bachelors" in the form of chocolate grinders entitled "The Bachelor Grinds his own Chocolate." The two gendered panes of the Large Glass remain separate:

> If the "Large Glass," and thus the "love operation" of the two machines had been completed, the Bachelor Machine, "all grease and lubricity" would have received "love gasoline secreted by the Bride's sexual glands" in its "malic" cylinders for ignition by "the electrical sparks of the undressing" and mixing with the secretions of the ever-turning Grinder, would have produced the ultimate union. In its "incomplete" state the Large Glass constitutes rather, an assertion of the impossibility of union – of the sexual alienation of man and woman in a situation which Lebel describes as "onanism for two."[15]

In Sigal Primore's works the bride has detached herself from the glass and from the oppressive binarism of the image of sexual alienation. Her mechanistic image of femininity, its metallic sinuousness representative of a rationalised female sexuality in the service of some modernist ideal or other, hovers longingly in front of the photo of the opera house, eager to penetrate the luscious mysteries of cultural promise it holds out to her. It is a poignant image of cultural nostalgia, of the ideals of modernism looking back to the seductive fictions of the old world and its belief in culture's ability to transcend reality. The Bride's Other is no longer the entire gamut of grinders and malic tools but the fictions of the past it wishes to escape into as if it holds some promise of a union, cultural rather than sexual, which being trapped in Duchamp's mechanized "Glass" has barred her from. The work viewed as a whole perceives culture as performative, as a gendered spectacle of the desire for culture in which femininity is both staged and displayed, viewer and viewed. It seems particularly appropriate that all of these dynamics and desires be framed within the legitimating narrative of modernism, for, like the relation between Zionism and international Socialism, it too frames discourses within an illusionary internationalism and the shared goals and ideals of an ideology of "progress."

I am particularly interested in Primore's work because it seems to me to thematize and reflect on the condition of ambivalence and contradictory longings which the European oriented cultural life of the State of Israel manifests. This is a Second World ambivalence towards cultures of origin, rather than a Third

World relation to these, as can be seen via a comparison with the condition described by Palestinian-born writer Anton Shammas whose first novel was written in Hebrew, his second language. "In my humble case," writes Shammas

> as a Palestinian who was ungracefully deterritorialised by the Hebrew language (which Dante had described in the fourteenth century as the language of Grace) – what I am trying to do is deterritorialise the Hebrew language, or, more bluntly to un-Jew the Hebrew language and make it the language of personal narrative discourse. In a certain sense, that is what most of the writers of the Third world are doing these days: undoing the culture of the majority from within. The deterritorialisation of the colonizers' language is the only way to claim their own territory, and it is the only territory left to them to claim as an independent state – the only one they can afford to call a homeland.[16]

The clear purpose of such a project is denied within European oriented Israeli culture, at least overtly, since the relationship with its oppression is more complex; after all it was the Jewish intelligentsia in many of these originary cultures who contributed to its cultural formation or who took part in internal processes of its deterritorialization. Perhaps it is a nostalgia for such a position that we are experiencing, a hankering after diaspora which allows us an internal oppositional role. Perhaps those of us who occupy positions of clearly articulated ambivalence and who work to thematize and research those past European cultures from which our ancestors were expelled and to which we at some level gravitate and try and make our own have become "the Diaspora's diaspora," to coin a phrase. Nowhere are these contradictions and ambivalent states more clearly visible than in the condition of femininity within the Israeli State, as I have tried to map it out in my brief and inadequate survey through encounters with a set of visual representations.

The value of Sigal Primore's work for my argument is that it is so insistent on critically examining the myths of cultural heritage and is so uncompromising in pointing out the subtle and insidiously positioned superiority of the European heritage within collective cultural fantasies and identity formations. In her astute recognition that culture and cultural rituals are profoundly gendered and provide a refuge space away from the sorrow and the constant unease that accompanies the daily life of the State of Israel, she is also exposing the rhetorical fictions of women's identities. The external trappings of the "new beginning" have collapsed back inwardly onto the extreme poles of feminine identity, each in its own way a fantasy projection of an impossibly romantic ideal which claims a new identity but seems unable to actually provide a set of new, or even revised, values for that identity. Instead it lives out its contradictory destiny and acute ambivalences through endless stagings of cultural desire and through the production of internally conflicted femininities

that attempt, with great difficulty and at great cost, to bring about some form of denied reconciliation.

Notes

Taken from "Daughters of Sunshine – Diasporic Impulses and Gendered Identities," *Race and Gender in Visual Culture*, ed. Lisa Bloom, Duke University Press, Durham, 1997 and "Daughters of Sunshine – Diasporic Impulses and Feminine Identities," in *Judische Kultur und Weiblichkeit in der Moderne*, Ed. Sigrid Weigel, Böhlau Verlag, 1994.

1 Of the many works, both scholarly and literary that I have read in pursuit of these interests, two in particular stand out as having shaped my critical thinking on the constructed relations between European Jews and their sense of place. Amiel Alcacaly's book *After Jews and Arabs – Remaking Levantine Culture*, University of Minnesota Press, 1993, showed me clearly that while there had indeed been a relationship between Jews and place it was not the claimed one of European Zionism but the lived one of the Arab Jews of the Levant and the religious Jews who settled there in the years prior to Zionist domination. Similarly Ella Shohat's book *Israeli Cinema – East/West and the Politics of Representation*, University of Texas Press, 1987, first began to explore a model of thinking Israeli culture in terms of First and Third world tensions and through the analytical models of the critical analysis of colonialism. While their work may not be quoted here extensively, since my preoccupation is primarily to interrogate dominant ideology through an attention to gender and sexuality, it nevertheless serves to continuously inform and embolden my arguments.
2 Theodor Adorno, *Minima Moralia*, p. 36.
3 Abdul JanMohamed and David Lloyd, "Towards a Theory of Minority Discourse," Introduction to *Cultural Critique*, No. 6.
4 Arif Dirlik, "Culturalism as Hegemonic Ideology and Liberating Practice" in *Cultural Critique*, No. 6, p. 7.
5 All translations from Hebrew into English are my own, David Grossmann, *See Under: Love*, Sifriyat Hapoalim, Jerusalem, 1986.
6 For a radically new reading of the relation between Zionism, Judaism and territoriality as articulated through the ideology of a return to "homeland" see Boaz Evron, *A National Reckoning*, Tel Aviv, Dvir Publishing, 1988.
7 Esther Fuchs, *No License to Die*, Tel Aviv, Ecked Publishing House, 1983.
8 Ada Maimon, *Women Build a Land*, Herzel Press, New York, 1962.
9 Shulamit Lapid, *Gey Oni*, Tel Aviv, 1984, quoted in Mira Ariel, "Creatures of Another Planet," *Politika*, No.27, July 1989.
10 Daphna Izraeli, "The Golda Meir Effect," *Politika*, No. 27, July 1989.
11 Emil Feuerstein, *Women Who Made History*, Israel Ministry of Defence Publications, Tel Aviv, 1989.
12 D.G.Sh. advertising agency Tel Aviv for Gottex Intl. July 1989.
13 Cover Photo, *Naamat*, June 1989.
14 *Feminine Presences*, Tel Aviv Museum of Art, Summer 1989.
15 William Rubin, (incorporating quotes from Duchamp) in *Dada and Surrealist Art*, N.Y. 1968, p. 40.
16 Anton Shammas in Philomena Mariani (ed.), *Critical Fictions – The Politics of Imaginative Writing*, (DIA Center for The Arts, Discussions in Contemporary Culture, No. 7) Seattle, Bay Press, 1991, p. 77.

10

THE HILL BEHIND THE HOUSE

An Ashkenazi Jew and Art History

Eunice Lipton

<div align="right">Paris, January 1992</div>

We'd barely stepped into his house, when smiling and filling our glasses, our host said: "I'm so tired of the American press talking about how Jewish this writer is and that writer is. Who cares really?"

Now, this man *looked* Jewish, and to be honest that's why we'd sent him an inquiring note in the first place – that, plus the name Hofenberg on *someone's* mailbox in the hallway. I glanced at Ken and Carol, they at me: Maybe we made a mistake. Always the quickest to take offense, I was ready to leave. But soon the wine and fireplace did their work and we found that we were excited to be having this conversation here in Paris – this *type* of conversation. Nonetheless, we set to disabusing our host. We had not noticed such discussions in the press. Yes, there were many Jewish-American writers and they were regularly reviewed, but any special calling attention to their – what shall we call it, ethnicity? – that wasn't the case.

Francis Hofenberg, our dapper 61-year-old half-English, half-French host, backed off, but a half hour later, his eyes hard, his lips white, he said: "Look, my friends, Hitler accomplished what he set out to accomplish. He destroyed European Jewry. What does it mean to be a Jew now? Forget about it."

Forget about it?

I have often wondered why I became an art historian, such a glamorous profession for a working-class Jewish girl born in the Bronx to Communist parents in 1941. Art didn't figure in my childhood; we never went to museums. My mother did have some Mexican things she loved – a plump orange vase, a carved wooden tray. And, yes, there was a brownish print of ballet dancers by someone named Degas and another picture drenched in burgundy by Renoir.

<div align="center">179</div>

But I don't remember where they came from, and no one ever talked about them. It was music and literature that stirred our passions – Bizet's *Carmen*, Tchaikovsky and Rachmaninov's piano music, Dostoyevsky, Turgenev, Gorky. So how did it happen that I became expert in the pleasures of seeing? I, along with so very many other Jews in America – Bernard Berenson, Walter Friedlaender, Seymour Slive, Erwin Panofsky, Sidney Freedberg, Meyer Schapiro, Linda Nochlin, Robert Rosenblum, Carol Duncan, Al Boime, Leo Steinberg, Linda Seidel, James Ackerman, Clement Greenburg, Harold Rosenberg, Rosalind Krauss?

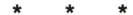

It's winter 1945, Hurleyville, New York. The white-haired grandpa pulls the little girl along, his ruddy, smiling face a talisman. He roars, she giggles through the snow, up the main road of the village, this quiet town in the Catskills where Jews and Gentiles live together. Rushing by the houses and the hills, the old man pulls the sled filled with the child's merriness and the pristine beauty of the day. The girl, holding tight, loves the wind nipping at her cheeks, her silken hair coaxed out of hiding. She's 4 years old, and today she's a queen, her Grandpa's warm expanse of back her guardian.

> "How are you doing, *mein kind*?"
> "I'm dreaming, grandpa. I'm dreaming of mommy and Grandma's soup and . . ."

As their house drifts into view, the girl is imagining the thick soup and warm bread on the table, but suddenly something cold slips around her heart. Something about her Grandma by the gate, her hair loose, her soft mouton coat flapping in the wind, a thin house-coat pulled tight around her legs and hips and breasts.

> "Grandma?"
> But grandma looks at Max, her husband, and pushes a newspaper into his hands.
> "*Nem* a look, Mendel," she cries, half in English, half in Yiddish, tears running down the creases of her face, the sparkle in her eye extinguished.
> "Max. Max. *Was kennen mir tun*?" What can we do? The Grandma – Anna – moans.

The child throws her hands up to her ears. The newspaper slips to the snow, and the two old people stand there weeping.

The girl's eye wanders the vista near and far, back and forth, left and right; everything's gone grey and still. Her glance lingers on the newspaper at their feet – some pictures, stick figures like chicken bones eaten clean, black and

white striped pajamas. She pulls at Max's hand, but he ignores her. She pulls again, this time smiling up at him. He lifts her, his arms so all around that she can see his hands on both sides.

"Chanaidl," he says – Anna – "Let's eat. We've been dreaming of your nice soup with the barley and carrots and noodles. Come inside, Chanaidl." As he says this, Max brushes tears from his face and hers and gently pushes a stray lock of hair behind his wife's ear, "Come, *meydele*."

They eat their meal together silently.

Afterwards the little girl sits down in a corner of the spacious kitchen; she's waiting for her grandma to finish the dishes. Near her are the red geraniums that come in for winter; their orangey velvet transfixes her. But just as she reaches to touch their soft friendly parts, she notices a story-picture on the wall and falls instead to staring at it. In the picture, there's another little girl who is stretched out on two wooden chairs. She is half under a blanket with one arm hanging down. Her lips burn a red spot in her face, her golden hair spreads along a pillow. A kindly man in a black suit sits nearby, leaning towards her, worried. There's a table to his left with a small glass bottle, a lamp with tilted green shade, a cup with a spoon resting in it. On the other side of the child's head is a low rough-hewn bench with a large bowl and pitcher. Behind her hover dark figures, a woman weeping, a man standing alongside. The little girl gazing at the picture is not sure what's happening. Over and over again she scrutinizes every detail. Her eye wanders the light and dark surfaces; the colors – now gold, now green, now black – absorb her; she repeats this activity endlessly. It calms her.

Winters are long in Hurleyville, and although the little girl loves her grandparents, she wishes she had some children to play with. For instance, she wishes she could play with Pearl across the street. Every day lately she says, "Grandma, can I play with Pearl?" And every day Grandma says: "No, it's too late today"; or, "No, I can't come to get you later"; or, "No, they were hollering this morning." But on the day when the newspaper falls to the snow, Grandma looks at her and says, "*Kind*, they're Gentiles over there; they're not Jewish like us. You don't want to play with them."

This makes the girl angry. What's "Jewish"? She's heard this word before, and she's seen the two pretty white buildings in town with the towers and the colored windows and the crosses, and she knows she can't go inside them, she even has a feeling she would die if she did, that some witch would eat her up. She also knows that her grandparents shop on one side of the road in town and not the other. And there's a bakery about which she thinks Grandpa says "Jewish." It's from that pastry shop that the old man brings her the wonderful warm cakes with the white sugar stripes and raisins.

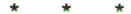

Certainly many a Jew of my background – first generation American, parents born in Eastern Europe whose first language was Yiddish – chose professions

that took them far, far away from the chilling specter of murdered Jews. Indeed, we were legion as we fastidiously stepped out of earshot of the centuries-old moan: "What did we do to deserve this? Why do they hate us so?" As the child in Hurleyville threw herself into the painting of the doctor contemplating the dying girl (Figure 10.1 – see Note 1.), so did I, the grown woman, turn a habit of my heart into professional expertise – and armor. Somewhere, unconsciously, I decided never to make a spectacle of myself – a *shanda fur de goyim* (an embarrassment in front of the Gentiles) – I would try to dress and sound like everyone else. I would enter a profession where they would least expect to find me. Then they couldn't kill me. They wouldn't know who I was. So, I wound up all my pain and fear, everything I saw that day in my grandparents' aching hearts and sorrow-filled faces and threw it through the trajectory of my gaze into the contemplation of pictures. I pushed away – pressed way, way down – all the horrors the cold-blooded murder of Jewish people held for me, not least of which was that I might lose the only people who loved me, that my grandparents' hearts would turn to stone, that their eyes would never look upon me with tenderness again. I pressed this terror, sublimated this hurricane into esthetic wonder and intellectual perusal. In this I found the pleasure of my senses and my mind. And respectability. I became an art historian.

To this day I find it hard to admit that I wrote several articles and a book about Degas, and never addressed his rabid and – as Linda Nochlin put it – his

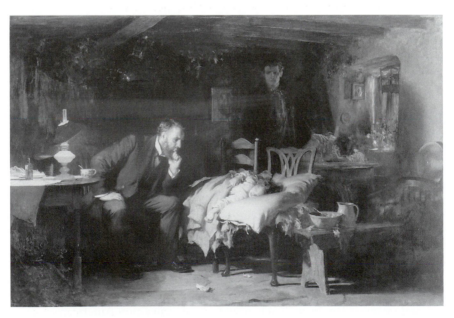

Figure 10.1 Sir Luke Fildes, *The Doctor*, 1891. Tate Gallery, London. ARS, New York.

"ordinary" anti-Semitism (see Note 2). I acknowledged it, but brushed it aside. What *I* was interested in, I would say to myself, were his images of women. My concerns were beyond, superior to, any considerations of racism; art held aloof from such issues: "I'm not Jewish, I'm an art historian."

A number of experiences in the winter of 1992 made me re-think these certitudes. One was the incident described in the epigraph to this article. Another was this: I learned one afternoon that many European Jews after World War II did not tell their children they were Jewish. This repulsed me. How *could* they? Were they ashamed? Why would they be? Hadn't the war "vindicated" them? Wasn't the world horrified by what Jews had suffered? Didn't everyone think Germany was an evil society, and Jews innocents? Then a French friend married to a French Jew who hadn't learned he was Jewish until he was 24 turned to me angrily and said, "Don't you realize how afraid they were? They knew it could happen again." Afraid? Why it had never occurred to me. Or, rather it had "occurred" to me and so terrified me that I "forgot" it. That's why, I finally understood, I ignored Degas' anti-Semitism. I couldn't tolerate the thought that I could be that vulnerable; I simply could not — was incapable of admitting this terror to myself. So, I held to my respectability, and I hoped disguise.

Nonetheless, and contradictorily, I was proud of being Jewish. I'd often embellish my speech with the little Yiddish that I knew. I always *said* I was Jewish. But it was *I* who said it, not others. I thought I couldn't be caught off guard, that the disclosure was my choice. But I always lived and worked among Jews, first in the Bronx in the 1940s and 1950s, then in Washington Heights, then on the Upper West Side of Manhattan. I went to the High School of Music and Art, which I considered Jewish, and then to City College and New York University. I taught at City and State universities in New York. Looking back on it, I realize now that I "saw" Jewish everywhere — not a hard thing to do in New York — but that unbeknownst to myself I was constantly constructing a ghetto for myself in which to feel safe and protected from the Gentile world. Where Gentiles existed in my world I simply didn't notice them, even when they were my friends. Becoming an art historian was part of this delusional and protective strategy. I needed to be where Jews were, that is I wanted a profession that would allow me tacitly to acknowledge my Jewishness through the company I kept, but I also wanted to hide, to be Gentile. I wanted to assimilate, but on my own terms, and ambivalently.

So when it came to writing about Degas, I simply didn't notice his anti-Semitism. I excised from my mind the anti-Semitic facts of his life, the many references in the literature to his hatred of Jews: for example, Camille Pissarro, the Impressionist painter who was a Jew, casually referring to him as that "ferocious anti-Semite" (see Note 3). I never even wrote about his overtly anti-Semitic, "At the Stock Exchange" (Figure 10.2 – see Note 4).

In my book, *Looking into Degas: Uneasy Images of Women and Modern Life*, I dealt with paintings, drawings and prints of ballet dancers, washerwomen,

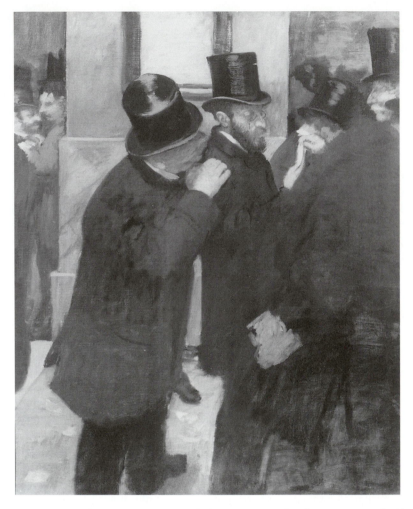

Figure 10.2 Edgar Degas, *Portraits à la Bourse*, Musée d'Orsay, Paris. © Photo RMN.

milliners and prostitutes. I wrote as a Marxist and a feminist. I analyzed the relationship between a near-aristocratic man like Degas and his working-class female subjects. That is, I detailed how he transformed his class and psychological experience – which I often noted was a mixture of contempt and admiration towards these women – into pictures. I was particularly interested in Degas' bather paintings, which I interpreted as transformations of a prostitutional motif. I was drawn by the pleasure of the pictures: women's bodies cared for and caressed, sometimes by themselves, sometimes by others; the delights of wildly mingled colors – pink-oranges against salmon against silver blue, greens speckled with rose; cramped, compressed spaces where swirling lines, curves and

angles met. How Degas could miraculously transform the traces of pastel excess and their unsteady path across the paper into forms my eye desired.

There was a painting, however, which bore evident similarities to the bathers, but which I assiduously avoided. Not that I didn't look at it, and wonder about it, but I always stopped short of writing about it. Titled "The Pedicure" (Figure 10.3 – see Note 5), it represents a little girl seated on a daybed in a child's room, a rich child's room. She is wrapped in a sheet out of which protrudes one little hand and one leg from the knee down. The pedicurist is partially hidden by a spindle-backed, straw-bottomed chair that in turn is obscured by another white sheet on which the girl's leg rests. In the background is a dresser where a small water pitcher and bowl are located, and

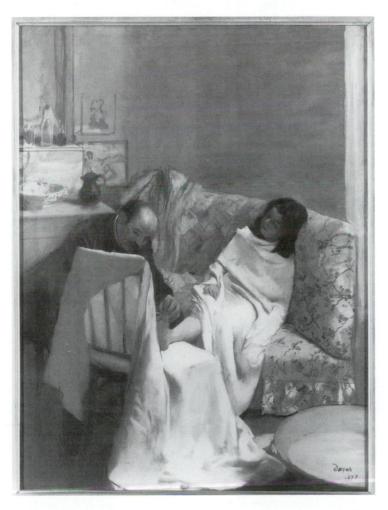

Figure 10.3 Edgar Degas, *Le Pédicure*, Musée d'Orsay, Paris. © Photo RMN.

this is abutted by one end of the daybed at the corner of which some garments hang, presumably what the little girl was wearing before she undressed for her pedicure. In the bottom right corner of the picture is a large washbasin.

"The Pedicure" is a suggestive and muted painting. The washbasin and removed clothing plus the little girl's languor – even stupor – suggest vulnerability. Though nothing precisely threatening is happening, an atmosphere of malaise pervades the picture.

Another provocative painting of Degas' that I ignored is called alternately "The Interior" and "Rape" (Figure 10.4 – see Note 6). It is a puzzling nocturnal picture with a man in shadow leaning against the door of a bedroom, his legs spread, his hands in his pockets. Across an eerily lighted room sits a woman, who, like the man, is partially in shadow; she is three-quarters turned away huddled sideways on a simple wooden chair. Her white chemise slips off her left shoulder. Between the man and the woman is a silky bed with iron bedstead across which is thrown what look like a woman's street clothes. A corset lies on the floor. A small, round, wooden end-table is near the middle of the painting with a lighted, shaded lamp and open vanity box or small suitcase. It is a hot painting, and a mean painting. Both psychological and physical danger pulsate in it.

These works would seem to have fit easily into my consideration of Degas' art. Issues of class and gender are at their heart, and the style of both is the realist one that interested me all my professional life. I now think that I avoided

Figure 10.4 Edgar Degas, *Interior*, Philadelphia Museum of Art: The Henry P. McIlhenny Collection in memory of Frances P. McIlhenny.

these paintings because unconsciously I was reminded of Fildes' "The Doctor," the painting that had so riveted me as a child in Hurleyville and into which I had projected and buried unbearable feelings. In fact, the stylistic and literal similarities between "Rape" and "The Doctor" are startling: the almost identical diagonals of the beds in each; the nearly interchangeable pose of the seated figures; the tables with particularized and emotionally laden objects, the triangular lampshades. A major emotional difference among the paintings, however, is that the sad but powerful doctor in one is transformed into a vulnerable woman and girl in the others. "The Pedicure" and "Rape" like Fildes' "The Doctor," show a man and a woman, or girl, together. The women are in jeopardy; the threat of death and violation chew at the edges of the paintings.

It may be that I became an art historian because I happened on a picture when I was a child onto which I projected my deepest terrors. It is where I sought to bury the Holocaust, for an Ashkenazi Jew like myself that foremost of unsilenceable events. The study of pictures became the locus of my repression, and a terrain of solace and pleasure. It was the vehicle of my assimilation.

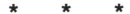

What would writing as a Jewish art historian look like? We know something about what writing as a woman is (see Note 7). But as a Jew? Maybe it would be something like this:

I've always had secret loves in paintings, rather like the pornographic fantasies you never tell anyone for shame. My embarrassment comes from liking something I – and I'm afraid others – will construe as sentimental and nostalgic. I fear that trusting and savoring the pleasures of the past can only get me into trouble. I hear the injunction to move on, don't look back, let the past go. Or, if you must remember, think about betrayal and abandonment, not pleasure. Otherwise a golem will snatch everything away from you.

"The Hermitage at Pontoise" (Figure 10.5 – see Note 8) by Camille Pissarro is the first picture you see when you walk into the Thannhauser Collection at the Guggenheim Museum in New York. It's a big green painting inflected with gold, white and brown. There are solid mauve square houses along a road that mounts the center of the picture. People chat along the road. The green has more yellow than black in it; it's a sunny, friendly green. The mauve is more white than brown. Pissarro has chosen a tranquil, ordinary moment for his painting.

I love the painting, as I do others like it – big, lush landscapes with neither beginning nor end, pieces of an inviting continuum. It enfolds me, draws me in; it respects the road and the quiet joy people can take in each other's company. There is a certain reverence in this picture for community and social intercourse. There are peasants in landscapes by Constable and Corot, but they are small and socially inconsequential, they are spots of color. But in Pissarro the figures are important. You can imagine them, a piece of their lives, even the words they speak to each other.

Figure 10.5 Camille Pissarro, *The Hermitage at Pointoise, c.* 1867. Solomon R. Guggenheim Museum, New York, Thannhauser Collection, Gift of Justin K. Thannhauser, 1978. Photo: David Heald, © The Solomon R. Guggenheim Foundation, New York.

I am reminded here of something Emmanuel Lévinas wrote in *Difficult Freedom: Essays on Judaism*:

> The banal fact of conversation . . . quits the order of violence. This banal fact is the marvel of marvels. To speak, at the same time as knowing the Other, is making oneself known to him. The Other is not only known, but he is greeted (see Note 9).

This happens in Pissarro's paintings even when the figures are tiny; it does not happen in Monet. Lévinas thinks this conversation, this looking in the face, as he terms it, is quintessentially Jewish. He continues in the same essay,

> The face, for its part, is inviolable; those eyes, which are absolutely without protection, the most naked part of the human body, none the less offer an absolute resistance to possession, an absolute resistance in which the temptation to murder is inscribed: the temptation of absolute negation. The Other is the only being that one can be tempted to kill. This temptation to murder and this impossibility of

188

murder constitute the very vision of the face. To see a face is already to hear "You shall not kill." (See Note 10)

Perhaps this is too much to say about a mere landscape, but I read in Pissarro's painting an honoring of human dignity.

Historically, Jews haven't owned land, although my grandparents did. Was there something about being in America that gave them the idea that they could? And something perhaps in France that said the same to Pissarro? France, after all, had a reputation of being good to Jews. Until Dreyfus. This painting by Pissarro was done nearly thirty years before the Dreyfus Affair.

And the Hurleyville of my childhood? The town, the hill, the people, the sense of community? The Jews. Even if I didn't think about it, I knew who was Jewish and who wasn't, even when I was 5 years old. Also, I had such a longing to cross the street and climb the hill behind the house where Pearl, the Gentile girl, lived. Then one time when I did climb it with some friends, we stumbled on spectacular views which we never, never found again, mythic views that never can be found again.

Notes

1 This painting by Luke Fildes is called *The Doctor* and was painted in 1891. It is located in the Tate Gallery, London.
2 Linda Nochlin, "Degas and the Dreyfus Affair: A Portrait of the Artist as an Anti-Semite," in *The Dreyfus Affair: Art, Truth, and Justice*, ed. Norman Kleeblatt (Berkeley, CA.: University of California Press, 1988), p. 108.
3 Camille Pissarro, letter to his son, Lucien, January 21, 1898, in Camille Pissarro, *Letters to his Son Lucien*, ed., with assistance of Lucien Pissarro, John Rewald (Santa Barbara, CA.: Peregrine Smith, Inc.), p. 409.
4 Painted in 1879 and located in the Musée d'Orsay. Linda Nochlin brilliantly analyzes this picture in "Degas and the Dreyfus Affair," op. cit. pp. 99–101.
5 Painted in 1873, located in the Musée d'Orsay.
6 Painted c. 1868–9, located in the Philadelphia Museum of Art.
7 Nochlin, for example, in her astonishing article, "Courbet's Real Allegory: Reading The Painter's Studio," writes, "For me, reading as a woman . . . the Irish beggar woman constitutes not just a dark note of negativity within the bright Utopian promise of the allegory of the *Painter's Studio* as a whole but, rather, a negation of the entire promise. . . . Figuring all that is unassimilable and inexplicable – female, poor, mother, passive, unproductive but reproductive – she denies and negates all the male-dominated productive energy of the central portion." See, "Courbet's Real Allegory: Reading The Painter's Studio," in Sarah Faunce and Linda Nochlin, eds, *Courbet Reconsidered* (New York: Brooklyn Museum, 1988), p. 27.
 See also Eunice Lipton, *Alias Olympia: A Woman's Search for Manet's Notorious Model and Her Own Desire* (New York: Penguin, 1994) for an interpretation which puts the author's feminine subjectivity at the center of the story.
8 This painting is located in the Guggenheim Museum and was executed in 1867.
9 Emmanuel Lévinas, *Difficult Freedom: Essays in Judaism*, trans. Sean Hand (1963 and 1976; Baltimore: The Johns Hopkins University Press, 1990), p. 7.
10 Ibid., p. 8.

Part IV

POLAND–BRAZIL

11

IMAGING THE SHTETL

Diaspora Culture, Photography and Eastern European Jews

Carol Zemel

Diaspora derives from the Greek *diaspeirein*, to spread about, but to most of us, the term is less benign; it implies a disabling fragmentation and scattering of a once-unified people. This unity stands as the "before" – the time and space before dispersal – and as a cherished cultural myth; it evokes the site of "home" and territorial nationhood. But diaspora implies duration as well as geography. A diasporic people endures dispersal for lengthy periods. The long-ing for return remains – formulated in shared cultural rituals and reinforced by inter-community ties – at the same time as the diasporic condition acquires its own coherence and becomes a way of life. Thus, more than the condition of exile, which is bound by memory *and* experience to a still-existing homeland, diaspora society is "at home" in its dispersal, and there it teeters between assimilation and difference with varying degrees of comfort or unease.

Perhaps no people has troubled definitions of modern nationhood more than the Jews. Though their identity as "nation" derives from biblical texts and has endured since antiquity, for centuries Jews existed in the European imagi-nation as metaphors of exile, guest inhabitants repeatedly condemned for their refusal of Christianity to various expulsions and wandering homelessness. But if they were a people without a land, a diaspora, they were not without their distinctive geographies: Spain and North Africa, Turkey and the Levant, the United States – all have been home to great Jewish cultures.

From the sixteenth to the twentieth centuries, Jews lived in great number in the vast region that stretched from modern Lithuania through Poland, Russia and Ukraine. In 1797, the Russian Empire declared the area a Jewish "Pale of Settlement." Intended as a buffer zone between the Russians and Poles, the Pale became, in effect, a supranational territory, and for its Jewish inhabitants, a space of diasporic consciousness that transcended shifting frontiers and whose landmarks were synagogues, study centers and rabbinical courts. Within the Pale, Ashkenazic Jews developed an extensive *shtetl* [village] culture, by

which is generally meant a Yiddish-speaking, provincial society, orthodox in its religious practice and traditional Jewish way of life.[1] By the 1920s, however, the *shtetl* culture of Ashkenaz had been transformed by half a century of modernization, secularization and emigration to cities in Europe and America. For many Jews, this was an ambivalent undertaking – an escape from ethnic and economic oppression, but also an escape from "self" or home, a flight from *shtetl* orthodoxy's self-confinement in the past.

This essay concerns images of eastern European Jews produced in the 1920s and 1930s by two Jewish photographers, Alter Kacyzne and Moshe Vorobeichic. The work is similar in subject, but different in photographic style: pictorialist documentary in the case of Kacyzne's images, modernist photo-montage in Vorobeichic's work. Both photographers, however, represent a traditional, diasporic society at a moment of modernization, when Jewish culture in Eastern Europe was rapidly changing, but contrary to conventional thinking, was not dying or lost. We can see signs of this modernizing encounter in Kacyzne's much-reproduced photograph of a *kheder* (school-room) taken in 1924 (Figure 11.1). The locale is Lublin, but the obscuring shadows in the image mask any specificities of setting and render it generic: this is any pre-war *kheder* in the Pale. In it, we see little boys in caps and side-curls sitting side by side, their chins barely reaching the reading table, while a bearded *melamid* (teacher) hovers over them and guides them through the *aleph-beyz* (ABCs). The image marks an important moment in a Jewish boy's life, as he begins the journey from childhood play to religious study and affir-

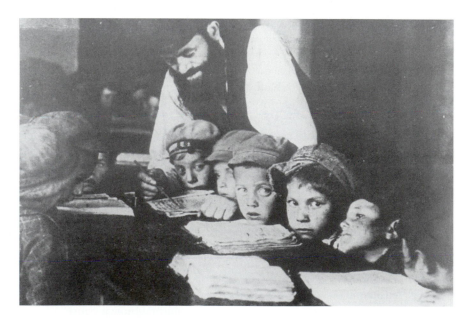

Figure 11.1 Alter Kacyzne, *Kheder in Lublin* (1924).

194

mation of the "people of the book." Like most kids, their attention wanders – this is part of the picture's charm. They exchange glances, whisper or daydream. But two wide-eyed fellows at the image center, their heads visually punctuated by the *melamid*'s white sleeve, stare down the table toward us, and doing so, they activate the picture's real dynamic: the sudden intrusion of camera and photographer, of technology and modernity, into this traditional space.

Although it is structured differently, the picture by Moshe Vorobeichic made in 1931 (Figure 11.2) is no less a confrontation of tradition and modernity. The encounter here is hardly intimate, as the viewer looks from some distance,

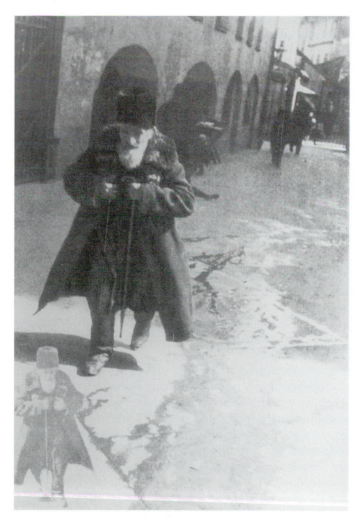

Figure 11.2 Moshe Vorobeichic, "The Day is Short," from *The Ghetto Lane in Vilna* (1931).

almost separate from the depicted space. A white-bearded old man makes his way along the icy pavements of an arcaded street. In fur hat and flapping over-coat, clutching two canes and his *tallis* bag under one arm, the man is deter-mined, purposeful, but also a somewhat awkward silhouette. And though dark figures in the background suggest pedestrians and commerce, the setting is mainly characterized by the man and the arched passage: both are aged and both are picturesque. Here too, the picture's air of timelessness is interrupted, not, however, by the photographer's intruding presence, but by the photo-graph's modernist montaged style, which shatters the cohesion of the image and flash-forwards the Jewish elder into history as a small, pale, apparitional echo at the lower left.

Despite their stylistic differences, both images subject a traditional society to the modern viewers' scrutiny. Their meanings today, however, are not always easy to define. Some see them as sentimental and nostalgic; others find in them some social commentary or even critique. And almost inevitably, the pho-tographs are shrouded or – to use Michael Andre Bernstein's term – "back-shadowed" by the tragic aura of the Holocaust. "Backshadowing," Bernstein writes, "is a kind of retroactive foreshading in which shared knowledge of the outcome . . . is used to judge the participants . . . *as though they too should have known what was to come.*"[2] Not only do we look at these pictures with the poignant knowledge that most of their subjects were murdered in the war, the images themselves are almost predictive after the fact: the people and activities – indeed, the culture – shown are doomed, and the pictures seem to forecast that destiny. This effect was initiated with the New York daily *Forvarts'* publi-cation in 1947 of *The Vanished World*, a photo-book that included many of Kacyzne's images.[3] Of course, photographs in general seem to stop time; the future and death are held in abeyance, lurking at the edge of the frame. And given the scale of the Jewish catastrophe, some backshadowing is inevitable here. Nevertheless, without dismissing the post-war response, I believe these images deserve less tendentious readings, readings that set aside the aura of impending doom and are grounded instead in the diasporic and nationalistic context of those interwar years.

In fact, pictures like these were made for a variety of reasons: documenting social conditions, celebrating forms of Jewish culture, commemorating a soci-ety that some thought would assimilate and thereby disappear.[4] But as images of Jews by Jewish photographers for international Jewish audiences, they also constitute images of a people – self-images, in fact – and in doing so, they set before us photographic self-formulations of a Jewish identity. My interest, then, is not only the pictures' content, but also their status as cultural projects: that is, I am concerned with the ways in which they photographically config-ure a people and the possibilities they suggest, both in form and content, for Jewish society and culture in the modern nation state.

As collections – they are not family snapshots, after all – these photographs locate and define what Benedict Anderson has called an "imagined commu-

nity," a community in national consciousness rather than fixed territory.[5] In their visual formulations of a society, circulated through print media well beyond their points of origin, we might say that the pictures perform a cultural task; Homi Bhabha labels it, in a literary context, "narrating-a-nation."[6] Like national epics, novels or tales of panoramic social sweep – the Yiddish literature of Mendele and Sholem Aleichem for example – these collections selectively celebrate, critique and render iconic aspects of ethnic identity and Jewish community life.

But what makes the model of nation-narration especially useful is the ambivalence both Bhabha and Anderson claim is a condition of nation-making and nation-discourse. Bhabha writes of "a particular ambivalence that haunts the idea of the nation, the language of those who write of it and the lives of those who live it," and he cites Anderson's position that " 'nationalism has to be understood [through the] . . . large cultural systems that preceded it, out of which – as well as against which – it came into being.' "[7] Seen this way, national consciousness both cherishes its history and repudiates elements of its past. To accommodate this ambivalence, nation-narration is riven with polemic; it overdetermines its anxiety in stereotypes, and its emphases – on youth and old age, poverty and labor, religion and study in these photographs – can be signposts of tension and disjuncture, as well as strength. If we apply Bhabha's model of nation-making to the conditions of diaspora, with its varying degrees of assimilation and difference, the process is even more uneasy and ambivalent.

There are various models of citizenship in diaspora, but most examples – Native Americans, French-Canadians, African-Americans, and Jews – disturb notions of national homogeneity. Even "melting pot" or "mosaic" nations, like the United States or Canada, are troubled by diasporic allegiances and encourage some assimilation or uniformity of social style. As a long-established minority population, the Ashkenazic Jews of Eastern Europe were separate from the surrounding Gentile communities in varying degrees. Some rapidly assimilated, speaking Polish and identifying themselves as "Poles of the Mosaic faith"; more, however, retained their Yiddish language and some degree of orthodox tradition.[8] But whatever their practice as Jews, their self-consciousness as a diaspora people was underscored, encouraged as well as daunted, by the burgeoning nationalisms following the First World War of newly constituted states of central and eastern Europe – Poland, Czechoslovakia, Hungary, Romania. For minority populations as numerous as Jews in these settings, the tensions of diaspora loomed large.

Jewish intellectuals argued the issue of diaspora and nationhood with fervor. Two groups called for radical change: assimilationists disavowed both Jewish nationalism and diaspora consciousness, while Zionists assailed the value of life in exile and asserted Israel was the "natural" Jewish homeland and the only safe haven from oppression. Between these polarities were the possibilities of what historian Simon Dubnov called "diaspora nationalism," an assertion of

autonomous identity based on language, religion, and custom, rather than land or territorial claims. In an essay of 1909 entitled "The Affirmation of the Diaspora" (a reply to Ahad Ha-Am's "Negation of the Diaspora"), Dubnov wrestled with the double consciousness that diaspora culture demands: a longing for Israel as a spiritual – if not national – center, and a secure future of national rights and cultural autonomy. Without renouncing the dream of Israel, Dubnov declared that:

> in the Diaspora we must strive, within the realms of the possible, to demand and to attain national-cultural autonomy for the majority of the [Jewish] nation. . . . In order to strengthen the Diaspora we will use the weapons of national struggle which served us for thousands of years and which are adapted to the world view of our time. You ask what wall shall we erect in place of the fallen ghetto walls? Every period has its own architecture, and the powerful vital instinct will unmistakably tell the people what style to use for building the wall of national autonomy which will replace the former religious "fence to the fence," and will not at the same time shut out the flow of world culture.[9]

Of course, to some extent, Dubnov begged the question. There was no "unmistakable" recipe for building that semi-permeable diaspora wall. But in many respects, the social structures of the *shtetl* – schools, synagogue councils, social welfare and charitable societies – provided the framework for life beyond the "fallen ghetto walls." In cities like Minsk, Vilna, Warsaw, and Lvov, where the Jewish population swelled, the orthodox habits of the *shtetl* were augmented by a network of educational, social, and cultural institutions. The Jewish labor organization known as the Bund was founded in 1897; the Czernowitz Conference of 1908 proclaimed Yiddish a Jewish national language; an extensive print culture – literature, journalism, and an illustrated press – flourished. By the 1920s, when these pictures were made, the classic texts of modern Yiddish literature by Mendele Mocher Sforim, I. L. Peretz, Sholem Aleichem were well known to Jewish readers. Warsaw boasted more than a dozen Yiddish dailies in the same period, and a Jewish Press Photographers' Guild was established in that city in 1910.[10] All of these signaled the emergence of a secular intelligentsia and a Jewish public that drew *shtetl* culture into modernity and a self-consciously national frame.

No matter how settled the community, cultural production in a diaspora – like social relations – also betrays the tensions of difference. Despite invocations of the Biblical Second Commandment, Jewish culture was by no means an-iconic or without images. And with the development of the Jewish *Haskala* (Enlightenment), modern Jews in Eastern Europe produced an avowedly Jewish art in visual media – painting, graphic arts, photography and film – as well as modern Yiddish literature, music and theater. To be sure, in the modern

world, proficiency in the visual arts means training in art academies, and success depends on access to modern markets and audiences.[11] But in the decades between the wars, many Jewish artists exhibited in the art salons of the major cities, and like their Gentile colleagues, they formed cultural associations and exhibition societies – the *Yung Yiddish* group in Lodz, for example, or the Jewish Society for the Propagation of the Fine Arts in Warsaw.[12] At the same time, artists such as Chagall, Soutine and Vorobeichic – artists trained in Russian and Lithuanian academies – intermittently joined their Gentile colleagues in international art centers like Paris, where they found critical recognition and another public for their art.

The large number of Jewish artists active in Poland between the wars testifies to the vitality and promise of this form of cultural production in diaspora. Clearly, there was no lack of Jewish artists – in Eastern Europe or beyond; what is missing is their place in modernist histories. Art history in the modern period has vacillated between categories based on style – abstraction, expressionism, etc. for example – presumably universalizing, but tacitly framed by Western European structures and hierarchies, and categories based on nationalist schools. And within that historiography, "modern Jewish art" has been a troublesome critical category: too Jewish or parochial for the stylistic universalizers, and too avant-garde (read assimilationist, or parochial) for the nationalists.[13] It is only with the more pluralist approaches of postmodernism that in-between positions on this axis find historical place. In that frame, Chagall's Jewish subjects may be considered, like his contemporary Malevich's Russian themes, or Soutine's less explicit Jewish referents, varieties of the national cultural expression sweeping Europe in the early decades of the century.[14] Of course, the success of Soutine and Chagall is bound to their assimilation within an international art scene, where the Jewish content of their work was less welcome than their avant-garde styles. The same is true, as we shall see, of Moshe Vorobeichic. Jews faced dilemmas of "membership," whether as artists or as ordinary citizens.

Such contradictions are especially apparent in the high art historiographies, which most emphatically perpetuate the universalist/nationalist cultural paradigm. The effect may be different when images move outside those high-stake cultural domains, and as is often the case with photography, are annexed to print media and mass culture. Circulated through books, journals or newspapers, images may function like a (subliminal) literature, with broad cultural reach to widespread or far-flung sectors of diaspora community.

These effects of training, style, circulation and audience are shaping factors in the impact of these two photo collections. Alter Kacyzne's documentary pictures, designed for a mass audience, offer a broad repertory of scenes and types. Best known as a poet and playwright, Kacyzne was a photographer as well, with an extensive portrait practice in Warsaw, photographing, among others, his colleagues in literary and theatrical circles. He was also a disciple of Scholem Ansky and wrote the screenplay for the 1937 Yiddish film version of

Ansky's play *The Dybbuk*. This connection may well have shaped his photo-graphic practice, for as Ansky had done in pre-Revolutionary Russia, Kacyzne, too, traveled through Eastern Europe photographing scenes of Jewish life. His pictures appeared in several contexts: some were taken for Jewish welfare agencies like the Hebrew Immigrant Aid Service (HIAS), and as such their mission was clear: to detail an impoverished people and their "rescue" by modern Jews.[15] But many pictures appeared in the Art Section of the *Forverts*, the leading Yiddish daily paper in New York, with a circulation of over 200,000. Commissioned by the paper's editor Abraham Cahan, and published there under captions like "The Principal Streets of Grodno, Poland" (December 30, 1923) or "Pictures of Jewish Life and Characters" (December 5, 1923), they rely on the potent "thereness," the so-called realism of the doc-umentary camera to extend the diaspora community even as they create a seemingly unmediated ethnography of the *shtetl* and eastern European Jewish sites.[16]

The documentary qualities are evident in postcard-like images of syna-gogues, markets and towns. Some are shown as landmarks, like the fortress syn-agogue of Husiatyn with its crenellated roof, crowning a hillside. Meaning in such images is produced by the pictorial conventions of landscape – the romantic, the rustic, the picturesque – and by the capacity of the photograph both to generalize – or "logo-ize," as Anderson puts it – and to specify. To our eyes some two generations later, such structures, towns and markets suggest a generic place; the market views could be any number of Jewish centers in the Pale, large and small, swarming with carts and horses, and figures haggling for goods. But to the immigrant readers of the *Forvarts* in the American diaspora, this was a known geography. It was also a world relinquished, and as much as it triggered memory, it reiterated decisions to leave or to modernize. Whatever affection viewers felt at the sight of village streams, busy markets, wooden houses and synagogues was matched by the discomforting sight of muddy streets and dilapidated houses, barefoot children in tattered clothing, bent old men. However effective as nostalgia or ethnography, this is hardly a typical myth of national pride, or ownership. Synagogues are the only monuments; houses are picturesque shelters, not property; the broad vistas are about exchange and barter; and in line with the laws against Jewish ownership, there is little sense of land or landedness. As cultural reportage in the *Forverts'* illus-trated section, that is, in an American frame, such pictures confirmed the dis-tance between the old country diaspora and the modernity of the new.

A closer view of this ethnography shows the disappearing traditions and types of the *shtetl*. As if at random – the hallmark of the documentary style – Kacyzne's camera takes in the incidents of the street: a uniformed schoolboy and father at the margin of one picture, with a shoeless boy in the background amid waiting carts and horses. The visual passage to this child – a popular emblem of rural poverty – must move through the framing figures of two older men in the long-coated costume of orthodoxy, slow-footed on their

canes, negotiating the mud. Along with such scenes – whose material discomfort and orthodoxy are visually linked and tacitly disavowed – are other traditional types: artisanal figures like a romantically lit cobbler; an old man in the synagogue, enclosed in prayer and solitude; the *kheder* boys beginning their study of religious texts (see Figure 11.1). Women appear less often, but also as social genre. Market women suggest hard work; bewigged religious women instruct groups of girls; elderly *bubbes* [grandmothers] – not loving mothers – nurture children and evoke the affective space of family. As familiar figures of tradition and orthodoxy, they too seem to fix *shtetl* society in an unmodern frame. But these figures also perform the more positive pole of nation-narration's ambivalence. Drawn from stereotype, cast as revered icons of *shtetl* society, they also represent its modern possibility.

Indeed, this is not a homogenous assembly of picturesque types. Underscoring the social framework of Kacyzne's camera are images of a modern world: a team of tanners, a group of *gymnasium* (high school) teachers, striking factory workers, and members of the socialist Jewish Bund. In contrast to the documentary village scenes, these pictures often frame special events or they are camera-staged group portraits, and they lack the social flux and unplanned immediacy of the street and market views. Still, their presence in Kacyzne's collection signals the variety of Jewish life in the region and its transformative possibilities. And taken together with the more picturesque imagery, they suggest the social terms of a diasporic future: the artisan becomes the industrial workforce, the orthodox scholars become the teachers, the barefoot kids and *kheder* tykes form gymnastic and athletic groups, street-corner idlers become the mainstay of the Bund.

There are also omissions in this emphatically public and proletarian frame. There is little sign of the Jewish intellectual or cultural society prominent in Kacyzne's studio practice.[17] Family life and intimacy – the mainstay of bourgeois snapshot photography – is scarcely visible, and Eros or desire – the mainstay of mass culture – is only glimpsed in photographs like the dark, Jewish beauty (Figure 11.3) provocatively labeled "the rabbi's daughter," a figure who might easily join the actresses and beauty queens in the *Forvarts'* picture page. In general, these photographs are remarkably modest; physical pleasure appears as clean living and idealistic, with occasional pictures of children's camps, sports teams and clubs as representatives of Jewish social modernity.[18] The more numerous images of rustic poverty and workers, however, the prominence of bearded elders and traditional types, the attention to religious structures and study, the emphasis on childhood and old age – all this suggests a poor, pious and even de-eroticized populace, and hardly candidates for modern nationhood.

The ambivalence, then, of these images as ethnographic salvage and nation-narration appears in their fixing of *shtetl* culture in a powerless and non-threatening picturesque, while at the same time using those terms – overdetermining them, in effect – as a framework for the future. For American

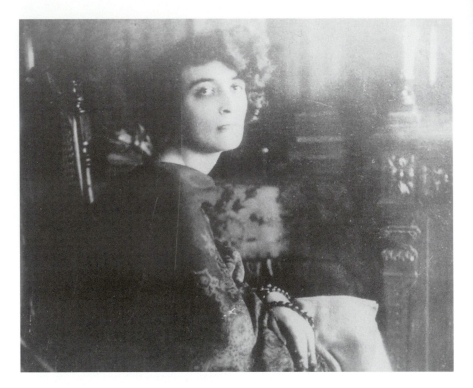

Figure 11.3 Alter Kacyzne, *The Rabbi's Daughter.*

readers of Yiddish *Forvarts*, this was memory to be acknowledged and supplanted; the pictures emphasized difference and reframed lingering immigrant guilt as nostalgia or relief. Even in Eastern Europe, where *shtetl* landmarks, labor, learning and prayer were a more immediate heritage, the images underscored the temporal gap between the camera and its objects, the *shtetl* as past and the photograph's modernity. Through Kacyzne's camera, picturesque sites and social difference become social documents and cultural emblems, just as the photos also point to new social formations and the vigor of modernity. These terms then are held in tension: how to modernize? how to use and transform the past? Rather than closure on these questions, Kacyzne's images shape the *mythos* and matrix of modern diaspora consciousness.

The ambivalent combination of tradition and modernity is handled very differently in Moshe Vorobeichic's photographic volume, *The Ghetto Lane in Vilna*, published in 1931 (Figure 11.4). Vilna, of course, was no *shtetl*. Known as the "Jerusalem of Lithuania," the city was a center of Yiddish scholarship, dating back to the seventeenth century and the renowned rabbi known as the Vilna Gaon [genius], and exemplified in the modern period by YIVO [*Di Organizatie fun der Yiddisher Vissenshaft*], founded in 1925, dedicated to the study and promotion of Jewish history and modern Yiddish culture.[19]

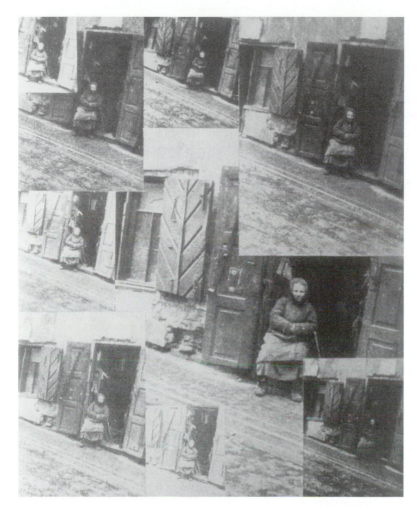

Figure 11.4 Moshe Vorobeichic, *The Ghetto Lane in Vilna* (1931), cover.

Vorobeichic was a conventionally trained artist. He studied at Vilna's Jewish art academy, at the Bauhaus in Germany – where he worked under the *nom de l'art* "Moi-Ver" – and in Paris, where he counted vanguard figures like Fernand Léger among his friends and colleagues. Thus while the "ghetto lane" of his title encloses Vorobeichic's work in a *shtetl* picturesque, the montaged images with their bilingual Hebrew-German and Hebrew-English captions are clearly meant for a modern, internationalist Jewish milieu. An introduction by Yiddish novelist Salman Chneour acknowledges both the project's modernism and its social purpose.[20] "This Album," Chneour wrote in this brief essay,

Is not meant to satisfy the tastes of only the aesthetic few, but also the taste of the masses, to bring them in touch with the Jewish street. It shows true Jewish life and its ethnographic materials make it a hand-book for everyone.

Affirming with these words the truths of art and ethnography, Chneour and Vorobeichic offered sophisticated readers a progressive guide to "true Jewish life." The pictures compile a familiar iconography: synagogues, laborers, *bubbes* and market women, rabbis and old men. The book opens and closes with a smiling laborer bonded to the elegant architecture of Vilna's great synagogue. Then, in dramatically cropped and tilted images, the camera seems to zoom cinematically from point to point. Streets are cobbled corridors seen from odd angles, making the viewer an omniscient – but again, distant – surveyor of these sites. Two pages showing books from the Strashun Library emblematize Vilna's scholarly culture and Jewish identity as "the people of the book." Other pages rehearse the poverty and picturesque types. A repeated pattern of wooden shutters encloses a seated market woman; a cluster of hands evokes the stereotype of Jewish argument and lively bargaining; a pile of tin and shoes labeled "The Wealth of Israel" makes an ironic statement about Jews and money; a group of children are montaged under the sheltering veil of a watchful *bubbe*-madonna, labeled to suggest generational contrast as "Two Worlds."

Vorobeichic's album not only renders traditional sites and figures as photographic icons, it literally re-frames a diaspora people, and uses the style of the book to link its content to modernity. The fusion of traditional content and radical style in these images draws a poor, laboring, scholarly and spiritual populace into modernist culture, but only as pictorial fragments and artifacts. At the same time, the disruptions, juxtapositions and combinations that drive the pictures' formal success reify and force home a distinctive identity. The fragmented figures, gestures and objects become fetishized emblems of Jewish tradition, seized by the camera from the social clutter of the past to function as potent icons of dispersal, flux and modernity. Thus, Vorobeichic, too, conveyed the ambivalence of nation-narration. Harnessing traditional Jewish culture to a modern discourse, he installed it in the protectorate of international modernism and pictorially modeled the diaspora consciousness of his milieu.

As different as Vorobeichic's photographic strategies and audience are from Kacyzne's – one mass culture, the other high art – both offer versions of a vital Jewish cultural space. In distinctive ways, these representations of *shtetl* and Jewish tradition play against but also to core structures of the modern nation: its poverty, piety, and difference are the nation's strength and weakness, stability and oppression, the tests of its tolerance. With their shared emphases and varying photographic styles, these collections mark out the sites, figures, and changing rituals of a diaspora Jewish culture. The *shtetl* artisans, market women, urchins and pious men, may seem exotic and strange in the modern state – though less so perhaps in Catholic Poland. But through Kacyzne's doc-

umentary and Vorobeichic's montage, they are also called to modernity, their energy organized not through property, militancy, or empire but as continuity around industry and labor, learning and community.

Sixty years ago, the pictures may well have offered Jewish viewers moments of nostalgia and confirmation of the decision to modernize. To be sure, the future of these photographers was bound to the coming catastrophe: Vorobeichic emigrated to Israel before the war; Kacyzne was murdered by Ukrainian Nazis in 1941. But notwithstanding political and social tensions of the period, the pictures did not simply resonate as "loss." To viewers now as then, they pose issues of modernization, assimilation and the status of a "distinct society" within the modern state. With less certainty and more complexity than conventional nationalism, the pictures pose both the pride and the ambivalence of diaspora consciousness and minority nationhood.

Notes

1 "Ashkenaz" is the term used to designate the Jews of Central and Eastern Europe.
2 Michael Andre Bernstein, *Foregone Conclusions; Against Apocalyptic History* (Berkeley, University of California Press, 1994) p. 16.
3 *The Vanished World* contained images by Kacyzne, Roman Vishniac, Menachem Kipnis and others.
4 For an account of Jewish photographers in Poland, see Lucjan Dobroszycki and Barbara Kirshenblatt-Gimblett, *Image before our Eyes* (New York, Schocken Books), pp. 1–38.
5 Benedict Anderson, *Imagined Communities, Reflections on the Origin and Spread of Nationalism* (London, Verso, 1991).
6 Homi K. Bhabha, "Introduction: Narrating a Nation," pp. 1–7, in *Nation and Narration*, Homi K. Bhabha, ed. (London and New York, Routledge, 1990). See also "DissemiNation: Time, Narrative and the Margins of the Modern Nation," 139–70, in Bhabha's *The Location of Culture* (London and New York, Routledge, 1994).
7 Bhabha, "Introduction," p. 1.
8 For these variations, see Ezra Mendelson, "The Jewries of Interwar Poland," in *Hostages of Modernization; Studies on Modern Anti-Semitism, 1870–1933/39*, Herbert A. Strauss, ed., v. 3/2, (Walter de Gruyter & Co., 1993), pp. 989–95.
9 Simon Dubnov, *Nationalism and History: Essays on Old and New Judaism* (Philadelphia, 1958), pp. 186–7.
10 For photography in the Yiddish press see Dobroszycki and Kirshenblatt-Gimblett, *Image before my Eyes*, pp. 20–31.
11 In Poland, many Jewish artists trained at art schools in Cracow, Warsaw, or they journeyed to academies in Berlin, Vienna. For useful introductions to the subject, see Jerzy Malinowski, "The *Yung Yiddish* (Young Yiddish) Group and Jewish Modern Art in Poland 1918–1923," *Polin* 6 (pp. 223–30); Zygmunt Hoffman, "Painting," pp. 72–6, in Marjan Fuks, *et al., Polish Jewry, History and Culture* (Warsaw, Interpress Publishers, 1982). For Jewish artists in Russia, where a Jewish art school operated briefly in Vitebsk, see the exhibition catalog *Russian Jewish Artists in a Century of Change 1890–1990* (New York, The Jewish Museum, 1996). For Eastern Europe, see the issue on Eastern Europe of *Jewish Art* v. 21/22 (1995–96).
12 Malinowski, "*Yung Yiddish* Group."

13 The 1996 *Too Jewish* exhibition at New York's Jewish Museum, curated by Norman Kleeblatt, raised some of these troubling issues for contemporary American art.

14 Recent exhibitions like *Russian Jewish Artists in a Century of Change* (New York, The Jewish Museum, 1996), address the relation of Jewish artists and the international avant-garde.

15 Kacyzne made a series of photographs for HIAS detailing the steps to emigration. Most of his pictures are housed in the YIVO Archives, New York.

16 Another version of such a project might be the materials – visual and literary – in the cultural supplement of the Polish-Jewish daily *ND*. Though different obviously in its specific audience, the paper shared some of the *Forvarts'* modernizing and diasporic agendas. For discussion of the *ND*'s position, see Michael Steinlauf, "The Polish-Jewish Daily Press," *Polin* 2, pp. 220–45.

17 In letters to Cahan about his photo commissions (often complaining about payment and costs), Kacyzne raised the issue of subject matter – the inclusion of orthodox types and the appeal to workers through proletarian imagery. My thanks to Roberta Newman, New York, for generously sharing her research on Kacyzne's letters with me.

18 It is worth nothing the similarity of this iconography to Zionist self-imaging. See Michael Berkowitz, *Zionist Culture and Western European Jewry before the First World War*, Cambridge: Cambridge University Press, 1993.

19 For the history of Jewish Vilna, see Henri Minzceles, *Vilna, Wilno, Vilnius* (Paris, Editions La Découverte, 1993).

20 Long active in Vilna's cultural circles, Chneour [Schneour] lived in Paris after 1923. See Minzceles, p. 336.

12

ALICE HALICKA'S
SELF-EFFACEMENT

Constructing an Artistic Identity in Interwar France

Paula J. Birnbaum

> *I had imagined myself entering with ease what I understood to be the*
> *artistic world of Paris. My reserved attitude, due to my timidity, spared*
> *me much worry and jealousy . . . But sometimes I regret having expe-*
> *rienced life as a spectator and not an actor.*[1]
>
> (Alice Halicka)

> *Is this me, this no-body that is dressed up, wrapped in veils, carefully*
> *kept distant, pushed to the side of History and change, nullified, kept*
> *out of the way, on the edge of the stage, on the kitchen side, the bedside?*[2]
>
> (Hélène Cixous)

The painter Alice Halicka (1889–1975) was born with the family name
Rosenblatt, the eldest daughter of a wealthy Jewish physician from Cracow.[3]
Upon arriving in Paris in 1912 to pursue a career in painting, she fabricated
the Polish name "Halicka" to rhyme with her given name, "Alicja," suggesting
a desire to conceal her Jewish background from the French public. In a *Self-
Portrait* (Figure 12. 1) of this period, we see the artist at 24 years of age, an ele-
gant young woman dressed in a stylish hat and fur-collared cloak. Her facial
features are carefully defined, the large, dark, almond-shaped eyes highlighted
by thinly arched brows and a long, straight nose. Hints of rouge and lipstick
add color to her otherwise sallow complexion, drawn out by a long, slender
neck, high cheek-bones, and pursed lips. The portrait clearly embodies the
physical ideals of bourgeois femininity as they were defined at that historical
moment in France, just prior to World War I. Given that Halicka had just
changed her name, her carefully scripted signature in the upper-right corner
of the painting may be seen as the label of the artist's identity as cosmopolitan
"Polonaise," a refined and aristocratic looking woman artist newly arrived in

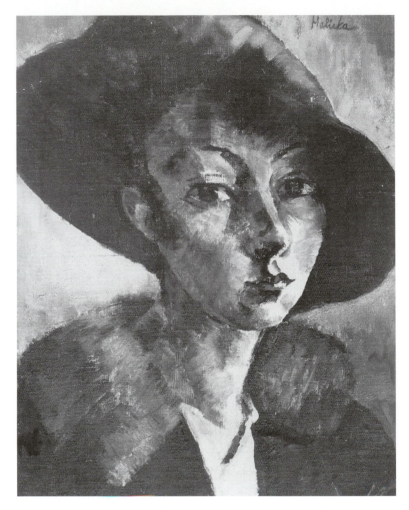

Figure 12.1 Alice Halicka, *Self-Portrait*, 1913. Malène Marcoussis Collection, Paris.

Paris. By establishing her difference in terms of nationality, and not of race or ethnicity, the self-portrait thus becomes Halicka's first public moment of "passing" before a French audience well-known for its history of hostility towards Jews.[4]

Halicka painted the *Self-Portrait* just after her marriage to her compatriot Ludwig Markous, the cubist painter from Warsaw who, following the encouragement of Guillaume Apollinaire, had changed his own name to "Marcoussis" after a small region in France.[5] Like many other early twentieth-century assimilated Jewish artists and critics, they converted to Catholicism for pragmatic reasons and were both baptized.[6] They married in the Church and sent their one daughter to Catholic school, not telling her of her own Jewish her-

itage until the eve of World War II. Both artists were naturalized as French cit-
izens in 1938. Throughout their lives, many of the couple's friends and critics
did not openly admit knowledge of their Jewish heritage. In fact, Halicka did
not even mention her ethnicity in her published memoirs of 1946, despite her
account of the atrocities of the War.

Halicka and Marcoussis were among many Jewish émigré painters working
in Paris during this period who were evaluated frequently for the degree of
"Frenchness" demonstrated in their work. For many of their critics, however,
Halicka's oeuvre did not fit the preconceived model of French artistic iden-
tity as readily as did Marcoussis's. For example, in a review of her work the
prominent pro-cubist critic André Salmon remarked first on Halicka's "*Polish
origins*," and second, her status as "the wife of Marcoussis, whose military
participation in the First World War was a noble attempt to pay back the state
for his decidedly *French* artistic formation as a cubist painter."[7] A critical
assessment of Halicka's oeuvre is absent from such remarks. Salmon chose to
discount her as an artist and emphasize her roles as Pole and wife.
Furthermore, he congratulated Marcoussis on his military participation as a
means of compensating the State for his early exposure to a "French" style of
painting.[8]

Many of Halicka's critics consistently viewed her artistic production as less
compatible with their model of French artistic identity than was Marcoussis's.
A 1930 account of the couple by the Paris-based Polish art critic Zygmunt St.
Klingsland reinforced this position:

> Finally, without repudiating their Polish citizenship, they [Halicka and
> Marcoussis] are proud to be *Montmartrois* by predilection. In effect, by
> the essential qualities of their painting, they have every good reason to
> claim Parisian citizenship. Marcoussis possesses this right much more
> than does Halicka.[9]

Why did Klingsland, himself of Polish descent, believe that Marcoussis was
more deserving of a Parisian or French artistic identity than was Halicka?

Halicka's attempt to stake a place for herself at the center of Parisian avant-
garde culture was made doubly difficult by her diaspora identity and her posi-
tion as a woman within a traditional heterosexual couple. Whereas Marcoussis
engaged consistently in a cubist aesthetic (which was itself associated with
"Frenchness") and often featured the Parisian landscape in his work, Halicka's
work shows much less confidence in her position within the Parisian art
world. The dramatic stylistic and thematic shifts which define her oeuvre
suggest that she continually questioned her role within French patriarchal cul-
ture. In many of her works – as in the 1913 *Self-Portrait* – she turned to the
subject of the female body as the site of a particular kind of diaspora cultural
production. Ultimately, an examination of the different strategies of self-
representation at the heart of her practice reveals a highly complex aesthetic

response to the questions of identity and difference in early twentieth-century French visual culture.

The Atelier

In 1924 Halicka exhibited a large oil painting entitled *The Atelier* (Figure 12. 2) at the annual Salon des Tuileries in Paris. The painting offered the public a glimpse of the artist's home life in the tradition of a "family portrait." It was staged in the studio space that Halicka shared with Marcoussis in Montmartre from the time they first were married, in 1913, until their exodus from Paris

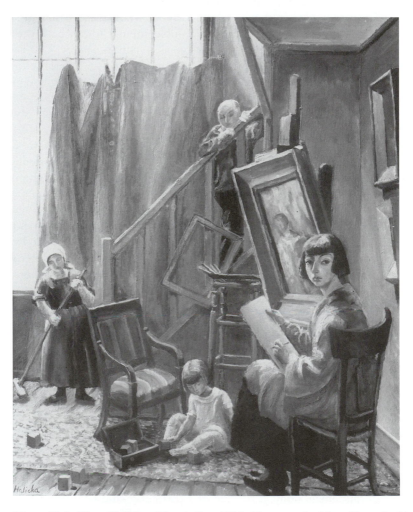

Figure 12.2 Alice Halicka, *The Atelier*, 1924. Photograph: Marc Vaux Archive, Musée National d'Art Moderne, Centre Georges Pompidou, Paris.

upon the eve of World War II. The family lived in a separate apartment located behind the studio, but each member is curiously present here, cramped together into what appears to be a narrow work-space.

Halicka has presented the *Atelier* from an oddly foreshortened perspective, with the four depicted figures together forming a pyramid-like compositional structure. Her own self-portrait, while the most proximate to the viewer's gaze, is nonetheless pushed to the lower right-hand margin of the composition. The artist is seated in a straight-backed chair in a three-quarters pose, her head turned so that her gaze directly confronts the viewer. In contrast to her 1913 *Self-Portrait* as fashionable "Polonaise," Halicka has portrayed herself as an artist engaged in sketching amidst an *atelier* full of works in various stages of progress; however, not one pencil or brush mark is visible upon the small canvas or drawing tablet that is posed in her lap. Perhaps she also intended to portray herself as partially engaged in watching over her then 2-year-old daughter, Malène, who is portrayed seated upon a rug on the floor at her mother's feet. While the child appears to be self-absorbed in her play, she nonetheless must have provided a distraction for Halicka while she attempted to work in her studio.

Behind Malène at the foot of the stairs, Halicka has included a portrait of the family's Breton housekeeper, Marie Ménézo, who is portrayed here sweeping the studio floor. Her inclusion in the margins of the *Atelier* is reminiscent of the representation of domestic women in seventeenth-century Dutch genre painting, which Halicka had studied during a brief stop in Holland just prior to her work on this painting. While she went so far as to represent the woman that she hired to assume the household work, Halicka ultimately did not choose to portray herself as completely relieved of traditional female duties, given her proximity to her child. The maid's presence emphasizes the couple's bourgeois status, and also is suggestive of the artist's awareness of the different cultural values assigned to women's "work" based upon social class.

Between the maid and the child, one cannot help but notice a large, imposing chair, its emptiness reinforced by the odd angle at which the artist has chosen to place it within the composition. Perhaps Halicka is reminding the viewer of a pointed human absence at the studio's center, as the stately chair might symbolize Marcoussis's role as head of the household.[10] The artist's husband is visible well above and to the right of this empty chair, his head forming the apex of the compositional pyramid. He, like the maid, appears unnaturally diminutive in comparison to Halicka's self-image, standing on one of the top steps that leads to a loft beyond the composition's edge. Marcoussis does not appear to be working at this very moment, nor is he portrayed in any overt interaction with his wife, child, or maid.

Edouard Woronieki, a critic of the 1924 Salon des Tuileries writing for the international revue, *La Pologne*, curiously described the *Atelier* as portraying Marcoussis "at work," while Halicka pensively "meditates before her easel."[11] While Woroniecki claimed that Halicka intended to introduce the viewer into

the world of *her* studio here, he nonetheless defined her professional activities as more ethereal and thus less concrete than those of her more famous husband. She most likely was absorbed in looking at her own reflection in a mirror in an effort to portray herself, evidenced by the reversal of her sketching hand. True, not one mark is visible upon Halicka's drawing tablet or canvas, yet Marcoussis might be described as even that much farther removed from his own painterly practice in his marginalized position on the balcony staircase. Ironically, Woroniecki mistakenly described the couple's young daughter as absorbed in play with "her dolls," rather than what were actually the more gender-neutral wooden building blocks. It is Malène, in fact, who appears to be the one family member who is most obviously absorbed in a creative activity within the painting.

One might argue that the *Atelier* narrates Halicka's self-perceived failure in 1924 to fulfill her fantasy of occupying the central space of the couple's studio, and more symbolically, of avant-garde culture at large. While the diminutive-looking Marcoussis appears to wait and watch in the wings as a spectator barely able to support his own weight, Halicka similarly has marginalized herself in the lower-right corner, estranged from the brushes, palette, easel, and empty picture frames, with her daughter at her feet. Perhaps she intended to represent her husband at work here, in that he, as both painter and head of the household, gazes down from the balcony in the direction of his wife and child. Halicka could be posing in the *Atelier* as a model for one of her husband's cubist works of the period, while seated on the edge of the chaotic workspace that they supposedly shared.[12] One can imagine in producing such a portrait of his wife that Marcoussis ultimately might amble down the balcony staircase and resume his position in the empty chair, maintaining control of the palette, brushes, and central work space while Halicka remained relegated to the marginalized roles of model, muse, and mother within her own narrow corner of the studio.

The *Atelier* represents the results of Halicka's first ten years in Paris, a period in which she immigrated from Cracow, converted and married Marcoussis, gained access as a woman to the avant-garde circle in which he was actively involved, and then had a child. During this time she strove to develop her own cubist practice, culminating in the five-year period in which she was isolated from her husband while he fought for France in World War I. The spatial congestion caused by the overlapping of angular objects in the *Atelier* is distantly reminiscent of both Halicka's and Marcoussis's cubist production from before and during the war. Although Marcoussis is better known for his role as a proponent of cubism, Halicka in fact produced a large number of her own cubist works between the time of her arrival in Paris in 1912 and the end of the war in July, 1919.[13]

Halicka's *Still Life* of 1914 (Figure 12. 3) is an example of one of her early cubist works, its fragmented golden and gray-toned rectangular planes entered a pictorial discourse begun in 1907 by Picasso and Georges Braque. The

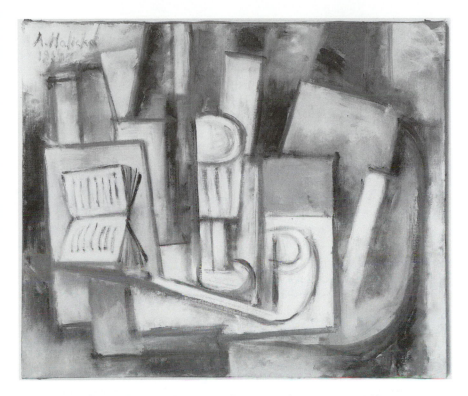

Figure 12.3 Alice Halicka, *Cubist Still-Life*, 1914. Oil on canvas. Malène Marcoussis Collection, Paris.

generic objects she chose to portray – open book, pipe, and goblet – do not speak specifically of Halicka's female identity in the household. They are the stock in trade of cubist still life and also appear regularly in Marcoussis's cubist works of the period. Critics of the 1914 Salon des Indépendants, among them Guillaume Apollinaire, nonetheless lauded Halicka's still-life paintings as "among the most interesting."[14] Even after her reputation for figurative paintings such as the ambitious *Atelier* was established following a series of post-war solo exhibitions in Parisian galleries, many of Halicka's most supportive critics described her oeuvre as indebted to cubism.[15]

While Halicka may have striven for critical recognition as a cubist painter during the years just prior to and during the Great War, it was only in retrospect, particularly in the final years before her death, that she came to terms publicly with the notion that Marcoussis had limited her access to this particular avant-garde milieu. In a 1974 interview with Jeanine Warnod, she recalled that during the pre-war years, when the couple received visitors in their home from the ranks of the cubist circle, Marcoussis would dominate the conversation.[16] Halicka remembered feeling frustrated over the fact that Marcoussis

would never let her get a word in edgewise. For example, her disappointment is obvious in her description of Marcoussis and Juan Gris, a regular visitor to their shared studio, as the "two alchemists" who "wanted to keep the secrets of cubism."

Although Halicka may have dabbled in cubism in the shadow of her husband during 1913 and 1914, once the war broke out and Marcoussis voluntarily enlisted in the French military her professional ambition to become a cubist painter intensified. Marcoussis did not rejoin her until nearly a year after the Armistice in 1919. Halicka therefore had ample time to focus upon her own work. She described in her memoirs how she spent most of this period alone in Paris, working "with ardor" and making a brief trip to the Touraine with colleagues in the summer of 1918, when the Germans approached Paris. In Warnod's 1974 interview with the artist, however, Halicka provided a second account of this period which is inconsistent with her earlier one. She claimed that during the final period of the war she decided to leave Paris for the reclusive home of family friends in Normandy. There she described having worked diligently at developing her own cubist practice. Once displaced from her "shared" studio space at the center of the Parisian art world to the more solitary margins of this house in Normandy, Halicka apparently became engaged in her own serious period of cubist experimentation. She painted daily in both oil and gouache, and apparently produced well over sixty cubist works of varying dimensions.

Halicka's works produced during this period of isolation, whether in Normandy or in Paris, show a decisive attempt at defining a space for herself as a cubist painter in her own right. It seems plausible that it was only in the absence of her husband and the potentially stifling atmosphere of their shared work-space that she was able to produce an ambitious series of cubist paintings. One also must consider as further attestation to the seriousness of her enterprise the fact that Halicka obtained substantial amounts of canvas, paper, oil paint, gouache, pencils, and other essential and costly materials during a time when the French economy was depressed. Also noteworthy is the fact that she chose to sign and date all of her works from this period, suggesting her pointed desire to validate herself at that moment as a rigorous artist who could work independently and productively in the very avant-garde style favored by her absent husband.

Given her isolation in her Montmartre studio and her apparent seclusion in Normandy, one might conclude that Halicka was liberated by her distance from Paris as the center of the avant-garde and all of the accompanying distraction and potential competition implied by the ambiance of the shared work-space she would later portray in the 1924 *Atelier*. At the same time, however, one might argue that it was only in having shared her studio with Marcoussis before the war in her role as wife and potential muse that she ever would have gained the requisite access to the ideas, discussions, and works of art that enabled her to go on to pursue her own form of cubism. It was pre-

cisely her limited exposure to the collaborative processes of aesthetic experimentation that might have motivated Halicka to accomplish all that she did during the years of her husband's absence.

The seriousness of Halicka's cubist enterprise is further supported by the fact that she intended to exhibit her paintings and gouache studies to the post World War I Parisian public. She explained in her memoirs how before the war she had befriended and painted the portrait of a compatriot, Leopold Zborowski, a young Jewish man who had immigrated to Paris after escaping persecution in Galicia and who had aspirations of becoming an art dealer.[17] While she in fact denied ever having "adhered" to the "discipline" of cubism in her own work,[18] Halicka described how Zborowski had offered her a contract at the war's end, but Marcoussis, apparently untrusting that he would make regular payments, forced her to decline. Halicka admitted her resulting "regret," as she apparently trusted that Zborowski was good for his word and demonstrated great professional promise. She noted how he became a successful art dealer in Paris, the exclusive representative of Amadeo Modigliani as well as other prominent School of Paris painters.[19]

At the very end of her life Halicka disclosed the even more devastating effects of Marcoussis's discouragement upon her cubist production. In her 1974 interview with Warnod, she recounted how when her husband returned from the battlefield in 1919 and first witnessed the results of her cubist enterprise, he exclaimed that "one cubist painter sufficed per family."[20] Halicka apparently responded to Marcoussis's comment by destroying some of her cubist oeuvre (the exact number of works is unknown), and abandoning sixty works in both oil and gouache in the attic of the friends' house in Normandy where she had produced them. Warnod, as interviewer and life-long friend of the artist since the days that her father, the art critic André Warnod, had endorsed her early work, concluded that Halicka simultaneously had been "compliant" and "too independent" to continue to paint like her husband, and so she consequently "changed her style and forgot her cubism."[21] It seems that Halicka was "compliant" to the extreme of self-effacement, and consequently felt she had no choice but to acquiesce to the demands of her overbearing husband either by hiding or destroying her work.

Looking back at the 1924 *Atelier*, we can see that although Halicka may have adapted her style to a more overtly figurative one, the fact of the repression of her cubism is very much present. The painting might be interpreted as a reminiscence of that period of cubist productivity that she felt Marcoussis selfishly had taken away from her upon his return from the front. It narrates Halicka's personal response as a 35-year-old woman to the couple's reinstallment in their Parisian studio space, and all of the domestic responsibilities that accompanied the "sharing" of that space, particularly after the birth of their child in 1922. The painting provides a resonant pictorial prelude to what the artist could hardly admit verbally fifty years later: "Always dissatisfied, I often changed styles. After the cubist period that I abandoned by effacement, I was

obliged, in order to earn a living, to create designs for fabric and wallpaper."[22] One thinks of the blank canvas posed in the artist's lap in the *Atelier*, and can only imagine the effects of years of repression upon her artistic identity. Halicka assumed responsibility in her old age for the eradication and abandonment of the cubist works that she had produced during the war with such rigor, protecting Marcoussis from potential public disdain. She chose instead to describe her own self-effacing actions as the result of her allegedly erratic aesthetic tastes and perpetual "dissatisfaction" with her work, played out in the continual stylistic and thematic shifts within her oeuvre.

Responding to the financial needs of the family, Halicka abandoned her own painting for a short period after the birth of her child in 1922 and pursued textile design so that Marcoussis could return full-time to his artistic career.[23] Ironically, she sustained her husband's post-war cubist project by producing designs for the very textiles – wallpaper and fabrics – recycled by Braque, Picasso, and Marcoussis himself in their own pre-war production of cubist collage and *papier collé*. Her primary objective at that time, in addition to supporting the family, was to restore her husband's public reputation to what she exclaimed he deserved: "cubist of the first rank."[24] Looking back at the 1924 *Atelier* as a reminiscence of that sacrifice Halicka later would claim never to have regretted, one might note how she portrayed her young child absorbed in creative play with cube-like blocks on the floor. Ultimately, in reading this painting as a painful summation of what the artist would describe as her cubist effacement at the very end of her life, Halicka has given her daughter the very agency to create from "cubes" that her own husband had taken away from her.

Painting in the Jewish margins

Halicka engaged in various stylistic and thematic shifts following her cubist effacement that ironically led her back to her Polish homeland on two separate occasions in the early twenties. During these trips she produced a series of figurative works confronting the subject of the Jewish ghetto of Cracow that subsequently were exhibited in Paris in several solo exhibitions. While these works do not engage in as literal a form of self-representation as the 1924 *Atelier*, they disclose yet another layer of Halicka's discomfort towards her identity as a Polish Jewish woman artist who was part of a bourgeois couple in interwar France. By focusing upon specific stereotypes of the working-class, Jewish female body, many of these paintings and works on paper reveal Halicka's desire to define her own corporeality in decidedly bourgeois, French terms.

In a 1921 gouache from this series entitled *Friday Evening* (Figure 12.4), exhibited that same year at the Galerie Berthe Weill, a group of ghetto inhabitants are gathered before an open passage-way upon the eve of the Sabbath. A candelabrum is present as Halicka's ambivalent marker of identity, the symbol of the Jewish hearth. Seen behind a window, its golden, painterly arms blend

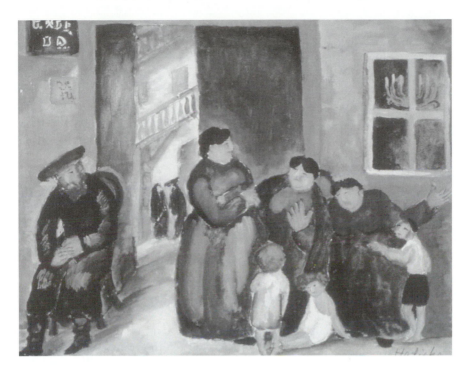

Figure 12.4 Alice Halicka, *Friday Evening*, 1921. Ewa Fibak Collection, Paris.

into the muted gray tones of the glass. Ironically, the window panes that partially obscure this object of Jewish ritual form the symbol of the Christian cross. These floating references to conflicting religious identities are oddly juxtaposed on the opposite side of the composition with two square street signs bearing illegibly scripted Hebrew letters. The crafted letters reveal the artist's desire to label the spaces of Jewish identity, in this case using the cryptic language of the Jews themselves as a marker of ethnic difference. By strategically framing the composition with these obscured and fragmented symbols, Halicka invites the cultured French spectator to enter a space that is normally off limits, the site of an exotic "Jewish underworld," to use the words of one critic.[25] It is not clear, however, whether the artist intended for the narrow opening in the ghetto walls to refer to an entrance or an exit. The elusive spatial demarcation reinforces her conflicted position as both insider and outsider in Polish-Jewish culture.

Halicka's shame and even loathing towards her identity is further apparent in her representation of the Jewish female body. Note the similar treatment of the three women depicted in conversation in the foreground: round, doll-like heads attached to corpulent, maternal bodies, huddled closely together and draped in varying shades of dark, floor-length fabric. These full-figured, expressive bodies become a prototype for Halicka's representation of the

working-class Jewish woman, a stark contrast to her own slender and stylized appearance as evidenced in her 1913 *Self-Portrait*. Three small children function as extensions of the women's maternal bodies, recalling the proximity of the artist's daughter to her own self-portrait in the 1924 *Atelier*. While on the one hand this uniform figure type offers a stereotype of the Jewish female body as Other, it also conveys the possibility of the artist's empathic identification with her subject matter through an idealizing employment of maternity imagery. Contemporary responses to such works ranged from one critic's enthusiasm for her "sincere" expression of "sympathy and humor" to another's feigned intimidation by the "fearful and menacing Jews" who inhabited the "leprous décor of the ghetto."[26] The critic André Warnod's emphasis upon her apparent distance from her subject matter was the most common reaction: "Halicka lived for a long time before observing with a painter's eye this monstrous setting. For her, it was for many years only an awful neighborhood that one passed through by carriage, very quickly, when there was no other choice."[27] Despite Halicka's Jewish background (of which this critic seems to have been ignorant), she likely would have been protected from the quarters of the indigent Jews during her formative years in Cracow given her family's elevated social position.

The popularity of Halicka's Polish ghetto scenes prompted the French publisher Henri Jonquières to commission her in 1925 to create a series of lithographic illustrations for the first French edition of Israël Zangwill's novel, *The Children of the Ghetto*, first published in English in 1892. Given the general public's lack of knowledge of Halicka's Jewishness, it seems ironic that she accepted a contract to illustrate the first French edition of a book by a Zionist author whose subject was the urban Jewish conflict between assimilation and tradition as it played out in the London Jewish ghetto of Whitechapel. In many of the works that Halicka produced for this series, it was the familiar stereotype of the Jewish mother that was the most recurrent, repeated in seven out of ten representations of women of the ghetto. For example, the three women depicted at the center of one of these works (Figure 12. 5) look nearly identical, recalling their painterly counterparts in the 1921 gouache produced in Cracow. In this image, however, Halicka's lithographic pencil caricatures the women's orientalizing features, bulbous noses, and thick wigs of dark hair in greater detail. Their stereotyped Semitic appearance recalls the popular satire of the turn of the century French Jewess and her thick-lipped, slanted-eyed male counterpart that circulated in the wake of the Dreyfus Affair.[28] One thinks back to the artist's own contrasting self-image in the 1924 *Atelier*, with her slender face, long, straight nose, and stylized coiffure. Exposed amidst a swarming, sooty crowd of other non-desirable bodies of the ghetto, these full-figured women become Halicka's ultimate caricature of the Jewish female body as Other. Their repeated appearance in her oeuvre encapsulates the artist's recurring fears about herself and her own irrevocable Jewishness.

These were fears that I believe were shared and even encouraged by

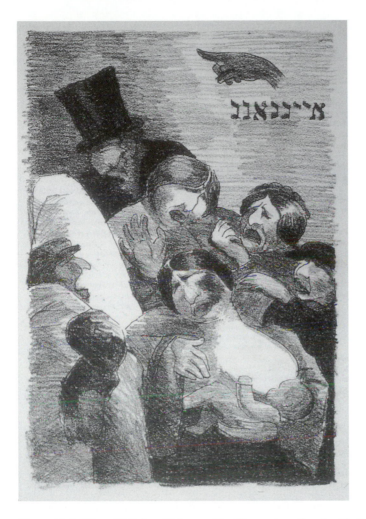

Figure 12.5 Alice Halicka, Lithographic illustration for Israël Zangwill, *Les Enfants du Ghetto*, Paris, Editions Jonquières, 1925. Malène Marcoussis Collection, Paris.

Marcoussis, who in a joint interview of the couple took credit for Halicka's depiction of the Jewish "type":

> We painted them, these Jews of Poland, engaged in their work, their rest, their pleasure, with their emphasis upon gesture, the grimaces of their entire bodies that translate into simultaneous feelings of joy and sadness, that tormented, vaguely hallucinatory quality, that makes a sabbath out of the most innocuous sale of fish. It is I who saw all of that.[29]

219

Ironically, there are no depictions of this Jewish "type" in Marcoussis's oeuvre.

Marcoussis's rhetoric on Polish-Jewish identity implies a collaborative aspect to Halicka's production of self-effacing representations of the women of the ghetto. In her own memoirs written twenty years later, Halicka reiterated his assessment by describing the mood of the ghetto as "hallucinating" and "mysterious."[30] Not only was she responding to her own desire to conform to French bourgeois culture in her representation of this subject matter, but also to that of her domineering husband. One need only recall his disapproval of Halicka's desire to associate herself with Leopold Zborowski, the art dealer who had expressed interest in her cubist work. Zborowski apparently was one of many less acculturated Jews in Paris that Marcoussis chose to shut out. Perhaps in response to the negative stereotypes of Jewishness promoted by her husband, Halicka came to question her own repressed ethnic identity in the female imagery that she produced during this period. Through her conflicted use of labeling versus effacement, caricature versus empathizing imagery, her Jewish ghetto scenes of the 1920s demonstrate her own self-loathing as it relates to certain long-lived cultural categories of otherness.

Paris as center

Halicka's depictions of the Jewish ghettos of Cracow and London, confined to the period between 1921 and 1925, are all the more chilling given that their public life anticipated the relentless mood of anti-Semitism in France in the 1930s that would lead to the Vichy collaboration. It was during this period of intensified nationalism and xenophobia that she was first attracted to the theme of the sparsely inhabited Parisian landscape, the predominant subject of her work produced during the period both prior to and following World War II. Ironically, she chose to focus upon the theme of French national monuments – Place de la Concorde, the Tuileries Gardens, and the bridges that cross the Seine – in a series of works created during several lengthy visits to New York between 1935 and 1938. Some of these works were produced as part of an advertising campaign for her New York-based friend and compatriot, the prominent, Polish-Jewish cosmetics industry mogul, Helena Rubinstein. Rubinstein may have been particularly attracted to these images of Paris as a means for promoting her beauty products to American *nouveaux riches*, who likely associated the glamorous world of cosmetics and high fashion with romantic views of the French capital. For example, in a 1935 painting entitled *The Tuileries* Halicka featured the silhouettes of two Parisian women with cinched waistlines strolling toward the looming obelisk of the Concorde.[31] Such slender and stylized female figures, reminiscent of her own self-representation, offered a stark contrast to the plump, maternal bodies from her Jewish ghetto scenes of the prior decade. Given the degree to which Halicka may have desired to efface her ethnic identity, there was probably an

attraction in having been perceived in the United States as a fashionable, French female painter whose idealized images of "la Parisienne" and her scenic "homeland" held wide appeal. It was perhaps in this spirit of accultura- tion that Halicka chose to return to Paris in 1938, even though she had been warned that her Jewish heritage would put her in great danger given the rise of European anti-Semitism.

After the conclusion of World War II, Halicka returned to Paris as a widow following years in hiding in the South of France and decided to write her memoirs. This document, with its reproduction of one of her romanticized images of the *Place de la Concorde* on the cover, might be viewed as another attempt by the artist to claim Paris as her metropolitan center, while simulta- neously accounting for her role as an assimilated woman artist in the fringes of the French avant-garde. While she may have come to terms with some of her feelings of anger toward Marcoussis for excluding her from the cubist circle, she nonetheless chose in her memoirs to feature his work throughout the text as opposed to her own. In particular, Halicka's inclusion of her husband's engraved portraits of prominent figures such as Picasso and Apollinaire stand as a testament to her own marginalization from the nucleus of the cubist group. One thinks back to her 1913 *Self-Portrait*, and can only imagine all of the ambition and desire that the young, newly married artist suppressed over the years in order to support her husband's career.

In 1969, fifty years after Halicka had destroyed a number of her cubist paint- ings and hid the remainder in that house in Normandy, they were returned to her. Sixty of these works were featured in a solo exhibition at the Parisian Galerie 22 in 1973, a year before the artist's death. Many of the canvases and works on paper included in the exhibition were sold to an enthusiastic audi- ence, giving the then 84-year-old Halicka center stage within the Parisian art world as a cubist painter in her own right.

Notes

Shorter versions of this paper were delivered at the Frick Collection and Institute of Fine Arts Symposium, New York, 1995 and at the annual meetings of the Western Association of Women Historians, Pacific Grove, CA, 1995 and the College Art Association, Boston, MA, 1996. Special thanks to Steven Z. Levine, Stacy W. Garfinkel, Amy J. Lyford, and Jennifer L. Shaw for their helpful criticism at various stages, as well as to my colleagues at the Institute for Research on Women and Gender at Stanford University. The article generates from a chapter in my dissertation, "Femmes Artistes Modernes: Women, Art, and Modern Identity in Interwar France," Ph.D., Bryn Mawr College, 1996. All translations are my own unless indicated otherwise.

1 A. Halicka, *Hier (Souvenirs)*, Paris, Editions du Pavois, 1946, pp. 53–4.
2 H. Cixous and C. Clément, *The Newly Born Woman*, trans. by B. Wing, Minneapolis, University of Minnesota Press, 1986, p. 69.
3 At that time Cracow was part of Galicia, the southern province of Poland that was incorporated into the Austro-Hungarian Empire during the Partition period and granted autonomy in 1868.

4 In assessing Halicka's desire to assimilate one must also bear in mind the even deeper-seated anti-Semitic feeling that existed in Poland prior to her arrival in France in 1913. See Magdalena Opalski and Israel Bartal, *Poles and Jews: A Failed Brotherhood*, Hanover and London, University Press of New England, 1992.

5 On the inquiry into Apollinaire's supposed Jewish origins (he changed his own name from Kostrowitzka) and his role in Marcoussis's name change see A. Halicka, *Hier*, p. 57.

6 See *The Circle of Montparnasse*, eds K. Silver and R. Golan, New York, The Jewish Museum, 1985 and R. Golan, "From Fin de Siècle to Vichy: The Cultural Hygienics of Camille (Faust) Mauclair," in *The Jew In the Text*, London, Thames and Hudson, 1995.

7 A. Salmon, *La Revue de France*, 1924, Paris, Halicka Archives.

8 Ironically, many anti-cubist art critics countered Salmon's claim by describing cubism not as a style of French national identification, but rather as an *art boche*, implying a Germanic brand of barbarism and lack of restraint. This debate was fueled by the fact that so many of the practicing cubists – including Pablo Picasso, Jacques Lipchitz, and Juan Gris – were not of French origins. See C. Green, *Cubism and Its Enemies*, London, Yale University Press, 1987; K. Silver, *Esprit de Corps: The Art of the Parisian Avant-Garde and the First World War, 1914–1925*, Princeton, Princeton University Press, 1989.

9 Z. St. Klingsland, "Marcoussis et Halicka," *l'Oeuvre*, 1930, Paris, Halicka Archives, Book III, p. 49.

10 My reading of the empty chair as symbol of Marcoussis's domain as both painter and male head of the household has been influenced by Anne M. Wagner's recent interpretation of an empty chair at the table depicted in Claude Monet's *Le Déjeuner* (1868–69, Frankfurt, Städelsches Kunstinstitut) in "Why Monet Gave Up Figure Painting," *Art Bulletin* 76, no. 4 (Dec. 1994) 613–29.

11 E. Woroniecki, "Le Salon des Tuileries," *La Pologne*, 1924, Halicka Archives, Book III, p. 322.

12 See L. Marcoussis, *Alice Halicka*, date unknown, oil on glass, 65 × 35 cm., Private Collection, Paris, reproduced in J. Lafranchis, *Marcoussis: sa vie, son oeuvre*, Paris, les éditions du temps, 1961, p. 80, cat. F.52.

13 For more on Halicka's position among women artists working within cubism see G. Perry, *Women Artists and the Parisian Avant-Garde*, Manchester/New York, Manchester University Press, 1995.

14 G. Apollinaire "Le Salon des Indépendants," *L'Intransigeant*, 28 Feb. 1914, reprinted in *Guillaume Apollinaire: Chroniques d'art, 1902–1918*, ed. L-C. Breunig, Paris, Gallimard, 1960, p. 430.

15 See E. Tériade, "Halicka (Galerie Druet)," *Cahiers d'Art*, May, 1926, p. 80.

16 J. Warnod, "Alice Halicka et ses souvenirs," *Terre d'Europe*, vol. 48, May 1974, p. 3.

17 See A. Halicka, *Leopold Zborowski, c.* 1912, oil on canvas, Collection of Boleslaw and Lina Nawrocki, Warsaw. This portrait is discussed in Halicka, *Hier*, p. 64.

18 Halicka, *Hier*, p. 54.

19 See *Les Peintres de Zborowski: Modigliani, Utrillo, Soutine et leurs amis*, Lausanne, Fondation de l'Hermitage, 1994.

20 J. Warnod, "Alice Halicka," p. 1.

21 Ibid., p. 5.

22 Ibid.

23 Halicka, *Hier*, pp. 83–4.

24 Ibid. p. 74.

25 J. Carco, *Comoedia, c.* 1924. Paris, Halicka Archives, Book III, p. 5.

26 F.G., *New York Herald Tribune*, 1925, Halicka Archives, Book II, p. 393; A. Warnod, *L'Avenir*, 1924, Halicka Archives, Book I, p. 293.

27 A. Warnod, *Comoedia*, Nov. 13, 1922, Paris, Halicka Archives.
28 See *The Dreyfus Affair: Art, Truth & Justice*, Ed. N. Kleeblatt, Berkeley/Los Angeles/ London, University of California Press, 1987.
29 S. Ratel, "Marcoussis et Halicka: ou le Cubiste éloquent et la Femme silencieuse," *Comoedia*, Oct. 1926, Paris, Halicka Archives, Book III, p. 18.
30 Halicka, *Hier*, p. 82.
31 See Halicka, *Les Tuileries*, oil on canvas, location unknown, reproduced in Dorothy Dudley, "Four Post-Moderns," *American Magazine of Art*, vol. 28, Aug. 1935, p. 540.

13

HÉLIO OITICICA'S PARANGOLÉS

Nomadic experience in endless motion

Simone Osthoff

Théorie de la vraie civilisation.
Elle n'est pas dans le gaz, ni dans la vapeur, ni dans les tables
tournantes, elle est dans la diminution des traces du péché originel.
(Charles Baudelaire)

We tend to define diaspora cultures as nomadic and migrant, products of constant movement, of living in the "between," of seeing the world from an inside/outside perspective. The duality of the nomadic experience, however, according to Gilles Deleuze, does not necessarily involve geographic displacement:

> Some voyages take place *in situ*, are trips in intensity. Even historically, nomads are not necessarily those who move about like migrants. On the contrary, they do not move; they stay in the same place and continually evade the codes of settled people.[1]

Deleuze's definition of the nomad, as one who constantly reframes and subverts cultural paradigms, can be a useful model for examining the circulation of ideas among vastly different cultures.

In Brazilian art, a clear example of this form of nomadic action is found in the trajectory of visual artist Hélio Oiticica (1938–1980) whose rich legacy, despite growing international recognition still represents an old doubt: "Is an experimental avant-garde possible in an underdeveloped country?"[2] This question, asked by Catherine David, one of the curators for Oiticica's 1992–94 international traveling retrospective, underscores the difficulties encountered by artists working outside the artistic mainstream struggling to establish dialogue where one-way exchanges have been the norm.[3]

Oiticica died in 1980 at the age of 43 leaving a fascinating body of work,

224

created between the late 1950s and his death, that he referred to as "experi-
mental proposals." Oiticica's work from the 1960s, particularly his "Parangolés"
and installations – *Tropicália* from 1967 and *Eden* from 1969, and his late-
1970s performances titled "Delirium Ambulatorium" – are rare examples in
Brazilian art of the combination of critical rigor, conceptual cohesion, original
inventiveness, and material precariousness. Oiticica incorporated and subverted
a modernist aesthetic by engaging it with the realities of underdevelopment.
The result was the merging of two very different cultural traditions – a
Western aesthetic canon that privileges opticality and metaphysical knowl-
edge, and Afro-Indigenous oral traditions in which knowledge and history are
encoded in the body, and ritual is profoundly concrete. Without romanticizing
misery or adopting a nationalist and populist agenda, Oiticica dove into the
richness of vernacular culture to expand the geometric abstract legacy inher-
ited from Neo-Plasticism, Suprematism, Constructivism and Art Concrete.
Further, he incorporated time and movement into geometric abstraction to
give it new meanings through contamination with Samba, Carnival, and pop-
ular architecture.

Between painting and dance, architecture and music

In an article from 1965 entitled "Ambiental Art, Post-Modern Art, Hélio
Oiticica," the critic Mario Pedrosa traces Oiticica's development from purely
plastic concerns into the existential, culturally-based and postmodern.[4] In this
process of moving between modern and postmodern aesthetics, Pedrosa
noticed that Brazilian artists participated "this time, not as modest followers
but in a leading role."[5] Pedrosa stated that Oiticica's initiation into Samba
expanded his work from being object-based to environmentally-based, a
process that incorporated the kinetic knowledge of the body, the structures of
popular architecture and the cultural environment in which they existed.
Oiticica's relation with *Mangueira*,[6] one of the oldest and most famous *favelas*
(hillside slums) in Rio de Janeiro, marks his passage from purely optical con-
cerns to environmental ones, where aesthetic, sensorial, existential, and ethical
concerns are all interconnected.

Oiticica's creations became increasingly interactive as he moved from
object-based to body-centered works in which viewer participation was the
central focus. In the late 1950s and early 1960s, he expanded ideas inherited
from Mondrian and Malevich to explore a geometrically-based language in
his search that integrated color, structure, space and time. The fusion of these
elements, according to him, condemned the two-dimensional picture to disap-
pear, bringing it into three-dimensional space.

Pursuing a fusion rather than a juxtaposition of these elements, Oiticica
stated that as color frees itself from two-dimensional space and from represen-
tation, it tends to "in-corporate" itself: "It becomes temporal, it creates its own
structure, so the work becomes the 'body of color.' "[7] Between 1958 and 1964,

he created several series of constructed paintings. "Spatial Reliefs," "Bilaterals," "Nucleus," "Penetrables," and "Bólides" were painted wood constructions that increasingly moved away from the wall, either as suspended structures hanging from the ceilings, or colorful labyrinthine constructions entered or manipulated by the spectator.

Color played a key role in Oiticica's development. He searched for the essential energy of color and wanted to free color in space. He spoke "of a necessity of giving color a new structure, of giving it a body." His "Bólides" (in Portuguese, a word meaning fireball or nucleus) started as containers for pigments, and developed, throughout the 1960s, into a range of different objects and materials – built and found, constructed or appropriated, large and small – to be handled or entered by the viewer. Although "Spatial Reliefs," "Nucleus," "Penetrables" and "Bólides" increasingly invited the active participation of the viewer, it is with his series of wearable creations, titled "Parangolés," and later on, with two installations – *Tropicália* and *Eden* – that Oiticica's work became centered on the body, promoting through interactivity radically new sensorial experiences.

From his colorful painted structures of the early 1960s, Oiticica derived his first Parangolé, created in 1964, transforming hard-edged geometric planes into folds of wearable materials made specifically to be worn and danced with (Figure 13.1). The Parangolé was a type of cape inspired conceptually by the Mangueira Samba School to which Oiticica belonged. Often made for particular performers, they were, according to Oiticica, "proposals for behavior" and "sensuality tests." With this series of uncanny wearable creations made of cheap and ephemeral materials often found on the streets, work and body merge, through dance and movement, into a hybrid of geometric and organic forms. The participant wearing the Parangolé dances with it, exploring kinesthetically its multiple possibilities: twirling, holding, and dynamically manipulating the Parangolé's folds and materials.

Among the many implications emerging from this fusion of geometric abstraction and Samba, is the return to the mythical, primordial structure of art – a recreation of the self through initiatory ritual. Oiticica described his relation to the popular Samba, making reference to the mythic dimension evoked by dance:

> The rehearsals themselves are the whole activity, and the participation in it is not really what westerners would call participation because the people bring inside themselves the "samba fever" as I call it, for I became ill of it too, impregnated completely, and I am sure that from that disease no one recovers, because it is the revelation of mythical activity[. . .] Samba sessions all through the night revealed to me that myth is indispensable in life, something more important than intellectual activity or rational thought when these become exaggerated and distorted.[8]

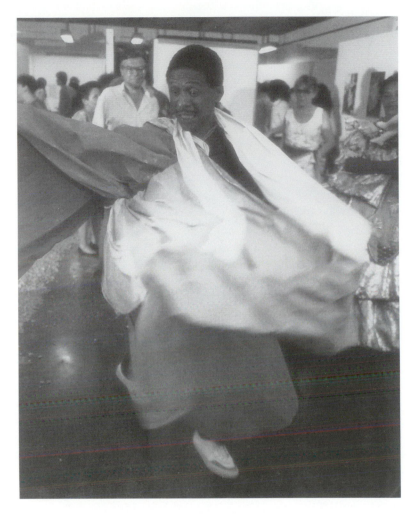

Figure 13.1 Nildo of Magueira wearing Hélio Oiticica's *Parangolé P4 Cape 1*, Rio de Janeiro, 1964. Photo courtesy Centro de Arte Hélio Oiticica, Rio de Janeiro.

For Oiticica, Samba was a conduit for the flow of energy and desire, a relay creating social and cultural connections (Figure 13.2).

"Purity is a myth": Tropicália and Eden

Expanding the Parangolés' architectural origins, Oiticica made two large installations in the late 1960s, which he referred to as "experiences": *Tropicália*, built for the show "New Brazilian Objectivity" at the Museum of Modern Art in 1967; and *Eden* at the Whitechapel Gallery in London in

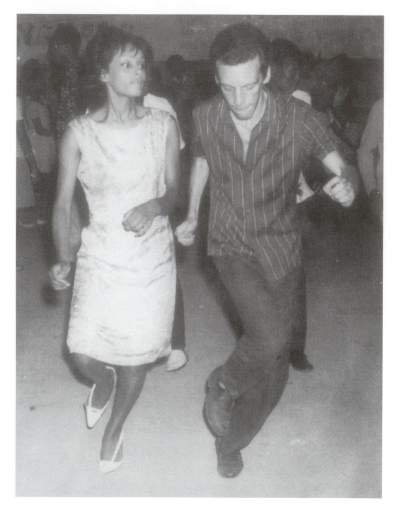

Figure 13.2 Oiticica rehearsing at Manqueira, Rio de Janeiro, 1965. Photo courtesy Centro de Arte Hélio Oiticica, Rio de Janeiro.

1969. These installations gave new spatial context to his "Bólides," "Penetrables," and "Parangolés" by placing them among natural elements such as water, sand, pebbles, straw, and plants, and inviting viewers to take off their shoes and incorporate leisure activities (for instance, something as simple as lying down) in their occupation of the space (Figure 13.3).

Addressing the possibility of the creation of a "Brazilian image," *Tropicália*, inspired by the popular architecture of Mangueira, gave name to the emerging Tropicalist movement and opened a cultural discussion that is still far from exhausted.[9] Among the many complex issues *Tropicália* raised is the notion that "the myth of 'tropicality' is much more than parrots and banana trees: it is the

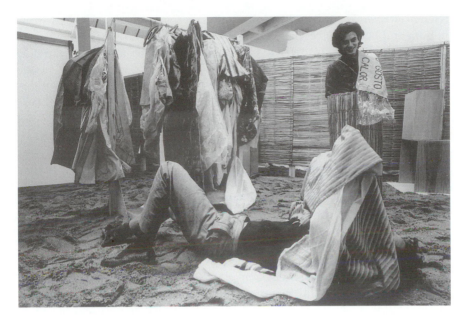

Figure 13.3 Hélio Oiticica and Torquato at the Whitechapel Gallery, London, 1969.
Photo courtesy Centro de Arte Hélio Oiticica, Rio de Janeiro.

consciousness of not being conditioned by established structures, hence highly
revolutionary in its entirety. Any conformity, be it intellectual, social, or exis-
tential, is contrary to its principal idea."[10] In *Tropicália*, Oiticica wrote on the
side of one Penetrable : "A Pureza é um Mito" (purity is a myth), confronting
a purist modernist trope with a hybrid esthetic of cultural contamination. In
his essay also titled "Tropicália," as in other writings, Oiticica, in calling
attention to the dangers of a superficial, folkloric consumption of an image of
a tropical Brazil, stresses the existential life-experience that escapes this
consumption.[11]

In "The Great Labyrinth," Catherine David compared the emancipatory
projects of Oiticica and Glauber Rocha who by 1964, after the international
success of his third film *Deus e o Diabo na Terra do Sol* (Black God, White
Devil), had become the spokesperson for the New Latin America Cinema.[12]
Among the most important and controversial avant-garde artists of the 1960s,
they lead much of the debate concerning the creation of a non-colonized
image of Brazilian culture. Both Glauber Rocha – in cinema – and Oiticica –
in the visual arts – addressed the issue of abject poverty, turning misery,
scarcity, and lack of technical resources into an expressive creative force.
"Misery," wrote Gilles Deleuze in relation to Cinema Novo, was "raised to a
strange positivity."[13]

Oiticica's second large installation, titled *Eden*, was built at the Whitechapel
Gallery in London in 1969. *Eden* was more abstract in its architectural

references than *Tropicália*. Although a utopian environment related to many notions and behaviors of 1960s counter-culture, *Eden* was not, however, nostalgic for the Paradise before The Fall. It displayed no desire to return to pure beginnings. Oiticica's *Eden*, rather, attempts to erase the concepts of sin and guilt altogether, creating a space of leisure to be enjoyed by the viewer. Oiticica's emphasis on joy, pleasure, humor and leisure, celebrates subversive carnivalesque strategies, which confront rigid hierarchies of thought and a productivist pleasure-denying work ethic.

New York and Rio de Janeiro in ambulatory fashion

In 1970, Oiticica received a Guggenheim fellowship and moved to New York. For the 1970 Information Show at New York's Museum of Modern Art, he built twenty-eight *Ninhos* (Nests) that also encouraged viewer participation in the exploration of space and behavior. During the 1970s while residing in New York, Oiticica adapted his architectural works to the scale of his loft, creating a constructed environment similar to Kurt Schwitters' 1925 "Merzbau" collage constructions in his apartment in Hanover. Like Schwitters', Oiticica's home became a laboratory of spatial experiments. Mixing art and life in an even more radical way, his activities during this time, outside the museum and gallery circuit, moved underground. Oiticica explored other media in the forms of writings, maquetes for environments, audio-visual experiments, and collaborative works. Away from the political pressure and polemics that characterized the 1960s in Brazil, Oiticica continued to develop his experimental program.[14]

During the last years of his life, after returning to Brazil in the late 1970s, Oiticica created "Delirium Ambulatorium" (delirious walk) events that involved the continuous nomadic action of his perambulations in the streets of Rio de Janeiro. The Delirium Ambulatorium events resulted in three "urban-poetic" performances involving other artists, friends, and the participating public: *Mitos Vadios* (Vagabond Myths) in São Paulo in 1978, a parody of the São Paulo Biennials proposed by artist Ivald Granato to which Oiticica brought tokens from Rio de Janeiro; *Kleemania*, a homage to the centenary of Paul Klee's birth, including the event *To Return Earth to Earth*, in which Oiticica brought fertile earth from the Jacarepaguá neighborhood and laid it upon a barren area in the Caju neighborhood in Rio de Janeiro in 1979, as a symbolic act of undoing a Bólide and fertilizing the area; and *Esquenta pro Carnaval* (Warm up for Carnival), in Mangueira in 1980. These three events underscored Oiticica's intention to define his work in terms of process, as well as through the deconstruction of previous works, as opposed to the frozen canonization of his early ideas in artistic objects.

His Delirium Ambulatorium actions were described by Oiticica as a demystification of his experiences from the 1960s. His relationship with the streets, the poor and Bohemian neighborhoods of Rio, were a fundamental

part of his work that continued to feed his creativity in the late 1970s: "All places in Rio de Janeiro have for me a concrete, live meaning that I call 'concrete delirium' – the Sugar Loaf mountain, the famous Central Train Station and its surrounding streets, the downtown area, the shantytowns of São Carlos, Mangueira, Juramento, these places are the ones I know more closely."[15] When asked if he came back to Rio to re-encounter his "roots," that is, Samba and popular experiences, Oiticica was decisive:

> I hate this business. You can write there, the roots have already been ripped out and burned a long time ago. There are people with a "prodigal son" complex, which is a Brazilian cancer, that many times reaches the most refined artists. I however, have been inoculated against this cancer. In New York I was asked: "Don't you miss Mangueira? And Rio?" I answered that I can't miss Mangueira because *I am Mangueira*. I did not miss it because I ate the whole fruit. *Saudades* are felt by the ones who only had a bite.[16][17]

Oiticica's relationship with Brazilian art and culture was, as Frederico Morais observed, an intense love/hate affair. In this tense balancing act, Oiticica loved much of Brazil with the same passion with which he despised its patriarchal and authoritarian aspects, "its tendency to compromise and conform, its lack of character."[18] In relation to international cultural influences, Oiticica proposed the old cannibalist strategy of consuming the consumer culture,[19] rather than avoiding or evading it. According to him, in order to transcend a colonialist condition, one needed to devour the positive things it created, the possibility of avoidance being merely a sort of mirage that only deepens provincial isolation. For Oiticica a Third World culture lacks nothing. One lives it fully or not at all. Life in the margins of artistic centers was not a second-hand product, but a site of rich cultural encounters. Its dynamic, based in all the contradictions inherited by a colonial condition, is a source of energy and creativity, as Oiticica demonstrated throughout his career.

Subversive strategies: Crelazer and the Suprasensorial

Oiticica created a web of relations around the sensual body and the many spatial forms with which it interacts. His participatory works are based on two key concepts: "Crelazer" and "Suprasensorial." Crelazer, one of Oiticica's neologisms meaning "to believe in leisure," was for him a necessary condition for the existence of creativity and is based on joy, pleasure, and phenomenological knowledge. The second concept, the Suprasensorial, involves the expansion of the individual's normal sensory capacities for the discovery of an internal creative center. The Suprasensorial can be represented by hallucinogenic states (with or without drugs), religious trance and other altered states of consciousness, such as the ecstasy and delirium facilitated by Samba dance. For Oiticica,

the Suprasensorial created a complete de-esthetization of art that underscores transformative processes. In his words:

> This entire experience into which art flows, the issue of liberty itself, of the expansion of the individual's consciousness, of the return to myth, the rediscovery of rhythm, dance, the body, the senses, which finally are what we have as weapons of direct, perceptual, participatory knowledge, . . . is revolutionary in the total sense of behavior.[20]

Oiticica's interest in music, dance and the body in motion, his interest in smooth space, to continue using Deleuzean terminology, expanded his early interest in the geometric grid. The play between order and chaos, structure and anarchy, the tension between reason and folly, and the balance of coexisting opposites in the same space, are always present in his work. In this ambiguity, reverie and revolt were never far apart, as the London-based critic Guy Brett has already pointed out.[21] Leisure for Oiticica was first and foremost a revolutionary anti-colonialist strategy, as the titles of some of his Parangolés exemplify: *Sex, violence, that's what pleases me* (Cape #7); *Cape of Liberty* (Cape #8); *Out of your skin/ grows the humidity/ the taste of earth/the heat* (Cape #10); *Of Adversity we Live* (Cape #12); *I Embody the Revolt* (Cape#11); *I am Possessed* (Cape #13); *We are Hungry* (Cape #14).

The Brazilian art critic Frederico Morais in an introduction to Oiticica's posthumous book *Aspiro ao Grande Labirinto* (*I Aspire to the Great Labyrinth*) defined Oiticica through his subversive marginality:

> Oiticica's work was the realization in the aesthetic and ethical planes of what we could call a theory of marginality. A radical marginality, not only an anti-art supported on the art system. His radical thought led him to consider art as a form of revolt against all types of oppression, being it intellectual, aesthetic, metaphysical and especially social.[22]

Some of Oiticica's ethical beliefs were expressed in his 1965 Box Bólide titled *Homage to Cara-de-Cavalo*. It was a homage to Mangueira's famous outlaw, Oiticica's friend, hunted down and brutally machine-gunned in Rio by the police, his body perforated by more than one hundred bullets. Cara-de-Cavalo, literally, "Horseface," was a bandit labeled "the number one enemy of the city." This box Bólide contained photographs of Cara-de-Cavalo's body, words, and a bag of red pigment (Figure 13.4). A few years later, in 1968, Oiticica made another homage to Cara-de-Cavalo in the flag-poem "Seja marginal, seja herói" (Be an outcast, be a hero), a homage to what he saw as the individual revolt of the bandit. According to Oiticica, violence was justified as a means of revolt, but never as an oppressive one.

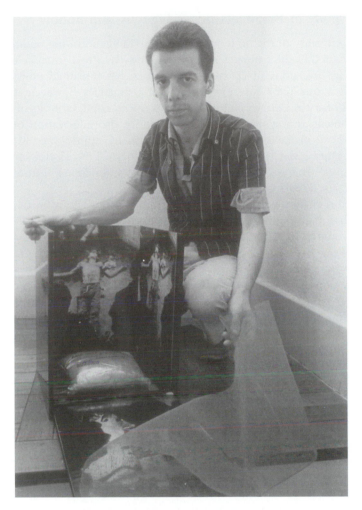

Figure 13.4 Hélio Oiticica with Box Bólide 18 *Poem Box 2, Homage to Cara-de-Cavalo*, 1966. Photo courtesy Centro de Arte Hélio Oiticica, Rio de Janeiro.

Oiticica's initiation into the life of Mangueira represented a unique experience in the history of Brazilian art. Today anyone, from foreign tourists to middle-class housewives, can join in the Samba school parades. An experience such as the one Oiticica had in the 1960s, however, has become virtually impossible. Artists today no longer climb hillside slums, they land there by helicopter, as did Michael Jackson recently in the *favela* Dona Marta, using the *favela*'s abject poverty as a ready-made backdrop for his questionable socially concerned video *They don't think about us*, directed by Spike Lee.

The body in Brazil: elastic, ambiguous, and hollow

In Brazil, the sensuality of the body, rooted in Afro-Indigenous oral traditions, is openly celebrated in the Samba. Carnival, the four-day Pre-Lenten celebration with all its inversions of everyday hierarchies, has remained politically ambiguous. As a metaphor for subversive artistic practices however, it has proven revolutionary as Oiticica, among others, demonstrated. From its origins to its establishment as a symbol of national identity, the valorization of the Samba goes hand-in-hand with the valorization of ethnic mixing and hybridization. During the 1930s, especially with Gilberto Freyre's classic book *Masters and Slaves,*[23] miscegenation became a positive and original feature, the strength in fact, of Brazil's tropical civilization.

Of course, this change in attitude towards ethnic mixing, from hostility to appreciation, has many political implications. On the one hand, this celebration directly counters colonialist fetishization of racial "purity," reversing the concept of miscegenation as degeneration of breeding and character. On the other hand, miscegenation *per se* did not erase social asymmetries nor dissolve historical hegemonies. And the myth of miscegenation and racial democracy that exists in Brazil is increasingly discredited by the reality of racism as the black population remains mostly poor without economic, social, or political mobility.[24] Culturally and religiously, however, African traditions have been well woven into the national fabric. It is important to remember, though, that the sensual "marron Bombom" body (candy brown) celebrated as sexually desirable, is also the same body that faces hunger, is abused by the police, and often dwells year round in abject poverty.

In Brazil, Afro-Indigenous populations have, of course, no easel painting tradition. Their heritage is inscribed, rather, in body paintings, textiles, music, dance, ritual, oral history, proverbs and aphorisms. The incorporation of history, memory and ritual into the body produced a very different notion of identity than the one found in the West where bodies usually support single identities. In most Afro-Brazilian traditions, bodies are hollow, unreliable, crossed by external energies and spirits, by other voices. In trance rituals, bodies become altars, horses, instruments or mediums over which there is no total control. Provisional identities are common during Carnival, a collective celebration in which the participant is both actor and spectator who enjoys the freedom of losing identity at will. Contingent identities are further expressed through the subtleties of the verb "to be" in Portuguese, which is translated by the verbs "ser" (relative to the essence of being) and "estar" (relative to a temporary condition), making identities even more flexible.

Symbolic thinking, expressed through popular proverbs and aphorisms, permeates the culture and especially the cult of the Oríshás, the Afro-Brazilian divinities. African religions, syncretized with Catholicism and other spiritual traditions, are especially influential in the Brazilian states of Rio de Janeiro and Bahia where religions such as Umbanda and Candomblé flourish.[25] The Afro-

Brazilian scholar Abdias do Nascimento refers to the Candomblé religion, emphasizing its accessibility and relation to everyday social life:

> Religions of European origin generally worship static, inaccessible, distant, essentially dead gods. African religion is different. The Oríshás (deities) come out of their cosmic habitats and "mount" a human medium's body. They dance, eat, drink, make love. Candomblé is pure vitality, never an "opiate of the proletariat." Its gods are dynamic, they embody a deep sense of freedom. . . . I don't advocate simply that we recall our past. My Oríshás are not immobilized in time or space. They are powers of the present. They emerge in daily life and in secular matters.[26]

Samba's origins among Afro-Brazilian religions makes it concerned more with the renewal of life than with escape through salvation. Samba, considered the Brazilian "school of the body," emanates from sexuality and physicality seen as expressions of the spiritual world. Anti-puritan by nature, Samba celebrates eroticism, desire and pleasure, mending dichotomies, and erasing boundaries between the secular and sacred, religion and magic.[27] The direct connection between Samba, Carnival and religious trance rituals exemplifies the fluctuating, and permeable boundaries in this rich tradition. *Capoeira*, a martial art performed by slaves disguised as a dance practice, an art of cunning that is still practiced today, is yet another example of the central role of ambiguity in the survival of African traditions in Brazil. All this knowledge and agency encoded in the body played an important role in the resistance of colonialization, and Brazilian avant-garde artists since the 1920s have derived creative energy and philosophical insight from these sources.

Brett further emphasizes the place of the body in Brazilian culture, observing that: "Like most such generalizations about national character, perhaps, the 'popular culture of the body' exists both as a stereotype and a truth. It is what makes it possible to read a phrase 'Brazilian elasticity of body and mind' in both a football report and an article on Lygia Clark!"[28] In Brazil, bodies are indeed more elastic and identities are contingent upon time and space.

Oiticica celebrated the body's energies and sensuality traversed by life, and sometimes, by death, as his Box Bólide *Homage to Cara-de-Cavalo* exemplifies. In his work, we find the paradoxical mixture of the sublime and the grotesque which is at the center of life in the Third World. This experience of the body is, of course, not *only* of the joyous, cordial, and playful. Although a positive attitude towards the body is characteristic in Brazil, the body is still problematic. There is also a violent and abusive side of the attitude toward the body that Oiticica had to acknowledge in order to attain its freedom and plenitude. Oiticica had to cross many social barriers to become part of the marginal world of Mangueira. And I believe it is the range of emotions, tensions, and

contradictions he addressed, inside and outside his work, that makes his legacy so powerful (Figure 13.5).

Oiticica's original trajectory, that began by misreading Malevich's *White on White*, coincidentally ended in a statement about "black on black."[29] In his last interview, Oiticica continued to fuse formal abstraction with Samba culture through the sensual body. Commenting on his Delirium Ambulatorium event at Mangueira in January of 1980, *Esquenta pro Carnaval* (Warm Up for Carnival), he stated:

> There [at Mangueira] I saw a man wearing something really beautiful. It was a type of black transparent nylon shirt through which the body could be seen. I want to make a black garment like that one, but it is not going to be a Parangolé. The way I see it, it has more to do with the Bólide. Something that keeps moving, and I found it beautiful because the man was black and you had black over black. I want to discover other people's sensuality through mine.[30]

Oiticica's premature death at the age of 43 left at loose ends the many threads he explored, both as an artist and a thinker, in his meteoric career. His fertile legacy continues to generate both new artistic dialogues and controversies.[31] Oiticica's experimental creations assume an array of forms with conceptual rather than formal coherence. Ranging from paintings to writings, from

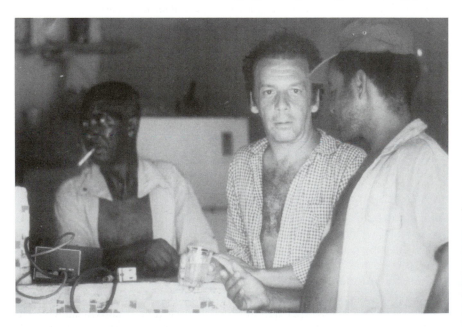

Figure 13.5 Hélio Oiticica at Mangueira, Rio de Janeiro, 1968. Photo courtesy Centro de Arte Hélio Oiticica, Rio de Janeiro.

sculptures and objects to public actions and events, from constructed immersive environments to found and appropriated objects, from wearable creations to ambulatory experiences through Rio's bohemian, marginal, and poor neighborhoods, Oiticica's works emphasize sensorial expansion through leisure activities. His subversive artistic practices continue to challenge us as they remain open-ended, acknowledging the fluidity of life moving between different cultural traditions. In his trajectory, the geometric abstract legacy becomes corporal, transforming the transcendental, universal, utopian space of modern abstraction into an embodied, interactive, live experience: a form of endless nomadic action.

Notes

1 Gilles Deleuze, "Nomad Thought," *The New Nietzsche,* (Cambridge: MIT Press, 1985), 149.

2 Catherine David, "The Great Labyrinth," Guy Brett, Catherine David, Chris Dercon, Luciano Figueiredo and Lygia Pape, eds, *Hélio Oiticica,* (Minneapolis: The Walker Art Center, 1993), 248. This comprehensive catalog accompanied Oiticica's international traveling retrospective from February 1992 to February 1994 (Rotterdam: Witte de With Center for Contemporary Art; Paris: Galerie Nationale du Jeu de Paume; Barcelona: Fundación Antoni Tapies; Lisbon: Fundaçao Calouste Gulbenkian; and Minneapolis, MN: Walker Art Center). It contains Oiticica's most important writings and essays besides critical texts by Guy Brett, Catherine David, and Waly Salomão. Oiticica's works and archives can be seen at the Centro de Arte Hélio Oiticica, Rua Luis de Camões 68, Centro, Rio de Janeiro, RJ, Brazil, CEP 20060–040. Tel: (021) 232–2213, 232–1104, 232–4213; Fax: (021) 232–1401. Curator: Luciano Figueiredo.

3 Guy Brett illustrated the cultural hierarchy between South American and Euro-American artists observing that: "There was an interesting comparison to be made between the exhibition of Hélio Oiticica, a Brazilian artist, which took place in London at the Whitechapel Gallery in 1969, and an exhibition of Robert Morris, the American minimalist, which took place at roughly the same time at the Tate gallery. Both exhibitions had a participatory element for the public, and the differences between the two approaches were very fascinating . . . but it was very unlikely at the time that such comparisons would be made because of the immensely greater prestige enjoyed by American artists in London. To have suggested a comparison on equal terms between a famous American and an unknown Brazilian artist would have been somehow "improper." For a Brazilian writer to have made claims for Oiticica in direct comparison with Morris would have seemed the height of naive nationalism, and even for a non-Brazilian it would have been difficult. The same naiveté on the part of the British or North Americans, went, well, unnoticed here." See *Witte de With* Cahier No. 2 (June 1994): 90. For a further general discussion, see Nelly Richard, "The International Mise-en-scène of Latin American Art," *Witte de With* Cahier, No. 2 (June 1994): 83; Nelly Richard, "Postmodern Disalignments and Realignments of the Center/Periphery," *Art Journal* No. 51 (Winter 1992); and Mari Carmen Ramírez, "Beyond 'the Fantastic': Framing Identity in U.S. Exhibitions of Latin American Art," *Art Journal* No. 51 (Winter 1992). For related discussion see my "Orson Welles in Brazil and Carmen Miranda in Hollywood: Mixing Chiclets with Bananas," *Blimp* 33 (Spring 1996): 42–49.

4 Mario Pedrosa, "Arte Ambiental, Arte Pós-Moderna, Hélio Oiticica." In *Aspiro ao Grande Labirinto* (Rio de Janeiro: Rocco, 1986), 9–13.

5 Pedrosa, 9.

6 See Alma Guillermoprieto, *Samba* (New York: Vintage Departures, 1990). Guillermoprieto lived for one year in the favela of Mangueira. In *Samba*, she gives an account of this experience while examining the history and culture of black Brazilians and the social and spiritual energies that inform the rhythms of Samba. For a complete history of Rio de Janeiro's Samba schools, see Sérgio Cabral, *As Escolas de Samba do Rio de Janeiro* (Rio de Janeiro: Lumiar Editora, 1996).

7 Oiticica, quoted by Guy Brett, "The Experimental Exercise of Liberty," *Hélio Oiticica*, [2] 227.

8 Oiticica, quoted by Guy Brett, "Hélio Oiticica: Reverie and Revolt," *Art in America*, (January 1989): 120.

9 Adopting an esthetic of mixing and contamination, the Tropicalist movement of the late 1960s aggressively combined high and low and industrial and rural cultures, merging political nationalism with aesthetic internationalism, Rock & Roll with Samba. It included all the arts – theater, cinema, poetry, visual arts and popular Brazilian music (especially the works of Caetano Veloso, Gilberto Gil, Gal Costa and Maria Betania). It also inaugurated the "aesthetic of garbage," explored by the second phase of Cinema Novo. It represented a return to cannibalist strategies in the arts, leaving behind the more austere "aesthetic of hunger," with its simplistic Manichean opposition between pure popular nationalism and the alienation of international mass culture. See Luiz Carlos Maciel, *Geração em transe-Memórias do tempo do tropicalismo* (Rio de Janeiro: Ed. Nova Fronteira, 1996); Torquato Neto, *Os Ultimos Dias de Paupéria*, compiled by Waly Salomão, (Rio de Janeiro: Max Limonad Ltda, 1982); Celso Favaretto, *Tropicália, Alegoria Alegria*, (São Paulo: Kairós, 1979); Caetano Veloso, *Alegria, Alegria*, compiled by Waly Salomão, (Rio de Janeiro: Pedra Q Ronca, 1977).

10 Oiticica, "Tropicália" (March 4, 1968), in Brett *et al.*, *Hélio Oiticica*, [2] 126.

11 Oiticica, "Tropicália," 124.

12 Catherine David, "The Great Labyrinth," in Brett *et al.*, *Hélio Oiticica* [2] 248–59.

13 Gilles Deleuze quoted by Robert Stam and Ella Shohat, *Unthinking Eurocentrism*, (New York and London: Routledge, 1994), 256.

14 The year 1968, a historic milestone in many Western countries, marked in Brazil the beginning of an era of state terrorism. The military government in power since 1964 issued the AI-5 (Fifth Institutional Act) signed by military President General Costa e Silva on December 13, 1968. The AI-5 closed Congress and suspended all political and constitutional rights, initiating a period of political oppression and persecution, youth revolt movements and counterculture. The period is the darkest one in the history of the Brazilian military dictatorship. The suspension of human rights opened the way to political persecution, torture and censorship, making it extremely difficult for artists to work. According to Zuenir Ventura, ten years after the AI-5 was declared, approximately 500 films, 450 plays, 200 books, dozens of radio programs and more than 500 songs, along with a dozen soap opera episodes, had been censored. See Ventura, *1968 O Ano que Não Terminou* (Rio de Janeiro: Nova Fronteira, 1988, p. 285). The AI-5 was responsible for an artistic and intellectual diaspora (Oiticica included) and for the fragmentation and isolation of artistic production in Brazil. Cultural production in the 1970s became mostly marginal, isolated from the public and hermetic, communicating only to a small elite. During the 1980s, the country slowly returned to democracy, and little of the irreverent experimentalism of the 1960s survived.

15 Oiticica, quoted by Celso Favaretto, *A Invenção de Hélio Oiticica* (São Paulo: Edusp, 1992), 224. Translation mine.

16 *Saudade* is a word with no direct translation into English but at the heart of the Brazilian identity. It means to long or miss something or someone, a melancholic feeling Brazilians inherited from the Portuguese. One can feel *saudade* for loved ones, for places, for foods, for one's culture. It can also mean nostalgia of old times, of things which are no longer, or to be homesick. It is always bittersweet and poetic, often the subject of Samba and other popular music forms.

17 Favaretto, 221. Translation mine.

18 Oiticica, "Brazil Diarrhea", in *Hélio Oiticica*, [2] 18.

19 The cannibalist strategy was created by the Brazilian avant-gardes of the 1920s. The "Anthropophagite Manifesto" ("anthropophagy" literally means cannibalism) was published by Oswald de Andrade in 1928 calling for the cannibalization of European culture in Brazil (the manifesto can be found in Dawn Ades, *Art in Latin America*, Yale University Press, 1989, pp. 312–13). It highlighted the superiority of Afro-Indigenous myths and traditions in relation to the Christian ones, for they were without the double standards of morality and repressed sexuality that artists found in patriarchal Catholic behavior. The Anthropophagic movement pointed to the "out of placeness" of European ideas in Brazil using inversion, humor, and parody as subversive anti-colonialist strategies. Oiticica's installation *Tropicália*, 1967, gave its name to the Tropicalist movement (1968–70) which aggressively mixed high and low, industrial and rural cultures, combining political nationalism with aesthetic internationalism. Tropicalism recycled cannibalist artistic practices in the visual arts, theater, cinema, poetry, and especially in popular Brazilian music. In 1998, the theme of cannibalism became the curatorial strategy of the twenty-eighth São Paulo Biennial: a homage to the continuous presence of this powerful metaphor for the Brazilian arts throughout the twentieth century.

20 Oiticica, "Appearance of the Supra-Sensorial", in *Hélio Oiticica*, [2] 130.

21 Brett, "Hélio Oiticica: Reverie and Revolt," 120.

22 Frederico de Morais introduction to Hélio Oiticica, *Aspiro ao Grande Labirinto,* (Rio de Janeiro: Rocco, 1986), np.

23 The generation of the 1930s was famous for its rich contribution to the discussion of national identity. They were, among others, sociologist Gilberto Freyre, *Masters and Slaves* (Casa Grande e Senzala), (1933); historian Sergio Buarque de Holanda, *Roots of Brazil* (Raizes do Brasil), (1936); and Caio Prado Junior, *Political evolution of Brazil* (Evoluçâo Politica do Brasil), (1933).

24 Zuenir Ventura, *Cidade Partida,* (São Paulo: Companhia Das Letras, 1994) addresses this widening gap between the poor and the middle-class population in Rio as well as the heroic efforts made by the group *VIVA Rio* and other individuals to counter rising feelings of fear and racism creating tense social relations in the city.

25 Umbanda, more commonly found in the Rio de Janeiro region, is a syncretism of the Orixá cult (spirit possession) with Catholicism, Kabala, and the spiritism of Alain Kardec. Candomblé, centered in the state of Bahia, is considered closer to African traditions.

26 Abdias do Nascimento and Elisa Larkin Nascimento, *Africans in Brazil* (Trenton Africa World Press, Inc., 1992), 54. For a related discussion on the concreteness of thought and ritual in oral-based traditions, see Marilyn Houlberg, "Magique Marasa," in Donald Cosentino, ed., *Sacred Arts of Haitian Vodou* (Los Angeles: UCLA Fowler Museum, 1995) 273–4. Holberg's observations about the physicality of ritual in many Afro-American religious ceremonies can illuminate the discussion on the concreteness of Oiticica's notion of the body. The artistic traditions of Haitian Vodou have also been examined in the light of a postmodern aesthetic by M.A. Greenstein, "The Delirium of Faith," *World Art*, No. 3, 1996: 30–5.

27 Robert Farris Thompson, *Face of the Gods* (New York: The Museum of African Art, 1993), 154. Thompson points out the importance of food and music in

the continuity of oral traditions: "At a micro-analytic level, culture was transmitted by specific and local means. The persistence of Yoruba cooking in both Cuba and Brazil, for example, kept up morale and continuity in many undetected ways. African women, Yoruba in particular, dominated the culinary arts of colonial Bahia, and enriched the cuisine of the entire nation with the introduction of palm oil and malagueta pepper. Keeping alive their wholesome taste for fresh greens – as opposed to the meat and bread of the Portuguese – helped keep the Yoruba themselves alive. Foods were written codes. African systems of logic and belief followed unsuspected from the kitchen, giving the Gods the dishes they craved. [For instance], black-eyed peas (meaning the essence of existence in Yoruba tradition), brought on ships from the motherland, was an ideographic material of mystic continuity. Whites loved this food often combined with shrimp, but had no idea that they embodied secret writings. Symbolic meaning was everywhere, even in the colors of foods."

28 Guy Brett, "In Search of the Body," *Art in America* (July 1994): 59. Rio de Janeiro based artist Lygia Clark (1920–1988) shared with Oiticica an artistic dialogue that lasted throughout their careers. Their complementary trajectories contributed to the development of an original vocabulary of interactivity.

29 Oiticica's interpretation of Malevich's *White on White* points to the direction his work would take. In Oiticica's words, Malevich's *White on White* was: "a necessary state in which the plastic arts divest themselves of their privileges and WHITEN THEMSELVES INTO SKIN/BODY/AIR: the drive towards absolute plasticity and Suprematism, are drives towards life, and they lead us to take our BODY (to discover it) as its first probe." Quoted by Brett, in *Hélio Oiticica,* [2] 227.

30 Oiticica's last interview, "A última entrevista de Hélio Oiticica" by Jorge Guinle Filho, April 1980. Quoted by Favaretto "A Invenção," 226. Translation mine.

31 A recent article of mine "Lygia Clark and Hélio Oiticica: a Legacy of Interactivity and Participation for a Telematic Future," *Leonardo* (MIT Press Vol. 30, N. 4), explores Clark's and Oiticica's interactive and participatory creations pointing to their practical and conceptual relevance for artists working with digital communications technology. An example of the still controversial power of Oiticica's work is the incident that occurred between Mangueira dancers wearing Parangolés and the Dutch curator of Malevich's exhibit during the opening of the 1994 São Paulo Biennial. Wim Beeren, shouting "get out!" ordered Samba dancers to leave Malevich's room as they performed throughout the Biennial space celebrating 30 years of the introduction of the first Parangolé performance at the Museum of Modern Art in Rio de Janeiro.

14

MEMORY AND AGENCY

Bantu and Yoruba arts in Brazilian culture

Henry John Drewal

A central problem for an adequate theory of cultural history is how peoples' ideas and aspirations are transformed into practices and products. This chapter explores the arts histories of the African diaspora in Brazil, specifically Yoruba- and Bantu- speaking peoples and their descendants. I suggest that specific African theories of agency – *aṣẹ* or "performative power" among the Yoruba, and *mooyo/nkisi* or "empowering prescriptions" among Bantu peoples – help explain how Afro-Brazilians forged and continue to forge distinctive artistic worlds despite Euro-Brazilian attempts at cultural hegemony.

By *agency*, I mean the instrumentality of creating one's reality – the process of turning aspirations into practices and products. Such agency never occurs in a vacuum or by accident, but rather emerges out of what already exists. It is a response to events and situations, some that open up possibilities, others that close them off. Thus, people shape culture and history, just as culture and history shape them in complex ways. My focus on agency and suppressed or hidden accounts in both the historical literature and in contemporary social practices is informed by recent discussions on the nature of evidence, knowledge, and representation in issues of cultural dominance and resistance. The history of African diaspora arts *is* the history of self and cultural assertions of identity, where identity concerns *being* in the world. The study and analysis of African diaspora arts – the forms, images, practices, and ideas that persisted as well as those that disappeared or were largely transformed in specific situations – can provide keys to understanding the internal cultural dynamics operating in histories of cultural encounters – and the evidence of the arts in such histories.

When Africans were brought against their will to the Americas they may have come empty-handed, but they didn't come empty-headed. Even during the horrors of the Middle Passage, Africans in their shared misery began to form their own associations on board the ship, where they called each other in KiKongo *malungo*, friend, comrade.[1] This initial effort at *re-membering*, that is, restructuring society and the past, created a new synthesis from diverse cultural

elements, a process known as *creolization* or *transculturation*. Soon after arrival in Brazil, Africans adapted or established sacred and secular associations for mutual help, solidarity, and liberation.

One of these was the Catholic lay organization, or *irmandade*. Afro-Brazilians, whether they were Muslim, Christian, or followers of ancestral gods, managed to operate effectively within such Church groups, using them to their own advantage, and for their own purposes.[2] Thus the women of Boa Morte (Figure 14.1) carry their Christian icons in procession on Church festival days, as well as their beads of devotion to Africa's gods (*òrìṣà*) for night ceremonies. In addition, they wear on their bodies silver, copper, and gold waist pendants known as *balangandans*. Seen as "jewelry" by Euro-Brazilian society, such regalia actually served as commemorative objects and protective amulets. Cylindrical pendants, representing containers for documents of manumission, were symbols of freedom and assertive action or *aṣé*. Other symbols (keys, fish, birds, animal teeth) were associated with a variety of faiths, both African and non-African. Rather than thinking of this as a matter of religious "syncretism" which tends to convey a sort of "blending, homogenizing process," I would suggest we recognize the distinctiveness of each faith, the simultaneous interplay and juxtaposition of multiple beliefs and practices for persons whose histories demanded a refined, subtle, and effective facility for

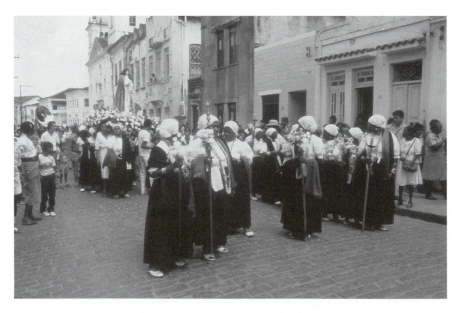

Figure 14.1 The women of the Catholic lay Sisterhood of Boa Morte carrying their Christian icons in procession while proudly displaying their beads of devotion to African gods. Photo: Author, 1987.

multiple consciousness. What was required was flexibility, a strategic pragmatism to multiple realities in order to be adepts at survival.

Background

From the fifteenth century, European expansion greatly accelerated and intensified the global encounters of cultures with radically different forms and concepts of art and artistic production. In Brazil, as in other parts of the Americas, such encounters involved Europeans, indigenous peoples, and Africans, especially Yoruba- and Bantu-speaking peoples. Yoruba-speakers were brought in the tens of thousands to Brazil between 1790 and 1850. Their large numbers, their late arrival during the Atlantic slave trade, as well as their clearly-articulated tenet of action and agency based on the concept of *aṣé*, "performative power; the ability to accomplish something," may help to explain their religious and artistic achievements.

Bantu-speaking peoples, primarily from Central Africa, came earlier and over a longer period of time (sixteenth to eighteenth centuries). Their theory of agency is contained in the terms *ntu* (being/existence), *mooyo* (life force) and *nkisi* (empowering objects) that make actions possible. The ideas of *mooyo/nkisi* are manifested in the socio-political and economic organizations Bantu peoples established in seventeenth century Brazil – free, independent political entities called *quilombos* or *mucambos*.

In what follows, I will suggest the ways in which Afro-Brazilians have used expressive culture, both forms and performances, to construct identities. I will also show how these forms of artistic expression have been and continue to be socially mobilized to confront, divert, and resist hegemonic forces in racist Brazilian society today.[3]

One nineteenth-century example can be seen in the Church of Lapina, Liberdade-Salvador which was designed and built sometime around the 1860s and 1870s by Manoel Friandes (b. December 25, 1823; d. August 4, 1904). Friandes was African, possibly Yoruba, but more particularly he identified himself as an African-Muslim or *imale*, the Yoruba word for Muslim. We know that he was a well-known and successful architect and builder who was commissioned to do a large number of commercial and ecclesiastical buildings throughout the city of Salvador, Bahia.[4]

The Lapina Church stands as a monument to nineteenth-century Afro-Brazilian religious and cultural resistance in architectural form, to self-expression in the face of hegemonic forces. The exterior of the church (Figure 14.2) is very staid and unelaborate in comparison to many Brazilian Baroque churches. Commissioned by the Church, which must have known he was Muslim, Friandes created a subdued, quiet, Christian exterior.[5] But within, he designed a forcefully exuberant Islamic space (Figure 14.3) with Moorish arches, decorative tiles, and most striking of all, Arabic script etched into the walls over the arches surrounding the nave and containing excerpts from Old

Figure 14.2 The exterior of the Church of Lapinha. Photo: Author, 1993.

Testament accounts of the Creation. How and why did Friandes obtain the patronage to design and construct this church, especially since the church was built not long after a series of armed revolts led by African-Muslims through-out the first half of the nineteenth century, the last and most violent taking place in 1835?[6] How did he negotiate the obviously Muslim interior design and combine it with the equally obvious Christian imagery? What did Friandes think and say about what he was doing, and how did it fit in with his other architectural projects? Is this an example of subversive expression – an assertion of self-identity as a Muslim, as an African, as a cultured, sophisticated professional man? Or all, or some (or none?), of the above? What were the responses of the Church hierarchy and parishioners? The Church of Lapinha

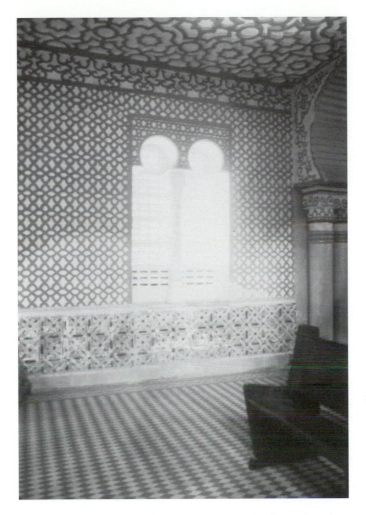

Figure 14.3 The Islamic interior of the Church of Lapinha. Photo: Author, 1993.

certainly stands as a monument to the enormously complex, seemingly incongruous, and fascinating juxtapositions of the contested religious ideologies, racial and class hierarchies, political possibilities, and economic forces that Afro-Brazilians had to negotiate. This monument is part of a hidden history, like so many others about Afro-Brazilians, waiting to be researched and told.

Bantu presence and impact in Brazil is evident in inscriptions on the land and in language. Bantu peoples arrived in large numbers throughout the seventeenth century and were dispersed to the north-east and further south. An early study of African influences in Brazil produced several remarkable maps (Figure 14.4) of the country, especially the north-east, showing countless

245

Figure 14.4 A map showing African influences in Brazil. From Mendonca, 1935.

African names for communities, historical events, and persons, mostly of Bantu origin.[7] For example, *mocambo* and *quilombo* refer to communities of escaped Africans, and the Yoruba word *exu* connotes a crossroads, but more than this, a locus of conflict, action, and decision. Thus an African presence fills Brazilian maps, both physical and mental.

African presence is also evident in language. Many Yoruba words and countless Bantu/Quibundo and Kikongo words and expressions have become a part of Brazilian Portuguese. The Yoruba words deal primarily with religion and the culinary arts while most of the Bantu words concern social, economic, and political matters (power, war, conflict, disorder, pursuit, flight, and action) that

resonate in the histories of two Afro–Brazilian phenomena – *congadas* and *quilombos*.[8]

Congadas and quilombos

Congadas (from the African word Kongo) are dramatizations of the coronations of African kings and queens, diplomatic missions and battles. In the state of Bahia they date to the beginning of the seventeenth century.[9] They seem to have been permitted by Portuguese officials to encourage inter-ethnic rivalries, to divide and thus more easily rule Africans. Yet Africans used them as a model and mechanism for self-government that helped shape socio-political institutions, processes, and ideals. For example, some of the late seventeenth-century *congadas* commemorated Queen Njinga Nbandi of Angola who died in 1663 after fighting valiantly to maintain the independence of her realm against the Portuguese. In the 1820s and 1830s the French artist Jean Baptiste Debret documented a Kongo king and queen in a church and an African funeral pageant not unlike the *congada* tradition (Figure 14.5).[10] Note especially the fellow in the foreground doing a handstand/cartwheel which may relate to a Bantu African performance tradition (*capoeira*) I discuss later. The memory of such powerful African rulers helped Afro-Brazilians to *re-member* their past, that is, bring it into existence in tangible ways; this was performed identity in which *bodily praxis was combined with material re-invention*. Thus these African elements – coronations of rulers, assertions of ethnicity, and military prowess –

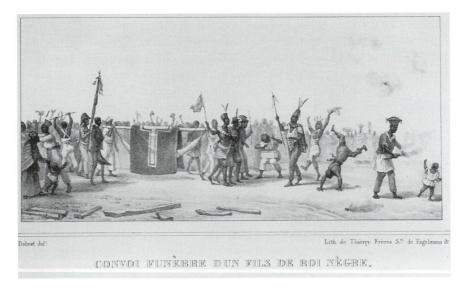

Debret del. Lith. de Thierry Freres S.te de Engelmann &

CONVOI FUNÈBRE D'UN FILS DE ROI NÈGRE.

Figure 14.5 From J.B. Debret, *Voyage Historique et Pittoresque au Brésil, ou séjour d'un artiste Français au Brésil*, 1834–5, vol. 3, plate 16.

probably had a significant impact among Afro-Brazilians, especially in the north-eastern state of Alagoas, where many Bantu-speaking Africans fled slavery and fought to create numerous independent communities called *quilombos*. The most famous was Palmares which survived most of the seventeenth century (1630–1695).[11] Its leader Zumbi continues to be the primary symbol for the Black Consciousness movement in Brazil today. November 20, 1995, the 300th anniversary of the death of Zumbi, was declared the National Day of Black Consciousness and was marked by conferences in different parts of Brazil and an unprecedented massive march in Brasilia protesting racism and the plight of black Brazilians.

The history of *quilombos* may be linked with the African martial art form of *capoeira*, a tradition of action and resistance through subversion.[12] The basic move or *jinga* has as its goal to respond to and move with a force, redirecting and transforming it – a moving metaphor of how Afro-Brazilians engaged hegemonic forces and subverted them. *Capoeira*, forged in an oppressive context, stressed the interplay of constraint versus freedom, the tactics of improvisation, and above all, the use of cunning, wit, and deception (called *malicia*) to defeat one's opponent.

Lizar paintings of Capoeira

Capoeira, undergoing a renaissance in Brazil and elsewhere, has also inspired many contemporary Afro-Brazilian artists. One of them is Sidnei Lizardo (Lizar) who remarked, "It is an Afro-symbol [of Black cultural resistance] that still has power today."[13] His works evoke a sense of flow, movement and action (Figure 14.6). Color harmonies are fundamental to Lizar's work. In some works they are subtle plays of hues, muted and often translucent washes, one laid over the other. Others are studies in bolder, more contrasting colors. Their juxtaposition segments, rather than unifies, the composition. The intensity of the colors pulls and pushes the forms against each other. Whether figuratively or abstractly rendered, his paintings capture the essence of *capoeira* – its grace, power, speed and rhythm. Due to police harrassment, *capoeira* had to hide its true nature as a martial artform. It did so by adding other arts – music, song, and dance. In a similar way, Lizar camouflages *capoeira* in abstractions in order to have us engage with color, line, form, and composition. His is a kind of visual *malicia* – playful wit and subterfuge, a stratagem for success in an art market controlled by Euro-Brazilians.

My final examples of Afro-Brazilian assertive actions using the arts come from the 1993 Carnival in Brazil. The Black Consciousness movement in Brazil continues to struggle to spread its message to wider audiences as revealed in a battle to control representation: the public controversy about the 1993 carnival decorations in the streets of Salvador, Bahia.

It began when city officials announced their decision to "celebrate" Salvador as the "city of the *òrìsàs*" (African deities honored in *candomblé*).

Figure 14.6 Sidnei Lizardo inspired by *capoeira*. From H. Drewal and D. Driskell, *Introspectives*, 1989, plate 5.

What they did not do was consult those most concerned – òrìṣà devotees, the *candomblé* community as officially represented by the Bahian Federation of Afro-Brazilian Cults (Federacao Baiano do Culto Afro-Brasileiro – FBCAB). This created a heated debate and protest, and a series of articles and editorials in the local newspapers and on television. Eventually the city negotiated a compromise. It agreed to reduce the number of decorations and to avoid direct reference to specific òrìṣà icons and symbols, replacing them with gener-alized "folkloric" images (Figure 14.7). It also eliminated a plan by the artist (a white Bahian) to create elaborate "decorations in *pemba* (sacred chalk)," that had been billed as the "symbol of Salvador." This was a hard battle to win, and yet at least a partial victory was achieved despite the odds. For once, the gen-erally independent, decentralized, politically and economically powerless Afro-Brazilian religious organizations were confronting powerful political and economic forces aligned with the government, the tourist industry, corporate businesses, and the Catholic Church. The Federation (FBCAB) was resisting the long-term Brazilian tradition of "folklorizing" or marginalizing African culture and religion, here being used for explicitly profit-making purposes of attracting tourist dollars to the most "authentic," that is, "exotic" carnival in Brazil.

Many questions surround this episode. What would have happened if FBCAB

Figure 14.7 A folkloric billboard for Carnival 1993. Photo: Author, 1993.

had been consulted in advance? Would they have agreed to go along with the plan? Would they have opposed it? Would they have helped shape it? If they had demanded that the city, *Baia de todos os santos*, the "Bay of *all* the Saints" include Catholic saints with African *òrìṣà*, or if city officials had suggested adding saints, would FBCAB have agreed? Would the Catholic Church have agreed, or would they have opposed this juxtaposition of saints with *òrìṣà*? There are many issues and questions to be considered in order to unravel the forces operating in this debate, and how and why they played themselves out as they did.

The creation of the world (and Brazil) according to Yoruba myth?

Our final example comes from the 1993 Samba School competition in Rio de Janeiro. In the midst of all the images of barely-clad bodies of the 1993 Rio

Carnival broadcast on Brazilian Globo TV, came images and a popular Samba song created by the Samba School Villa Isabel that celebrated an African Genesis – the creation of the world according to Yoruba legend. Not only did key figures in the Yoruba myth appear, such as the supreme creator Olorun and divine sculptor of life Oxala, but also several key Yoruba philosophical concepts. One, that served as the keynote for the entire extravagant display and song, was *GBALA*, the Christianized Yoruba word for *save, rescue, redeem*, translated as *resgatar, salvar*. The myth and theme were used to proclaim an environmentalist theme. One float (Figure 14.8) presented images of living forms emerging from clay (the medium from which Oxala shaped life) and surrounding a "tree of life," the tree also being a primary site of many

Figure 14.8 One of Villa Isabel's Carnival floats. From *Isto Es*, February 1993.

Afro-Brazilian altars and offerings. As the Samba School passed in review, the lyrics flashed on the television screen for viewers to read, learn, and sing.

It was a fantastic spectacle of life animated by *aṣẹ́*, but how are we to understand its significance? What were the intentions of its creators, and how and by whom were they formulated? What was its reception, its impact upon those who witnessed it live in Rio, or the millions of Brazilians who watched it on television? Was this the same kind of appropriation by dominant society that the Bahian Federation of Afro-Brazilian Cults opposed? Or by incorporating elements of Yoruba culture and language (Olorun, Oxala, *gbala*, and *orixas*) into the monied spectacle of Rio's Samba Schools, was Brazilian carnival giving space, legitimacy, and importance to African elements in the formation of Brazilian identity, or was it primarily a co-optation of an exotic, marginal mythology with no real connection to Brazilian realities? How are we to judge the nature of this artistic expression and its impact in formulating consciousness, its role in mobilizing social movements in Brazilian society? A systematic survey of the factions and "players" involved in this contest might suggest *how* specific interests were (or were not) turned into practices and *why*. These are some of the important questions surrounding issues of hegemony and resistance, agency and effect, and how we are to understand African diaspora arts and their impact in shaping society, culture, and identity.

In closing, according to my colleague Olabiyi Yai, Yoruba-speaking peoples have always thought of themselves as a *diaspora* and their artists as *are*, "itinerant persons," forever strangers on the move engaged in "constant departures" of creative invention. A Yoruba saying expresses it well: "Outside the walls of your home you have the right to choose the name that pleases you" (*oruko to wu ni laa je lehin odi*).[14] For centuries in Africa, during the horrors of the Middle Passage, and more than four hundred years of slavery and oppression in the Americas, Africans and their descendants have defined themselves using a multiplicity of means: re-membering the past; interpreting their situations pragmatically; adopting a variety of strategies and tactics in visual and performed artistic expressions to either subvert or confront the dominant society; and then taking action using the concepts of *aṣẹ́*, or *mooyo/nkisi* or *capoeira*'s tactic of wit and cunning, *malicia*, in order to survive, and even more, to thrive.

Notes

1 A. Ramos, *Las Poblaciones del Brasil*, translation by T. M. Molina, Panuco, Mexico, Fondo de cultura economica, 1944, p. 175.

2 D. Poole, "The Struggle for Self-Affirmation and Self-Determination: Africans and People of African Descent in Salvador, Bahia, 1800–1850," unpublished PhD dissertation, Indiana University, 1992.

3 For example, questions of hegemony do not simply involve the interactions of Africans, Indians, and Europeans. The same issues have operated *among* different African peoples as they attempted to define and assert their cultural identities in the

252

Americas. Thus Bantu-speaking peoples forged a cultural world that resonated with Central African ideas and forms that spread throughout Brazil, but especially the Northeast and around Rio de Janeiro. When West African peoples (Ewe, Fon, Gun, Mahin, Nupe and others) arrived in the 18th century, new cultural elements were added. Then at the end of the 18th and the first half of the 19th century came the last major influx of Africans – Yoruba-speaking peoples – whose massive numbers and cultural dynamism helped to create a dominating presence in many spheres of Brazilian and Afro-Brazilian life. Thus the complex interplays among *many* African peoples complicate greatly our understandings of the cultural "power plays" that have shaped African-Brazilian and Brazilian identity today. I thank C. Daniel Dawson for pointing to these issues, and for his suggestions and insights.

4 M. R. Querino, *Artistas Bahianos*, Rio, Imprensa Nacional, 1909, p. 206. I thank Snhrs. Cide Texeira and Pierre Fatumbi Verger for helpful information on Manoel Friandes.

5 The attribution of the Lapinha Church to Friandes has been called into question and remains subject to confirmation.

6 J. Reis, *Rebeliao Escrava no Brasil: A Historia do Levante dos Males (1835)*, 2nd Ed., Sao Paulo, Editora Brasiliense, 1987 [1986].

7 R. Mendonca, *A influencia africana no portugues do Brasil*, 2nd edn [illustrated with maps and engravings], Sao Paulo, Companhia Editora Nacional, 1935, oppos. p. 252.

8 J. T. Schneider, "An Afro-Brazilian Database Relevant to Cultural Transfer," *Anthropological Linguistics*, Winter, 1986, pp. 433–454 and *Dictionary of African Borrowings in Brazilian Portuguese*, Hamburg, Helmut Buske Verlag, 1991.

9 A. Ramos, 1939, *The Negro in Brazil*, translated from the Portuguese by Richard Pattee, Washington, DC, the Associated Publishers, Inc., 1939, chapter VIII; A. Ramos, *Las Poblaciones del Brasil*, translation by T.M. Molina, Panuco, Mexico, Fondo de cultura economica, 1944, pp. 159–71.

10 J. B. Debret, *Voyage Historique et Pittoresque au Brésil, ou séjour d'un artiste français au Brèsil*, Paris, Didot Fréres, 1834– 35, 39 [1965 edition published in 3 vols], Rio, Edicao comemorativa do IV centeario da cidade de sao Sebastiao do Rio de Janeiro, distribuidora record, Rio, vol. 3, plate 16 (bottom).

11 M. A. Luz, *Agada: Dinamica da Civilizacao Africano-Brasileira*. Salvador: UFBA, Centro Editorial e Didatico, and SECNEB, 1995, pp. 400–428.

12 C. D. Dawson, "Capoeira: Africa's gift to Brazil, Brazil's Gift to the World," mss in press; B. Almeida, *Capoeira: A Brazilian Art Form*, Berkeley, North Atlantic Books, 1986; J. L. Lewis, *Ring of Liberation: Deceptive Discourse in Brazilian Capoeira*, Chicago, Chicago University Press, 1992.

13 H. Drewal and D. Driskell, *Introspectives: Art by Americans and Brazilians of African Descent*, Los Angeles, California Afro-American Museum, 1989, p. 41.

14 O. B. Yai, "In Praise of Metonomy: The Concepts of 'Tradition' and 'Creativity' in the Transmission of Yoruba Artistry over Time and Space," in Abiodun, Drewal, and Pemberton, eds, *The Yoruba Artist: New Theoretical Perspectives on African Arts*, Washington, DC, Smithsonian Institution Press, 1994, pp. 112–114.

15

PRACTICING MODERNISM

". . . for the master's tools will never dismantle the master's house . . ."[1]

Aline Brandauer

I

The history of art has had comparatively few interventions into what can be generally called sub-altern studies. I use that term not to refer to the activity of recuperating categories of art for traditional documentation, but rather to the analysis of ways in which those categories are determined and their consequent effects and implications for cultural practice. There are increasing examples of the first, which serve to save information as well as to feed ever-widening markets. The second is much rarer in our field because it *assumes* the first and radically alters the categories of the discipline. It is this alteration that is the focus of this essay.

What I would like to do, in response to case studies of "diaspora and modern visual culture"[2] is to raise issues about this topic in a more theoretical frame. What seems at stake in our discussion are the identity conditions of modernism itself, and how those begin to shift as we look at its development outside the metropolitan centers of Europe and North America, or, alternatively, from the points of view of those whose agency has been ignored or suppressed in its development. If, to generalize, one considers that the term "modernism" refers both to an epistemological bracketing that prizes increasing self-referentiality, and to cultural products that come about in an industrializing or industrialized society, the initial models have been derived necessarily from European and North American examples – for the simple reason that industrialization took place there first. As one looks at developments in other parts of the world or acknowledges multiple cultural entities in the traditionally cited places, alternative models of "the contemporary world" present themselves, thus complicating easy descriptions of a modern aesthetic or agenda.

The late Raymond Williams took the comparatively conservative view of this dilemma in "The Emergence of Modernism" when he exhorted scholars – or culture workers – to

see ... the imperial and capitalist metropolis as a specific historical form, at different stages: Paris, London, Berlin, New York. It involves looking, from time to time, from outside the metropolis, from the deprived hinterlands, where different forces are moving and from the poor world which has always been peripheral to the metropolitan systems. This need involve no reduction of the importance of the major artistic and literary works which were shaped within metropolitan perceptions. But one level has certainly to be challenged: the metropolitan interpretation of its own processes as universals.[3]

For Williams, it is the urban center as symbol and embodiment of "the modern" that must be viewed from multiple viewpoints; the country can give us viewpoints on the city that it cannot provide for itself – as, of course, the country can be read by the city in equivalent fashion. But this still leaves us in a world where the discourse is determined by the voices of empire, no matter how well-meaning. The "city" remains a so-called first world phenomenon whose polyphony comes from the competing classes within its dominant occidental culture, whose overarching voice is assumed.

II

Diaspora, more than nomad or certainly exile, is, as Carol Zemel writes in this volume, based on the idea of "a fragmentation and scattering of a once-unified people."[4] A people once unified by what? Race, perhaps, but culture certainly – and culture is a term that is itself increasingly under fire in a shifting semantic universe.[5] The word, so deeply invested with the progressive modernism of the late nineteenth and early twentieth century[6] has itself accrued connotations of monolithic and often primitivizing intent.[7] "Your culture" or, more often, "their culture" inscribes difference determined by the outsiders.[8] "Culture," therefore, becomes the imputation of a unified, often transhistorical, field of behavior whose origins spring from Western scientific discourse. To have a culture is, by definition, to admit that multiple cultures exist but only if evaluated in functional categories determined by anthropology. If a culture involves ways of eating, mating, dealing with death and stratifying a group of people, it follows that someone or some discipline has determined that those are relevant categories. Trinh, for example, reads against the grain of the language of the so-called Great Master that pronounces truths from the space of scientific logic. By emphasizing the inclusion or exclusion of pronominal reference in passages such as the following from Malinowski's *Argonauts,* Trinh reveals both the assumption of who controls the universalizing concept of "human nature" and who remains its ultimate example with auxiliary information imported from "the natives."

Perhaps as *we* read the account of these remote customs there may emerge a feeling of solidarity with the endeavors and ambitions of *these natives*. Perhaps *man's* mentality will be revealed to *us*, and brought near, along some lines which we never have followed before. Perhaps through realizing *human* nature in a shape very distant and foreign to us, we shall have some light shed on *our* own. In this, and in this case only, we shall be justified in feeling that it has been worth *our* while to understand these natives, *their* institutions and customs.[9]

This model is one in which the "culture" of the natives is determined by Trinh's "Great Masters" (in this case instantiated by Malinowski) almost entirely for the needs of their (the Great Master's) own society. And here's the rub – for this model can and does lead to a vision of multiculturalism, but *not* one of plurivocality. This is the problem felt so acutely by the first wave of post-colonial authors like Frantz Fanon as they searched for a language they could own.[10] In *Black Skin, White Masks* Fanon returns over and over to the issue of language; is he using the imperial language (in this case French) to describe his colonial status or is he necessarily described by it. Is there, he opines, a way out? To address a wider audience he must use the European language, he is after all a writer and a doctor, but can the voice he uses speak of the specificity of his position as he experiences and creates in multiple worldviews. Frantz Fanon moves, in less than ten years, from theoretical concern about language and attempts to unravel social codes to political radical. By 1961, the Martiniquean doctor is advocating a separate but new set of cultural constructions in *The Wretched of the Earth*.

Leave this Europe where they are never done talking of Man, yet murder men everywhere they find them, at the corner of every one of their own streets, in all the corners of the globe. . . .
So, my brothers, how is it that we do not understand that we have better things to do than to follow that same Europe? . . .
Come then, comrades, the European game has finally ended; we must find something different. We . . . can do everything as long as we do not imitate Europe, as long as we are not obsessed by the desire to catch up with Europe . . .
Yet it is very true that we need a model, and that we want blueprints and examples. For many among us the European model is the most inspiring . . . We have therefore seen in the preceding pages to what mortifying setbacks such an imitation has led us. European achievements, European techniques, and the European style ought no longer to tempt us and to throw us off our balance.[11]

Fanon advocates, therefore, an alternative modernism. Moving toward a more equal, and more economically developed world is part of his vision – in

no way does he want an agrarian utopia – but it is not that universal modernity advocated by European capitalism. Nor is it capitalism's equally universalizing, necessarily dependent pendant, Soviet-style communism. Fanon's suspicion of totalizing systems extends to overarching socialism, and tends strongly to the models of Che Guevara and subsequent "Third World" variations that were intended to insure plurivocalism, however tragic their outcome.

III

The post-colonial diasporic vision was put succinctly several years ago": "There is a Third World in every First World and vice versa."[12] This point is at the center of each of the chapters in this volume – especially if we let go of the slightly outdated formulations of First, Second, Third, and, especially suspect, Fourth worlds. Diaspora, the nomad[13] and the foreigner[14] all are stories of *interpenetration* – that most feared and *gendered* enemy of formulations of "modernism" and the nation state. The coexistence and inevitable cross-pollination of "cultural traits" and values are often viewed as threatening to both the diasporic group and, for lack of a better term, the "host" group.

Metissage can often itself become identified with the closed imaginary of the nation, such as in Mexico. In that country, the Revolution of 1910 increasingly sought to forge a nation whose spirit contained the best of all the races and cultures that inhabited Mexico. The "Cosmic Race" as politician and philosopher José Vasconcelos called it, would be firmly based in the indigenous roots of the country but incorporate the attributes of Europeans as well.[15]

This strategy runs the risk of stopping the discourse of interpenetration by locking down uncertainty of identity, of the play of *différance* and difference into closed definitions that reiterate and continuously re-present static identity conditions. This strategy can also be seen in the melting-pot formulation of the U.S. or certain liberal readings of British post-colonialism.

A more direct example of the seduction of a monolithic image of the nation state and its inability to sustain permeability as a possibility, much less as a positive aspect reveals itself throughout modernist imagery. Klaus Theweleit's work on the fantasy life of Freikorps members reveals this displacement of nation as phallocratic state threatened repeatedly by the double threats of internal and external enemies, the inchoate fears of desire, menstrual blood and the stench of the battlefield. "The monumentalism of Fascism," writes Theweleit,

> would seem to be a safety mechanism against the bewildering multiplicity of the living. The more lifeless, regimented and monumental reality appears to be, the more secure the men feel. The danger is being-alive itself.[16]

Now, it is easy – a relatively cheap shot – to talk about the phallocentric aspects of modernism and its feminist critique. Certainly we've all been there

and done that. What has been less talked about is the positive aspects, the constructive aspects of a model of permeability for historians. The question that I would like to pose is: what might those aspects be above and beyond the necessary and daunting work of revising the historical record? And what of the nature of evidence, which I will bring up again soon.[17]

IV

Trinh T. Minh-ha, that subtle and indefatigable commentator on these issues, addresses the problem of how to conceptualize "identity" as nodes in a shifting web of actions and subject positions. Told as the story of alternative "Third World" ways of knowing and communicating in a village meeting, the tale is wrapped itself in *différance* and difference:

> The story never stops beginning or ending. It appears headless and bottomless for it is built on differences. Its (in)finitude subverts every notion of completeness and its frame remains a non-totalizable one. The differences it brings about are differences not only in structure, in the play of structures and of surfaces, but also in timbre and in silence. We – you and me, he and she, we and they – differ in the content of the words, in the construction and weaving of sentences but most of all, I feel, in the choice and mixing of utterances, the ethos, the tones, the paces, the cuts, the pauses. The story circulates like a gift; an empty gift which anybody can lay claim to by filling it to taste, yet can never truly possess. A gift built on multiplicity. One that stays inexhaustible within its own limits. Its departures and arrivals. Its quietness.[18]

This short text is a description of Trinh's desire to push away from or to avoid (surely not simply to transcend) the dualities of modernism with its concurrent real cruelties to real people. What, she asks, does it look like to not be in this framework – and she answers that the effects of the modern dilemma are experienced in the Third World but that the epistemological models of modernism are not the universals Euro-Americans would like to believe. But once again it is the "Third World in every First World and vice versa" where the crux of the matter lies. And that actuality is at the root of the modern, with developments of global economy, communication, colonialism and dependence. Trinh is placing herself in the breach described above by Fanon.

The multiplicity is the gift that diaspora studies will bring to modernism as its constant production in the interstices of the industrial and imperial projects becomes better known. Carol Zemel's study of the representation of the *shtetl* for diasporic Jewish audiences complicates not only the issue of constructing nationhood for pre-Israel Jews, but also confounds the extraordinarily clear and important work of Raymond Williams on the country and the city. The

anxiety revealed by Zemel in the determination of diaspora nationalism is, I believe we will discover, inherent in the foundations of modernism and nationalism itself. The reading of the country, of the old ways, sought after but equally fervently denied, pulled into representation as fragments are but the tip of the iceberg. The *suturing* that post–Althusserian scholars of "purely Western art" have been discussing for a quarter of a century will be increasingly revealed in the modern project as studies like those comprising this volume continue to be written.

Suturing is also almost painfully obvious in the self-conscious manipulations of nationhood and gender politics engaged in by Marcoussis and Halicka, according to Paula Birnbaum. Attempts to eradicate specific histories with their national and religious particularities in order to fit in, to "pass" as was said of Blacks and Jews in the United States, throws the "passer" not into a partic-ular but different set of cultural behaviors, but directly into the maw of Trinh's Great Master with his universalizing reductive terms. But here the problemat-ics of agency arise – to be given voice in the work of H.J. Drewal and Simone Osthoff on different diaspora.

V

Henry J. Drewal's discussion about Bantu and Yoruba arts in Brazilian culture reaches deeply into the reaches of interpenetration. Memory and agency; legacy and action. The argument centers on the nature of evidence, both in historical interpretation and in the knowledge and action of re-membering. History, by definition, and as we know, is concerned with texts. Preferably the real thing: ink on paper. Lacking that, however, clever historians have taken to calling increasing numbers of things or kinds of things, texts. Happily subject-ing all those kinds of things to textual analysis, the forward-looking historian still looks back with the gaze of Trinh's Great Master.[19] Drewal challenges this directly by considering two notions, performativity and agency, as they func-tion polyvalently. Such practices as *capoiera* and the Samba, claims Drewal, re-member fragmented knowledge and reconfigure it within a creolized or transcultural present where, of course, it may signify very differently than it did in its original context. The development and transmission of cultural knowl-edge under atrocious repression followed by attempted co-optation is sited in *the body*. The body as *active* epistemological site is still little understood within historical studies – in large part because of its resistance to being fully glossed as text and, closely related, because of its resistance to dualistic enlightenment models of knowledge. The body has been much theorized recently, but largely as a passive recipient rather than an instigator. Henry Drewal's chapter is just the sort of model that diasporic studies can engage in to shift not only our ideas about modern visual culture, but also the nature of evidence.

As with Zemel's piece on representing the *shtetl*, Hélio Oiticica's serious play with European high modernist art highlights the interpenetrations of

various worlds within "Modern art." Yet his model, child of a much later and changed universe, *embodies*. As Simone Osthoff aptly points out, this artist is a nomad, one of those who can reframe and de-territorialize cultural paradigms *because of their ability to move between worlds*. Oiticica is not only on the forefront of post-modernism with Parangolés because of his ability to be, as the Mexicans say: *no soy de aqui no soy de alla* – neither from here nor from there – but because of his abilities to shift between types of practice qua evidence with ease and grace. Oiticica appears to have avoided the pitfalls Fanon describes by remaining in the interstices between different positions. He defused the universal by *using* its forms and in so doing placing himself in Trinh's village story that always evolves and shifts, that is owned by everyone and no one who tells it.

Fragments and fluidity characterize the form of many of these visions of diaspora, but to return to the development of the modern world the continual interpenetrations of people, cultural practices and economic and social realities ensured that the meanings and uses of chunks of cultural practice have floated far more widely than art history has yet accepted. Our discipline, however, has tools at hand, some rejected as being horribly old-fashioned, that can help us draw new maps of the territory.

Notes

1 Audré Lorde, "The Master's Tools Will Never Dismantle The Master's House," *This Bridge Called My Back: Writings By Radical Women of Color*, Watertown, Persephone Press, 1981, C. Morraga and G. Anzaldúa , eds, p. 99.
2 This chapter was initially the response to the four papers given in Nicholas Mirzoeff's 1996 College Art Association panel, "Diaspora and Modern Visual Culture," upon which this book is based. My thanks to Nick Mirzoeff, Allan Antliff and Claire Farago for their advice and Quetzil Castañeda for lively discussion and permission to cite from his forthcoming book.
3 Raymond Williams, "The Emergence of Modernism," *The Politics of Modernism*, London, Routledge, 1989, pp. 47.
4 Carol Zemel, page 193 this volume.
5 See, for example, Quetzil Castañeda, *In the Museum of Maya Culture: Touring Chichen Itza*, MN, University of Minnesota, 1996.
6 I refer especially to the cultural anthropology of Franz Boas and his followers.
7 Castañeda, ms. chapter 1.
8 Trinh T. Minh-ha, "The Language of Nativism: Anthropology as a Scientific Conversation of Man with Man," *Woman, Native, Other*, Bloomington, Indiana University Press, 1989, passim.
9 Ibid., p. 58.
10 See Frantz Fanon, *Black Skin, White Masks*, originally published in 1952.
11 Frantz Fanon, *The Wretched of the Earth*, New York, Grove Press, 1963 trans. Constance Farrington, pp. 311–13, originally published 1961.
12 Trinh T. Minh-ha, "Difference," *Woman, Native, Other*, p. 97–8
13 In its formulation by Deleuze and Guattari in, for example, *Nomadology: The War Machine*, New York, Semiotext(e), 1986.
14 This construction was taken up most vociferously by Eastern European intellectu-

als in Western Europe during the dissolution of the former Yugoslavia. Notable examples can be found in recent writings by Kristeva, Todorov and to a lesser extent Zizek.

15 José Vasconcelos, *La Raza Cosmica*, Mexico City, 1925. "Forging the nation" refers to another architect of *mestizaje*, archaeologist Manuel Gamio's *Forjando Patria*, Mexico City, Porrua, 1916. This line of reasoning still serves a political purpose. At the Théâtre de l'Odéon in Paris during the 1992 quincentennial, author and diplomat Carlos Fuentes assured an audience of diplomats, journalists and others, that what Latin America had to offer the world was the concept and valorization of *mestizaje*, which, he claimed was long-standing and unproblematic in Mexico. In light of the crumbling of Eastern European nation states, it was a brilliant remark, if untrue.

16 Klaus Theweleit, *Male Fantasies*, vol. 1, Minneapolis, University of Minnesota Press, 1987, p. 218, trans. Stephen Conway.

17 See also my "Documentary Film Divided: Titayna's Indiens, nos frères and the multiple spaces of Mexico, 1930," *Arte y Espacio: XIX Coloquio Internacional de Historia del Arte, 1995*, Mexico City, UNAM, 1997 for a discussion of the shifting nature of evidence and their roots in historical studies.

18 Trinh T. Minh-ha, "The Story Began Long Ago . . ." *Woman, Native, Other*, p. 2.

19 Ibid.

INDEX